Sexuality and Gender
in Early Modern Europe

This book's exploration of sexuality and gender in Renaissance literature starts from an assumption that would have seemed unthinkable a generation ago: that the "natural" phenomena of sex, gender, and subjectivity are *constructed* rather than essentially biological or fixed. The essays in this collection rise to the challenge of producing a new post-Foucaultian history of gender and sexuality. All of them have been influenced by feminism, and several deal with women not just as objects of representation, but as subjects and authors in their own right. Among the historical issues examined are the production and suppression of women's voices, the relation between illicit sexuality and social order, the ambiguity of beauty, lesbian erotics, birth-imagery and the birthing ritual, the class status of women, the "femininity" of masculine dress, and the sexual politics of courtesy. The volume provides a new perspective on the literature, art, and society of Renaissance Italy, France, and England.

Sexuality and Gender in Early Modern Europe

Institutions, texts, images

Edited by

JAMES GRANTHAM TURNER

CAMBRIDGE
UNIVERSITY PRESS

Published by the Press Syndicate of the University of Cambridge
The Pitt Building, Trumpington Street, Cambridge CB2 1RP
40 West 20th Street, New York, NY 10011–4211, USA
10 Stamford Road, Oakleigh, Melbourne 3166, Australia

First published 1993
Reprinted 1995

Printed in Great Britain at the University Press, Cambridge

A catalogue record for this book is available from the British Library

Library of Congress cataloguing in publication data
Sexuality and gender in early modern Europe: institutions, texts,
images / edited by James Grantham Turner.
p. cm.
ISBN 0 521 39073 7 (hardback). ISBN 0 521 44605 8 (paperback)
1. Literature 2. History 3. Feminism and the arts 4. Sexuality in art
I. Turner, James, 1947– .
NX180.F4S488 1993
700'.1'03 – dc20 92–26038 CIP

ISBN 0 521 44605 8 paperback

CE

Contents

৶

CONTENTS

Illustrations

ॐ

Notes on contributors

❧

CRISTELLE L. BASKINS, Assistant Professor of the History of Art at the University of Rochester, received her Ph.D. from the University of California at Berkeley. She is currently working on a book, *Adversity's Heroines*, which examines the construction of female exemplars in Renaissance domestic painting. She has published articles on Jacopo del Sellaio and confraternal patronage, and on images of "Griselda" and "Susanna and the Elders" in *cassone* painting.

JULIET FLEMING is Assistant Professor of English at the University of Southern California. She is the author of *Ladies' Men, the Ladies' Text, and the English Renaissance* (London, forthcoming).

JAMES F. GAINES is Professor of French at Southeastern Louisiana University and general editor of the "Sociocriticism" monograph series, published by Peter Lang. He has written widely on early modern French drama (Molière, Corneille, Du Ryer, Garnier), fiction (Scudéry, Furetière), and moralists (Pascal, La Bruyère, Boileau), as well as on the relations between visual and textual representation in French classical painting and sculpture.

CONSTANCE JORDAN is Professor of English at the Claremont Graduate School. Her publications include *Pulci's Morgante: Poetry and History in Fifteenth-Century Florence* (London and Toronto, 1987), and *Renaissance Feminism: Literary Texts and Political Models* (Ithaca, N.Y., 1990).

DAVID KUCHTA received his Ph.D. in history from the University of California, Berkeley, in 1991, and then became a postdoctoral fellow at the Rutgers Center for Historical Analysis. He is currently Lecturer in the Humanities Program, University of California, San Diego.

KATHARINE EISAMAN MAUS, Associate Professor of English at the University of Virginia, is the author of *Ben Jonson and the Roman Frame of Mind* (Princeton, 1985), and the editor of *Soliciting Interpreta-*

tion: Literary Theory and Seventeenth-Century English Poetry (Chicago, 1990) and *Four Revenge Tragedies of the English Renaissance* (Oxford, forthcoming). She is currently at work on a book entitled *Spectatorship and Interiority in English Renaissance Drama.*

JANEL MUELLER is Professor of English and Humanities at the University of Chicago, and editor of *Modern Philology*. Her relevant earlier scholarship, from the perspectives of this collection, includes essays on Queen Katherine Parr as author (in *The Historical Renaissance*, ed. Heather Dubrow and Richard Strier [Chicago, 1988], and in *Huntington Library Quarterly* 53 [1990]), and a briefer preliminary study of her subject here (in *Journal of Homosexuality* 16 [1991]). Mueller is currently at work on four essays on Milton's *Samson Agonistes* from diverse critical approaches, one of which situates Samson and Dalila within the competing gender discourses of the late Renaissance.

MARY PARDO is Associate Professor of Art History at the University of North Carolina at Chapel Hill. She has published articles on Savoldo, Leonardo, and Giotto, and is the author of a book, *Paolo Pino and the Origins of Venetian Art Criticism* (Berkeley, forthcoming). Her current research is on C. Cennini's and L. B. Alberti's contributions to the Renaissance analysis of the "parts of painting."

MAUREEN QUILLIGAN, May Co. Professor of English at the University of Pennsylvania, is the author of *The Language of Allegory: Defining the Genre* (1979), *Milton's Spenser: The Politics of Reading* (1983), and *The Allegory of Female Authority: Christine de Pizan's Cité des Dames* (1991). She is also coeditor of *Rewriting the Renaissance: The Discourses of Sexual Difference in Early Modern Europe* (1986). She is currently at work on a book about female political and literary authority in sixteenth-century France and England.

JOSEPHINE A. ROBERTS is the William A. Read Professor of English Literature at Louisiana State University. Her publications include *Architectonic Knowledge in the New Arcadia (1590): Sir Philip Sidney's Use of the Heroic Journey* (Salzburg, 1978), an edition of the poems of Lady Mary Wroth, and essays on Renaissance poets in a variety of journals, including *English Literary Renaissance, Huntington Library Quarterly*, and *Comparative Literature*. She is preparing an edition of Lady Mary Wroth's *Urania* for the Renaissance English Text Society.

MARGARET F. ROSENTHAL, Associate Professor of Italian at the University of Southern California, is the author of articles on Veronica Franco and late sixteenth-century Venetian literature. She has written a

book, *The Honest Courtesan; Veronica Franco, Citizen and Writer in Sixteenth-Century Venice* (Chicago, 1992).

GUIDO RUGGIERO, Professor of History at the University of Connecticut, has published two books: *Violence in Early Renaissance Venice* (New Brunswick, N.J., 1980) and *The Boundaries of Eros: Sex Crime and Sexuality in Renaissance Venice* (New York, 1985). He has also edited a volume with Edward Muir, *Sex and Gender in Historical Perspective, Selections from Quaderni Storici* (Baltimore, 1990), which is the first volume of a series of translations from the innovative Italian journal *Quaderni Storici*. In addition he is coeditor with Judith Brown of the Oxford University Press series *Studies in the History of Sexuality*.

MICHAEL C. SCHOENFELDT is Associate Professor of English at the University of Michigan-Ann Arbor. He is the author of *Prayer and Power: George Herbert and Renaissance Courtship* (Chicago, 1991), and is currently at work on a book entitled *The Conduct of Desire in the Renaissance*.

DOMNA C. STANTON, Professor of French and Women's Studies at the University of Michigan, is the author of *The Aristocrat as Art* (New York, 1980) and *Women Writ, Women Writing: Gender, Discourse, and Difference in Seventeenth-Century France* (Chicago, forthcoming), and the editor of *The Defiant Muse* (1986) and *The Female Autograph* (Chicago, 1987). In July 1992 she assumed the editorship of *PMLA*.

JAMES GRANTHAM TURNER is Professor of English at the University of California, Berkeley. He coedited *Politics, Poetics and Hermeneutics in Milton's Prose* for Cambridge University Press (1990), and has written *The Politics of Landscape: Rural Scenery and Society in English Poetry, 1630–1660* (Oxford, 1979), *One Flesh: Paradisal Marriage and Sexual Relations in the Age of Milton* (Oxford, 1987), and numerous articles on seventeenth- and eighteenth-century culture.

NAOMI YAVNEH recently completed her Ph.D. in Comparative Literature at the University of California, Berkeley, and teaches in the Italian Department at the University of California, Davis. She is currently at work on a project entitled *Re-presenting Rape in the Renaissance*.

Preface and acknowledgements

The essays in this volume – ranging through literature, art, and society in Italy, France, and England – rise to the challenge of producing a new history. All of them have been deeply influenced by feminism, and several deal with women not just as objects of representation, but as subjects and authors in their own right. None is content to apply a ready-made methodology or vocabulary, or to accept conventional divisions of subject matter; "institutions, texts, and images" intersect in each essay, though the different academic disciplines determine the emphasis. Most start from an assumption that would have seemed ludicrous or unthinkable a generation ago – that certain allegedly natural conditions are really "constructed" rather than essential or biologically fixed. This applies to one's own subjectivity, to the sense of belong[ing to] one gender or another, and to the core of sexual experience.

Michel Foucault called for a new "history of sexuality" in 1976[;] new field of study would break away from scientific models (s[uch as] positivist "sexology" or the "repressive hypothesis" of psychoan[alysis] and establish sexuality as the product of specific historical cond[itions] penetrated and controlled by discourse in the interests of power. Foucault's stimulating suggestions opened up an exciting possibility: he abolished, at a stroke, all existing methods of combining sex and history – the psychoanalytic speculations that were *ipso facto* impossible to prove, the "lascivious erudition" that seemed only one step removed from pornography, or the dour compilation of population studies. But he did not solve the problem of how to put these insights into practice. Most theorists and historians in the rapidly expanding fields of sexuality, family, and gender would now reject his findings and hypotheses, even if they respect the gadfly quality of his mind and explore the implications of his once-startling conjunction, "history" with "sexuality."

If Foucault can be superceded, then, it is partly because his provoca-
tive suggestions have succeeded too well. Countless studies now cite
him as an authority (sometimes as a substitute for real historical
evidence), and conclude, more or less triumphantly, that sexuality is
"constructed" by the particular texts under discussion. Fuller develop-
ment of his ideas runs into a further complication: Foucault's own
"histoire de la sexualité" changed course radically during its com-
position, creating two quite different models for imitation. As David
Halperin remarks, the first volume, "for all its admittedly bright ideas, is
dogmatic, tediously repetitious, full of hollow assertions, disdainful of
historical documentation, and careless in its generalizations," in marked
contrast to the parts published after Foucault's death (*One Hundred
Years of Homosexuality*, New York and London, 1990, p. 64). Yet the
influence of his earlier work – exaggerated, aphoristic, and paranoid,
especially on the subject of surveillance – remains far greater than that of
the later volumes, richly detailed and carefully argued studies of
antiquity that have set the agenda for younger classicists like Halperin.
A volume of essays like *Before Sexuality: The Construction of Erotic
Experience in the Ancient Greek World*, coedited by Halperin with
Froma Zeitlin and John Winkler (Princeton, 1990), sets the standard to
which historians of early modern sexuality should aspire.

The current collection thus moves away from the monolithic influ-
ence of early Foucault and aims to be more independent and eclectic,
deliberately drawing on multiple perspectives and disciplines. This
raises fundamental questions. What is involved in thinking historically
about sexuality? What are the theoretical preconditions – and problems
– of combining various disciplines into a genuine "history of sexuality"?
What is the relation among historians of society, literature, and art, and
can we establish common ground among literary characters, visual
images, and real individuals, or among the different national cultures of
Europe? If so, does this mean that sexuality is indeed a universal and
ahistorical phenomenon, as argued by right-wing philosophers like
Roger Scruton, reacting against Foucault? How does our understanding
of the "construction of sexuality" change when we study the role of
women, in society and the arts, during the "Renaissance" – if indeed the
term can be applied to women's history?

This "multidisciplinary" study began, years ago, during a conference
entitled "Perspectives on Love, Friendship, Marriage, Sexuality and
Women in the Renaissance," one of a series organized at the National
Humanities Center, North Carolina, by the distinguished literary

historian Jean H. Hagstrum, involving several of the current contributors. It can thus claim kinship with other work germinated by those symposia, notably the outstanding essay collection *Before Sexuality* (cited above). Even though the project has metamorphosed considerably since 1986, I hope that Hagstrum can still recognize his founding influence, on this and all studies of "sex and sensibility." My thanks are also due to the contributors themselves, who worked patiently through several revisions at my request; to Randolph Starn, who pointed me to new Berkeley dissertations from which I was able to commission essays; to a large array of anonymous readers; and to Kevin Taylor at Cambridge University Press, who helped to shape the volume and yet allowed it to expand beyond its first contracted scope. An earlier draft was even more cornucopian than this one, and I must take the responsibility for having trimmed the once-generous notes to a minimum.

A history of sexuality?

JAMES GRANTHAM TURNER

ટ્સ

If we put the sex back in history, where does this leave the Renaissance? In an essay frequently cited below, Joan Kelly asks whether women had a Renaissance at all: their material position weakened despite their idealization, and the apparently "feminine" aspects of court culture largely belonged to men.[1] The next generation is revising Kelly in two ways, either by reconstructing women's own self-definitions, including but not confined to their own sexual self-presentation – examples would be Rosenthal's work on Veronica Franco, and Gaines and Roberts on women's fiction – or by emphasizing those aspects of male sexual behavior that prompt us to ask whether *men* had a Renaissance. What if we seek our typical image of "Renaissance man" not in the Sistine Chapel, but in the Sack of Rome? What if we define as constitutive texts not Pico's oration on the dignity of man, but Aretino's almost unreadable descriptions of orgies and gang-rapes; not Gargantua's education or the Abbey of Thélème, where men and women participate in equal numbers, but the tricks of Panurge, who smears women (literally) with the crudest sexual material? Or rather – since a "historical" project requires the most comprehensive reading possible – could our starting point be the manifest connection *between* these abject and sublime moments?

Aretino's scenes of sexual violence reveal themselves to be densely historical in two senses. Firstly, they turn out to have a basis in fact; gang-rapes masquerading as vigilantism against prostitutes have been widely documented among the bachelries and "abbeys of misrule" of early modern Europe (see pp. 17–18). And secondly, they proclaim their own historicity, their own affinity with epochal events: "her eyes blood red, her cheeks swollen, her hair disheveled, her lips dry and cracked, her clothes torn to shreds, she looked like one of those nuns cursed by both mother and father who were trampled under the Germans' feet as

they marched into Rome."[2] The "public" realm of the Sack and the "private" realm of sexuality encode one another. The violated woman became a figure for the devastation of the city, while the Sack itself was conceived in sexual terms; before and after the event, Rome was represented as a new Sodom destroyed on account of the pope's affairs with men, as a violated virgin, and as the Whore of Babylon – an image made all too literal when the Lutheran troops raped nuns and sold off aristocratic women in rituals of public humiliation. (They also made sure to abscond with the Holy Foreskin.) Later accounts turn the violation of the nuns into gloating pornography, reversing Aretino while confirming the same association. In one case Aretino's whore-dialogue and a description of the Sack were combined in a single publication.[3]

How then should we read such passages and such authors? Ruggiero reads Aretino both for the content and the tone, using him as both a documentary source for the "culture of illicit sexuality" revealed in the archives, and an indignant satirist on behalf of women (pp. 13–17). Historians should weigh two further possibilities, however. Renaissance sexual discourse may be conventional rather than realistic, self-consciously emulating the stylized obscenities of Petronius and Martial or imitating the "lower bodily stratum" in an artificially gross and incontinent style. And this performative or gestural meaning may undermine the text's apparent moral concern. Aretino's speakers condemn the violence and pity the victim, but the description itself revels in its bawdy vocabulary and lingers over the erotic details of the body exposed to blows. The text effectively assaults the female reader and incites the male reader to share the rapists' sadistic pleasure, complicit in the "dirty joke."

The essays in this volume converge, from several different disciplines and cultural perspectives, on related questions: the historicity of sex and gender, the conflict of violence and idealization, the connection between the punitive and the normative. They seek to transform the bodily realm (reproductive or seductive) into figures of larger significance for the practice of art (Pardo, Maus), for the maintenance of masculine identity at court (Kuchta), or for the institutional treatment of women. All explore what Ruggiero calls "the nexus of discourse and organization" (p. 11), what we might term – recognizing the contribution of art history – the reciprocal constitution of institutions and representations, whether image or text. Are we then engaged in a single project of historicization, an "histoire de la sexualité" along Foucaultian lines, or

do disciplinary and cultural divisions intervene, divisions as concrete and specific as the historical forces we wish to uncover? Does the art historian privilege the image and the gaze in such a way as to detach them from the temporal, to de-historicize them? Does literary history likewise fetishize the individual text, abandoning the sort of large-scale verification that would count as real history? Do French and Anglo-American literary histories follow a separate path, embodying the differences between the two intellectual cultures, and if so, does this rift extend to feminist theory, which yields widely differing results according to whether a French, American, or British model is adopted?

Though this collection describes itself as *multi-* rather than *inter*disciplinary, it often claims common ground by interchanging the methods and materials of several disciplines. Ruggiero, a historian whose practice is rooted in archival research and whose theory derives from a sociology of boundaries and subcultures, calls for a "rereading" of Renaissance sexuality that includes close attention to literature, and illustrates his thesis from Aretino (who reappears as a perceptive art critic in Pardo's essay on the erotics of painting). Rosenthal, a literary scholar influenced by Ruggiero's work on Venice, uses the writings of two prominent Venetian women to show how each relates to the ideology of the city and the institution of marriage, and how each negotiates the divide between "public" and "private" realms – a distinction clearly more complex for women than for men. Jordan, a literary scholar who models her enterprise on intellectual history, extends this analysis of women's position to include male-authored treatises on women; she looks at the conceptual structures used to establish sexual difference, and finds economic and sociopolitical considerations permeated ideologic gender even when these were ostensibly based upon "natural" s biology. Baskins, an art historian with strong allegiances to cul history and semiotic theory, proposes that her chosen genre (*casson spaliere* painting) should be revalued because it "reveal[s] the strategic linkage of narrative, gender ideology, and sexuality in the production of Renaissance culture" (p. 37). A promising situation has developed: professional critics proclaim the supremacy of historicity, and historians call for the renovation of the discipline through a new mode of reading.

Most of the literary studies in this volume – whether based on close analysis of a few privileged texts, or a synthesis of broad reading – support their claim for historicity by citing recent historians' work on the material conditions of women's lives, the poverty that forced them into prostitution, the restrictions on their speech, the tensions provoked by female monarchy. Rosenthal and Jordan place idealizing defenses of

...en in a context of economic hardship and sexual exploitation. Maus correlates sixteenth-century notions of reproductive physiology with male expropriations of "a womb of his own" as an image of poetic creativity. Stanton moves from male fantasies of the birth-feast to the actual practice of midwifery, and then interprets these gynaecological satires as inverted comments on high politics – the rising *noblesse de robe* and the regency of Marie de Médicis. Similarly, Fleming suggests that ostensibly complimentary gestures toward the female reader in Elizabethan fiction actually express the hostilities and anxieties inspired by a female monarch at a particularly indecisive moment in the colonial subjugation of Ireland, a conjunction of anxieties that prompted many men to declare that English culture itself was becoming feminized. (The psychological mechanism of the "dirty joke" takes on specific historical meaning in Fleming's analysis.) Gaines and Roberts relate the differences in two women writers to their differing social situation, one isolated in a rigid English court, the other leading an emergent *salon* in France. Quilligan musters evidence for the punitive silencing of women to show the contemporary relevance and realism of the female-authored *Tragedy of Mariam*, set in biblical times; here, in another variation on the debates documented by Rosenthal, the public language of the heroine draws her into scandal and destruction despite her impeccably virtuous avoidance of the role of "public" woman. Even Mueller – who discovers a profound difference between text and context, between Donne's positive depiction of lesbianism and all previous scholarly and literary treatments of Sappho – weighs the utopian fantasy of female self-sufficiency against economic reality. Interestingly enough only Kuchta, the other professional historian in the group, dissociates his textual synthesis from what actually happened. By assembling dicta on masculine dress, Kuchta reveals the dominant "episteme" or "semiotic regime," a combination of gender ideology, sumptuary prescriptions, and theories of the sign. Gaines and Roberts likewise use the early-Foucaultian notion of the episteme (p. 290), but for Kuchta it shows only how "ideals of masculinity were constructed and contested," and provides no evidence of "the reality of sartorial practices" (p. 234).

The task of the literary historian, then, seems to involve a balancing act between empirical history and a discourse-centered rereading of the past. She appeals to demonstrable historical reality when it proves real violence and injustice, when it supports a suspicious reading of masculine writing and a realistic or transparent reading of the female-authored text. But such documentation must not undermine the fundamental belief that discourse and language play a supremely important role.

4

Consequently, the appeal to context normally involves not archival evidence, but prescriptive treatises, a form of discourse midway between traditionally "literary" and "historical" realms and presumably accessible to both. Yavneh compares Tasso's depiction of the temptress Armida with treatises on ideal female beauty, themselves synthesized from common sources in Dante and Petrarch. Familiar courtesy-books like Castiglione's *Cortegiano* and Guazzo's *Civil conversatione* provide the frame for several "rereadings" of literary dialogue (including Fleming's study of hostile manipulation in Guazzo's English translator). Schoenfeldt discovers in *Paradise Lost* the practice as well as the theory of Italian Renaissance courtliness – a practice here interpreted as a Machiavellian dance in which the powerful and the powerless maneuver for supremacy. Quilligan's section on *The Taming of the Shrew* uses the same conduct literature to prove the plasticity of social roles and the power of "conversation" to transform ostensibly natural human realities; though Shakespeare grants this facility to both partners during the rough courtship of Kate and Petruchio, the closing scene, by suppressing the metatheatrical framework that reveals the artificiality of all gender-roles, reinstates the ideology of fixed identity. Even this history of suppression, however, is based on a faith in the importance of discourse; patriarchy is assumed to invest more in controlling women's speech than in defining their sexuality.

Art history likewise draws upon historiography and discursive theory, though with different results. Pardo synthesizes cinquecento treatises and dialogues on art, and recent interpretations of Renaissance literature, to elucidate Titian's *Urbino Venus* and its visual analogues; Yavneh, conversely, uses an art-historical study of Venetian "sensuous half-length" paintings to explain the appearance and effect of Armida. Pardo evokes the historian Carlo Ginzburg's thesis of a shift in the perceived significance of the visual, though she finds this promotion of sight beneficial rather than dangerous, having selected art treatises rather than confession-manuals as her source. Baskins interprets painted images of Esther according to new theories of typology and semiology, and draws on the work of the historian Diane Hughes to suggest an analogy between the marks on the wood or plaster and the "badges" and ornaments designed to mark off alien races and professions (a topic also touched upon by Ruggiero). Baskins and Pardo both take traditional sources of documentation for art history (aesthetic treatises, patristics, typology) and push them towards new conclusions. Pardo turns from the erotics of Titian's content to the manner of depiction, the seduction of the artist's touch and the sensuousness of

paint itself; her textual sources elucidate *how*, not *what*, paintings signify. Also breaking away from iconography, which assumed "a seamless correspondence between text and image" (p. 51), Baskins finds a conflict between the official meaning assigned to Esther (a mere foreshadowing of the Virgin), and her physical and sexual representation, her irreducible "bodily presence" (p. 38). (Presumably this refers to the illusion of corporeality created by pigment, though the placing of the figure in relation to architectural space also contributes to the sexualized effect.) Visual embodiment wins the day, breaking out of the typological framework and scattering its claim to control meaning. Thus, despite their interest in literary sources and literary theories that declare the body to be a text and the visual mark a form of oppression, these two (very different) art historians remain loyal to the substantive and integrative power of visual representation, their chosen object of professional study.

It is interesting, in this disciplinary light, to compare contributors' assumptions about the gaze and the blazon.[4] For a historian of texts such as Yavneh, the eroticized gaze intrudes menacingly, threatening rape, and the itemized pictorial description effectively "dismembers" its subject; Yavneh simultaneously expresses a suspicion of the visual and a faith in the power of language – understandable in those of us paid to teach texts rather than images. (Aretino's pornography reminds us, however, how close could be the link between textual and physical violence.) For a visual historian like Pardo (drawing on the same sources, such as Nancy Vickers' interpretation of Petrarch), the gaze and the portrait reintegrate the body into a coherent image by means of an ineffable "touch" that cannot be conveyed in language (pp. 58–65, 69, 81). Yavneh chooses texts that portray the construction of ideal beauty as aggressive (necessitating the absence of real women) and neurotic to the extent that it is sexual: her writers fear that their *pennelli* might prostitute the mistresses they create through writing (pp. 138–40). In the texts favored by Pardo, the work of "love's stylus" (in the gaze) is both mutual and beneficient, a transformation-into-art without loss of identity (p. 57). For Stanton, again, the gaze is sinister and Foucaultian, "titillated" rather than seductive – the panoptic gaze of the narrator, who spies on women during childbirth and steals their language, disarming it by reducing it to female "chatter" or *caquet*. We might assume, then, that for the art historian sight is always potentially delightful, whereas for the literary historian language is always potentially heroic while sight leads to the foul practices of the voyeur and the overseer. For Stanton the "recuperative" power of

language works for good as well as bad, as seen in her move from male simulations of "chatter" to the apparently authentic voice of Mathurine, female jester to a female court; this obscene, rebuking figure becomes a model of the oppositional critic, confronting sexual ideology and gender-blindness in twentieth-century theorist and seventeenth-century satirist alike.[5]

Though disciplinary loyalty to the medium helps to explain the diversity among "historians of sexuality," scholars remain profoundly divided between recuperative and suspicious modes of reading, between integrative and destructive visions of Eros, between a history of empowerment and a history of victimization.[6] Schoenfeldt, for example, ascribes far more power to Milton's Eve than most feminist critics allow, decoding her verbal declarations of submission as performative gestures that declare her social initiative; here a "suspicious" approach to the discourse of courtesy (inspired by Kelly's rereading of Castiglione) combines with a "recuperative" model of female agency. Fleming does the reverse: her authors explicitly address women, announce a special devotion to women's interests, and identify their narratives as a woman's genre, but Fleming reveals an increasingly violent sexual charge which compromises the female reader rather than complimenting her. Maus remains critical of the male poet's cross-gender identification with the female, even in the complicated case of Milton. Mueller, on the other hand, seeks to rescue Donne from the imputation of abusing the "masculine persuasive force" of his verse. Drawing on the thinking of Julia Kristeva and Luce Irigaray, Mueller suggests that male personation of female sexuality need not involve colonization and degradation. The "utopian" reconstruction of lesbianism in "Sapho to Philaenis" allowed Donne to express a new appreciation both of marriage and of single-sex friendship – removing their potential conflict by combining them into a single female couple – without diminishing erotic passion. This optimistic reading brings Mueller closer to Pardo's appreciation of Titian and Speroni than to most of her fellow professors of literature.

"Rereading the Renaissance," then, must involve a transformation in modes of reading as well as a quantitative increase in data. "Historical"/ documentary and "literary"/discursive approaches should both be carefully weighed against the circumstances and consequences of the individual text. We should attend to the limits as well as the powers of words and images, especially to those features of representation that might make it unrepresentative. Renaissance discourses on sexuality and gender cultivated a dissociation between ostensible meaning and

performative occasion. What kind of evidence, for example, can be derived from the prescriptive treatise; does it express deeply internalized norms, or does it erect a wishful reversal of the existing world? Or from the paradoxical encomium, which aims to destroy by ridicule, rather than to promote, beliefs that include the right of women to govern and the perfection of lesbian sexuality? Rereading means decoding. Paradoxical praise appears to exalt its subject while undermining it; in Fleming's phrase, such texts are "marked as being beside the point" (p. 158). Its reverse is *sprezzatura*, the promotion of one's own value by well-contrived false modesty and self-deprecation. But can we always be sure which model operates, whose bluff is being called? The masculine desire to expropriate female procreativity certainly justifies Maus' suspicion, and certainly reveals its absurdity in the *Caquet* pamphlets studied by Stanton. But we should recall that Montaigne referred to his own essay "Sur des vers de Virgile," perhaps the most profound meditation on sexuality in the Renaissance, as itself "un flux de caquet" (III.v).

Notes

1 See, for example, Kuchta's revision of Kelly on male apparel (p. 233).
2 Pietro Aretino, *Sei giornate*, ed. G. D. Bonino (Turin, 1975), pp. 256–7, trans. Raymond Rosenthal as *Dialogues* (New York, 1972), p. 267; Nanna recounts the treatment of the kindly and attractive courtesan "madonna nol-vo'-dire," in a sequence of half-indignant and half-pornographic descriptions of men's brutality to prostitutes. The *trentuno* or rape by thirty-one men also provided a bawdy poem (*c.*1535) and an episode in the pseudo-Aretinan *Puttana errante* (1660?).
3 Antonio Rodriguez Villa, *Memorias para la historia del asalto y saqueo de Roma* (Madrid, 1875), p. 141 (Brandano of Siena calling the pope "Sodomita bastardo" and predicting the destruction of Rome because "he has robbed the Mother of God to adorn his harlot, or rather his friend"); Judith Hook, *The Sack of Rome, 1527* (London, 1972), pp. 156, 172; André Chastel, *The Sack of Rome, 1527*, trans. Beth Archer (Princeton, 1983), pp. 22–4, 36, 38, 103, 244; Pierre de Bourdeille, seigneur de Brantôme, *Oeuvres complètes*, ed. Ludovic Lalanne, vol. 1 (Paris, 1864), pp. 274–6 (speculations on the pleasure the rape victims felt, comparison of nun's flesh to that of the partridge); Caspar Barthius rewrites Aretino's third dialogue and combines it with the Sack in *Pornodidascalus, sive colloquium muliebre Petri Aretini ... addita expugnato urbis Romae* (Frankfurt, 1623). The sexual meaning of the Holy Foreskin is questioned by Arnold Davidson (citing Chastel on the Sack), but the context sketched above surely undermines Davidson's contention that the concept of "sexuality" is wholly anachronistic when applied to the Renaissance; "Sex and the Emergence of Sexuality," *Critical Inquiry* 14 (1987), 26.

4 In addition to the examples discussed here, see Pardo's (and her sources') very positive interpretation of the Narcissus myth (p. 81), and Ruggiero's use of the early-Foucaultian concept of the "disciplinary" gaze (p. 26).

5 Stanton leaves it open whether the texts ascribed to Mathurine are themselves male fabrications.

6 This hermeneutic dilemma applies to cultures and societies as well as to texts and images, as can be seen in Kelly's essay; her negative reading of women's position in the Renaissance depends on a correspondingly euphoric interpretation of the Middle Ages.

Marriage, love, sex, and Renaissance civic morality

GUIDO RUGGIERO

ৰ⋗

That major shifts occurred in the Italian Renaissance at the turn of the sixteenth century, shifts that would continue to be worked out across the rest of the early modern period, and not just in Italy but across Europe, is a truism of Renaissance scholarship. But now new questions arise about those shifts, as the historical canon, based on politics, war, and high culture, with an underpinning of social detail, begins to dissolve before the onslaught of a series of "other" histories, such as the "new" social history, women's history and the history of gender, and the history of mentalities. We have to rethink the Renaissance – a pleasure that grows out of the pain of sacrificing earlier givens. Perhaps the issues involved were best faced early on by Joan Kelly when she asked in "Did Women Have a Renaissance?" whether the old periodization of the Renaissance had any meaning for the history of women, if the period and the vision of the period were constructed in terms of a history that focused on the high culture of élite males. Was that periodization useful for conceptualizing the much more complex past she and others were investigating?[1]

I would like to propose in this essay a project for rereading the Renaissance that, to be successful, will need a cooperative effort between those who study the texts of literature and those who read the texts of history, especially in the archives – an interdisciplinary effort in terms of the boundaries currently drawn perhaps, but one that shares an interest in the close analysis of texts in their historical perspective common to much of the new social history and the new cultural poetics of criticism. This rereading would center upon marriage, family, society, and the disciplining of the body. For Renaissance historians the issues involved have garnered attention over the last few decades largely because of the new initiatives in social history that stressed the importance of the family, first from a sociological perspective, and then from a more

anthropological one; the many insights of women's history which problematized much that was taken as given and made the period richer and more complex; and the new cultural history which broke the stranglehold of a narrow élite-oriented canon that had limited the range of the Renaissance. The centrality of marriage as a social institution has already been recognized, and its most important features identified: the emphasis on marriage, especially at higher social levels, as a social and economic institution of the family where the individual desires (and/or love) of the central couple were secondary; the significant age differential between marriage partners (again greater at higher social levels); the emphasis on sex within marriage as an ideal (especially important for women); and the attempt to place all sexually mature women in marriage and in an honor dynamic that disciplined their lives and their sexuality primarily through the males of their families.[2] I would like to suggest that for Italy, and probably for other Renaissance cultures and societies, it is equally crucial to study the stresses put on this organization of marriage by what was seen as illicit sex.

I would begin, then, by showing that, across the period, the perceived importance of marriage played a central role in the development of a civic discourse that relied heavily on the public and social nature of what might be labelled "civic morality." This discourse served both to legitimate and define the city-state and to provide a set of ideal goals for the latter's use of power. As that discourse of civic morality gained shape and power, it intersected with an increasingly articulated and important counterculture of the illicit, grown up partly in response to the inherent contradictions in the dominant cultural vision of the correct placement of sex in marriage. Much of Renaissance life and culture, both high and low, can be understood as turning around these two nexuses of discourse and organization: a licit world of marriage and family, legitimating and defended by a discourse of civic religion and morality; and an illicit world of love and sex outside marriage with a coherent discourse of its own – the most striking example being the pornographic writings of Pietro Aretino.

Aretino, the family, and civic morality

To appreciate fully the structure, dimensions, and impact of civic morality in the Renaissance would require a careful rereading of Renaissance texts from the level of political theory and theology down through sermon literature, the language of governance, and literary

reflections on society, to the level of what has been labelled "popular culture" and "popular religion." But the position of the family in this discourse seems clear. Leon Battista Alberti, for example – famed in his age for his wide-ranging skills and raised to the status of "Renaissance man" by later historians – argues in *I libri della famiglia* that procreation was not merely a family or private matter, but had ramifications for "counties, regions and the whole world." Through the voice of his relative Lionardo, Alberti proposes a "pre-Rousseauian" gendered theory of the genesis of society from the family: women, weak but nurturing, first created the home and remained "busy in the shadow"; men, "by nature more energetic and industrious," sallied forth to gather the necessities of life. The family unit works together, not just to procreate, but to guarantee the continuity of future generations and to train "the heir" in citizenship. "Children whose character is excellent are a proof of the diligence of the father, and an honor to him. It is generally thought better for a country, if I am not mistaken, to have virtuous and upright citizens rather than many rich and powerful ones." Thus the association of marriage, procreation, family, child-rearing, and citizenship begins to connect into a vision of society based on the family, distinguished by its moral building of a disciplined citizen.[3]

Of course this was an ideal, and the responsible "rereader" must test it against the archival record: the reality may well have been that fathers did not train their heirs, that citizens were not moral, and that this civic morality begun in the family did not very effectively create the order that it was supposed to. But it was these very disjunctions that helped to make this moral vision so satisfying, for they explained why society was not as it should be. Family and fathers had not performed their moral duties, and thus, rather than a moral society, the urban world of the Renaissance was a violent and relatively unruly place. As Alberti sums up nicely, the goal of the family was to avoid poverty for its members if possible, and to assure "reputation, honor, good custom and morality."[4]

Other theorists and rhetoricians amplified this vision of marriage as the centerpiece of civic morality – a facet of the larger civic discourse of the Renaissance that Alberti reflected in his work more as a given than as a reasoned argument. Francesco Barbaro, like Alberti, saw the choosing, training, and domestic role of the wife as central to constructing an ordered household that in turn would raise moral and upright rulers of society. After outlining the moral qualities that a wife should have, Barbaro considers how she can impress those qualities on the household that she administers and train her children to meet those

same standards: "The child's moral education ... in infancy continues under the mother's guidance, until a pious, dutiful, and self-restrained young person is prepared for intellectual training under his father's direction."[5] First the mother, then the father, were to create individuals capable of the moderate and moral life that made possible an ordered society; marriage formed the family and the family formed the citizens. As Giovanni Caldiera put it, in a trilogy that develops precisely the interconnections of theology, the family, and the state, "just as every economy resembles a polity, so also the home is in the likeness of the city."[6] This discourse of civic morality based on the family did not do away with either the discipline of honor or the discipline of government; rather it provided an interlocking structure of discipline that in many ways also offered a supporting legitimation for society.

The moral family as the basis for the state empowered the state in ways that are difficult to see from the modern perspective, and in turn the moral state empowered the family; we should be careful not to impose an anachronistic public/private dichotomy. The family from the perspective of civic morality worked at several levels. First, it institutionalized sex in its correct place in an ordered and disciplined Christian society: within marriage. In turn, the correct result of sex, legitimate children, were also placed in a nurturing and moral environment. It also, crucially, educated them and instilled in them an internal discipline still largely based upon traditional honor and reputation. In addition it married them correctly, within their own class, thus theoretically assuring the social hierarchy and protecting it from the dangers of love, passion, and sex. Nicely, while this discipline was internalized, it was also monitored by the family, for honor and reputation, even as they became more individual, remained familial as well; thus the family as a building block for a moral society would ideally provide much of the order necessary for the existence of society. Such, then, was the ideal; the reality could be very different indeed, as contemporaries never ceased to point out. But even as the Renaissance failed to live up to such ideals, the way in which that failure was articulated once again seems to reveal the strength of civic morality as a central discourse for social order and concepts of the state.

While civic morality might seem an apt vision around which to organize a society, a reading of Aretino reveals its malevolent and impracticable side. Aretino's cynical and irreverent survey of the options available to women – in a series of dialogues between the aged prostitute Nanna, her friend Antonia, her daughter Pippa, a nurse, and a midwife – takes us to the heart of the issues involved. He creates, in

effect, an "immoral family" that exactly mirrors the dynastic and social concerns of civic morality. In the first three dialogues the mother and her advisor formally review the career possibilities open to the daughter (nun, wife, and whore), while in the later dialogues mother educates daughter in the violence of the male customer, the vulnerability of the prostitute, and the tricks she must perform to function fully in illicit society. Fictional and ironic though it is, this vision of a commercialized and amoral society justifies Antonia's conclusion:

> I believe that you should make your daughter Pippa a whore: for the nun is a traitor to her sacred vows, the wife an assassin of holy matrimony; but the whore attacks neither the convent nor the husband. In fact ... her shop sells that which she has to sell ... So be open-handed with Pippa and make her a whore from the start.[7]

Although Nanna's flamboyantly pornographic and racily demotic life-story exaggerates the case, it highlights deeper truths about Renaissance life that were intimately intertwined with the contemporary discourse on, and practice of, marriage, love, and romance. Nanna begins her tale with her entrance into the convent as a young girl, assuming she was joining a world of religious commitment and fervor where the true highest form of love would be hers, but actually finding an orgiastic ferment of sexuality which she paints with a voyeuristic brush (Dialogue I). Certainly neither Aretino nor Nanna could have expected their readers or listeners to believe that all convents were so corrupt. But for many, especially upper-class, women the religious life was pressed upon them by their families to salvage family honor when a dowry could not be raised, or when a suitable marriage could not be arranged for other reasons. The result was that some convents were virtually as scandalous as Nanna claimed: in San Angelo di Contorta in Venice during the fifteenth century, for example, no less than fifty-two nuns, including several abbesses, were involved in affairs significant enough to become public knowledge; and one noble nun, Filipa Barbarigo, had ten prominent Venetians prosecuted for having had sexual relations with her over a long period of time.[8] Quite simply their "shop" was not producing the pure love and spirituality it claimed; thus, in a perverse way, Aretino could play with the argument that convent life was dishonest while that of a prostitute was not, because "her shop sells that which she has to sell." His attack could be heard by many Renaissance readers.

Nanna fled the convent to seek the honest life of a wife (Dialogue II), but found little that was honest there either. In a parody of upper-class

marital arrangements, the lively and independent daughter found herself virtually sold into slavery – labelled marriage – with an old man "who only lived because he was still eating." Nanna's communal education begins with her mother's technique for recovering the virginity she had lost in the convent, continues as neighborhood women and friends show her how to escape the prison of her marriage through adultery, and ends when, caught in bed with her lover and attacked by her suddenly active and irate husband, she cooly "buried a little knife that I had in his chest and his pulse beat no longer."[9] Thus, as Antonia sums it up, the wife became literally "the assassin of matrimony." Once again Aretino exaggerates the case against Renaissance marriage for effect, but his point had considerable weight. Arranged marriages, marriages contracted for family objectives and economic motives, especially in the context of a double standard for sexual behavior, could be dishonest and little better than a form of servitude for women. Thus Aretino and his characters can say to their readers that there is only one honest life for a woman in the Renaissance – that of the prostitute – and they could be heard. In the *Sei giornate* Aretino turns civic morality on its head and, whether consciously or merely moved by the inherent illogic of the structures of the dominant discourse, he does so by attacking the very ideological base of the central institutions that placed women in Renaissance society: the honesty of marriage and the convent. Nanna's defense of prostitution and her attack on the ideology of matrimony and the convent could be read, for all its obscenity and voyeuristic titillation, essentially as a moral attack on the dishonesty and immorality of the position that women had been forced into by Renaissance society. Aretino may in fact have intended this, enjoying the strange conjunctures created by being at once a destroyer of forms – violent, outrageous, misogynistic, and perverse – and a moralistic defender of women.

Aretino's illicit discourse thus confirms both the central importance of Renaissance marriage and the forces that undermined it. For civic morality, by placing marriage at the heart of social and political institutions, made it a very complex and unwieldy arrangement, and invested it with layers of signification that crucially colored perceptions not only of love and sexuality, but also of social order, stability, and organization. And significantly it appears that as this discourse of civic morality became more and more of a given in Renaissance culture, it helped to formulate yet stricter gender stereotypes and increased pressure to restrict and place women firmly in a disciplined domestic space. We might surmise as well that these clearer definitions, the setting of more fixed boundaries tied more tightly to what were perceived as the

underpinnings of society, helped also in the conceptualization and articulation of certain aspects of illicit sex as being more than just the small sins of natural pleasure that we see mildly punished in the fourteenth century and mildly proscribed in the confession manuals of the late Middle Ages – small natural sins that Boccaccio and other early *novellieri* could lightly wrap their humor around. In Renaissance civic morality – and in the distorting mirror of Aretino – the universe became once again Manichean, with the world of the licit focusing on marriage, family, and a morally ordered society, squared off against the world of the illicit that seemed to reject marriage as both the central institution of society and its moral basis.

The world of the illicit

This latter world that Nanna had picked for her daughter was one that rejected marriage to focus instead on the courtesan, the prostitute, the concubine, the rake, the libertine, the "sodomite," and the male "adolescent." In the high and late Renaissance it was a world that had its own evolving values, customs, and institutions. Being illicit, its discourse or range of discourses tended to be much less unified than the evolving ideologies of civic morality, listing now towards the libertine, now towards the prostitute, now towards sodomy. But it shared a common aversion to marriage, and a common celebration of sexual freedom for males beyond the morality of society and religion. Moreover, it tended to celebrate a way of life that most upper-class males in urban settings lived in the years between the onset of puberty and marriage, and that many continued to live thereafter, in fact, in fantasy, or perhaps more importantly in sympathy. This was a marginal world, I would argue, largely from the perspective of the ideal of civic morality (and the perspective of much of modern scholarship); in reality it was a world that at least upper-class males lived in for a significant part of their lives and that intersected in many ways with the lives of more humble men and women as well. In sum, if we are to understand a broader Renaissance, our rereading must search out this world and its discourses as well.

The key to this world seems to turn around several problems inherent in the licit vision of sexuality in marriage as the moral base for society. First was the late marriage age of males in comparison to that of females. Upper-class women in the Renaissance married in their early teens, almost as soon as they reached puberty. Nanna, entering the convent as

virtually a child, reflects this urgency to place women as soon as they became sexually mature. Upper-class males married much later, the late twenties being the ideal. As a result females moved in a way directly from childhood to adulthood, whereas males had a long intermediate period in some ways similar to what we label adolescence today. But that period of male "adolescence" was viewed with ambivalence; these young males – attractive as future scions of their families – were also feared in practice, as well as often uneasily laughed about in literature for their tendencies to deflower daughters, commit adultery with wives, and disturb the calm, disciplined flow of business in urban society. Civic morality, with its promise of a disciplined citizen, broke down most visibly before this male "adolescence." Significantly, however, this only demonstrated more forcefully the importance of marriage for civic morality, as what distinguished those males in the eyes of society was their unmarried status. The result was on the one hand a sterner call for civic morality, and on the other the further growth of a formally illicit and low world of sex.

A brief sketch of the nature of this illicit world seems in order, as its full complexity in the late Renaissance is little appreciated. Violent sex is perhaps the most difficult place to begin. Often it was disturbingly unconcerned with sex or the pleasures of the body and seems more a subset of misogyny and assault. But rape, perhaps the most studied form of sexual violence, was seldom a simple violent crime in the Renaissance. In fact, in some ways it even played a role in the licit world of marriage. The records of prosecution for rape, for example, reveal that women were often given the "option" of marrying their attackers. Only further research will discover if this practice was predicated upon the pressure women felt to marry and the difficulty they faced if their rape became public; or if claims of rape were a ploy to avoid paying the cost of a dowry (even a ploy that males sometimes participated in against the interests of their own family); or a social convention that allowed women to claim rape when a promise to marry was broken after sexual intercourse had been initiated. Probably all three broad categories were at work, with a change in emphasis towards the latter as the period progressed.[10]

Group assaults, which in the urban environments of Renaissance Italy may well have involved a larger social range of males than in rural France where they have been primarily studied, also moved between the two worlds in ways that make them difficult to categorize. On the one hand they were often justified by participants as "disciplining" women who did not adhere to community standards of sexual conduct.[11] Of course

this was a defense, but that it could be used so ubiquitously underlines the power of the vision. Thus here again rape could be conceptualized as a safeguard of civic morality. But with youth-gangs victimizing women we are on an uneasy borderline for Renaissance society; "discipline" could easily become dangerous asocial license, and the courts' careful attention to such matters suggests a degree of ambivalence at least at the level of the law and the ruling class. Also in this area we are squarely within an adolescent male world where access to marriage, licit sex, and the more recognized powers of adulthood were limited. Did the same gangs that raped women frequent prostitutes and prostitution districts? Were they and their gangs an important part of the world of illicit sex? This, of course, was not the ideal of civic morality, but once again only further research will separate out the complex issues involved. Behind these complexities there lurked the predatory male, the darkest side of an aggressive vision of masculinity, and an association of violence with sex that needs more careful study for its specifically Renaissance setting.

Premarital sex and adultery do not fit very neatly into the world of the illicit either. Once again in the Renaissance both seem to have been to a great degree marriage-oriented, especially at lower social levels. Premarital sex was often a preliminary step on the way to marriage (even occasionally to the dismay of the patriarchs of élite families), and was certainly feared as such at all social levels. Even when that was not the case, future marriage was normally the justification for premarital sex: young women seemed to have regularly sought a promise of marriage before succumbing to male blandishments; males seem to have regularly given such assurances even in cases that bordered on rape; and parents and society at most social levels below the topmost seemed to have been little troubled by intercourse followed by marriage.[12] In this way it also occasionally offered a means for love to become involved in marriage decisions; something that from the perspective of civic morality was not deemed a good idea. Thus premarital sex contributed little directly to the culture of illicit sex, although formally it swelled the numbers of those involved in illicit activities. In fact, such exposure may in part explain the rather relaxed acceptance of the illicit that typified the early Renaissance and the continuance of partial toleration as the high and late Renaissance strove more aggressively to limit and control it.

The case of adultery is also complex. Many of those involved were primarily concerned with creating sexual pairings outside marriage that to a great extent reproduced marriage, but that were based upon love. This suggests an interesting point. While love appears to have been viewed as a dangerous emotion for founding something as socially

important as marriage, as the Renaissance progressed a wide range of sources suggest that it was hoped that it would develop within marriage. When it did not, adultery could be viewed with a certain sympathy, although family and honor certainly complicated the situation, especially for women.[13] Again, this was strictly speaking illicit activity, but it mirrored the accepted social world. And that mirroring was often taken to its logical conclusion by adulterers running off together with the help of relatives or neighbors to set up a new life as a "married" couple. But there were other types of adultery as well. One ideal type stretching back at least to the courtly tradition of the Middle Ages seems particularly significant – the love between a young male and an older married woman. This ideal seems to have a deep structural relationship with the evolving culture of illicit sex tied again to the crucial transition years of male adolescence. Only further study of adultery prosecution and a careful rereading of literature will allow an evaluation of the degree to which this theme was a reflection of a literary *topos* or a real-life stage of training for the developing male.

But while all three of these formally illicit activities melded in important ways with the licit world – not as strange as it might seem at first glance, since truly strong cultures survive not merely by destroying opposing visions, but also by incorporating and disempowering them – they also created the stereotype of the predatory male operating beyond marriage and the boundaries of licit society. This is perhaps most forcefully expressed in the libertine literature of the seventeenth and eighteenth centuries, in Casanova, *Dom Juan*, and de Sade. But the type is a Renaissance one, and the criminal records,[14] as well as the *novella* tradition and the drama, seem to be littered with this character in various guises. Even autobiography plays with the type, as one can see for example in Benvenuto Cellini's violent boasting. The rake's progress, or that of the predatory male, may be valuably rethought from the perspective of the illicit world which he was assumed to inhabit and represent.

With the introduction of a new and more virulent strain of syphilis at the end of the fifteenth century, the impact of disease on the world of illicit sex should have been profound. Its rapid spread through Europe is documented by diaries, literature, and a new outpouring of sermons, legislation, and apocalyptic predictions that identified the disease as the scourge of God for a society that had not lived up to the ideals of Christianity. And those ideals were often expressed in terms of civic morality. But perhaps because society had regularly experienced more immediately deadly scourges since the mid-fourteenth century, and

perhaps because syphilis could be assimilated to the *topoi* already associated with the familiar fears of leprosy, this new disease was assimilated with surprising speed and surface equanimity.[15]

Nonetheless, at deeper levels syphilis may have had a significant impact on male perceptions. Perhaps most importantly the association of this virulent disease with sex helped to confirm the deep unease of Western society with carnal pleasures. The danger of sex, especially of all sex not aimed at its legitimate goal – childbirth in marriage, where physical danger threatens the woman alone – was underlined in a new and direct way in this pandemic. The simple, careless, and asocial pleasure of illicit sex that the criminal records of the early Renaissance seem to suggest in their assessment of adultery and fornication, and that is perhaps reflected in the early *novelle* tradition as well, now had an extra bite that could not be ignored. And very significantly for the culture of the illicit, syphilis was from early on closely associated with prostitutes, who were seen as spreading the disease throughout society. Thus the illicit gained an extra reason for being suppressed, and it is not surprising that disease metaphors that had already been used to condemn both the prostitute and the illicit gained force in the early sixteenth century. All this may have served, however, to make that world of predominantly male pleasures more reflective and self-conscious, helping it to gain further structure and form. Perhaps, then, the evolving culture of illicit sex found in syphilis an unlikely ally, as certain males began to see syphilis as a mark of belonging to an illicit world.

The most visible point of this developing world of illicit sex throughout the Renaissance was the commercial realm, populated by a hierarchy of women ranging from the common prostitute to the élite courtesan. Prostitution created a "shop" of sex (in Aretino's term), which helped to subtract it from the marriage nexus in a way that was theoretically attractive to society, transforming it into merely another form of "safe" contractual relationship. That commercialization in turn provided a social placement, albeit illicit, for large numbers of women who could not be placed by marriage, usually for financial reasons. Some women may have used the gains of their profession to raise a dowry and gain a licit status in marriage; many certainly had that hope. Thus, even prostitution in some ways was tied to the dominant culture of licit sex. Although legal within carefully defined limits, from the last decades of the fifteenth century the illicit nature of prostitution was increasingly stressed – as if what had once been a necessary social evil was becoming a dangerous disease that threatened society. The prosti-

tute also figured prominently in the literature of the period, and not merely as the evil or fallen woman: she could be the protagonist, victim, or heroine, and especially at the upper levels of the profession she could be the author. Most significantly, however, for the world of illicit sex, the legality, popularity, and cultural attainments (at the higher levels) of courtesan and prostitute made them a visible focal point for the culture of the illicit, and to a degree for its society.

By the late fifteenth century we can identify as many as five or six levels of prostitution in the major cities, for just as the urban society of the Renaissance was an extremely hierarchical one, so too was prostitution. At the humblest and least organized level fell the numerous women who drifted in and out of the trade as necessity or chance moved them. They operated from the streets, or more informally from taverns and inns, and drew their trade usually from the lower social levels. Much more visible, in the records at least, were the women – required in most Renaissance cities by law to register as prostitutes – who worked in brothels. It appears that their clients were most frequently local artisans and foreigners. Interestingly many of these houses were organized much like Aretino's convent, with an "abbess" responsible for the discipline of the "sisters," and a form of cloisterization that severely limited a sister's time outside the brothel. A third group comprised registered prostitutes who worked independently, usually in cohort with a male or female manager. Male managers appear to have dominated the profession, but as the Renaissance progressed, women played an increasingly significant role. Aretino's Nanna and Pippa, however insulting their depiction as foul-mouthed plebeians, do at least control their destinies without the intervention of men. For these prostitutes their reputation, appearance, and cost were central in determining the level of their clients. Unregistered prostitutes who worked on their own or for managers may well have comprised two groups: less appealing women who avoided registration because their earnings were small, and the higher quality, more expensive prostitutes whose trade benefited from more freedom of movement and who saw registration as limiting or demeaning.

Finally, there existed a relatively new form of prostitute, the courtesan, who was almost always unregistered and lived on her own outside the legalized area of prostitution with as much style as possible. Usually she had a woman as a manager, but what gave her the power to transcend her more humble compatriots was one or a series of upper-class male protectors who provided the wealth and the political and social status to allow her to move easily beyond the restrictions placed on prostitutes.

We might well ask where this new form of prostitute came from – a rebirth of the classical hetaira, or a requirement of the courts of increasingly princely cardinals and popes? Unfortunately little information exists on the evolution of the courtesan. What seems clear is that the style caught on quickly because it satisfied new social imperatives. Aristocratic males found in the courtesan, as they found in new fascinations with manners and display, yet another area of life where they could demonstrate the gulf that yawned between themselves and the rest of society. (Needless to say, men were not prepared to share this freedom with their wives, their social equals.) Here once again sex stands the world on its head, for with the courtesan the illicit culture of sex moved squarely into the frame of the high culture of society. In fact, many of those very men who were engaged in defending the ideals of civic morality were at the same time intimately involved with the low made high. When the future French king Henri III, visiting Venice on his way back to France for his coronation in the summer of 1574, deserted the public festivities designed to honor his rule to enjoy a night with Veronica Franco – the most famous courtesan of the day, and an excellent poet as well – we have perhaps the most famous example of the complex and regular mixing of "high" and "low" that was possible in this area of the illicit world.

Concubinage, essentially once again a commercialization of sex, theoretically provided an intermediate ground between prostitute and wife. In fact, however, the concubine like the prostitute could become not merely a passing stage in the life of the young male on the way to marriage, but a permanent feature and thus a significant aspect of the world of the illicit. Also it appears that there was a hierarchy in concubinage: at the lower social levels concubinage was an option for couples who could not raise a dowry for marriage, and as such it seems to fit better in the context of licit society; at the higher social levels it was, at least in theory, more of a financial arrangement involving a lower-class woman kept by an upper-class man.

As Aretino pointed out, the prostitute and the concubine were not the only sexualized institution outside marriage. We have seen that convents played a role in this world of illicit sex, and the same was widely alleged of monks and other male clergy. While some of this must be discounted as one aspect of an anticlerical tradition, the criminal records provide much interesting material to evaluate such stereotypes and reveal in plentiful case histories that clerics played an important role in the culture of sexual transgression. Churchmen from such records appear to have been especially active in three areas of concern to civic morality: as

initiators of homoerotic affairs, as keepers of concubines, and as adulterers. The first was often associated with their educational functions and their easy access to the young; the second seems to have been associated usually with the women who took care of their other personal needs – maids, servants, washerwomen, cooks – and the third (with increasing frequency) was associated with some very interesting fears about their unusual power over women in confession. This fear of confession may have struck a deeper concern of masculine society, for with confession an outside and theoretically superior force could enter the family and challenge male power and control – a fact stressed *ad infinitum* by both pornography and Protestant polemic.

Finally the changing nature of sexual practice and theory at the highest levels of the church also certainly merits a closer examination, as the pope moved from Renaissance prince to director of one of the most massive attempts at social and sexual disciplining ever undertaken in the West. Throughout the sixteenth century, and especially following the Council of Trent, the papal court seems to have shifted, at least formally, from a virtual model for the culture of the illicit (certainly at the level of élite groups) to its strongest adversary. Of course, the changes that went on behind that shift in appearances were not nearly so straightforward, and may in many ways have followed a very similar parabola to that of the general culture of the illicit as it was forced to retreat before the reform sentiments of the age, sentiments fanned by civic morality as well as by religious fervor.

Masculine identity and the subcultures of sexuality

As noted earlier, one of the primary denizens of the illicit world was the adolescent of the upper classes. A late marriage age for males predicated upon economic and social concerns, a late political coming of age for most in Italy (with, of course, some highly visible exceptions), a limited access to economic life and to future wealth, and a very limited role to play in society in general – all these factors made adolescence a particularly difficult time. This was especially true in terms of finding and expressing a sexual identity in an acceptable manner. Reaching a certain sexual maturity at puberty that expected adult males to be sexually aggressive, and in general active rather than passive, a "youth" found himself passive in virtually every way – except, perhaps, in soldiering and expressions of violence – until he was admitted to full manhood in his late twenties or early thirties with marriage. The

subculture of "sodomy" that evolved in the Italian Renaissance, at least, may have provided another avenue of male acculturation, one that appears to have been for many not so much an alternative to prostitution as an additional aspect of the broader world of the illicit. Young males in their early teens began as passive partners to an older man who in turn served them as an active model and teacher for adult status, not just sexually but in general. With time – as far as we can gather at this early stage of research into the court records of Venice and Florence – these youths developed into active sodomites beginning to take on an adult male role. From there they could make a transition to the active heterosexual role out of preference, simply for variety, or out of family loyalty and the desire to fulfill the ideals of civic morality. They could also remain bachelors, which was seen with increasing frequency in the late Renaissance as being in the interest of the family, since it helped limit the number of heirs among whom the patrimony had to be divided.

In this light much of the subculture of sodomy – or at least that aspect of it which might be labelled homoerotic, as in theory all "unnatural" sex was labelled sodomy in the Renaissance – was less of a threat to society and its disciplining forces than might at first be evident. This is probably a significant factor in what appears to have been a rather accepting attitude towards the young passive partners in such relationships. In Florence and Venice, adolescent partners labelled "passive" were usually given minimal punishments – a few weeks in jail or a beating – whereas those labelled "active" were treated much more harshly. In Venice, perhaps the sternest city in Italy, "active" older males were normally burned at the stake and, until late in the fifteenth century, burned alive. The passive partners were not seen as a particularly grave threat for they were young men, at least theoretically, in a kind of adolescent limbo on the way to marriage and the sexual ideal of society. They were not "homosexuals" in a modern sense, but merely young males still passive but becoming active, who were committing, on their side of the relationship, a minor crime and sin. Yet as this subculture of sodomy evolved and emerged, especially in the larger cities of the high and late Renaissance, the fears it generated struck more deeply and intersected more dangerously with civic morality. Of particular concern were the males who did not make the transition from passive adolescence to active adult male heterosexuality. Such men seemed to be much more in open conflict with licit society, for they could be seen as undermining the "correct path" to adult male status. It may be indicative of this developmental vision that Benvenuto Cellini in his *Vita* can seem to play with homoerotic themes early in the telling of

his life – as in the well-known scene where, as a young man himself, he cross-dresses his young male neighbor as the most "beautiful" prostitute at a dinner party. But as he becomes older, in his retelling of his life (and in the courts of Florence) he rejects, often violently, any innuendos of homoeroticism; what was play for a youth has become serious for an adult.

Significantly, it appears that this subculture intertwined in several ways with the subculture of the prostitute. In Florence and Venice at least, areas that were known for prostitution were often known for homoerotic activities as well. Laws were passed in both cities outlawing cross-dressing by prostitutes as males to attract customers, the implication being that the two were dangerously interchangeable. Even moralists like San Bernardino of Siena attested to the perception of a relative interchangeability by calling for prostitution as an antidote to sodomy. Male prostitution in turn seems to have been interspersed with female. Perhaps again the key to this was the male adolescent as the primary denizen of the world of illicit sex. Still, as this aspect of the subculture evolved, it also developed its own distinctive customs, values, and language, which to a greater or lesser degree overlapped with those of prostitution and require a much closer study, both in the archives and in the literature of the period. Just as a brief example of the type of material to be found, when in 1590 the Camaldolese friar Vicenzo da Vicenza wanted to proposition one of the novices in his monastery, having convinced the young man that he could enter locked rooms at will using magic, he came in one day and found him there virtually naked "with everything visible." Immediately he slipped into a kind of Aretinesque slang, propositioning him by saying, "I see that your shop is open ... and that you have oysters, if you wish I will oysterize you."[16] Was there, then, a specifically homoerotic culture in the Renaissance (as certain historians following Foucault seem overly anxious to deny even before the research has been done)? Or was sodomy merely another aspect of the illicit? Or, as seems more likely, did it combine both – with some adolescents merely passing through on the way to adulthood, and others staying on in a world that must be understood in terms of the Renaissance rather than as a precursor of the modern? At this point only further research will tell.

Like sodomy, but apparently with even less moral responsibility, prostitution offered a parallel path to adult male status for adolescents. Once again we begin with a "youth" starting his sexual life in a situation where his socialization as a male calls for action and aggression, but his actual experience and position make both unlikely. The mythic

prostitute with her experience and her active reputation, much like the active partner in a homoerotic relationship, was in this vision a key to the transition from passive to active. With her – as would be stated with increasing frequency – the boy became a man; once again the danger is taken out of prostitution, which is placed in the service of the cultural ideals of licit society. What actually happened in such relationships was probably seldom as simple as the ideal. And, perhaps more importantly for our analysis, the situation was *seen* to be increasingly complex in the late Renaissance. It appears that many men in the world of illicit sex found ways to avoid that transition and to remain irresponsible "boys" vis-à-vis Renaissance gender stereotypes: as bachelors frequenting prostitutes or keeping concubines; as physically adult males remaining "sodomites"; or even as adult males continuing to play the role of the young rake, preying on the wives and daughters of their peers, and behaving in other ways that seemed directly to threaten the ideals of civic morality. Remaining within the world of the illicit, they did not serve as husbands, fathers, or citizens; rather it was feared they inhabited a corrupt world that was undermining the very values of civilized society.

The prostitute in this vision was often seen as atypically active and powerful in her sexuality, a vision that clearly fitted only uneasily with the sexual stereotypes of society. This is yet another reason why the governments of the Italian city-states were so concerned to discipline prostitution effectively. Their strategy was very similar to what Foucault describes as the treatment of the "insane" and "criminal" in the nineteenth century. First, there was an attempt at a "Great Confinement" – government sought to confine prostitutes either in brothels, or restricted areas of the city, or both. Special clothing or identifying badges were also designed to help separate them from the general population, and, by identifying them, to make them literally visible to the disciplining "gaze" of society and government. Needless to say that was a significant reason why prostitutes sought to avoid complying with such regulations, and the more powerful at least succeeded. But as the more aggressive attack on the world of the illicit, made largely in the name of civic morality, accelerated at the end of the fifteenth century and the beginning of the sixteenth, that gaze went much deeper. Most cities empowered special patrolling bodies to police areas of prostitution and to assure that the plethora of restrictive legislation enacted was enforced. We even begin to encounter in this period more aggressive attempts to register prostitutes and enforce physical examinations, to isolate and theoretically protect them against disease. Finally, a whole new range of

quasi-monastic secular and religious institutions sprang up in the sixteenth century, partially in response to syphilis, partially in accord with a general reforming attack on the world of the illicit, and partially motivated by a desire to discipline and contain independent women beyond the family's control. Although the names might vary, most Italian cities of the sixteenth century had a range of charitable institutions, such as a house of the Convertite, for repentant prostitutes; a house of the Incurabile, for those sick with syphilis or simply too old and decrepit to continue in the trade; a house of the Zitelle, for young unmarried girls in danger of becoming prostitutes; and a house of the Malmaritate, for those with marital problems that might lead them to fall into the trade. These institutions hoped to make progress in all three areas by restricting prostitution and eliminating the primary economic and social factors that were seen as underlying it.[17] As this attack on the world of the illicit washed across the sixteenth century, legitimated by the intertwined rhetoric of civic morality and religious reform, it spawned a truly impressive array of texts, literary, administrative, and religious, that offer a unique opportunity for observing the confrontation between the licit and the illicit.

So far this world of illicit sex has been discussed largely as if it were dominated by males. To a degree convents were an exception, and at least some courtesans were powerful enough to challenge the stereotype; but nonetheless it was male-dominated much like the legitimate world. Yet the formally powerless found their sources of power, the passive had their secret activities, the victims could also turn the world on its head. One may argue about whether these reversals occurred in fact or merely in fantasy, but even fantasies of power have great weight. Women especially were considered masters of the magic of love and sex, and occasionally they went beyond simple magic to align with the dark powers of the universe and become witches. Both magic and witchcraft provide a wealth of information about sex and the illicit, the transferal of religious symbols to the sexual world, the development of specifically women's meanings of things including the sexual, and the reification of many of women's sexual values and desires in the context of supernatural power.[18] Much of that information is contained in the rich records of the Inquisition in Italy, which from the late sixteenth century was very concerned to stamp out such activity by women (and at times to discover its true dimensions and meanings), but it also exists as a relatively unseen subtext in much of the literature of the period.

The attack on magic and witches was, however, merely one area of the much broader disciplining movement that swept Catholic Europe

following the Council of Trent. Perhaps the central strategy of that "reform" was to control the family from within (e.g., sexually, morally, and even in the choice of marriage partner) with the discipline of the Church, a truly radical policy when one remembers to what extent licit society was seen as turning on the family. But in a way this was just another logical outcome of the civic morality of the Renaissance. If the family was the truly significant building block of a civic and moral society, control of the family was the central issue, both in the moral and the political spheres. Thus, although in broad outline a rationale for such an offensive by the Church had existed from its early days, the sixteenth century, especially after Trent, saw the Church appropriate the discourse of civic morality (clearly not without resistance from evolving states) and develop its own institutions to discipline the family, marriage, and sex for an increasingly broad segment of society. And the family focus on this strategy meant that the mother, nurturing, and the home became both more important, and more important to control and dominate, either through legislation or through obscene travesties like Aretino's Nanna and Pippa. All this made the end of the sixteenth and early seventeenth centuries a period of truly spectacular conflict at many levels.

In the first decades of the sixteenth century, I would argue, Aretino was writing at a moment of transition when the potential for conflict was particularly great. As one can see in Machiavelli and numerous other commentators, civic society in Italy seemed to be collapsing in the face of a host of challenges – invasion, economic devastation, disease, and corruption. Civic morality was the answer more than ever, and it dominated the discourse even of the supposedly amoral. But not all accepted that vision, and Aretino, first among those who played with questioning it, faced the issue squarely, arguing that the virtues of civic morality were actually vices. And he argued this in a way that was at once curiously modern (in terms of markets and capital, by claiming to face honestly what was being sold), and suggestively traditional (in terms of an earlier popular vision of sex, by calling for an acceptance of the carnal nature of life). For those who would dominate society, however "free" their own sexual behavior, the illicit underground was increasingly seen as a radical rejection of the central forms of licit society, taking on, in the tensions of the first half of the sixteenth century, a much more threatening aspect. One significant result was an aggressive and impassioned attack on the world of the illicit, both in words and deeds, which in turn engendered a less well known but no less important defence.

Given the perversity of Aretino's laughter, it is hard to know whether he was a leader in the attack, a mocking defender, or merely a clever and outrageous writer who could play all the sides in a little-understood war of values and cultures. But for this essay Aretino's intentions matter less than his ability to evoke that war and suggest to us its parameters. The Renaissance needs a rereading across the board from literature to archival documents to understand the development of this conflict and its impact on love, marriage, sex, and society as a whole in Renaissance Italy and across Renaissance Europe. Nanna felt that Pippa had to be surrounded by books to play the role of courtesan and sell pleasure; now we should reread those books, and the archives as well, for the pleasure of rethinking the Renaissance.

Notes

1 (1977), repr. in *Women, History and Theory: The Essays of Joan Kelly* (Chicago and London, 1984), pp. 19–50.

2 Although in this essay I shall not attempt to provide citations for all the issues discussed, the literature in this area has grown so rapidly over the last two decades that I should list the most important studies: see the special issue of *Renaissance Quarterly*, "Recent Trends in Renaissance Studies: the Family, Sex and Marriage," ed. Stanley Chojnacki, vol. 40 (1987), esp. Barbara B. Difendorf, "Family Culture, Renaissance Culture," 661–81; David Herlihy and Christiane Klapisch-Zuber, *Les Toscans et leurs familles* (Paris, 1978), abbreviated in English as *Tuscans and Their Families: a Study of the Florentine Catasto of 1427* (New Haven, 1985); Klapisch-Zuber, *Women, Family, and Ritual in Renaissance Italy*, trans. Lydia G. Cochrane (Chicago, 1985); and my *Boundaries of Eros: Sex Crime and Sexuality in Renaissance Venice* (New York, 1985), esp. the bibliographical essay on pp. 199–206.

3 Ed. Cecil Grayson, in *Opere volgare*, vol. 1 (Bari, 1960), pp. 42, 105–6, trans. Renée Neu Watkins as *The Family in Renaissance Florence* (Columbia, S.C., 1969), pp. 58, 111.

4 Alberti, *Famiglia*, p. 29; Watkins, *The Family*, p. 47.

5 *De re uxoria* (after 1415), cited in Margaret L. King, *Venetian Humanism in an Age of Patrician Dominance* (Princeton, 1986), p. 97.

6 See King, *Venetian Humanism*, pp. 105–18, for a full discussion of Caldiera.

7 *Sei giornate*, ed. Giovanni Aquilecchia (Bari, 1980), p. 139.

8 Ruggiero, *Boundaries*, pp. 70–86.

9 *Sei giornate*, p. 90; Nanna ironically fulfils her husband's wish "to have me for his wife or die" (p. 50).

10 See Ruggiero, *Boundaries*, pp. 89–108, and Sandra Cavallo and Simona Cerutti, "Female Honor and the Social Control of Reproduction in Piedmont between 1600–1800," in Edward Muir and Guido Ruggiero, eds., *Sex and Gender in*

Historical Perspective, Selections from Quaderni Storici (Baltimore, 1990), pp. 73–109.

11 See Jacques Rossiaud, "Fraternités de jeunesse et niveau de culture dans les villes du Sud-est à la fin du moyen âge," *Cahiers d'Histoire* 1–2 (1976), 67–102, and Introduction above, p. 1.

12 See my "'Più che la vita caro': onore, matrimonio, e reputazione femminile nel tardo rinascimento," *Quaderni Storici* 16 (1987), 753–75, and Lucia Ferrante, "Honor Regained: Women in the Casa del Soccorso di San Paolo in Sixteenth-Century Bologna," in Muir and Ruggiero, eds., *Sex and Gender*, pp. 46–72.

13 See Ruggiero, *Boundaries*, pp. 45–69, esp. pp. 64–6.

14 For the rake's progress of Giovanni Battista Faceno, see Ruggiero, "'Più che la vita caro,'" esp. 759–62.

15 Anna Fao, "The New and the Old: The Spread of Syphilis (1494–1530)," in Muir and Ruggiero, eds., *Sex and Gender*, pp. 26–45.

16 Venice, Archivio di Stato, Sant'Ufficio, B. 66, Testimony of Fra Vicenzo da Vicenza, 2 April 1590, no folios. Finding another novice in a similar state of undress, he said to him: "Do you want me to squeak [*scrizzi*: literally, the sound a shoe makes on a hard floor] with you?" His examiners had to ask what this meant and he explained that it meant "either to kiss or do similar things."

17 See Sherrill Cohen, "Convertite e Malmaritate: Donne 'irregolari' e ordini religiosi nella Firenze rinascimentale," *Memoria: Rivista di storia delle donne* 5 (1982), 46–65, and "Asylums for Women in Counter-Reformation Italy," in Sherrin Marshal, ed., *Women in Reformation and Counter-Reformation Europe: Private and Public Worlds* (Bloomington, 1989), pp. 166–88; Ferrante, "Honor Regained."

18 These remarks grow out of a book that I am completing, tentatively titled "*Carne Vale*: Tales of Passion and Power in the Late Renaissance."

Typology, sexuality, and the Renaissance Esther

CRISTELLE L. BASKINS

ॐ

Fifteenth-century Tuscan domestic painting includes the Old Testament heroines Judith, Susanna, and the queen of Sheba in its repertory of narrative subjects. Esther, *ebrea* and queen of Persia, appears occasionally on painted dowry chests or *cassoni* and wall panels or *spalliere*, those domestic furnishings customarily commissioned for newlyweds' private living quarters and bedrooms.[1] A set of panels presumably for a *cassone* by Filippino Lippi circa 1480 (figs. 1 and 2), a *cassone* frontal by the workshop of Apollonio di Giovanni circa 1460 (fig. 3), and a fresco cycle of *Uomini famosi* or "Famous People," including Esther by Andrea del Castagno for the Villa Carducci at Legnaia circa 1450 (figs. 4 and 5), form the basis of the following discussion.[2]

The displacement or substitution theme central to the story of Esther introduces another story of displacement central to the definition of Renaissance domestic painting, that tale of incremental and successive pictorial development told by Giorgio Vasari in his *Lives of the Artists* of 1550 and 1568. The prejudicial positioning of Renaissance domestic painting below civic and ecclesiastical art might be explained by recalling the plot whereby Esther receives her crown after the expulsion of the previous queen, Vashti. For Vasari, the *cassoni* and *spalliere* of the fifteenth century were eclipsed by public monumental painting, and those mere furniture painters were to be replaced by an aristocracy of genius. Given the Vasarian bias towards biography and monumental genres in art history, *cassone* painting has been characterized as craft, as derivative rather than innovative, and as a foreshadowing – typologically speaking – of the achievements of Botticelli and his shop toward the end of the century.

But the numerous extant Florentine *cassone* panels, often removed from the original chests on which they appeared, argue for a reevaluation of the genre. Not only are the panels elaborately historiated with

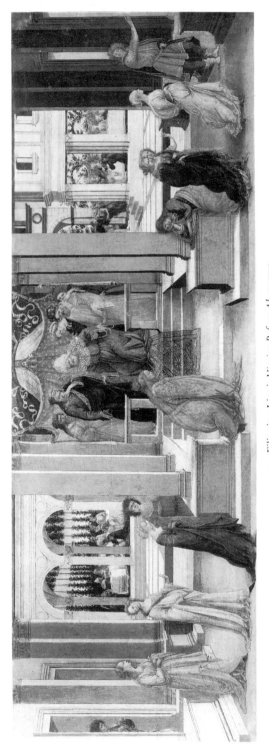

1 Filippino Lippi, *Virgins Before Ahasuerus*

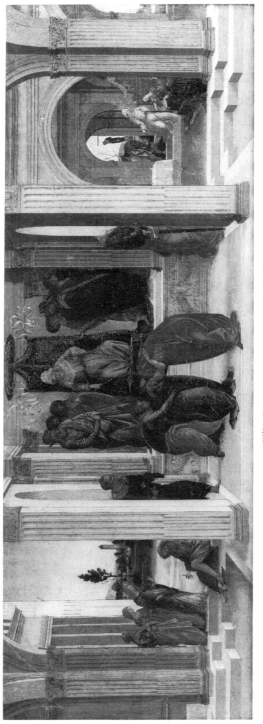

2 Filippino Lippi, *Esther Pleads for the Jews*

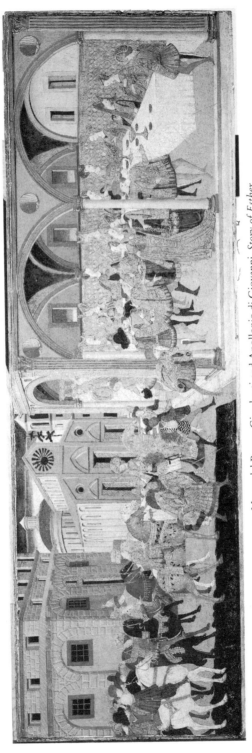

3 Marco del Buono Giamberti and Apollonio di Giovanni, *Story of Esther*

4 Andrea del Castagno, *Uomini famosi*

5 Andrea del Castagno, *Uomini famosi* (reconstruction drawing by David Walsh)

primarily secular subjects, but their expense and patronage relate to the escalating dowry wars and sumptuary aspirations of fifteenth-century patrician families. Even if *cassone* painting lacks sufficient documentary evidence to ascertain the patronage goals of specific families in detail, the broad repertory of subject matter addressed to both bride and groom allows us to speculate about the function of such domestic images in relation to Renaissance gender ideology.[3] When unburdened of retrospective judgments, when viewed as something other than a genre to be supplanted or replaced by monumental painting, domestic pictures like those *cassoni* featuring Esther reveal the strategic linkage of narrative, gender ideology, and sexuality in the production of Renaissance culture.[4]

Esther, texts and types

The plot of the Book of Esther may be paraphrased as follows:

> The Persian king Ahasuerus has deposed Vashti, his queen, and decides to find a new one. A young Jewish girl named Esther wins his favor and becomes the new queen. Her adopted father Mordecai becomes involved in a quarrel with the king's vizier, Haman. Haman plots to slaughter all the Jews in the empire to revenge himself against Mordecai. His plot is discovered and, by the efforts of Esther, Haman is executed and the enemies of the Jews destroyed. Mordecai becomes the king's vizier and institutes the festival of Purim to celebrate this great victory.[5]

This canonical paraphrase emphasizes the inversions and retribution of the plot; it omits the protagonist's clandestine Jewish identity, however, thus neutralizing the way in which Esther, like Judith, exercises a fatal attraction on her enemy Haman. As a *femme fatale*, Esther participates in the fulfillment of prophetic history since she enacts fate or *fatum*, that "which has been said [*fari*] in prophecy."[6] But the figure of Esther on wedding furniture brings typological readings of the Old Testament story familiar from biblical exegesis, sermons, and plays into the domestic interior where family policy and gender ideology complicate the heroism of the *femme fatale*.[7]

Esther elicits contradictory readings of the female body; she both secures a typological parallel with the Virgin Mary, and simultaneously threatens typological coherence through a corporeal unruliness or autonomy portrayed as alien female sexuality. Esther's clandestine Jewish identity and flagrant sexuality as harem favorite and enchantress able to bend the royal will of her husband Ahasuerus, to overturn false

decrees, and to obtain revenge on the Persians generates anxieties of contagion that cannot be dispelled by a typological relation between Esther and the Virgin, nor naturalized with reference to the practice of apostate conversion and marriage. A non-canonical close reading of the Book of Esther reveals that Esther's triumph over the evil Haman stems as much from King Ahasuerus' assumption that the advisor has raped the queen as from the revelation of his iniquity against the Jews. The emphasis in the biblical text on the heroine's beauty and sexual potency undermines the retrospective juxtaposition of the Virgin Mary's conception and Esther's childlessness; the associations of the rape exceed prophetic history. For St. Paul, the birth of Christ signifies the replacement of the Jews of the Flesh by the Israel of God, but, as this essay will argue, the bodily presence of Esther in Renaissance painting withstands such a figurative function and thus problematizes pictorial typology.

Of the many instances of sexualized language and imagery in the Book of Esther, Esther's prayer to God "for herself and for her people" includes a rereading of her royal crown as a cloth stained with menstrual blood:

> I abominate the sign of my pride and glory, which is upon my head in the days of my public appearance, and detest it as a menstrous rag, and wear it not in the days of my silence. (14:6, recalling Isaiah 30:22)

While the language of inversion here pervades biblical texts – the reversal of high and low as in the juxtaposition of head and genitals, the contrast between the public and private body, and the divided allegiance to temporal or spiritual authority – the explicitly gendered terms of Esther's binary sign "crown-rag" require definition, and such definition in turn problematizes the appropriation of Esther through Christian typological texts and pictures.

In Esther's prayer the crown stands for royal power, the menstrual cloth for female powerlessness and humility. The crown belongs to the male political intrigues of the Book of Esther, while the "rag" relates to the woman's sphere or harem, where conception and parturition secure the king's favor and alter power relationships. In Filippino Lippi's first panel, the royal crown is violently removed from the disobedient Vashti in the upper-right corner of the composition; she will be replaced in the royal household by the curtseying profile figure of Esther in the centre foreground (fig. 1). Esther appears prior to her coronation among a parade of nubile women subject to the king's sexual monopoly. Vashti, in contrast, refused to appear before the male assembly at her husband's

banquet, depicted at upper left, because she may have been expected to display herself in the nude.[8] Her refusal, or corporeal resistance, amounts to political insurrection. Vashti is disempowered, stripped of her crown – and literally marginalized by Filippino's composition – because she refused to display herself as a body; Esther, on the other hand, will be rewarded with a crown for her submissive physical display before the court. The substitution of Esther for Vashti reveals that the crown or political power is vulnerable to the threat of unpredictable and disobedient female bodies. But even if the crown may be transferred from one queen to another, as women Esther and Vashti are equivalent in their generative capacity, in their recourse to the "rag."

Just as the crown permits a dual reading in Esther's semiotic system, so too does the "menstrous rag." The shedding of menstrual blood denotes a present state of childlessness, but it also indicates the female body's readiness to conceive, or its generativity, in Esther's case a potential never to be realized. Old Testament generativity is not transparently natural or neutral, however, but rather it creates meaning, part of what Elaine Scarry calls the "making of body into belief":

> The ordinary alternation in the female body between the conditions of being sometimes "not with child" and sometimes "with child" becomes within these [Genesis] stories the intensified and absolute conditions of "barrenness" and "fertility" ... barrenness is absolute because it means "unalterable" except by the most radical means, unalterable except by divine intervention.[9]

The ideology of generation or procreative power in the Old Testament survives in Christian typology, although the lines of descent are denied. Where Old Testament generativity stresses the miraculous power of God to create life through the human body, St. Paul conceives of the Christians as newly created humanity; the Pauline "New Jerusalem is like a barren woman who is miraculously blessed with many children."[10] Organic metaphors characterize this process, terms like "shadow" and "fulfillment," the bringing to "fruition" of God's promise; the Christians, however, do not claim a direct or literal genealogy, but rather a "figural" descent from the Hebrews.[11] In this construction, the covenant of the Law generates generations of Jews, but the new covenant established by Christ establishes a truer and final lineage from God to man.

The logic of typological figuration is elastic, all-embracing, within the framing context of Christology. However loosely linked, typological analogies focus on actions or narrative, forming what Robert Alter

calls "type scenes" or purposefully deployed repetitive compositional patterns.[12] For example, Esther experiences a divine election or elevation analogous to Mary's Annunciation or Coronation; Esther unexpectedly becomes queen of Persia, and the Virgin becomes the queen of Heaven. St. Bernard called Mary "quasi altera Esther" ("almost another Esther"), and St. Bonaventure compared Esther to the Virgin, "quae ducata est in cubiculum regis in assumptione" ("led in majesty into the chamber of the king").[13] In an anonymous fifteenth-century *sacra rappresentazione* or vernacular drama, "Della Regina Esther," Esther refers to herself repeatedly as the *ancilla* of Ahasuerus, recalling the annunciate Mary's "ancilla dei."[14] The Persian name Esther means "star," easily paralleled with Mary, "stella maris" ("star of the sea"); like Mary, Esther is a mediatrix between the humble and the powerful; and finally, like Mary, Esther is the "Sponsa-Ecclesia."[15]

Erich Auerbach explains this "figural" connection between two concrete historical eras, Hebrew and Christian, in terms of a validating unity; taken in a less affirmative sense, one might emphasize the dissociation or deception inherent in typological thinking ("Figura," p. 53). The very logic of typology based on resemblance or analogy must also serve to disrupt and distance, to deny family ties. The making of Esther's "body into belief" through typology juxtaposes a sexuality unmotivated by procreation with the Virgin's procreation disassociated from sexuality. Esther's childlessness does not just contrast with the Virgin Mary's spectacular conception that once and for all altered the world, it is also a larger manifestation of the distance to be maintained between the Old Testament Jews and the New Testament Christians.

Before turning to the fifteenth-century domestic pictures which inherited this contradictory construction of Esther, we might explore the manner in which typology retrospectively generates the type or foreshadow. St. Jerome offers an example of typological *rapprochement* or accommodation with reference to St. Paul's borrowings from pagan texts; the "other," pagan or Jew, appears as a subjugated woman, as an object of desire and castigation:

A type of this sort of wisdom is described in Deuteronomy under the figure of a captive woman. The divine voice commands that if an Israelite desires to have her as a wife, he shall make her bald, pare her nails and shave her hair. When she has been made clean, then she shall pass into the victor's embrace. If we understand that literally, isn't it ridiculous? And yet we ourselves are accustomed to do this when we read the philosophers, when the books of secular wisdom come into our hands. If we find anything useful in them, we apply it to our own doctrine; but if we find anything – with regard to idols,

love, the care of secular things – that is inapplicable, these we shave off, for these we decree baldness, these we cut away like our nails with a very sharp blade.[16]

According to St. Jerome, it is only by cutting away, shaving off, and disempowering that the alien can be domesticated and, vice versa, that the Christian can tolerate his own desire to espouse the "other." Recalling Esther's semiotics, we might say that for Jerome the crown must surrender to the "rag," the ornamental or seductive body-text must be divested and rendered abject before a conjugal embrace. Shorn of her hair, the captive woman must surrender not only the ornamental or seductive aspect of her appearance, but also the badge of gender itself. As the captive woman then registers both desire and castigation in Jerome's example, so do the ancient or Old Testament heroines appropriated by Renaissance humanist philological or Christian typological reading strategies.[17]

The Esther story pits the universalizing aims of typology against the Pauline romance of desire and castigation; rather than assuming a consistent iconography in medieval and Renaissance texts, what is cut away or shaved off from the Esther story differs from author to author. For example, in Dante's *Purgatorio* 17, 25–30, the protagonists enact a scene of retribution, of "anger punished," in which Esther is simply identified as "sposa" rather than active agent, and the crucified Haman becomes a type for Christ. In Petrarch's *Trionfi*, Ahasuerus' replacement of Vashti with Esther represents not so much righteous castigation of disobedience, as a "malicious remedy" for lovesickness, that is to replace his wife.[18] Ahasuerus "drives one nail out with another," and his foolish belief in the possibility of improvement through replacement puts him in company with Holofernes and Herod, similarly love-sick leaders.[19]

If typology retrospectively constructs the Old Testament "other" as prefiguration or foreshadow, and literary sources alternate between the theological or erotic aspects of the Book of Esther, the meanings applied to Jews in fifteenth-century Tuscany were similarly provisional and unstable.[20] In Renaissance Italy, as in Esther's Persia, Jews were the subject of contested relationship and problematic definition. Diane Hughes suggests that Franciscan preaching in mid-fifteenth-century Italy fueled anti-Semitism and led to an increased desire for the enforcement of distinctions between Christians and Jews. Hughes' study further suggests that sexual ideology entered inevitably into these negotiations of difference: Jews and prostitutes were equated as purveyors of contagion, while civic dependence on moneylending and

extramarital sexual services was denied.[21] And yet despite the vehement punishment reserved for interfaith sexual contact and the taboo declaring that "coition with a Jewess is precisely the same as if a man should copulate with a dog," Jewish women could convert in order to marry, and these apostate marriages were acceptable in both civil and ecclesiastical courts.[22] As the example of apostate marriage makes clear, forms of social exclusion offer the means of accommodation even as they respond to foreclose contact between Jews and Christians.

From the art historian's point of view, the most significant move in this struggle to maintain the separation of the Jewish community – to forestall economic and social encroachment in the form of usury and intermarriage – is the attempt to control visual representation by legislating Jewish costumes and badges. In 1463, for example, the Florentine government renewed a resolution to impose the *segno* or Jewish badge in order to resolve much "confusion and miscognition":

> Considering that many Jews have to stay in Florence and almost none of them wear the sign, there is so much confusion that it is difficult to tell the Jews from the Christians, and this is followed by many omissions and errors.[23]

In response to this semiotic uncertainty the Florentine statutes attempt both to legislate the distance or separation of the Jewish community, and to delimit its incorporation through the *segno*. The economic motivations of this separation are clear in the case of Brescia where, in 1494, after the establishment of a *monte di pietà* or financial institution, the Jews were expelled from the city. Hughes cites the conflation of sexual and economic pollution with which the Brescian city fathers justified their expulsion of the Jewish community:

> While the Christian church may tolerate the Jews, it has in no way decreed that they have to be tolerated in Brescia; they should be treated as public prostitutes, who because of their filth are tolerated [only] while they live in a bordello, even so should those Jews live their stinking life in some stinking place, separate from Christians. ("Distinguishing Signs," 29)

The illicit profit of moneylending is expressed as illicit sexual pleasure; only when the city had established financial independence, however, could it afford to expel the source of its pollution. As in Jerome's example of typological appropriation through castigation, Renaissance anti-Semitism retrospectively constructs its "other," masking mercantile or sexual contact as pollution or contagion, denying economic as well as literal offspring. That both profit and progeny are to be controlled by means of an exterior sign thus indicates an investment in the visual or pictorial to demarcate the difference between Jews and

Christians, as well as to indicate their resemblance through typological analogies or type scenes. The fifteenth-century *segno*, or "distinguishing sign," points to the imbrication of anti-Semitism and typology in domestic pictures of Esther.

Esther and the type scene in domestic painting

Fifteenth-century domestic pictures of Esther are informed by a variety of textual accounts – from the Bible to Josephus, from Dante to vernacular drama – by the cultural practice of nuptial gift exchange, and by the ideology of anti-Semitism; from these heterogeneous sources they establish a legible visual typology derived from Marian narrative, composition, and figure types. Equating type and antitype, the pictures also privilege what Lisa Jardine calls the "saving stereotype," an uneven balance between Old and New Testament, Esther and the Virgin Mary.[24] Esther is a type for the Virgin, but the Virgin's life establishes type scenes for the representation of her Old Testament predecessor.

These type scenes featuring Esther diverge from their referential function in textual exegesis in that descriptive, narrative, or "reality" effects exceed and overdetermine their typological charge.[25] Renaissance narrative painting or *istoria* proposes a referential complexity in tension with symbolic or typological clarity. The Apollonio di Giovanni shop *cassone* frontal, for example, associates Esther and the Virgin through the metonymic placement of the church of SS. Annunziata in the center background (fig. 3). For Florentine contemporaries the miracle-working image of the Annunciation found there made SS. Annunziata the preeminent local site for identification with the Virgin.[26] The *cassone* composition stages two distinct scenes to the right of the church; first Esther accepts Ahasuerus' ring in the loggia, then she is seated during her banquet at the right margin of the panel. The image of SS. Annunziata topographically associated with the Virgin encourages the viewer's identification of Esther with the Church or *Ecclesia*, connoting her antithetical relation to Vashti as *Synagogue*. While such architectural references serve less thematically weighted purposes, marking out local landmarks or the patron's neighborhood for example, the emphatic placement of the Virgin's church in the center of the composition proposes a layer of typological meaning in the narration of the Old Testament story.

Apollonio's comparison of Esther to a literal *Ecclesia* remains unique in fifteenth-century domestic painting, a typological solution without

successors. Filippino Lippi, in contrast, draws on typological parallels to the Virgin Mary's annunciation and coronation when he depicts Esther's election by Ahasuerus from the eligible virgins of Persia (fig. 1). Esther's body language here mimics that of the annunciate Virgin, an imitation easily accomplished given the Renaissance shop practice, common to "major" and "minor" painters alike, of repeating postures and figure types from modelbook drawings. Esther kneels obediently in front of Ahasuerus and, although the pendant sleeves partially obscure the position of her arms, Esther's submissive crossing of her breast foreshadows the Annunciation.[27]

Esther's status as Ahasuerus' chosen queen competes with the pictorial demands of narrative time and space in Filippino's panel. Her itinerary, while appearing to complete the circuit of the other parading women in the foreground, actually presents Esther already inside the throne room; she bows behind the low socle while the other women parade in front of it.[28] Filippino then shifts between temporal registers; Esther is both part of the procession and outside it, a participant in the narrative events and a parallel to the Virgin Mary, "blessed above all women."

The Apollonio di Giovanni shop and Filippino Lippi's *Esther* ensembles demonstrate that typological figuration is purposive rather than a chance effect of Renaissance shop practice; rather than a careless or hackneyed repetition of modelbook types and formulae, such pointed repetitions established typological resonances. Whereas Filippino Lippi provides type scenes or narrative analogies to the Virgin Mary in his depiction of Esther, Andrea del Castagno's fresco of *Uomini famosi* literally pairs their bodies (figs. 4 and 5). Castagno's display of these "Nine Worthies," representatives of military might and learning, arms and letters, hinges on the half-length *sopraporta* figure of Esther on the longer of the two adjacent frescoed walls. The overall composition juxtaposes the male and female "Worthies," three men to either side flanking the female figures. According to their inscriptions, the three crowned and centrally positioned women – the Cumaean Sibyl, Esther, and Tomyris – liberated their countries or peoples. The legend under Esther originally read, "Ester regina gentis sue liberatrix" ("Queen Esther liberator of her people").[29] While the inscription demands that the audience view Esther in her heroic capacity, and her placement among other historical female "Worthies" suggests a celebration of feminine heroism, the placement and posture of Esther demand a typological reading since they mirror the figure of the Virgin Mary diagonally opposite.

Both Esther and the Virgin are centered on their respective walls,

shown in half-length, positioned over doors. While the completion of the side wall with its half-length Madonna flanked by Adam and Eve may not be contemporary with the *Uomini famosi*, it has been argued nonetheless that the figures of Esther and the Virgin create a typological pairing.[30] Even the liberation reference in Esther's inscription creates an ahistorical or non-narrative Marian analogy; Esther intercedes on behalf of the Jews, and Mary redeems mankind from the sin of Adam and Eve, who are shown flanking her.

Esther's assumption of the half-length format so firmly identified with the Virgin Mary in fifteenth-century art estranges the two figures as much as it forges a *rapprochement*. The half-length format is conventional for quattrocento Madonna and child imagery or for female profile portraits, but it is exceptional for Old Testament heroines such as Esther at mid-century.[31] The Virgin's figure is framed by angels who part the curtains of a large baldacchino; her truncated form is naturalized and located in a lunette as if in her customary appearance over an altarpiece or tomb. Esther, on the other hand, has no additional framing devices to naturalize her peculiar half-length figure. Framed only by the same fictive architecture as the full-length "Worthies" to either side of her, Esther's body makes no concessions to its fragmentary state, unlike the Virgin whose embrace of the Christ child creates a closed composition masking the break of the door frame. Esther, in contrast, breaks the containing frame by turning in three-quarter view as if to engage Tomyris in conversation.

Esther functions as the keystone of the "Nine Worthies," yet she is partial, incomplete, a truncated female body (fig. 6). She crowns the cycle with a deceptive appearance of wholeness. Not only does the half-length format present an exceptional configuration of Esther, but the doorway below Esther's truncated torso perversely occupies the focal point of the fresco cycle. This threshold serves both as the convergence area for the perspective system, appealing to optical experience, and as physical invitation, to traffic between rooms. The *sopraporta* format itself engages the gender connotations of Renaissance anthropomorphic architectural allegory. The window or *sopraporta* represents a sexualized, feminine architectural space in which women are on display for a male gaze; in Renaissance portraits women frequently occupy such liminal architecture. In this sexualized space, then, Castagno's Esther wears the crown and crowns the series, yet the bunched cloth grasped between her fingers at the lower margin of the composition connotes the "rag," the generative function of the female body and its incitement of desire and castigation.[32]

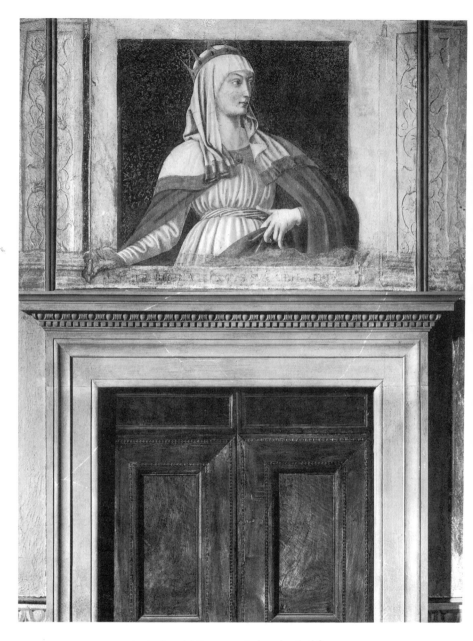

6 Andrea del Castagno, *Esther*, detail of figure 4

If Castagno's fresco does sexualize the childless Esther, proposing a generative body at the central, generating point of the cycle, then how does this body figure in the typological scheme? In the case of the Virgin Mary, the sexual connotations of the parted cloak or billowing baldacchino refer to birth-imagery; birth in turn validates the Virgin as mother of us all. Esther, however, does not become a mother in the Book of Esther, producing no heroic son to parallel the son of Man.[33] Any allusion to her thwarted procreative capacity in Castagno's fresco is extraneous, then, a meaning found in the female body in contrast to the biblical narrative and exceeding the typological function to emphasize the barrenness of the Old Testament.

Esther's entry into a typological scheme is complicated by her racial as well as sexual ambiguity; a woman but not a mother, she is a national hero, "liberator of her people," who conceals her Jewish identity. Only the Apollonio di Giovanni shop *cassone* panel depicts the disguised interfaith marriage of Esther and Ahasuerus (fig. 3). The *ebrea* Esther appears in the *cassone* painting like the quattrocento Christian bride who might have received the chest; she lacks any distinguishing sign or defamatory badge, and her apparel does not differ from that of the Persians.[34] Although the absence of Jewish clothing for Esther is characteristic of the syncretic use of costume in early Renaissance painting, the conflation of historical and contemporary costume parallels Esther's clandestine identity in the Persian court where difference cannot be maintained by external appearance or signs. The typological parallel of Esther and *Sponsa Ecclesia* cannot entirely defuse the secret Jewish identity of Ahasuerus' bride.[35] That same Florentine audience trusting to the *segno* to differentiate Jews from Christians confronts in Esther *cassoni* the staging or thematization of clandestine identity; the hidden *ebrea* engages connotations of apostasy and concomitant fears of defilement of patrilineal purity for contemporary viewers.

The Apollonio di Giovanni shop panel does not frame the image of Esther's wedding with its pretext, the exile of the disobedient Vashti. Rather than a parade of eligible virgins as in Filippino Lippi's first panel, we find instead a cavalcade including the king and his courtiers prefacing the wedding. At the loggia, the king dismounts, enters, and takes Esther's hand in marriage. We know from the Book of Esther that Ahasuerus chooses Esther for her unadorned physical beauty as much as for her obedience:

> She asked for nothing except what Hegai the king's eunuch, who had charge of the women, advised. Now Esther was admired by all who saw her. When Esther was taken to King Ahasuerus in his royal palace in the tenth month . . .

the king loved Esther more than all the other women; of all the virgins she won his favor and devotion, so that he set the royal crown on her head, and made her queen instead of Vashti. (2:15–17)

The Book of Esther describes the heroine's "beauty," but Clement of Alexandria presages St. Jerome's prescriptions for chastising her alien appeal; for Clement, Esther's resistance to ornament becomes an argument against embellishing the body:

> As for women, the only one we know of who used ornaments without blame is Esther. Her action in making herself beautiful had a mystical significance, however, for, as the wife of her king, she obtained deliverance for her people by her beauty when they were being slaughtered.[36]

Renaissance physiognomics, distantly echoing Clement and Jerome, equate physical beauty with virtue or moral beauty, but the deprecating equation of ornament, sumptuary excess, and women undercuts beautiful female exemplars such as Esther.[37] The double messages about physical and moral beauty in the Book of Esther reappear in the play "Della regina Esther," when the king denies the traditional concerns of Renaissance marriage policy, that is, family, dowry, and beauty, in his definition of a desirable bride. Yet despite his protestations to the contrary, Ahasuerus cannot entirely omit beauty from his marital deliberations: "I have made up my mind to take a bride who in my estimation seems wise, peaceful, and also beautiful and of lovely appearance [*bella e di leggiadro aspetto*]."[38] But it is precisely Esther's lovely appearance which deceives the king in as much as her Jewish identity is invisible.

Like the *cassone* panel from Apollonio's shop, the fifteenth-century play emphasizes Esther's beauty and its effect on Ahasuerus while strategically omitting the harem setting and the multiple wives or concubines described in the Book of Esther. The play and the domestic painting historicize the plot, politics, and setting of Persia, but then familiarize the Old Testament past with contemporary costume, type scenes, and appeals to Renaissance gender ideology. Rather than the sybaritic Persian tyrant, the "carnal king," whose sexual appetite monopolizes the available women of his realm, the dramatic version of Ahasuerus echoes patrician marital strategy; domestic harmony drives his measured erotic economy. Rather than a Scheherazade or favorite of Ahasuerus' harem, the Esther of the play or of the *cassone* recalls instead "Mary, blessed above all women."

Deception, clandestine identity, and contagion permeate the intermarriage of Esther and Ahasuerus, but they also motivate the subplot of

the Apollonio di Giovanni shop *cassone* picture. The traitors Bigthan and Teresh appear to the left of the nuptial couple while outside the loggia Mordecai eavesdrops, leaning forward with a conventional hand-to-ear listening gesture. The *cassone* picture follows the Book of Esther and the fifteenth-century play closely; the traitors, eunuchs disgusted by the king's excessive expense in marrying a second time, plot his murder. Mordecai overhears the plot and makes their hidden intentions known to Esther.

The *cassone* picture juxtaposes the wedding of Esther and Ahasuerus with the treachery and deception it inspired in two of the king's false-seeming officials. As eunuchs the traitors are doubly false, neither men nor dutiful subjects. Given the interrelatedness of the wedding and the treason, can we say that Esther's wedding is redemptive, since once armed with Mordecai's information she will inform the king? Or is her own deception at issue here, compared to the treason of Bigthan and Teresh, but redeemed by her typological association with *Ecclesia* in the form of the Virgin's church of SS. Annunziata? Given the ambivalent status of heroines in domestic painting, in general, Esther's damaging association with the traitors Bigthan and Teresh qualifies her exemplarity and jeopardizes typological coherence. The eunuchs and the *ebrea* Esther both figure false-seeming at Ahasuerus' court.

The aspect of the Esther narrative furthest from Marian parallels and typological appropriation is the threat of rape by Haman at the end of the story; the Virgin's body remains ever inviolate, while Esther's body is potentially adulterous, violated, polluting as well as polluted. The Apollonio di Giovanni shop *cassone* panel positions the rape accusation prior to Haman's downfall at the right margin of the composition. Seated at right foreground during the banquet she requested from the king, Esther demurely averts her eyes and draws her arms across her body; she does not turn to meet Haman's stare. Ahasuerus and Mordecai face Esther; the king tucks his right hand into his belt, left hand out in an open-palm inquiry. Haman, standing at the end of the table, extends his left hand, palm up, as if in explanation.

In the play and the Book of Esther, the king leaves the loggia after Esther reveals Haman's villainous use of the king's signet ring to seal the death warrant of the Jews. When Ahasuerus returns he finds Haman falling upon Esther's mercy, and literally falling upon her banqueting couch or *letto*. In both the play and the biblical text, Ahasuerus assumes that Haman's posture indicates an attempted rape, asking, "Will he even assault the queen in my presence, in my own house?" (7:8). We might say that the king mistakes a conventional type scene or posture of

humble petition. Whereas Ahasuerus did not see Haman's real crimes, he now imposes capital punishment for a crime mistakenly construed. The king's misapprehension throws into question the motivation for Haman's punishment, in particular, and the reliability of visual signs, in general. Is Haman executed for his threat to the Jews, or is he punished for the supposed rape? The picture leaves the narrative *in medias res*, pitting the king against his former advisor with Esther's body between them. Her sexuality, strategically deployed by Mordecai and pleasurable for Ahasuerus, becomes a fatal trap for Haman; Midrash commentary explains the duplicity of the *femme fatale*: "just as the myrtle has a lovely fragrance but a bitter taste, so Hadassah [Esther] was fragrant for Mordecai but bitter for Haman."[39] Esther, in the guise of a fifteenth-century Florentine bride on the Apollonio di Giovanni shop *cassone* panel, however, is a chastened image of Renaissance feminine decorum, modesty, and chastity, distanced from the erotic tensions of the narrative plot.

While the Apollonio di Giovanni shop *cassone* panel omits Haman's execution, perhaps locating it on a missing pendant, Filippino Lippi includes the climactic finale to Esther's triumph over the genocidal Haman (fig. 2). In the right background Haman hangs on the very gibbet he had prepared for Mordecai. As in Filippino's first panel, the vignettes in the left and right midground thematically mirror each other as scenes of request; at left, a standing Esther confers with Mordecai, and at right, a kneeling Haman beseeches Esther for mercy. Haman's serpentine body within the right-hand arch of the throne room to the right of center foreground connects these framing narratives. Haman exits, but simultaneously turns back to hear Esther's request for the banquet at which he will be exposed as a traitor. While Esther makes her request before Ahasuerus in full knowledge of the death penalty she risks by appearing in court unsummoned, Haman will comply with Esther's summons without suspecting the punishment awaiting him.

More explicit than the Apollonio di Giovanni shop *cassone* panel, Filippino suggests the "rape" through the physical proximity of Haman kneeling in front of a seated Esther; the concentration on three figures here emphasizes the rivalry for possession of the queen, and contrasts with the festive banquet setting and female spectators of the Apollonio di Giovanni shop picture. Esther appears to swoon as Ahasuerus sprints into the loggia; the king's agitation and Esther's passivity together convey the erotic threat of Haman's posture. Esther's swoon before Haman echoes her posture in the center fore-

ground, where she braves the death penalty for her uninvited appearance before the king. There she clings to her accompanying maidens in a manner recalling the Virgin Mary's helpless faint and John the Evangelist's support during Christ's crucifixion. In Esther's subsequent swoon, her slumped off-guard position suggests vulnerability, if not yielding, to Haman's appeal; Midrashic commentaries would go even further, suggesting that Esther, another *femme fatale* like Judith, was willing to seduce an enemy of the Jews in order to bring him to justice without concern for her own punishment.[40] Like Judith, however, the gender inversions of her triumph and the seductive means employed render equivocal Esther's exemplary status.

In sum, each of the three examples of Esther examined here employ type scenes or pictorial typology, but in each case the female sexual body – the *femme fatale* – exceeds the sterility–fertility opposition of Hebrew and Christian, Old and New Testament. Since Esther substitutes for Vashti as well as for the Virgin, her "figura" threatens to collapse into aporia rather than to produce stable typological meaning. The typological coherence of the pictures is attenuated further by factors such as interfaith marriage, adultery, or "rape" that prove either to be irreconcilable with Marian analogies, or in conflict with the "saving stereotype."

In assuming the authority to bestow the crown on successive women, Ahasuerus unwittingly chooses the most inappropriate, and yet the most desirable bride. The unlikely queen, Esther, undermines the coherent relationship of political power to its external insignia; the crown, no less than the "rag," becomes an empty placeholder. In assuming the authority to read the Old Testament retrospectively and instrumentally, to exchange type for antitype, typology also mistakes desire for authority, reads castigation as the restorative act of doctrinal purity. A seamless correspondence between text and image as proposed by an iconographic reading of Esther *cassone* pictures overlooks the submerged motivations of the appropriation of the Old Testament heroine in Renaissance culture. Read together, the crown and the "rag" of Esther's semiotic system allow for conflicts between power and the body within interpretation. Just as the conflation of Esther's crown-rag locates meaning in undecidability rather than closure, so too domestic pictures of Esther generate meaning out of the conflicting discourses of female sexuality and Christian typology.

Notes

I would like to thank the J. Paul Getty Foundation for a Postdoctoral Fellowship, and the University of Rochester for a leave of absence, 1990–1. Mieke Bal, Ellen Callmann, Jeffrey Ravel, Elaine Rosenthal, Pat Simons, Randolph Starn, and James Turner have each contributed to my thinking about Esther. Translations from the Italian are my own.

1 For domestic painting, see Paul Schubring, *Cassoni: Truhen und Truhenbilder der italienische Renaissance* (Leipzig, 1923); Paul Watson, "Virtù and Voluptas in Cassone Painting" (Dissertation, Yale University, 1970); and Cristelle L. Baskins, "Lunga pittura: Narrative Conventions in Tuscan Cassone Painting circa 1450–1500" (Dissertation, University of California, Berkeley, 1988).

2 The complete Filippino Lippi ensemble also includes: *Esther summoned to Ahasuerus*, 48.1 × 43.18 cm. (Ottawa: National Gallery of Canada, no. 6085); *Vashti Leaving Ahasuerus*, 45.5 × 40 cm (Florence: Fondazione Horne, no. 41); *Triumph of Mordecai*, 48 × 43.18 cm (Ottawa: National Gallery of Canada, no. 6086); *Mordecai Laments for the Jews*, 47 × 41.5 cm (Rome: Galleria Pallavicini, no. 271). The Jacopo del Sellaio *Esther* ensemble, comprised of five *spalliere* panels in the Uffizi, Florence, the Budapest Fine Arts Museum, and the Louvre, Paris, merits a separate study.

3 Marianne Haraszti-Takacs, "Fifteenth-Century Painted Furniture with Scenes from the Esther Story," *Jewish Art* 15 (1989), 14–25, suggests that Old Testament subjects *per se* indicate Jewish patrons, but provides no documentary evidence.

4 My contextual approach is informed by Diane Owen Hughes, "Sumptuary Laws and Social Relations in Renaissance Italy," in John Bossy, ed., *Disputes and Settlements: Law and Human Relations in the West* (Cambridge, 1983), pp. 69–99; Hughes, "Representing the Family: Portraits and Purposes in Early Modern Italy," *Journal of Interdisciplinary History* 17 (1986), 7–38; Hughes, "Distinguishing Signs: Ear-rings, Jews, and Franciscan Rhetoric in the Italian Renaissance City," *Past and Present* 112 (1986), 3–59; and Constance Jordan, *Renaissance Feminism: Literary Texts and Political Models* (Ithaca, 1990).

5 Paraphrase from Sidnie Ann White, "Esther: A Feminine Model for Jewish Diaspora," in Peggy L. Day, ed., *Gender and Difference in Ancient Israel* (Minneapolis, 1989), pp. 161–77, 163.

6 Domenico Pietropaolo, "Iudit, *femme fatale* of the Baroque Stage," in Ada Testaferri, ed., *Donna: Women in Italian Culture* (Toronto, 1989), p. 280.

7 Hans Martin von Erffa, "Judith, Virtus Virtutum, Maria," *Mitteilungen des Kunsthistorischen Institutes zu Florenz* 14 (1969), 460–5.

8 As Josephus assumed; *Works*, trans. W. Whiston (Baltimore, 1830), p. 228.

9 *The Body in Pain: The Making and Unmaking of the World* (Oxford, 1985), p. 194.

10 See Leonhard Goppelt, *Typos: The Typological Interpretation of the Old Testament in the New* (1939, repr. Grand Rapids, 1982), pp. 138–40; St. Paul recalls Isaiah 54:1 in Galatians 4:28.

11 Erich Auerbach, "'Figura,'" in *Scenes from the Drama of European Literature* (Gloucester, Mass., 1973), pp. 11–76.

12 Robert Alter, *The Art of Biblical Narrative* (New York, 1981), pp. 47–62.

13 Quoted from Creighton Gilbert, "On Castagno's Nine Famous Men and

Women," in Marcel Tetel, ed., *Life and Death in Fifteenth-Century Florence* (Durham and London, 1989), p. 187.

14 Alessandro d'Ancona, ed., *Sacre rappresentazioni dei secoli xiv, xv e xvi* (Florence, 1872), p. 140.

15 Madelyn Kahr, "The meaning of Veronese's Paintings in the Church of San Sebastiano in Venice," *Journal of the Warburg and Courtauld Institutes* 33 (1970), 240–1.

16 Epistle 21 to Damasus, in *The Letters of St. Jerome*, trans. Charles C. Mierow (Westminster, Md., 1963), vol. I, pp. 109–33. I would like to thank Olga Grlic for this reference.

17 Stephanie H. Jed, *Chaste Thinking: the Rape of Lucretia and the Birth of Humanism* (Bloomington, 1990), discusses the gender implications of philological castigation.

18 Ed. Carlo Calcaterra (Turin, 1927), book 1:3, lines 62–6.

19 Boccaccio left Esther out of the "Good Women" in his treatise *De mulieribus claris*; see Constance Jordan, "Boccaccio's In-Famous Women: Gender and Civic Virtue in the *De mulieribus claris*," in Carole Levin, ed., *Ambiguous Realities: Women in the Middle Ages and Renaissance* (Detroit, 1987), pp. 25–47.

20 Michael Camille, *The Gothic Idol: Ideology and Image-Making in Medieval Art* (Cambridge, 1989), ch. 4, analyzes the construction of the Jews as "other" in medieval Christian culture.

21 "Distinguishing Signs," 16–24. Like the Jewish *segno*, earrings were contested and volatile signs in Renaissance display culture, shifting from their original asociation with Jewish women to their adoption by the upper classes in the sixteenth century.

22 See Camille, *Gothic Idol*, p. 171, regarding a case in thirteenth-century Paris. For Italy, see Cesare Colafemmina, "Donne, ebrei e cristiani," *Quaderni medievali* 8 (1979), 117–25. On apostate marriage, see Michele Luzzati, *La casa del ebreo: saggi sugli ebrei a Pisa e in Toscana nel medioevo e rinascimento* (Pisa, 1985), pp. 59–106.

23 Umberto Cassuto, *Gli Ebrei a Firenze nell'età del Rinascimento* (Florence, 1918), p. 372. The Jewish badge was instituted by Innocent III at the Fourth Lateran Council of 1215; see Israel Abrahams, *Jewish Life in the Middle Ages* (London, 1896), p. 296.

24 *Still Harping on Daughters: Women and Drama in the Age of Shakespeare* (New York, 1983), pp. 177–8.

25 Roland Barthes, "L'effet du réel," *Communications* 11 (1968), 84–9.

26 John Pope-Hennessy and Keith Christiansen identify SS. Annunziata as a local landmark in *Secular Painting in Fifteenth-Century Tuscany* (New York, 1980), p. 24. See Ellen Callmann, *Apollonio di Giovanni*, (Oxford, 1974), p. 66.

27 See Michael Baxandall, *Painting and Experience in Fifteenth-Century Italy: A Primer in the Social History of Style* (New York and Oxford, 1972), p. 51, for the five attitudes of the annunciate Mary glossed by Fra Roberto Caracciolo, c. 1480.

28 See Nelson Goodman, "Twisted Tales: or Story, Study, and Symphony," *Critical Inquiry* 7 (1980), 103–19, on the complexity of viewing itineraries.

29 Giorgio Vasari, *Le vite de' piu eccellenti pittori, scultori ed architettori*, ed. Gaetano Milanesi (Florence, 1888), vol. II, p. 670. For discussion of the textual sources see Christiane Joost-Gaugier, "Castagno's Humanistic Program at

Legnaia and its Possible Inventor", *Zeitschrift für Kunstgeschichte* 3 (1982), pp. 274–82.

30 The side wall and the *Virgin and Child* have been badly damaged. Marita Horster notes, without discussion of the evidence, that the doorway was cut under the figure of Esther after the completion of the fresco cycle: *Andrea del Castagno*, (Oxford, 1980), pp. 31, 178. Gilbert, in contrast, persuasively argues that the doorway is part of the original configuration: "Castagno's Nine Famous Men and Women," p. 187.

31 Pat Simons, "Women in Frames: the Gaze, the Eye, the Profile in Renaissance Portraiture," *History Workshop* 25 (1988), 4–30. On development of the format, see Irving Lavin, "On the Sources and Meaning of the Renaissance Portrait Bust," *Art Quarterly* 33 (1970), 207–26. See Robert L. Mode, "Ancient Paragons in a Piccolomini Scheme," in Robert Enggass and Marilyn Stokstad, eds., *Hortus Imaginum: Essays in Western Art* (Lawrence, 1974), pp. 73–83, for a half-length Judith in a late-fifteenth-century Sienese *Uomini famosi* cycle.

32 Simons, "Renaissance Palaces, Sex and Gender: The 'Public' and 'Private' Spaces of an Urban Oligarchy," (unpublished manuscript), analyzes the construction of "feminine" space in Renaissance architecture. See Donald K. Hedrick, "The Ideology of Ornament: Alberti and the Erotics of Renaissance Urban Design," *Word and Image* 3 (1987), 111–37, for erotic architectural drawings of the sixteenth century.

33 Caroline Feudale, "The Iconography of the Madonna del Parto," *Marsyas* 7 (1957), 8–24. Midrashic commentaries relate that Esther delivered a stillborn child upon seeing Mordecai in mourning clothes: *Jewish Encyclopedia*, p. 234.

34 For illustrations of Jewish costume, see Thérèse and Mendel Metzger, *Jewish Life in the Middle Ages: Illuminated Hebrew Manuscripts of the Thirteenth through Sixteenth Centuries* (New York, 1982). For Renaissance costume in general, see Stella Mary Newton, *Renaissance Theater Costume and the Sense of the Historic Past* (London, 1975), and Elizabeth Birbari, *Dress in Italian Painting 1460–1500* (London, 1975).

35 Vespasiano da Bisticci, for example, stresses this intermarriage of Jew and Gentile when introducing Esther in the preface to *Delle lode e commendazione delle donne*, c. 1480; see Ludovico Frati, ed., *Vite de uomini famosi* (Bologna, 1893), pp. 290–1. For deception as an element of Christian marriages, see Anthony Molho, "Deception and Marriage Strategy in Renaissance Florence: The Case of Women's Ages," *Renaissance Quarterly* 41 (1988), 193–217.

36 *Christ the Educator*, trans. Simon P. Wood, C. P. (New York, 1954), p. 209.

37 Hughes, "Sumptuary Laws," provides the most complete overview.

38 d'Ancona, ed., *Sacre rappresentazioni*, p. 140.

39 Jacob Neusner, trans. *Esther Rabbah I (Atlanta, 1989), p. 141.*

40 Commentary in Morton Enslin and Solomon Zeitlin, *The Book of Judith* (Leiden, 1972). See Horst Janson, *Donatello* (Princeton, 1963), p. 199, for Florentine dissent about the relocation of Donatello's *Judith* in 1504: "the *Judith* is a deadly symbol ... nor is it good to have a woman kill a man."

Artifice as seduction in Titian

MARY PARDO

ई≫

The critical appraisal of the figurative arts in the Renaissance was implicated in a large-scale reassessment of sensory experience – a reassessment in which the experience of the erotic played a crucial part. Since antiquity, it had been traditional to illustrate various issues pertaining to the analysis of sensation by citing examples from the arts. However, the illusionism of fifteenth- and sixteenth-century painting and sculpture assumed a particular relevance as the processes of sensation gained importance in the psychological speculation of the period. In this context, the rendering of erotic subjects became a kind of test-case for the sensory "truth" of the work of art. It is not just that the devices of illusionistic representation could be judged by their power virtually to ensoul the image of the desired body: the work of art, in its capacity as the medium for a kind of courtship between maker and viewer, was also seen to shed light on the psychic mechanism of erotic attraction.

This chapter takes one celebrated (and much-discussed) image of the beloved – Titian's *Urbino Venus* (fig. 7) – as the starting point for a survey of textual and visual evidence which broadens our view of the erotic in Renaissance figurative art. Like Titian's painting, much of this material is familiar to the student of Renaissance culture, but the scholarship in which it is featured has consistently emphasized the interpretation of subject matter, or the tracing of themes, over the analysis of the means of representation. I intend to do the reverse, and address the iconography of the *Urbino Venus* and its artistic kin only insofar as it allows us to approach more closely the Renaissance view of artifice itself as a vehicle for the erotic. With the aid of the *Urbino Venus* (and inspired by David Rosand's suggestive analysis of Titian's *Rape of Europa* of 1556) I propose to locate the erotic dimension of Renaissance figurative art in the very strategy of its making.[1]

A text made public one year before the completion of the *Urbino*

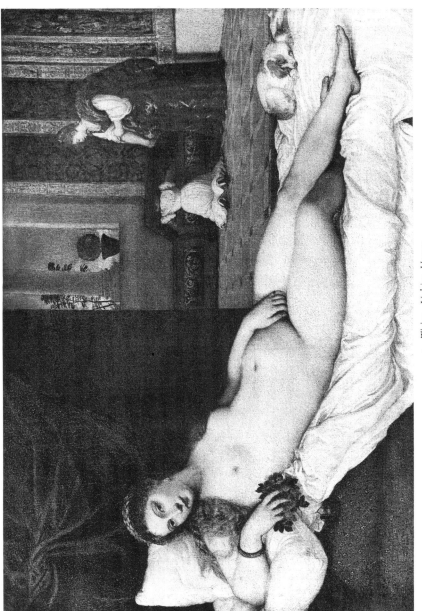

7 Titian, *Urbino Venus*

Venus can help us imagine a context for the painting's production and reception. In June 1537, while a guest of Pietro Aretino in Venice, the minor poet Niccolò Grassi gave a reading of the *Dialogo d'amore*, a work recently completed by the celebrated Paduan intellectual Sperone Speroni.[2] Aretino's published correspondence suggests that Grassi, acting on Speroni's behalf, was soliciting a critical endorsement from Venice's most influential publicist.[3] Albeit indirectly, this solicitation is also embedded in the text of the *Dialogo*, where a reference to Aretino's friend and chief artistic ally Titian supplies the pretext for bringing in Aretino as well, in an up-to-date recasting of the *ut pictura poesis*.[4]

In the exchange between Speroni's three interlocutors – the learned courtesan Tullia d'Aragona, her suitor Bernardo Tasso, and their mutual friend Grassi – Titian appears as a figure mediating between the imagery of the dialogue and the contemporary social reality framing it.[5] The passage leading up to Titian's insertion deserves to be cited at some length: it is a metaphorical account of amorous attraction based on the notion of self-portraiture, and lends the figure of the painter an unexpected resonance and ambiguity. Asked to explain ("not otherwise than Diotima in the dialogues of Plato") how it is that lovers reciprocate affection (or, indeed, dislike), Tullia describes the beloved's relation to the lover as in some sense specular and passive, but also asymmetrical and productive, like that of the painter to his work. In a yet deeper sense, love inverts natural laws of precedence and causation, and thus exhibits the fruitful arbitrariness of artifice. The passive "natural" love object in effect rewrites her assigned role:

> The lover ... is properly a portrait of that which he loves ... For "to love" is
> not as the word means, that is, to make or effect something, but it is rather a
> certain passion; and to be loved is not a passive but an active verb ... And I
> dare say that as the painter portrays the person's appearance with colors and
> with his artifice; and the mirror illuminated by the sun portrays not only the
> appearance, but the movement of the one mirrored; so the thing that is loved,
> by means of love's stylus, portrays itself and all that belongs to it, soul and
> body, in the lover's face and in his heart.[6]

By insisting on the male lover's passivity, Tullia inverts the Aristotelian tenet that loving is higher (because more active) than being loved, and more characteristic of the superior (as father is to son, or the artificer to his work) than the inferior in a relationship.[7] Grassi tries to blunt the force of this claim by objecting that pictures and images, as dreams and shadows of reality, shed no real light on love.[8] Tullia's reply sets the stage for Titian's entry:

TULLIA: But what is the world if not a lovely and vast gathering of nature's

portraits? This nature, wishing to paint God's glory but not being able to gather it all in one place, produced infinite species of things ... The world as a whole, then, is a portrait of God, made by nature's hand. The lover is portrayed, the mirror portrays, and the artist portrays; but the painter's portrait (which alone is commonly called "portrait") is the least perfect of these, as representing, out of a man's whole life, the color of the skin and nothing further.

TASSO: You do injury to Titian, whose images are such that it is better to be painted by him than to be engendered by nature.

TULLIA: Titian is not a painter, and his virtue is not art but a miracle; and it is my opinion that his colors are composed of that marvelous herb which, when Glaucus tasted it, transformed him from a man into a god. For truly his portraits have in them a *non so che* of divinity, such that, as the paradise of souls is in heaven, so it seems to me that in Titian's colors God placed the paradise of our bodies; which are not painted, but sanctified and glorified by his hands.

GRAZIA: Certainly nowadays Titian is a marvel of this age, but you praise him in such wise that Aretino would be astonished.

TULLIA: Aretino portrays things no less well in words than Titian does in colors ... And I believe that to be painted by Titian and praised by Aretino is like a new regeneration of men, who cannot be so worthless in themselves that they do not become something most noble and precious in the colors and verses of these two.[9]

Tullia d'Aragona praises Titian the portraitist, gifted like Aretino with the ambiguous (because deceptive) power to sanctify even the undeserving, but the context itself suggests more. After all, the cosmos itself is a portrait-gallery. Unlike the static art of mere makers with pigments, Titian's virtue shapes regenerated bodies, analogous to the lover's soul transfigured by the self-portrayal of the beloved. One might go further, and propose that the *Dialogo* features Titian at this point precisely because he is also the painter of seductive beauties, including the splendid nudes (like those from the *Sacred and Profane Love* of 1514, and the *Bacchanal of the Andrians* of 1523–5) that precede the *Urbino Venus*. Like the dialogue's interlocutors, Titian too is a connoisseur of the erotic.

Speroni's handsome compliment to the painter capable of creating "the paradise of our bodies" came at a crucial – indeed, a perilous – juncture in Titian's consolidation of his title as Venice's leading painter. Throughout the 1530s, even as his international fame rose steadily, Titian's supremacy at home was repeatedly (and successfully) challenged by one great rival, Giovanni Antonio da Pordenone (c. 1483–1539), whose speed of execution and daring use of sculptural modelling were being associated with Michelangelesque *terribilità*. Titian's most ambitious public projects for these years were executed under unaccustomed pressure, in open competition with Pordenone, who was stea-

dily gaining favor with Titian's most prestigious and dependable patrons. Concurrently, Pordenone had also begun to receive the sort of written publicity that meant so much to Titian in his bid for uncontested artistic leadership.[10] Under the circumstances, Speroni's tribute must have seemed a deliberate expression of solidarity for the embattled artist. Given the context, could it not also have been understood as alluding to Titian's superior mastery in fields other than those of the secular and religious commissions being contested by Pordenone? Pordenone's skill with illusions of mass and energy was most effective in subjects of a spectacular nature; the erotic image was a category in which he posed no special threat. For just this reason it seems possible that the *Urbino Venus* (produced, like the *Andrians*, for an aristocratic patron outside Venice) was conceived from the start as a display of the lyrical refinements that set Titian's paintings apart absolutely in the eyes of sophisticated viewers.

Speroni's dialogue is resolutely this-worldly in its characterization of love as a carnal passion – yet the sexual as such is also insistently assimilated, and dispersed, into a larger pattern governed by Petrarchan, as well as Ovidian, images of metamorphosis. The *Dialogo d'amore*'s superimposition of pictorial likeness, mirror-image, and amorous correspondence (psychic and physical), and its insistence on the elusive truth of metamorphosis, typify issues that will recur throughout this chapter. They are all to be found in the Renaissance discussion of the family of works to which the *Urbino Venus* belongs.

The *Urbino Venus* and the eroticism of bodies made by art

Generally speaking, scholarly opinion concerning the identity of the woman depicted in the *Urbino Venus* has fallen into one of two camps: the "literalists" (following a nineteenth-century line of interpretation) consider her a mere courtesan, and her setting a kind of ennobled brothel; the "allegorists" – who derive the horizontally deployed nude from images painted inside the lids of Renaissance wedding chests – identify her as the goddess Venus descended into a legitimate domestic interior, where she personifies lawful marital bliss and the promise of fecundity.[11] However, the recent literature on the painting has attended more closely to Titian's pictorial construction as a source of meaning, and the division between the two bodies of interpretation grows ever less distinct. If the devotees of the goddess are placing a greater emphasis on the eroticism of her gesture and its relation to the beholder, the

prostitute's advocates note the ways in which her image eludes a direct sexual interpretation. Both Rosand, who places the *Venus* in the wedding-picture category, and Daniel Arasse, for whom it is above all an object of erotic stimulation, show that it is best interpreted in light of its qualities as a pictorial demonstration-piece.[12]

We do not know the terms of the commission for the *Urbino Venus*, only that it was acquired sometime after 1 May 1538 by the twenty-four-year-old duke of Camerino, Guidobaldo della Rovere, who had been negotiating for it since at least March of that year.[13] In his correspondence with the agents handling the purchase, Guidobaldo unromantically described the figure as *la donna nuda* – the naked woman; she was not identified as a *Venere* until Vasari, who saw the painting in the ducal apartment in Pesaro, so named it in his *Lives* of 1568. But the documents do reveal that Guidobaldo was particularly eager to obtain the work, and feared it might be sold to someone else. It is also noteworthy that Guidobaldo's father, Francesco Maria, duke of Urbino – one of Titian's chief patrons between 1532 and his death in October 1538 – had already purchased from the painter a half-length portrait of the woman who posed for the *Urbino Venus* – the so-called *Bella*, now in the Uffizi. It has been suggested that the sitter was a favorite of the Urbinate rulers, and that Guidobaldo's anxious concern for her nude image might be explicable in light of his dynastic marriage, in 1534, to a child of ten, and his consequent enforced residence in the rugged provincial outpost to which this union gave him title.[14] The *Urbino Venus* would have offered Guidobaldo, then a man in his prime, far-removed from the pleasures of a cosmopolitan court and saddled with a still-adolescent wife, a consoling vision of adult sexual enticement.

Whether the *Urbino Venus* is granted an allegorical dimension or seen as nothing more than an "erotic genre scene," no doubt is raised in the scholarly literature concerning its carnal appeal. From the Renaissance painter's standpoint, this carnality would have been specifically framed by the courtly debate – codified by Leonardo da Vinci in the 1490s and incorporated in much of the art literature that followed – on the relative merits of the various arts, and especially painting and sculpture. The models for the debate were the traditional "defenses of poetry" already well established in the vernacular poetics of the fourteenth century; as an art of verbal figuration, poetry continued to provide standards for the classification of the figurative arts proper. The advocates of painting or sculpture argued such points as which of the two arts is least "mechanical," or most durable (and thus best suited to immortalizing its subjects), or which is more technically difficult or intellectually demanding. But

8 *Hermaphrodite*

they also drew on the legacy of late scholastic psychology, and debated the status of each art as an instrument of sensory knowledge.[15] Thus, sculpture-in-the-round could be said to be more complete, because it replicates the material extension, as well as the outward appearance, of the thing depicted – a truthfulness verified by touch, as well as sight. The counter-argument would be that painting is more comprehensive, since it displays a thing in its appropriate context, and does so with greater specificity – registering complexions, colors, textural nuances, and other visible qualities not available to sculpture. But the ultimate test of each art's sensory completeness lay in its effect on the beholder; in the debate between painting and sculpture, it was usual to cite as evidence the ancient stories about man-made effigies so natural and beautiful that onlookers became sexually aroused. The most famous of these was a statue, Praxiteles' Cnidian *Aphrodite*, which bore the stain of a young man's sexual assault. Indeed, sculpture was typically presented as the natural vehicle for erotic representation because the sense of touch, which judges the corporeity of bodies made by art, is also the very medium of sexual experience.[16]

The habit of thinking about works of art in terms of tactile versus visual information was already ingrained in the mid-fifteenth century, and even where the sexual interest of a work was not explicitly addressed, the tactile might give access to the erotic. A striking mid-fifteenth-century example is Lorenzo Ghiberti's eyewitness account of the discovery of a type of ancient statue that provided an important model for Titian's recumbent nude (figs. 8, 9). Ghiberti vividly illustrates how the act of touching could simultaneously certify the evaluation of sculptural quality and awaken deep erotic associations:

I have also seen in a temperate light sculpted things of great perfection, made with the greatest artifice and diligence; and among them I saw in Rome ... a statue of a Hermaphrodite of the size of a thirteen-year-old girl, which statue was made with marvelous ingenuity [*ingegno*]. It ... was found below ground in a road drain of about eight braccia: the top of the drain was level with the said sculpture. The sculpture was covered with earth to the level of the roadway ... It is not possible to express in words [*con lingua potere dire*] the perfection of this statue, of its doctrine, artifice, and mastery. [The figure] was on turned-over soil, upon which a linen-cloth was spread, and the statue lay atop the cloth and was turned in such a way that it displayed the male and female members, and its arms rested on the ground and were crossed at the wrist ... and one of its legs was stretched out; the cloth was caught on the big toe and where it was pulled an admirable art was displayed ... In this statue there were a great many delicacies [*dolcezze*], the sight discerned nothing [of them] if the hand by touching did not find them.[17]

9 *Hermaphrodite*, alternative view of figure 8

This extraordinary passage appears in a chapter from Ghiberti's unfinished art treatise that explains the importance of muted lighting for the proper recognition of sculptural quality. It combines appreciation for the chiastic torsion of the figure (a schema that reveals in one view what is concealed in the other: the Hermaphrodite's composite sex), and for the nuancing of the surfaces, which is fully available to the sense of touch alone. Ghiberti's touch – a master-sculptor's touch – identifies caressing subtleties (literally, "sweetnesses") of form that sight can barely intuit in lighting deliberately controlled to protect it from both excessive brilliance and obscurity. Such is the cumulative effect of Ghiberti's description that his educated groping appears to recapitulate the act of uncovering the buried sculpture (the experience lingers on in the characterization of the carved soil beneath the figure as turned with the spade). Even the restless action of the Hermaphrodite's outstretched leg, with the big toe pulling at the drapery, suggests, at the anecdotal level, that larger, archeological unveiling of the monstrous and beautiful form. Moreover, the verbal inexpressibility of the sculpture's artifice is like the quasi-invisibility of its modulations – it points to a realm of mute, penumbral insight and pleasure explored intimately, bit by bit. The form Ghiberti praises does not reveal a clear meaning; rather, it is the very form of the ambiguous.

By comparing his recumbent Hermaphrodite to a virgin on the threshold of womanhood, Ghiberti also depicts himself as a new Pygmalion. In the Ovidian tale, the sculptor carves an ivory maiden to console himself for the imperfections of real women, and is seduced by the beauty of his own handiwork, which he places in bed like a real lover. The first time Pygmalion touches the statue, it is to verify whether her apparent softness (the *dolcezze!*) denotes flesh or ivory. When Venus miraculously satisfies his secret yearning, it is by passing his hands over the recumbent effigy that he is finally persuaded of her metamorphosis into a living being.[18] The pleasures of craft expertise and erotic stimulation merge without strain in Ghiberti's account, which thus conveys the awareness that artifice – like nature in her moments of excess – freely crosses the boundaries of what is rational and proper in order to bring to light its own strange marvels.

Carlo Ginzburg has written on the "eroticizing of sight" that took place in the course of the sixteenth century, on a kind of public scale, as a consequence of the increased popular diffusion of images susceptible to erotic interpretation.[19] Ghiberti's testimony suggests that the conditions for the eroticizing of sight were already present in the descriptive illusionism pursued, and commented upon, by figurative artists of the

early Renaissance. More specifically, the artists' interest in matching visual and tactile stimuli, or shuttling back and forth between them, would have been a powerful inducement to revisit the classical exempla of an art whose "naturalness" could be gauged by its impact on the viewer's reproductive instinct – the instinct to make a body like itself. By the end of the fifteenth century, even the "defense of painting" could incorporate the dimension of the tactile while attempting to articulate what was irreducibly pictorial. Leonardo da Vinci led the way in this attempt, and arrived at formulations that shed light on the metaphorical range of Venetian erotic painting after 1500.

In the 1490s, Leonardo – who thought the eye was the only truly comprehensive organ of sensory knowledge – contrasted the power of painting with that of poetry and music by means of the following example:

> If you should represent to the eye a human beauty composed of a proportiona-lity of beautiful limbs, such beauties are not as mortal, nor do they decay as quickly as music. Rather, it remains ... and allows itself to be ... contemplated by you, and is not reborn like music by being repeatedly played, nor will it cloy you. Rather, it enamors you [*te inamora*], and induces all of the senses, together with the eye, to want to possess it, so that they would seem to want to compete in their combat with the eye. The mouth would seem to want it bodily for itself, the ear draws pleasure from hearing its beauties, the sense of touch would like to penetrate all of its pores, the nose ... would wish to receive the air ... breathed by it. But time destroys ... such a harmony in a few years, which does not happen to that beauty when it is imitated by the painter; for time preserves it ... and the eye, in performing its office, draws true pleasure from that painted beauty as it would from a living beauty.[20]

Leonardo here is not concerned with the sculptural as such (indeed, he scorned sculpture's physicality), but he is careful to collapse the activity of the other senses into the sovereign grasp of the eye, which in a painted image enjoys all of the pleasures offered by the seductive body. It is instructive to compare Leonardo's description of the senses in combat for possession of the beloved with the same theme expressed forty years later in Speroni's *Dialogo d'amore*. Tullia d'Aragona informs her friends that the noted poet Francesco Maria Molza denies that the senses are ever satisfied in love:

> If love ever made you experience this supreme joy ... then why [do lovers] draw apart somewhat and stop touching the beloved in order to satisfy the sight? And why, no sooner they have seen her, do they go back to embracing and pressing against her with renewed passion? ... It is impossible for our body's eyes, touch, and ears – which are material and dissimilar things – to be simultaneously pleased by love's joys ... The lover thus would wish not to

embrace the thing he loves, but to penetrate her with all of his living self, not otherwise than water being absorbed into a sponge; and since he may not do this he moans and sighs with desire in the very midst of his every joy.[21]

Thus the real, beloved body of which Molza speaks is in some measure less satisfying than the painted body which Leonardo opposes to the verbal or aural body of poet and musician.

Leonardo's claim seems less extreme when one realizes that he relied on a model of brain physiology and function that allowed him to posit a "sensory clearing-house" (the *imprensiva*) to which the optic nerve alone was directly connected.[22] The other sense-organs could only report indirectly to this organ of "inner sense" – located in the front ventricle of the brain, and responsible for providing the remaining mental faculties (imagination, judgment, memory) with a coherent, if pre-discursive, picture of external reality. For Leonardo, the image presented to sight is more completely and instantaneously available to the spirit than the images pieced together from the time-bound, and therefore partial, evidence of the other sense-organs.

The passage just cited turns into a critique of the lyric poet's ability to situate his chief subject – the experience of love – in the setting appropriate to love's sensory fulfillment. The argument thus shifts from the beloved's body as object of delight, to the emblematic landscape in which that body is situated by memory. What Leonardo does not acknowledge is that he is taking his weapons from the very poets he attacks. The lyric tradition, in fact, provides the standard for a kind of painting that would compete with poetry's vividness and metaphorical range:

> What moves you, o man, to ... leave family and friends, and go to country places by way of mountains and valleys, if not the natural beauty of the world? ... But [in a poem] the soul would not be able to enjoy the benefit of the eyes ... it would not be able to see shaded valleys furrowed by the play of serpentine rivers, nor be able to see the ... flowers which with their colors make a harmony for the eye ... But if in the ... harsh weather of winter the painter sets before you the same landscapes ... and others where you have received your pleasures beside some spring, you may see yourself as a lover with your beloved, in the flowered meadows, beneath the sweet shade of plants beginning to turn green.

This passage begins with a figure straight out of Petrarchan poetry, the seeker after novel beauties leaving behind familiar comforts in order to follow his soul's impulse. The journey is towards solitary, untamed places, where the memory of past amorous bliss can be renewed. As Leonardo realizes, such journeys are the pretext for poetical

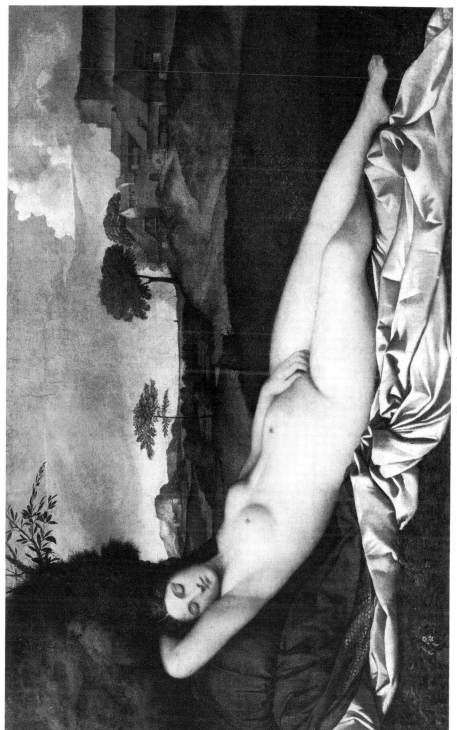

10 Giorgione, *Sleeping Venus*

composition: he proposes reenacting them in the painting's optically replete microcosm.

Recumbent figures and private chambers: prototypes, rivals

The direct prototype of the figure in the *Urbino Venus*, Giorgione's Dresden *Venus* (fig. 10), was painted some fifteen years after Leonardo wrote his lines on the landscape of amorous recollection (lines that identify the viewer of the painting as the actor of its fictions). The outdoor setting, the self-absorption of the sleeping figure, and the not-quite-open envelope of drapery separating her from the ground, remind us that this Venus is a descendant of the carved *Hermaphrodite* admired by Ghiberti. Her divinity is assumed from the fact that the right half of the painting, which was actually completed by the young Titian, originally included a seated Cupid brandishing an arrow.[23] Both here, and more markedly in the *Urbino Venus*, the figures' partly exposed pudenda are aligned with the vertical axis of the canvas, a placement that confirms their primacy in the hierarchy of the image. The gesture of self-touching reproduces, within the fictive space of the painting, the tactile verification craved by the viewer – not to mention the maker – of lifelike figures. Moreover, this verification is specified as something like sexual knowledge, or, more broadly, like the ecstatic doubling and displacement of self made palpable in the sexual act.[24] The venereal gesture actually cues the eye to look thus at the whole of the painting, which registers as an extension of the erotic body. Since the painted forms are literally intangible, and their illusionism is not a matter of simulated sculptural mass but of broad tonal and coloristic juxta-positions, both artists rely on the evocative properties of their surface-description to fill the viewer's imagination with sensory stimuli that bring together many kinds of touching. Flesh is made more palpable by its juxtaposition with satin, brocade, foliage, linen, metal, velvet, and fur.

The pastoral setting of Giorgione's *Venus* – which we might compare with Leonardo's landscape of shadowy groves and winding river-valleys in which "you may see yourself as a lover" – is a composite world in the special sense that its topography and vegetation respond to or reproduce the nude figure's shapes and contours. This is a commonplace observa-tion, but it should be understood in light of the Petrarchan quest for the beloved, forever lost, and forever reinvented out of memory fragments scattered in, and as, the warm breezes, shaded copses, luminous waters,

the rocks and misted horizons of the poet/lover's imagination. As Nancy Vickers has pointed out, this space inevitably mirrors its maker, whose act of re-membering is, after all, a self-portrayal.[25] An image such as Giorgione's offers a painter/lover's dream-vision; like the poet's, it is also an image of self displaced onto an other. As an artificially wrought spectacle of sensory repleteness, it may legitimately be compared, once again, to the *Sleeping Hermaphrodite*, the very figure of erotic transformation into the other.

Titian's figure, painted thirty years after Giorgione's, is necessarily a more self-conscious performance. In the intervening decades, central Italian artists working from antiquarian premises recreated the Roman Imperial erotic interior, with its monumental, curtained bed – the very type of object that dominates the foreground of the *Urbino Venus*. Titian had ample opportunity to study these developments carefully. They began with two celebrated series of erotic prints published in Rome between 1524 and 1527: Marcantonio Raimondi's engravings after Giulio Romano's *I modi* – which provoked a scandal and were soon suppressed – and Jacopo Caraglio's prints after Perino del Vaga's *Loves of the Gods*.[26] It is noteworthy that Pietro Aretino was involved in the project for the *Modi*: he would be a prime informant on this kind of erotica once he put roots in Venice after 1527, and it is this expertise that would earn him his place in Tullia d'Aragona's praise of Titian. As Ginzburg and, more recently, David Freedberg have observed, the print medium made possible an unprecedented diffusion of sexually explicit images in the cinquecento; consequently, it also attracted harsh censorship.[27] In papal Rome, shaken by the spread of the Lutheran reform, the uninhibited sexual imagery issuing from the studios of Raphael's most gifted heirs might even have seemed politically subversive, since its toleration could easily be interpreted as further evidence of the ecclesiastical establishment's moral laxity.

If the *Modi* and the *Loves* had a short-lived distribution, the genre to which they contributed had an explosive growth over the next ten years, especially in centers well-frequented by Titian, such as Mantua and Ferrara. In 1524, Giulio Romano became court artist in Mantua, and began his exuberantly licentious decorations for Federigo Gonzaga's Palazzo del Te. At about the same time he monumentalized the bedroom imagery of the *Modi* in a large oil painting of an amorous couple on an ornate canopied bed, being spied upon by an old procuress (figs. 11 and 12).[28] The composition, with its relief-like treatment and metallic tonalities, suggests a preciously neo-classical vision of something like a scene from ancient comedy, or, as has been suggested, from

the tokens known as *spintriae*, stamped with erotic bedroom scenes, and apparently used as coinage in the Imperial brothels.[29] Giulio's principal subject, however, is that extraordinary historiated bed, with its apple-green satin hangings and elaborately carved legs bearing little panels with lewd scenes.

It will be recalled that Titian was in close contact with Federigo Gonzaga from about 1530, when the duke arranged his first meeting with Charles V. At the Mantuan court (where he was employed through the later 1530s and befriended Giulio) Titian would also have seen Correggio's unprecedented Loves of Jupiter, datable to 1530–2, and including, in the *Danae* (fig. 13), a bedroom scene of horizontal format.[30] As in Giulio's *Lovers*, a large canopied bed is featured, but in addition an open window at the opposite end of the scene relieves the cloistered darkness of the room, and associates the glow of the figures with that of the distant, airy prospect.

No doubt the experience of Giulio's agile erotic wit, and of Correggio's images of sexual bliss (more fragrance than image), contributed to Titian's meditation on the reclining nude in a domestic interior. It is characteristic of the Venetian master that these examples did not induce

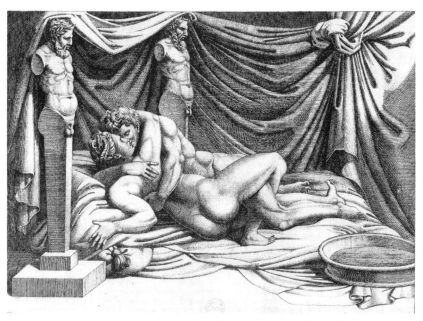

11 Marcantonio Raimondi after Giulio Romano, *I modi: First Position*

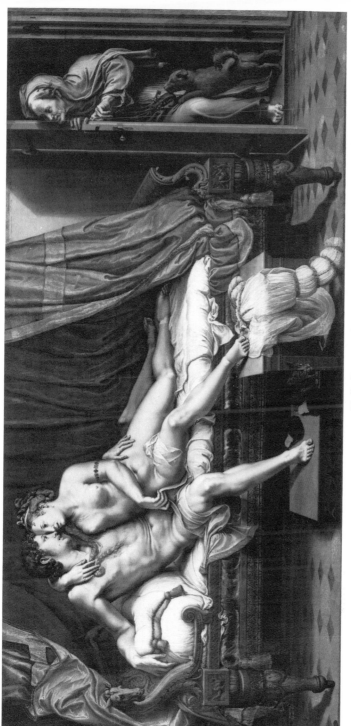

12 Giulio Romano, *Amorous Couple*

13 Correggio, *Danae*

him to attempt a comparable narrative expansiveness; rather, his response was to concentrate the image and simplify the viewer's approach to the main figure. But in addition he had to confront a very different kind of challenge: Michelangelo's recent consecration as a master of the painted erotic mythology.

In 1529, Alfonso d'Este, Federigo Gonzaga's uncle and the patron of Titian's Ferrarese mythologies of 1518–25, commissioned Michelangelo with a painted *Leda*.[31] This work, known only through copies (fig. 14; all but one – an engraving – were made from the cartoon rather than the finished painting), comments in a peculiarly Tuscan way on the sleeping nudes descended from the Dresden *Venus*. Like the subsequent presentation drawings for Tommaso Cavalieri, the *Leda* can be viewed as a carefully pondered demonstration of Michelangelo's *disegno* – his relentlessly sculptural, but also highly purified, graphic resolution of visual *concetti* or ideas (in most respects analogous to the poet's inspired imaginings).[32] Apart from the antique prototypes to which they both refer, the *Leda*'s sculpted predecessor is the Medici Chapel *Night* (fig. 15), begun by 1524. The statue's physicality is exaggerated by the tight compression of the pose (this challenges the fluid twist of the ancient *Hermaphrodite*'s dream-state, but conveys some of the same dual significance). Such is the force of the *Night*'s Gestalt that its rephrasing in the *Leda* creates the impression, at first sight, of a single-figure composition. It takes a moment to realize that Michelangelo's *concetto* is a narrative action – the copulation of god and mortal taking place in the shadow of the swan's wing, and compounded into a kind of monogram, a single composite entity. In the *Leda*, the main figure, as if released from the pressures of matter, generates a convex space; her lower body (locked in the counter-rotation of the swan's wings) rotates away from the viewer in a more provocative fashion than the *Night*'s, and the melody of the contours is more conspicuously studied. But for all this subtilization of the body, the appeal of the evenly modelled forms is to the touch, just as the erotic reverie itself is anchored in the explicit contact between the two bodies.

The *Leda* may have been known at the Mantuan court – a sketch after it has been attributed to Correggio – but we cannot cite written evidence for its effect on a knowledgeable audience until a decade after its completion, by which time it was enshrined as a model of pictorial invention, and had been joined by a second erotic mythology by Michelangelo.[33] In 1542, Aretino addressed a letter to Guidobaldo della Rovere concerning two paintings by Vasari, derived from Michelangelo's cartoons for the *Leda* and for a *Venus and Cupid* datable to

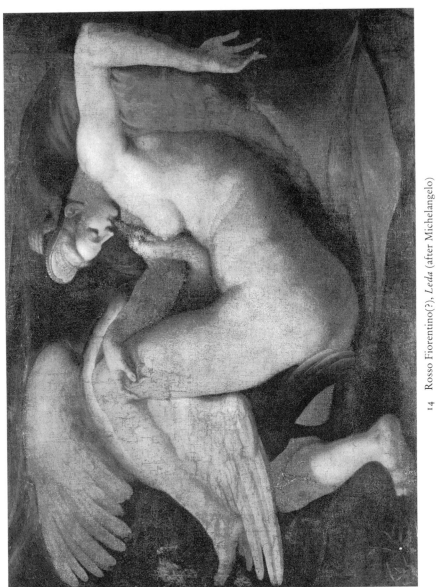

14 Rosso Fiorentino(?), *Leda* (after Michelangelo)

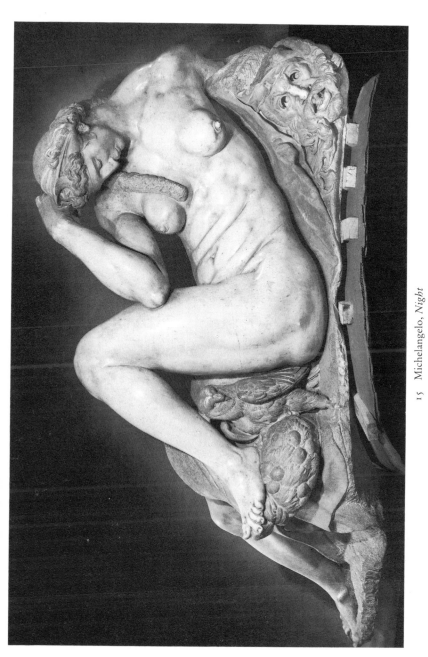

15 Michelangelo, *Night*

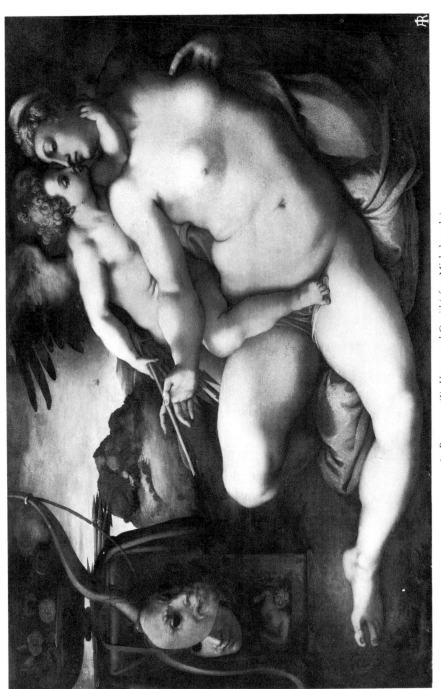

16 Pontormo(?), *Venus and Cupid* (after Michelangelo)

1532–3 (fig. 16; like the *Leda*, the *Venus* is only known through copies).[34] Vasari, who was in Venice in 1541–2, seems to have produced several versions of these paired mythologies and offered them to highly placed individuals as an advertisement of his skills; Guidobaldo must have appeared a likely prospect for patronage. Aretino wrote:

> I tell you for a fact that your ambassador was stupefied when he saw them ... One of the two images is Leda, but so yielding of flesh, ravishing of limb, and svelte of body, so sweet, easy, and fluent in her attitude, and so graceful in the nudity of every part, that the nude cannot be beheld without envy of the swan, who enjoys it with an emotion so like the real that it seems, as it extends its neck to kiss her, that it seeks to exhale into her mouth the spirit of its own divinity. The other is a Venus outlined with contours of a marvelous rotundity [*contornata con maravigliosa rotondità di linee*]. And because this goddess imparts her qualities in the desire of the two sexes, that prudent man has made, in the female's body, the male's musculature, such that she is moved by virile and womanly feelings through an artifice of elegant vivacity.[35]

Aretino's remark about the "inspiriting" of the *Leda* is a shrewd comment on the pneumatic quality of the forms, just as his characterization of the "masculine" *Venus* acknowledges (perhaps unconsciously?) its source in a reclining nude figure of the *Hercules Chiaramonti* type, which was known in Rome since the early sixteenth century.[36] More important, Aretino defines the thematic relationship between the two works in terms of the conjunction of beast and human, versus the double-genderedness of love itself. In Speroni's *Dialogo* the "masculine" Venus could have served as the emblem for Niccolò Grassi's definition of love: "That love is perfect whose knot binds and conjoins two lovers completely, such that, having lost their proper appearance, the two become some third thing [*un non so che terzo*] – not otherwise than is said in fables of Salmacis and Hermaphroditus."[37]

There is also a more literal implication to Aretino's treatment of these figures as physical and temperamental *contrapposti* (indeed, the format itself suggests that Michelangelo imagined the *Venus* as a pendant to the *Leda*). Implicit in the juxtaposition of these figures – the one in a compound posture that shows her from the side and partly from behind, the other frontal – is a reply to one of the clichés of the Renaissance debate between sculpture and painting: that the sculptor provides multiple views of a single figure, whereas the painter can only show one.[38] For Michelangelo, who even in his sculptures-in-the-round remained in basic respects a relief sculptor, pendant figures and arrangements, as in the Medici Chapel's Times of Day, provided something of the ideal completeness claimed for the single free-standing figure.

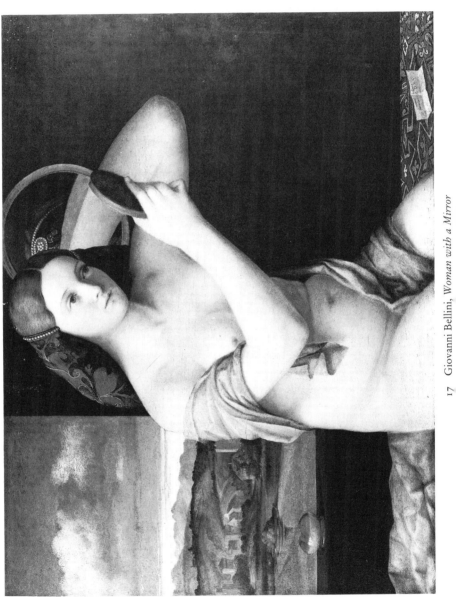

17 Giovanni Bellini, *Woman with a Mirror*

We may assume that when Titian painted the *Urbino Venus* he was fully aware of Michelangelo's presence in the arena of erotic representation. Against Michelangelo's highly compressed images, whose starting point is the real physical presence of the living figure, Titian proffers the more expansive fictions of pictorial ornament. It is indicative that, faced with recent contributions by such diverse artists as Giulio Romano, Correggio, and Michelangelo, Titian chose to revise a thirty-year-old composition. Compared to the prototype by Giorgione, Titian's painting replaces "nature" with "artifice" as a term of comparison in the poetic reconstitution of the figure by the viewer. To this end Titian draws on the lessons of yet another Venetian work from a bygone age, Giovanni Bellini's *Woman With a Mirror* (fig. 17), signed and dated 1515.[39] Bellini's figure is seated upright before a uniformly dark foil relieved by the circular mirror that reflects the back of her head, and by a rectangular window that echoes the proportion of her torso. Rona Goffen has recently discussed this painting as a representation of the sense of sight and, by extension, of the art of painting producing beauty (in this case, the young woman) through the mirroring of appearances.[40] It is a notion worth pursuing.

Mirror and window were indeed the terms of comparison in Leon Battista Alberti's influential definition of painting in his *De pictura* of 1435, which provided a lasting foundation for the perspectival art of the fifteenth and early sixteenth centuries. Their presence in this painting does suggest an emblematic juxtaposition; but in contrast even to his own earlier, more properly Albertian approach to the placement of the figure in its spatial frame, Bellini here relies on almost purely coloristic means for setting the young woman into space. Instead of enhancing the figure's three-dimensionality by completing the form of her head, the larger mirror displays, floating in virtual isolation, the pearls arranged at the back, and bordering the top of her hairnet – rosette and constellation, set in the dark pool of the mirror as if to show that light is both the essence and the ornament of all that one sees, and the first principle of the world's coloristic profusion.[41] On one side the figure (whose internal modelling is minimal) is a fair silhouette projected forward by its contrast with the somber background; on the other, the window's vertical edge is prolonged in the outline of her hip. This edge marks a kind of hinge at which figure and landscape are joined, a rose and cream rectangle opposing a green-gold and blue one. These spaces are tied together by the continuities between the woman's shoulder, her drapery, and the contours and tonalities of the landscape, as well as by the blues of the sky and the hairnet. The tonal-chromatic exchange

between near and far, body and landscape, seems to be summed up in the very act of grooming: the young woman tips her hand-mirror towards the window, as if adjusting the hairnet by looking at the reflection of the sky. The alabaster jar on the window-sill, colored like the tawny fields beyond, holds a sponge that has touched the figure's skin or hair, and that simultaneously evokes the painter's touch that blended and alternated the pigments to produce this uncannily well-groomed image. The play of visible and invisible reflections suspends the figure in an utterly autonomous space, though she is notionally within the reach of our hands, seated on the viewer's side of the parapet.

In the *Urbino Venus* the relation of viewer to figure is very different, since we are invited in by the woman's gaze, yet kept a step away by the marked parallelism between the picture's bottom edge, the mattress, and the figure, each reinforcing the other's quality of containment. But there are enough formal echoes of Bellini's earlier composition – such as the complementarity of the right and left sides, and the still-life object poised on the window-sill – to suggest a comparable affirmation of painting's uniquely visual means of expression. The thinking underlying Titian's serene vision is all in *contrapposti*, of which the most significant is that between the unitary and "incommensurable" – because animated – harmony of the female nude, and the composite "music" of spatial divisions and figural embellishments in the right background. The dark foil (bed-screen or wall) that spans the canvas so far as the central vertical axis, and simultaneously puts the accent on the figure's pudenda, sections the painted surface into equivalent and contrasting spatial realms. Arasse has shown that the floor of the adjacent room's Albertian space-box has its vanishing point along the central axis, at the height of the figure's left eye, but strictly for rhetorical (rather than space-clarifying) purposes. The bedchamber and the room with the servants (more properly a kind of picture-within-the-picture) are, as Arasse puts it, contiguous but not spatially continuous.[42]

Instead, the blunt bipartition of the space behind the figure establishes the picture-plane and lays bare, by that too-straight vertical of its edge, the elementary act of division (tonal as well as geometric), which is at the origin of the entire seductive fiction proffered by the artist. By aligning this procreative vertical with the hidden cleft of the woman's sex, Titian lays claim to that body as though it were his own (which it is) – and provides us (by a far more indirect route than Michelangelo) with another form of the amorous hermaphrodite. But he also leaves unsaid almost everything about that body. Like the Bellini, the *Urbino Venus* in the end draws our attention to the restricted means – the narrow, if

resonant, color range, the understated modelling, the selective, and even arbitrary disposition of elements – by which such opulence is realized (like love itself) as much in the viewer's mind as on the actuality of the canvas. Bellini used the mirrors to keep the viewer from fully entering the charged space of his fiction. Titian uses the duality of his painting's layout to alert us to the provisional nature of what is being depicted, suspending our attention between the paradisial body in the foreground, and the more social realm beyond, where the maidservants at the *cassone* retrieve the garments that will soon clothe, like paints on a bare canvas, the woman's nudity. We experience this even as we sense that the domestic picture-within-a-picture is an analogue to the woman's body, rather like the landscape in the more bucolic versions of the same theme.[43]

In *De pictura*, Alberti's characterization of painting as an art of optical certainty (the mirror of appearances) and harmonic measure (the perspectival window) was qualified by a fable of painting's origins "according to the poets." This fable brings us back to Tullia d'Aragona's lover/mirror/painter in Speroni's *Dialogo*, and to the imagery of Ovidian transmutation with which Speroni undercut the more dogmatic claims of his interlocutors:

> I used to tell my friends that the inventor of painting, according to the poets, was Narcissus, who was turned into a flower; for, as painting is the flower of all the arts, so the whole tale of Narcissus fits our purpose beautifully. What else is painting but the act of embracing by means of artifice that surface of the pool [*arte superficiem illam fontis amplecti*]?[44]

In Alberti's Italian version of the treatise the "embrace" (*abbracciare*) of artifice is easily identified as the act of measuring (the essence of the perspective formula), since Alberti's unit of measure for the perspective construction is the arm's length, or *braccio*. But the "embrace of art" is also a pun on tactile, and more properly carnal knowledge, which – by being strictly limited to the radiant surface of things – is paradoxically displaced inward, away from the objects of sense and into a mental space where it can be reconstituted as vision, to be reembodied in the painted work. In this respect it is the very opposite of that wordless and almost sightless touching exemplified by Alberti's older contemporary, the sculptor Ghiberti.[45] One might say, then, that the perspectival inset in the *Urbino Venus* is emblematic of the Albertian displacement from touch to vision, while the figure herself – so tantalizingly close to the edge of the frame – is a mirage of precisely that which is left out in the mirror's reflection: the possibility of contact, warmth, breath.

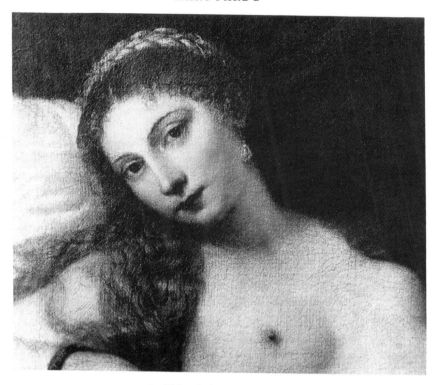

18 Titian, *Urbino Venus* (detail)

Not quite a mirage, however; Titian's predilection for coarse-grained canvas that simultaneously traps pigment and shadow (matter and air), assures for his painted figure a kind of magnified, literal epidermis (fig. 18) in which the painter's touch stands objectified.[46] The shimmer of actual light upon this woven surface does have a counterpart in the fine-grained hatching of Michelangelo's surviving studies for the head of the *Leda* (fig. 19), where the paper's pebbly texture is used to produce shadows of caressing luminosity. But Titian realizes the effect in the finished work, whereas Michelangelo might be expected to refine it away in the image transposed to a gessoed surface.[47] Rosand has called attention to Titian's responsiveness to the materiality of the support as the necessary condition for his development of an increasingly more palpable handling of the medium, capable of conveying all at once optical and tactile information – a development that began in the 1540s, with a series of large-scale reclining nudes derived from the *Urbino Venus*. Writing on the aged Titian's working method (which reportedly

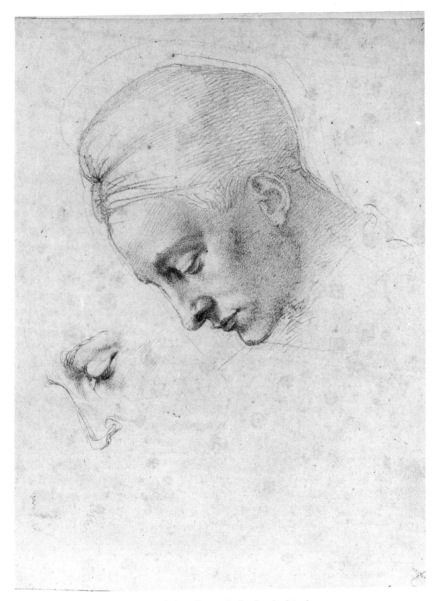

19 Michelangelo, study for head of *Leda*

entailed the use of the fingers in the final blending of the tints), Rosand concludes:

> The stroke of the brush was Titian's way of keeping in touch with [the] body; and we may imagine that his response to that body shared something of Pygmalion's with his creature ... Molding carnal effigies out of oily pigment, Titian extended the direct tactile experience of his painting by even abandoning the mediating implement ... to work directly with his hands.[48]

The *Urbino Venus* does not so much embody as promise this subsequent development of Titian's art.

In 1562, as Titian neared the last decade of his life, Battista Pittoni published the artist's *impresa* or device consisting of a bear licking its new-born cub, with the motto "Art More Powerful Than Nature" (*Natura Potentior Ars*; fig. 20).[49] This amounted to an old-age manifesto for the painter whose greatest triumphs in the imitation of appearances had always been associated with a surplus of natural talent, and less often celebrated as products of a meditated artifice. But the homely action of the she-bear – illustrating the ancient zoological commonplace that new-born bears are formless lumps until made over by their mother's patient grooming – may already have been on Titian's mind as early as the mid-1530s, while the young beauty who posed for the *Urbino Venus* was being "sanctified and glorified by his hands." In Speroni's *Dialogo*, the molding of the bear is one of the Ovidian images pressed into service by Grassi when he defends reason as the bridle of love. Grassi explains that if perfect lovers love so symmetrically that they fuse into a hermaphrodite, love itself is a composite, like the centaur:

> By chance have you ever heard that the bear is born a shapeless lump of flesh, and once it has been delivered, the mother with her tongue molds it such as we then see it? Reason does the same with that first love to which our soul – filled with the beauties it has seen – gives birth in our heart; and it happens with this love (because it cannot grasp the artifice of reason in that part of itself that we hold in common with the beasts) that its form is mingled with the bestial from the waist down, whereas in the other half formed by reason it becomes human, like us.[50]

The sculptural shaping of the bear, then, is like the touch of artifice, which is rational but which works on a substance, and with impulses, that are irreducibly carnal.

20 Titian's *impresa*, from Battista Pittoni, *Imprese di diversi principi* (Venice, 1564)

Notes

James Turner provided valuable suggestions and editorial advice for this project. I have also profited greatly from the knowledge, skills, and kindness of Andrea Bolland. I wrote this essay while on academic leave with a Postdoctoral Fellowship in the Arts and Humanities from the J. Paul Getty Foundation; in addition, a Junior Faculty Development Grant from the University of North Carolina at Chapel Hill facilitated my research.

1 See Rosand's *The Meaning of the Mark: Leonardo and Titian (The Franklin D. Murphy Lectures VIII).* (Lawrence, Kans., 1988), pp. 85–7, and see below, pp. 82–4.

2 On Speroni (1500–88), see Mario Pozzi, ed. and comm., *Trattatisti del Cinquecento*, vol. 1 (Milan, 1978), pp. 471–7.

3 Aretino wrote Speroni a congratulatory letter dated 6 June 1537; see Fidenzio Pertile, comm., and Ettore Camesasca, ed., *Lettere sull'arte di Pietro Aretino* vol. 1 (Milan, 1957), pp. 49–51. On 8 July, Speroni wrote to thank Aretino for his warm praises; see Pozzi, *Trattatisti*, pp. 791–5.

4 See Speroni, "Dialogo d'amore," in Pozzi, *Trattatisti*, pp. 545–8.

5 On Tullia d'Aragona (c. 1508–56), who moved from Ferrara to Venice in 1534–5, and returned to Ferrara in 1537, see Pozzi, ed., *Trattati d'amore del Cinquecento* (Rome and Bari, 1975; repr. of Bari, 1912, ed. G. Zonta), pp. XXVI–XXXI.

6 Pozzi, *Trattatisti*, pp. 545–6.

7 The key passages – alluded to throughout the discussion between Tullia and her two admirers – are in books 8–10 of the *Nicomachean Ethics*, 1158b–1159b, 1167b–1170a, 1174b–1176a. See Jonathan Barnes, ed., *The Complete Works of Aristotle* (Princeton, 1984), vol. II, pp. 1830–59.

8 Both Tasso and Grassi finally do deny Tullia the active role in the amorous exchange; see Pozzi, *Trattatisti*, pp. 549–50.

9 On Aretino as verbal artist and art critic, see Lora A. Palladino, "Pietro Aretino: Orator and Art Theorist," Dissertation, Yale University, 1981 (and especially ch. 7, on Aretino's poetic "portraits").

10 See Caterina Furlan's overview in *Da Tiziano a El Greco: per la storia del manierismo a Venezia, 1540–1590*, ed. Pallucchini (Milan, 1981), pp. 71–2, and Giorgio Vasari, *Le vite de' più eccellenti architetti, pittori e scultori italiani* (New York, 1980; facs. of Florence, 1550 ed.), vol. II, pp. 789–94.

11 For the *Urbino Venus* as a high-class "pinup," see especially Charles Hope, *Titian* (London, 1980), p. 82, and "Problems of Interpretation in Titian's Erotic Paintings," in *Tiziano e Venezia: Atti del Convegno internazionale di studi* (Vicenza, 1980), pp. 114–15 and 117–19. See also Hans Ost, "Tizians sogenannte 'Venus von Urbino' und andere Buhlerinnen," in J. Müller Hofstede and W. Spies, eds., *Festschrift für Eduard Trier zum 60. Geburtstag* (Berlin, 1981), pp. 129–49. The "allegorist" reading is argued by Edgar Wind, *Pagan Mysteries in the Renaissance* (1958; 2nd ed. New York, 1968), pp. 141–2. Theodore Reff, in "The Meaning of Titian's Venus of Urbino," *Pantheon* 21 (1963), 359–66, identifies the figure as a terrestrial Venus, and introduces the idea – now widespread – that it was commissioned to commemorate a wedding; those who

follow Reff find especially persuasive his argument that the chests depicted in the background are the paired trousseau-*cassoni* given to a new bride by her husband.

12 See Rona Goffen, "Renaissance Dreams," *Renaissance Quarterly* 40 (1987), 689–701; Arasse, *Tiziano: Venere d'Urbino*, Hermia (Venice, 1986), VIII; Rosand, "Ermeneutica amorosa: observations on the interpretation of Titian's Venuses," in *Tiziano e Venezia*, pp. 374–81.

13 Harold E. Wethey, *The Paintings of Titian*, vol. II (London, 1971), pp. 81–2, and vol. III (London, 1975), p. 203; for the documents, see G. Gronau, "Die Kunstbestrebungen von der Herzöge von Urbino (I. Tizian und der Hof von Urbino)," *Jahrbuch der Königlich Preussischen Kunstsammlungen* 25 (1904), Beiheft, 18–19.

14 See Ost, "Tizians sogenannte 'Venus von Urbino,'" pp. 142–6, and contrast Grazia Bernini Pezzini, *Tiziano per i duchi di Urbino* (Urbino, 1976), p. 43.

15 See David Summers, *The Judgment of Sense* (Cambridge, 1987), esp. ch. 4.

16 See Benedetto Varchi, "Lezzione nella quale si disputa della maggioranza delle arti e qual sia più nobile, la scultura o la pittura," in Paola Barocchi, ed., *Trattati d'arte del Cinquecento fra Manierismo e Controriforma*, vol. I (Bari, 1960), pp. 34–52 ("Disputa seconda"), and in the same volume Paolo Pino, "Dialogo di pittura," p. 129. For the assault on the Cnidian Aphrodite, see Pliny, *Historia Naturalis* 36, 21; the Lucianic *Erotes*, 15–16; and Athenaeus' *Deipnosophistae* 13, 605ff. Carl Nordenfalk, in "The Five Senses in Late Medieval and Renaissance Art," *Journal of the Warburg and Courtauld Institutes* 48 (1985), 13–17, illustrates allegorical images in which the sense of touch is represented by an amorous couple; apparently the motif of lovers kissing and touching became the standard image for "touch."

17 Lorenzo Ghiberti, *I commentari*, ed. Ottavio Morisani (Naples, 1947), p. 55. The actual statue discussed by Ghiberti has not been identified, but his description corresponds to a well-known Hellenistic type; see Phillis Pray Bober and Ruth Rubinstein, *Renaissance Artists and Antique Sculpture: a Handbook of Sources* (Oxford and New York, 1986), p. 130, no. 98.

18 *Metamorphoses* 10, 243–97; cf. Gianpiero Rosati, *Narciso e Pigmalione, illusione e spettacolo nelle* Metamorfosi *di Ovidio* (Florence, 1983), pp. 51–93.

19 "Tiziano, Ovidio e i codici della figurazione erotica nel '500," in *Tiziano e Venezia*, pp. 124–35.

20 A. McMahon, trans. and ed., *Treatise on Painting (Codex Urbinas Latinus 1270)* (Princeton, 1956), vol. II, fols. 11r–12v. McMahon's translation (from which I diverge on occasion) is in vol. I, pp. 28–30.

21 Pozzi, *Trattatisti*, pp. 529–30.

22 See my "Memory, Imagination, Figuration: Leonardo and the Painter's Mind," in Walter Melion and Susanne Küchler, eds., *Images of Memory: On Remembering and Representation* (Washington, D.C., and London, 1991), pp. 47–73 and 212–24.

23 See Jaynie Anderson, "Giorgione, Titian and the Sleeping Venus," in *Tiziano e Venezia*, pp. 337–42.

24 Goffen, who extends Anderson's epithalamic reading of the Giorgione to Titian's image, has recently explained the way in which these painted figures

touch themselves by citing Renaissance medical advice on how to encourage female emission (thought necessary for conception): see "Renaissance Dreams," 698–70.

25 See "The Body Re-membered: Petrarchan Lyric and the Strategies of Description," in *Mimesis: From Mirror to Method* (Hanover and London, 1982), pp. 101–9.

26 See Henri Zerner, "L'Estampe érotique au temps de Titien," in *Tiziano e Venezia*, pp. 85–90; Bette Talvacchia's entries in *Giulio Romano* (Milan, 1989), pp. 277–87; Lynn Lawner, *I modi, the Sixteen Pleasures: An Erotic Album of the Italian Renaissance* (Evanston, 1988); S. Boorsch and J. Spike, eds., *The Illustrated Bartsch (Italian Masters of the Sixteenth Century)*, vol. XXVIII (New York, 1985), pp. 86ff.

27 See Ginzburg, "Tiziano," and Freedberg, *The Power of Images: Studies in the History and Theory of Response* (Chicago and London, 1989), pp. 345–71.

28 *Giulo Romano*, pp. 274–5; for the motif of the spying old crone in the *Modi*, see p. 278.

29 Talvacchia has a work in press that deals with the classical prototypes for the imagery in Giulio's erotica, "Eroticism *all'antica* and its Transformation into Scandal in 'I Modi' of Giulio Romano"; see *Giulio Romano*, p. 277, where the *spintriae* are briefly discussed.

30 See Cecil Gould, *The Paintings of Correggio* (Ithaca, N.Y., 1976), pp. 130–1 and 270–1.

31 See Johannes Wilde, "Notes on the Genesis of Michelangelo's *Leda*," in D. J. Gordon, ed., *Fritz Saxl 1890–1948: A Volume of Essays* (London, 1957), pp. 270–80; E. R. Knauer, "Leda," *Jahrbuch der Berliner Museen* 11 (1969), 5–35; Charles de Tolnay, *Michelangelo* (Princeton, 1947–60), vol. III, pp. 106–9 and 190–6.

32 Michael Hirst, *Michelangelo and His Drawings* (New Haven and London, 1988), pp. 107–17, compares the Cavalieri drawings to love poetry, "above all sonnets," and discusses them in the context of Michelangelo's return to mythological imagery following his Ferrarese sojourn and Alfonso's commission for the *Leda*.

33 On the Correggio sketch, see Gould, *Correggio*, p. 134 and plate 194A.

34 On this project, and the dissemination of copies by Vasari, see de Tolnay, *Michelangelo*, vol. III, pp. 108–9, 194–6 and 222 (for the British Museum *pensiero* for the composition).

35 See Pertile and Camesasca, *Lettere*, vol. I, p. 247.

36 See Bober and Rubinstein, *Renaissance Artists*, pp. 168–9, no. 133.

37 Pozzi, *Trattatisti*, p. 514.

38 For Leonardo's version of this argument, see *Treatise*, vol. II, fols. 20v ff.; and Martin Kemp, *Leonardo e lo spazio dello scultore (Lettura Vinciana XXVII)* (Vinci, 1988).

39 Between 1515 and 1520, Titian and his workshop turned out several images of the *Lady at her Toilet* that show an awareness of Bellini's composition. See Wethey, *Paintings of Titian*, vol. III, pp. 162–5.

40 See her *Giovanni Bellini* (New Haven, 1989), pp. 252–3.

41 Along with the term "colors," cosmetics, points of light, and pearls were all used

as metaphors for verbal ornament in the classical rhetorical texts; see Quintilian, *Institutio oratoria* 9, 2, 102, or Cicero, *Orator*, 78–9. In this same sense, gold, rouge, and pearls are used by Petrarch in the *Rime Sparse* to evoke Laura's body/amorous artifice (which is also Petrarch's poetic art); see, for example, Sonnet 192, lines 5–6. References to styling hair – combing, curling, and braiding – were also common to both the Greek and Latin discussion of poetic style; see, for instance, Dionysius of Halicarnassus, *De compositione verborum* 26 (*The Critical Essays*, trans. S. Usher, [Cambridge, Mass., and London, 1985], vol. II, p. 225); or, in the twelfth century, Geoffrey of Vinsauf's *Poetria Nova*, lines 63–4 and 1943–5, in J. J. Murphy, ed., *Three Medieval Rhetorical Arts* (Berkeley, 1971), pp. 35, 103.

42 *Tiziano*, pp. 20–6, figs. 9 and 10. Arasse shows that the servants must be on an elevated platform, but doubts that the bed is sunk as low in its alcove as this would imply. The vanishing point sets the viewer's eyes on the same level as the reclining figure's left eye, which would mean that one looks *down* on the bed. But full-scale beds in the cinquecento were elevated; the viewer's position is thus improbable if it is taken literally.

43 The graduated passage from interior to exterior, as well as the transitional time of day, carry an echo of the Dresden *Venus*' layering into distance as a correlate to the sense of time passing. Of special interest is the potted myrtle on the threshold between indoors and outside; it is invariably identified as the plant from which bridal wreaths are made, but its emblematic range is wider. According to Pierio Valeriano (in the *Hieroglyphica* [Lyons, 1602; 1st ed. 1556]), Book 50, ch. 25; "one should not forget that the myrtle also signifies the woman's shameful parts ... Pollux takes the myrtle for a little piece of flesh which shudders from a certain lascivious motion in the woman's shameful parts."

44 Leon Battista Alberti, *On Painting and On Sculpture*, ed. and trans. Cecil Grayson (London, 1972), pp. 61–3 (para. 26).

45 There is, however, an odd family relationship between Ovid's Narcissus and Hermaphroditus episodes, which are like the visual and the tactile versions of the same dilemma – both sited on the edge of a crystalline pool that threatens (and realizes) the integrity of a naive adolescent. Cf. Georgia Nugent, "This Sex Which Is Not One: De-Constructing Ovid's Hermaphrodite," *Differences* 2 (1990), 160–85.

46 For this and much of the following, see Rosand, *The Meaning of the Mark*, pp. 56–88, and "Titian and the Critical Tradition," in *Titian, His World and His Legacy* (New York, 1982), pp. 1–24.

47 See Hirst, *Michelangelo*, pp. 73–4.

48 Rosand, *Meaning of the Mark*, pp. 56–61, 85–7.

49 See Rosand, "Titian and the Critical Tradition," p. 16, and Ovid, *Metamorphoses* 15, lines 379–81.

50 Pozzi, *Trattatisti*, pp. 538–9.

Renaissance women and the question of class

CONSTANCE JORDAN

ৈ&

When Friedrich Engels considered the economics of family life in his classic history of "class oppression," first published in 1897, he inaugurated a debate on the question of women and work that has yet to be concluded. He writes: "The first class oppression [in history] coincides with that of the female sex by the male," and, he goes on to note, this oppression arose from the distribution of economic power within monogamous marriage in which the man controls the couple's property, and the woman works merely for her subsistence. Women had not always been so disadvantaged: their "class oppression" followed a prehistorical stage in human social development in which property was common, and women were neither wives nor oppressed workers. Engels implies that the development of a subordinate class consisting only of women was the result of a natural hierarchy of the sexes, a position rejected by the Marxist feminist Christine Delphy, who argues that the economic exploitation of women generally (and not just wives) preceded rather than followed the creation of oppressive social and economic hierarchies.[1] She does not ask why women were exploited in the first place – surely an obvious question.

In any case, Engels' vision of the continuous economic exploitation of women throughout history asks to be brought further into focus, and perhaps most specifically in relation to the question of class as defined in terms of labor. It has been argued that such a notion of class is in itself out of place in discussions of early modern or preindustrial Europe. Class is a term to be reserved for an economics in which the labor force is "unfree," that is, in which workers sell not what they produce, but rather their labor. Thus, in accounts of life before the eighteenth century, we often read of artisans of various kinds, not the "working class." Only servants, apprentices, and so-called day-laborers (usually farm workers) are defined as "unfree" in an economic sense; that is, they

do not own, and therefore cannot sell, whatever it is they make.[2] It is, however, precisely in relation to this question of "freedom" that the feminist twist Engels gives his account of the origins of "class oppression," in effect identifying woman as the archetypal worker in relation to man as her "capitalist" or protocapitalist employer, establishes a perspective in which much of the literature of early feminist protest on the social, political, and economic status of women can be understood. While in Renaissance Europe not all employers were men, nor all workers women, it is generally true that women did not have the kind of social and legal standing that permitted them to be other than "unfree" in an economic sense: that is, they were laborers by definition, if not in fact. This was especially the rule for married woman, whose property rights were severely limited by law. By contrast, many men were "free"; they had a right to own the tools of their trade and to sell what they made.

The purpose of this essay is to assess more precisely the usefulness of considering Renaissance women in relation to the structures of class, and especially the status of the "unfree" worker, as these concepts were understood in contemporary texts on society and domestic government. My reader may find several caveats in order. First, many of the texts I consider voice pro-woman arguments and are committed to a critique of patriarchal practices, particularly as these were sustained by what was believed to be natural law. It is difficult and perhaps impossible for a twentieth-century interpreter not to see elements of this critique as anticipating twentieth-century arguments; for readers who see as anachronistic my claim that embedded in early feminist protest is a theory of comparable worth, I apologize. If there is a better term I would like to know it. Second, I hope I have shown how complex a picture of women as a category of person and a class of worker (in Engels' sense of that term) was available to persons living in preindustrial Europe. But the extent to which this picture reflects the actual conditions of life is a question that requires investigations well beyond what I have undertaken here; my analysis of "Ester Sowernam's" "honest woman" touches on only a very few data that roughly illustrate the real poverty of women during this period. Finally, I have deliberately set aside questions involving authorial intention. An author may reflect on a woman's position with a certain irony, he may "defend" her facetiously, but in this investigation what has interested me is that, whatever the author's tone, his text is evidence of a particular notion of woman and her place, as well as an indication that such a view was publicly recognized.

Womankind: ontological category, social rank, and economic class

Early feminist argument had initially to contend with the traditional view of humanity, or the genus *homo*, as split between two kinds of creatures, male and female, or *vir* and *femina*. Although most writers on domestic government conceded that in spiritual life sexual difference was effaced, it was widely asserted that in social and political life sexual difference established a hierarchy of persons, the female always inferior in her being and subordinate in her persons to the male. Here scriptural commentary on Genesis 1–3, and Aristotelian politics derived from his biology, proved authoritative for humanists such as Erasmus, whose works on family life helped to sustain the opinion that women constituted a *category* of person divinely and naturally created as *subject*, incapable of self-government or political command except in matters that had strictly to do with their own salvation. This most definitive separation of woman from man, her being made constitutive of a "class" apart from him (which, for the sake of clarity, I have termed an *ontological category*), established the basis for all further discussions of woman's status in this period. The nature of the separation – predicated on a woman's limited or defective humanity – dictated that the work or "offices" to which women were called would generally be domestic and private rather than civic and public, and that the effects of their social rank, inherited or acquired in marriage, would be negligible in comparison with those of men. The authority and power of the nobility were thus negotiable according to sex; by virtue of her categorical inferiority, a noblewoman exercised the privileges of rank on the sufferance of her husband or next male kin in most instances.[3]

But a closer look at the ways in which the creaturely nature of woman is described reveals the relative instability of the concept of ontological category. Erasmus illustrates the confusion to which it was subject: in his *Institutio matrimonii christiani* (1526), he writes that men and women are persons "equal in virtue" (*pares virtutem*), and in his *Colloquia*, that their equality results from their common creation in the image of God, which is expressed in their "mental gifts" (*in dotibus animi*) and fulfilled by their shared "membership in Christ" (*membri Christi*). Yet he does not grant woman the privilege of moral choice or practical autonomy that such "equality" would seem to justify in any clear or consistent manner. As a rule, he follows orthodox doctrine: a woman is to obey her male superior only when his course of action is moral. In practice, however, Erasmus equivocates. A woman can

sometimes "share [her husband's] authority," but he must "retain his authority at all times."[4]

Others took a harder line: Lodovico Dolce, in his *Dialogo della institutione delle donne* (Venice, 1545), has his spokesman say that "women are of a weaker nature [*più debole complessione*] than men," and must be educated accordingly: no matter what her rank, a girl is to be trained for household service. Even royalty must agree to spend time "spinning and weaving" (B5), a requirement that illustrates the socially leveling consequences of placing women in an ontological category, a category that furthermore implies a certain kind of work. Thus to be weak by nature means to do manual domestic work. Dolce agrees that a girl is to be educated, chiefly in religion and moral virtue (B7); her salvation is here closely tied to her willingness to behave as a natural inferior. Giovanni Michele Bruto makes a stronger case for the economic consequences of a woman's inferiority in his *Institutione di una fanciulla nata nobilmente* (Anvers, 1555). Because, he argues, even a noblewoman's office is "by nature" (*dalla natura*) entirely restricted to "domestic chores" (*le facende della casa*; D4v), a girl must not have an education (specifically in philosophy and humanistic letters) that might make her "ambitious" (*ambitiosa*) to try something more interesting than "laundering" (*il bucato*; E8, E8v).

But "nature" – the basis for seeing woman as categorically inferior to man, according to such writers as Dolce and Bruto – could prove to be a tricky concept. If a man is typically endowed with "courage and authoritie . . . in greater measure than a woman," as Robert Pricke claims in his *Doctrine of Superioritie and of Subjection Contained in the Fifth Commandment* (London, 1609; K2), it is also possible, he concedes, that a particular woman can be "wiser, more discreete and provident" than the man who is supposed to be her "head." Pricke maintains that in such a case a wife must continue to obey her husband; he does not consider the folly that may ensue from such an arrangement (L1). In his *Domesticall Duties* (London, 1622), William Gouge is more realistic. He also vacillates when describing the duties of a wife who is naturally more astute than her husband. In such cases he insists that justice come in on the side of "equitie," which dictates that the decorum of male authority is to be preserved: a wife's abilities – whether "honour [i.e., social rank], wealth, learning, or any other excellency" – are not to affect her "subjection" (K1v, S6). On the other hand, she is to take charge of domestic affairs if her husband becomes "blockish" (T8), and she can even dispose of their common property if she can "bring great good to the family" by so doing, that is, Gouge notes, if her husband is a

"gambler" (V2v). Here the need to conserve property suppresses decorum in favor of practicality. Elsewhere Gouge warns against giving women, and specifically wives, control over any property. A man's superior "nature" is jeopardized by a woman's wealth; rich wives will try to "rule over their owne husbands" (T1). In this view he is preceeded by Giuseppe Passi (among others), who in his *Dello stato maritale* (Venice, 1602) cites Aristotle's *Nicomachean Ethics* (in Latin translation) – "Wives dominate men because they have a large inheritance" (*propter amplitudinem patrimonii*; O3) – and so suggests why a husband, anxious to marry up the social and economic scale, might have reasons to reconsider.[5]

Predictably, early feminists attacked the notion of woman's categorical subjection to man as expressed by authors such as Erasmus, Dolce, and Bruto. They alluded to her abilities, whether innate or learned, but their arguments were often tied to questions of *social rank*. In theory, such writers proposed a social and (in some cases) political equality between men and women of the same rank. Here the relevant variable was not sex, but blood, or its mystical equivalent, which conferred upon or exacted from a person of a certain rank a correlative kind of behavior. Reasoning along these lines preserved the social hierarchy in its most public aspect, but tended to confound its domestic and private expression. The notions of "gentle" and "common" were no longer qualified by sex; the political implications of "male" and "female" were accordingly lost. Thus, it was thought, a state could be governed by a queen as well as a king; a duchess had the same prerogatives as a duke both within and without the household. The ideological force of this revisionist move lay in its interrogation of the concept of "nature" which, although it continued to determine a person's rank, to the extent that rank was inherited, no longer determined a person's role or office in life, to the extent that they were sex-specific.

The range of opinion on the meaning of social rank to women is even wider than that on her situation in an ontological category. At the same time, discussion of the topic more narrowly engages the question of economic class, as social rank so frequently entails an obligation to perform an appropriate kind of work. The anonymous author of *Dialogue apologétique excusant ou défendant le dévot sexe féminin* (Paris, 1516) gives a fairly full account of the social equality of husband and wife, the type for relations between man and woman. She is to him not as serf to lord, or servant to lady, or child to parent. Marital relations are rather determined by a "political or civil rule" (*politique ou civil domination*) and by laws to which they are equally subject: a wife lives

94

as does a "free burgess" (*franc bourgeoys*) within a city (a7, a8). The term "free burgess" is important because it confers upon the dialogue's hypothetical wife a legal status wholly at odds with what almost all women had to accept, that is, the condition of being "unfree" in the sense of having no right to manage or dispose of property either earned or inherited. Abstract arguments, such as that of the *Dialogue*, were often supported by others that drew on what was represented as history. Galeazzo Flavio Capella, in his *Della eccellenza et dignità delle donne* (Venice, 1526), invalidates, as evidence to support the idea that woman is a defective man, the fact that his contemporaries deny women "civil and sacred offices" (*officii e civili e divini*; A4v). In antiquity this was not so, he notes (citing Dido, among others), and moreover in his day offices were not always given to "the worthiest persons" (*i più degni*; D3): "this we see every day, for although a queen may be without any office, she may be worthier of one than a thousand other office holders who are actually at court" (D3v). Capella implicitly argues for the primacy of rank over sex, but he also represents rank as correlative with a potential to develop certain skills, rather than as mystically efficacious. The latter was the position adopted by writers concerned to legitimate the rule of the English queens regnant, Mary I and Elizabeth I.

John Aylmer's *An Harborowe for Faithful and Trewe Subjectes* (London, 1559) represents a concept of social rank based on a belief in the mystical power of blood, which confers the ability to perform appropriate offices. In this respect, Aylmer's argument appears retrograde; it claims that a queen may govern with the full authority of a king only because her unique relation to divinity guarantees her a perfectly developed capacity for rule. "Placeth he [God] a woman [on the throne] weake in nature, feable in bodie, softe in courage, unskilfull in practise, not terrible to the enemy, no shilde to the frynde?" asks Aylmer (B2v). And then answers, "well *Virtus mea*, saith he [God], *in infirmitate perficitur*" (B3). Having implied that women lack abilities commensurate with their rank, in contrast to men, Aylmer then reverses himself. He notes that Mary I, by giving away Calais, "shewed her[self] a loving worme [*sic*] and an obediente wife rather then a carefull governes," and so hints that she lost the channel port out of deference to the continental allegiances of Philip II; he adds that a king might have made a similar kind of mistake (L3). In any case, he observes, in England it is the parliament which rules, not the monarch. He instances the example of Henry VIII: those who denied "that his proclamations should have the force of statute were good fathers of the countri, and worthi [of] commendacion in defending their liberty" (H3). This is an astonishing

statement to make in 1559, limiting as drastically as it does the scope of the monarch's prerogative, but in the context of a defense of woman's rule, it implies that queens regnant are as good as kings because the government of each is circumscribed by the constitution. All the errors a queen can commit, a king can too (H3v).

In light of Aylmer's *Harborowe*, Torquato Tasso's later *Discorso della virtù feminile e donnesca* (Venice, 1572) seems imitative save for one of its points. While Aylmer had designated the rank of queen regnant an exception to the general rule of woman as a categorical subject, Tasso would consider all women of high rank exceptions provided that they exhibit "the masculine virtues" (*le virili virtù*; Bv). In such cases, they become "heroic ladies" (*donne heroiche*), and, he declares, there is "no difference between the work and the offices they perform and those performed by heroic men" (B3). Echoing Tasso, Nicolas de Cholières goes a step further; he gives a woman's rank the same kind of social significance as a man's, and sees that it confers upon a person certain rights and privileges. Translated as policy, this argument would have opened to women of high rank the various kinds of public office, such as magistracies, available to their male kin. In his admittedly facetious dialogue, *La Guerre des masles contre les femelles* (Paris, 1588), his feminist character Alphonse asserts that women ought to be given public responsibilities (*charges publiques*) in monarchies as well as republics (*estats aristocratiques que démocratiques*), because in both they retain their rank (*degré*). In other words, Alphonse proposes that rank authorize office – "a princess or a great lady does not yield her place to a rogue or a dirty churl" (L7v). To assess the meaning of this proposition one would have to know to what kind of place Alphonse refers. But at least in theory he argues that the social consequences of rank should come before the abstractions of sexual hierarchy. Robert Cleaver, in his *Godly Form of Household Governement* (London, 1598), enlarging the scope of Aylmer's argument on a queen regnant to include women of the nobility and gentry, also gives rank a meaning that might allow a woman to accept civic responsibility. Like de Cholières, however, he is vague: while a wife must remain subordinate to her husband in marriage, however much her rank exceeds his, he in such cases must "in divers actions of publike appearance hold her his superior" (Lv). What Cleaver might understand such "actions" to be is unclear. In English practice, a woman of superior rank than her husband sometimes retained at least its public manifestation; a woman of very high degree and an heiress sometimes gave her name and her rank to her husband, thereby guaranteeing the continuance of her family and its entitlement to

property. But neither case suggests that such a wife had more than a passive part to play in relation to her husband.[6]

The most vigorous early feminist arguments on social status claimed an equality of abilities between men and women of the same rank, whatever the rank. They were made by writers who stressed the real value of the work performed by artisanal or wage-earning women; in other words, they were fundamentally economic arguments. Both private and public activities were at issue. A woman's household work was declared as valuable as her husband's work outside the home; more broadly, work pertaining to a certain rank was valued without respect to the sex of the person who did it, even though such work could be assigned on the basis of sex. In the first case, writers complain that a woman's work is unpaid; she has merely her subsistence and no disposable property to show for it. In the second case, writers insist on the comparable worth of work done at particular levels of skill. Sustaining their arguments is the assumption that women are systematically underpaid for their labor in comparison with men. In these passages Engels' characteristically nineteenth-century and post-industrial idea of women as constitutive of an *economic class* in themselves has relevance because it conveys the gross economic correlative – economic "unfreedom" and effectual poverty – of what was understood as woman's ontological and social condition in preindustrial Europe.

The remarks of Bernardo Trotto's character Antonio, in his *Dialoghi del matrimonie e vita vedovile* (Venice, 1578), illustrate the manner in which misogynist attitudes could affect how women's work was perceived. Antonio asks what are "the effectual 'virtues' [i.e., value, worth] of women" (*le virtù donnesche in effetto*) if even a good and wise woman is "forever occupied in mean tasks" (*vili facenduccie*), such as cooking, sewing, and feeding children and fowl; in conclusion, he asserts, "the hour a man spends in wooing such a woman is worth more than the work she does in a lifetime." Aleramo, Trotto's feminist, can only answer that this domestic work has value; he does not say how much or that it should receive some kind of formal compensation (Bb3). True, by having Antonio speak of a woman's "effectual worth," Trotto suggests the real economic consequences of woman's effort: edible food, wearable clothing, and a guarantee of labor in the future, all of which have value. Other feminists analyzed more specifically the problem of women's, and especially a wife's, poverty relative to the wealth of men and husbands.

The Nobilitie and Excellencie of Womankynde (London, 1542), an English translation of Agrippa of Nettesheim's Latin defense of women,

comments on how property in a marriage is both acquired and managed. Knowledge of the widely different practices in antiquity establishes that a contemporary husband has no natural right to a couple's property, as virtually all common and customary law and most Roman law had decreed: "Women shulde not grind at the quyrne, nor drudge in the kytchen; nor the husbande shulde not say: wife I give the thys; nor the wyfe: husbande I gyve you this; bycause they shulde knowe that every thynge betwene theym [is] common."[7] The fact that a couple's property is, or ought to be, common challenges the prohibition against the wife's management of it. Her incapacity in this respect means, quite simply, that her economic well-being is preserved only at her husband's discretion; it has no fixed relation to the work she performs or the property she earns or inherits. A wife's powerlessness to manage or dispose of common property is the most egregious sign of her "unfreedom."

In other discussions of common property in marriage, the disposition of the dowry was frequently contested. Without a dowry a woman could hardly hope to marry; in marriage, however, whatever her dowry brought in was at her husband's disposal. Critics often claimed that husbands and fathers cared more for the dowry than the prospective wife. Claude de Taillemont, in his *Discours de champs faez à l'honneur … des dames* (Lyons, 1551), accuses both fathers and husbands of avarice: a father for using his daughter to make profitable economic connections; a husband for effectively stealing his wife's property. Taillemont asks why, since husbands "take wives in order to be served by them (as they admit they do), husbands ought not also to pay them money, as a wage and salary, rather than take from them, and spend their money … to the last penny" (e8v, f3). More than a half-century later, Nicole Estienne is still complaining that a wife's work is unremunerated: the husband compliments himself (*se glorifie*) on the fact that it is "by his work that his wife is nourished, and that he alone brings bread into the household"; the wife's work – to conserve, in effect to create a second and third use for goods acquired – is so undervalued that marriage becomes a form of "tyranny,"[8] or, to translate the economic meaning of that political term, a condition of exploitation. What all these writers protest is that most women, and especially wives, have no property under their control; that is, all they can sell is their labor for which they get only maintenance, no matter what kind of value that labor has. Of course this does not mean that women are uniformly destitute, but, as I have stressed, it does mean that they are technically "unfree" and hence economically at risk.

Women and the question of class

These observations on women's work must have helped readers recognize that to classify women in this way was a correlative of an agreement (whether causal or consequential) to categorize woman as inferior and subordinate to man, and hence also to nullify whatever of her privileges of rank could secure her a public office and authority over men. What was needed was an assessment of woman's work that placed all these factors into clear relation with each other – a task managed in most respects by a writer who identifies himself as a scholar of "feminine law" (*legge foemine*), Domenico Bruni da Pistoia, in his *Difese delle donne* (Milan, 1559; H3v). He begins by observing that women have different roles in different cultures, a move designed to demystify the idea of natural law and thus the basis for categorizing woman as inferior and subordinate. In place of natural law he adduces "custom" (*uso*), which is introduced to social practice by "agreement" (*consenso*), not imposed by "reason" (as natural law was in fact thought to be; C5v, C6). "Custom" can make itself appear to be natural law and so justify the creation of ontological categories. What would happen, Bruni asks, if custom dictated that men be treated as subordinate to women, "as one observes in some regions"? And he concludes: "It would not be reasonable [therefore] to judge that men are of less value and perfection than women" (H8v).

In actual practice, Bruni claims, it is obvious that men and women perform comparably within a given rank. He sees that rank determines offices both public and private; it entails the performance of appropriate kinds of work which may be sex-specific. But the offices and work performed within a given rank are of comparable worth irrespective of sex. "Each woman in her rank does as well as a man in taking care of her affairs and in organizing her tasks, however modest or imposing they may be; she behaves according to her station in life" (C3). Just as men who work at the manual trades do not think about "affairs of state," so women engaged in "domestic tasks" focus on practical matters. On the other hand, women who have achieved public office do as well as men: "If we look into the history of states, we will certainly find that women have given as impressive examples of themselves as has any forceful and virtuous man" (C3v, C5). Assertions of this kind could raise further questions. What, for example, were the mechanisms by which to alter the conditions in which customary inequities continued to appear natural? In his dialogue *La Vittoria delle donne* (Venice, 1621), Lucretio Bursati's misogynist character Alessandro declares scornfully that women's talk is of "common affairs, it has too much of the plebean [*plebeo*] in it, it reveals a great inferiority of spirit" (*bassezza d'animo*).

His defender of women, Gaudentio, observes that women's talk is of what they are forced to care for: let a widow take over the family affairs and the only difficulty she will have is with the debts she has inherited from her husband; let a woman receive an education, and she will produce marvelous work, as has, for example, Moderata Fonte (N8, L7v, M5v). These kinds of opportunities are not forthcoming, he goes on to say, because the forms of contemporary social life are determined by "the insolence [*insolenza*] of men. Otherwise, women would conduct business, trade, make contracts, and would assume the burden of all these responsibilities involving goods and property" (L7). In short, the comparable worth of the work performed by men and women is evident if attention is paid to cases in which men and women have similar opportunities to do work. Given such opportunities – which would be available were men to cease being "insolent" – men and women would show comparable rates of success and failure. As Gaudentio drily observes, there are plenty of men who "go to university, spend family money, and return home with a doctorate as witless as ever" (N2v).

"Ester Sowernam's" complaint: women's poverty and prostitution

Passages in Sowernam's *Ester Hath Hanged Haman* (London, 1617) represent women's work in ways that allow the modern reader to develop further the notion of woman as constitutive of an economic class. This is not to say that *Ester*, probably an answer to Joseph Swetnam's *The Araignment of Lewde Idle Froward and Inconstant Women* (London, 1615), is not intended to be taken as comic, at least in part, but rather to suggest that by taking seriously its comments on the "honest woman," certain features of the lives of working women become more distinct.[9] In this respect, Sowernam's comments complement what we know of the deteriorating economic conditions of the laboring poor during this period in England. As David Levine writes: "In widely separated villages and regions, the lesser peasantry was forced off the land, and the ranks of wage labour and vagrants swelled. The years 1570–1630 seem to have been the most violent, when a vicious cycle of famine and epidemic disease dealt a series of deathblows to the lesser peasantry."[10] Urban centers mushroomed with migrants from the country who were seeking work. And the country in particular saw an unprecedented rise in illegitimacy owing, Keith Wrightson maintains, to the worsening conditions of rural life. The poor had "fewer and less

stable opportunities ... to marry and set up independent families."[11] Given the servile status of woman's work, it is not surprising that the surviving records suggest she suffered hardships disproportionate to those visited on her male kin.[12]

Sowernam makes her complaint on behalf of the wage-earning woman who, married or not, had to rely on selling her own labor in order to live. Swetnam had caricatured the licentious and spendthrift woman who, created as a "helper," ironically only "helps" to spend what "man painfully getteth" through her indolence and cupidity. What "use" is such a woman, Swetnam asks (p. 222). Obviously her spending runs counter to the ideology supporting marriage. A wife could be said to earn her "maintenance"; beyond what it cost to keep her, she was not to spend but to conserve. A wife who "spends" is therefore being paid more for her domestic labor than what it costs to maintain her; in short, she swindles her husband.

Sowernam begins her counter-attack by noting that an offer of "maintenance" to a prospective wife is often deceitful; a man promises a woman marriage, but then compromises her virtue and leaves her to her "shame." "Maintenance," the best she could have hoped for materially as a wife, is denied her. The question of property is thereby reframed so that it is the woman not the man who is cheated of a fair share. A man may jeopardize his estate by his dealings with women; a woman risks ruining her life altogether. Her virtue is the only means by which she can secure "maintenance"; it is her total estate. Outside marriage, according to Sowernam's argument, she can seek employment as a wage-earner or a prostitute:[13]

> To bring a woman to offend in one sin, how many damnable sins do ... [men] commit? I appeal to their consciences. The lewd disposition of sundry men doth appear in this: if a woman or maid will yield unto lewdness, what shall they want? But if they would live in honesty, what help shall they have? How many pounds will [men] spend in bawdy houses, but when will they bestow a penny upon an honest maid or woman, except to corrupt them? (p. 241)

Rhetorically both accusatory and defensive, Sowernam's text appeals to the reader's ability to see beyond obvious hyperbole – "what shall they want," and so on – to the actual subject of the discourse. A female wage-earner will "have no help" – that is, hardly get a living or a charitable surplus – unless she "yields to lewdness"; once "dishonest," she will want for nothing except the condition of being "uncorrupted" or virtuous. In short, it would seem, such a woman may have propriety (as honestly in service or married) without property, or property (as a prostitute) without propriety. These are assertions that in their com-

prehensiveness exaggerate the case; there is more to women's work than these stark alternatives. Yet as a reference to the economic status of women as established by law and custom – women who (neither widows nor *femes soles*) are for the most part "unfree" workers because, even if they own property, they do not manage or profit from it – Sowernam's text is, I think, illustrative. Bruni had insisted that within a given rank, women and men did work of comparable worth. Sowernam reveals that the rewards of this work are distributed according to radically different criteria. Women who earn "honestly" are typically in want (and is what they earn also theirs to spend? Or is it appropriated as common property?); "dishonest" women lack nothing (they have the right to dispose of what they earn, but where? And in what society?). Implied, in any case, is that a woman's possession and control of property – the condition in which, free of paternal, fraternal, or marital constraints, she can want nothing – signify that her behavior is scandalous.[14]

The literature of the broad-side ballad offers a few examples of the social consciousness illustrated by Sowernam's complaint. One "wife" asserts that she is worth what it costs to keep her: "What you spend on mee, I take for my paine / For doing such duties as you would disdaine," among which is "bringing [up] faire babies."[15] But another less compliant complains of being worth more than she is given for her domestic work, which is typically only maintenance, and concludes this is "women's wrong": "Their labour's great, and full of paine, / Yet for the same they have small gaine."[16] In fact, lack of a discretionary income seems to have driven some wives to casual prostitution. In these cases, the amounts of property exchanged were small – a few shillings, half a bushel of wheat – but they were, presumably, entirely at the wife's disposal (Quaife, p. 134). When husbands acted as panders, as they sometimes did, the couple presumably shared the take, but if the marriage was traditional, its control was the husband's business. In the popular imagination the husband's greed was responsible for his wife's choice of work, which is usually represented as lucrative, if only for a time. The "merry cuckold" of a contemporary ballad celebrates his wife's worth as a prostitute: "My wife has a Trade that will maintain me ... / Of all that she gets, I share a good share; / She payes all my debts, then for what should I care?"[17] In Thomas Dekker's *The Second Part of the Honest Whore ... Persuaded by strong Arguments to turne Curtizan againe: her Brave Refuting those Arguments* (1630) the prudent wife succeeds in refusing to go on the market, claiming that the end of a whore's life is begging and the "Hospitall" (H1).

The unmarried woman who could not count on marital maintenance

seems to have been, as Sowernam observes, in even greater jeopardy. Servants or wage-earning girls who became pregnant by men of comparable rank might expect community sentiment to guarantee their marriage, which in fact it often did. But those who were seduced by men of higher rank could only hope for some kind of clandestine and unofficial maintenance, which could be made conditional on the woman's continued prostitution. It was assumed that if a woman was "clearly living well" yet with no "visible means of support" (i.e., from a male relative) she was a prostitute – precisely Sowernam's point (Quaife, pp. 54, 146, 150). These women were popularly represented as city (and usually London), as opposed to country, folk. Their prosperity was typically brief, as Dekker's "honest whore" maintains. The "fayre maid" of the ballad "A Fayre Portion" who lives in London on a "marke a yeare" admits that she "brave Roarers [does] importune" to find "high preferment" – at least for a time; with "her friends gone" she complains that she is "without a house to hide me."[18] And the "feather-heeled wenches that live by their owne" find that in Michaelmas Term, when "all the gallants are gone out o' th' town," "neither dyet nor cloaths they can earne."[19] Even the energetic tarts of the high-class whorehouse represented in Shackerley Marmion's scurrilous play *Hollands Leaguer* (London, 1632) renounce their own earnings and submit to the precarious government of a male pander in the end. An unmarried woman who was a servant or wage-earner may have included sex as a routine part of her work (perhaps as a guarantee of employment in a competitive market), a predicament illustrated by the "laundresses" in the ballad entitled "Choice of Inventions": "souldiers" give them "wages" for washing clothes but also leave "the lasses for to cry / 'Woe and alas! my belly!'"[20]

In sum, the proposition this essay entertains – that Renaissance women constituted an economic class in themselves, as technically "unfree" and legally dispropertied for the most part – asks for further qualification in light of Sowernam's picture of the fate of wage-earning women. For the economic class constituted by women in general, which in some loose way derived from their medieval "estate," was also conditioned by its caste character; this determined that in addition to the exploitation of their labor, which was systematic and obtained in all social ranks, women suffered from a vulnerability which was in theory peculiar to all women, although in practice visited on those for whom no legal arrangement (such as the status of *feme sole*) could provide even limited economic independence. Sowernam asks her readers to consider that the economic independence of such practically vulnerable women

(their lacking for nothing), if and when it occurred, was commonly gained at a very high price. In such cases, it was regarded as a phenomenon so marginal as to be virtually outside civilized society. For many, if not most, women who were technically "unfree" by law and custom – servants, all but privileged wives, practically all spinsters living with male kin – prostitution (sex for property) was, it would seem, the most likely kind of work to escape male control. Doubtless for many women, prostitution in this very general sense (if and when it occurred) was occasional and discreet. Once discovered, however, the illicit means by which such women had earned their property dictated the circumstances in which they could spend it.

Notes

1 Engels, *The Origins of the Family, Private Property, and the State* (New York, 1972), p. 129; see also p. 221. Delphy, *Close to Home: A Materialist Analysis of Women's Oppression*, trans. and ed. Diana Leonard (Amherst, Mass., 1984), p. 199); see also pp. 12, 13.

2 See Christopher Hill, "Pottage for Freeborn Englishmen: Attitudes to Wage Labour in the Sixteenth and Seventeenth Centuries," in C. H. Feinstein, ed., (London, 1979), pp. 338–50; and David Levine, "Production, Reproduction, and the Proletarian Family in England, 1500–1851," in Levine, ed., *Proletarianization and Family History* (New York, 1984), pp. 87–127.

3 Widows and married women who claimed the status of *feme sole* were exceptions. For the idea of woman as an ontological category, see Ruth Mohl, *The Three Estates in Medieval and Renaissance Literature* (New York, 1933); Shulamith Shahar, *The Fourth Estate: A History of Women in the Middle Ages* (London and New York, 1983; Ithaca, 1990), pp. 21–34.

4 *Le mariage chrétien*, trans. Cl. Bosc (*sic*) (Paris, 1714), pp. 24, 214, 217; *The Colloquies of Erasmus*, trans. Craig R. Thompson (Chicago, 1965), p. 271. The original Latin texts are collected in the *Opera omnia* (1704). All translations here and throughout this essay are my own. I have preserved original spelling except for typographical anomalies, such as vv for w, i for j, but followed modern practice for capitalization, punctuation, and accents whenever appropriate.

5 Custom and the law generally provided that women could inherit and pass on property, but not exploit the resources, both psychological and material, that property gives; Passi testifies to the fact that custom and the law did not always dictate practice. For women and inheritance during this period, see Jack Goody, "Inheritance, Property, and Women: Some Comparative Considerations," in Goody, Joan Thirsk, and E. P. Thompson, eds., *Family and Inheritance: Rural Society in Western Europe 1200–1800* (Cambridge, 1976), pp. 10–36.

6 See J. P. Cooper, "Patterns of Inheritance and Settlement by Great Landowners from the Fifteenth to the Eighteenth Centuries," in *Family and Inheritance*, pp. 192–305. On the incidence of women magistrates in England, see Mortimer

Levine, "The Place of Women in Tudor Government," in Delloyd J. Guth and
John W. McKenna, eds., *Tudor Rule and Revolution: Essays for G. R. Elton*
(Cambridge, 1982), pp. 109–23.

7 F3v, F4. This is a translation of *De nobilitate et praecellentia sexus foeminei*,
often thought to be facetious, but which, in any case, like de Cholières' text,
publicizes what were strongly pro-woman positions. In theory, common law in
England, and much customary law on the continent, regarded the property of a
married couple as "common" or jointly owned, but in practice control of this
property belonged to the husband.

8 *Les Misères de la femme mariée*, in *Variétés historiques et littéraires*, ed. Fournier
(Paris, 1855), p. 330.

9 "Sour" probably answers "sweet" in this contest of words. I quote from
Katherine Usher Henderson and Barbara F. McManus, eds., *Half Humankind:
Contexts and Texts of the Controversy about Women in England, 1540–1640*
(Urbana and Chicago, 1985).

10 "Production, Reproduction, and the Proletarian Family," pp. 89–91.

11 *English Society 1580–1680* (New Brunswick, 1982), p. 146.

12 The census of the poor in Norwich for 1570 – actually before the worst years of
the crisis – illustrates the poverty of women relative to men. Analyzing parish by
parish reports, I get the following breakdown: among couples listed as poor, 314
consisted of husband and wife, neither of whom worked; 4 consisted of a
working husband and an unemployed wife; 229 consisted of a working wife and
a husband who was either unemployed, ill, in prison, or "abroad" and giving his
wife "no help," in other words, who had deserted her; 179 consisted of widows;
and 93 of spinsters (most of whom had some work). Clearly, women were far
more likely to be poor than men. They were also more likely to have some form
of paid work: the vast majority of wives, widows, and spinsters were reported to
"spin white warp," that is, to participate in the "putting out" schemes of local
textile merchants. Their wages are not reported. John F. Pound, ed., *Norwich
Census of the Poor, 1570* (Norwich, 1971). Women of the "middling sort," some
of whom practiced trades, must have had a better income, although in which
sense they could be said to have owned property is less clear; see K. D. M. Snell,
Annals of the Labouring Poor: Social Change and Agrarian England, 1660–1900
(Cambridge, 1985), pp. 270–314.

13 I use the term "prostitution" quite loosely to mean exchanging sex for property
of some kind; if this was an occasional rather than habitual practice, and engaged
in by a woman who was married or earned a wage in some other capacity, the
woman in question would not have been recognized as a whore or a prostitute.
For a study of illicit sex in Somerset between 1600 and 1660, see G. R. Quaife,
*Wanton Wenches and Wayward Wives: Peasants and Illicit Sex in Early
Seventeenth Century England* (New Brunswick, 1979).

14 The propertied woman as both challenging male authority and engaging in
illicit sexuality is epitomized in Chaucer's Wife of Bath. According to
Deborah L. Rhode (and I regard this as stunning information), late twentieth-
century women confront economic challenges similar to those noted by
Sowernam, and "selling sexuality offers many women a measure of psycho-
logical and economic independence not otherwise available"; see her *Justice*

and Gender: Sex Discrimination and the Law (Cambridge, Mass., 1989), pp. 260, 262.

15 "A new Ballad ... touching the common cares and charges of household" (*c.* 1620), in W. Chappell, ed., *The Roxburghe Ballads* (n.d.; repr. New York, 1966), vol. I, p. 123 (henceforth *RB*).

16 "A merry Dialogue betwixt a married man and his wife," in *RB*, vol. II, p. 159.

17 "The Merry Cuckold," in *RB*, supplementary volume, ed. F. J. Furnivall, pp. 5, 6. Quaife reports on a case in which a husband panders for his wife, *Wanton Wenches*, p. 151.

18 "A Fayre Portion for a Fayre Mayd" (*c.* 1628), in *RB*, vol. I, p. 365. For the conventional distinction between virtuous country women and lewd city women, see "The Country Lasse," in *RB*, vol. I, and "The Milkmaid's Life," in *RB*, vol. II.

19 "Michaelmas Term," in Charles MacKay, ed., *A Collection of Songs and Ballads Relative to the London Prentices and Trades ... during the Fifteenth, Sixteenth and Seventeenth Centuries* (London, 1941), vol. I, p. 66.

20 "Choice of Inventions," in *RB*, vol. I, p. 110. For the fate of female servants, see Quaife, *Wanton Wenches*, esp. pp. 61–2, 101, 106–7, 113–15, 117, 154.

Venetian women writers and their discontents

MARGARET F. ROSENTHAL

୧∾

When travelers to Venice throughout the early modern period extolled the island Republic's stable government, its internal cohesion, and the sumptuous display of its artistic accomplishments, they echoed Venetian humanists who championed the Serenissima as a haven of unparalleled social and political concord. Created by male patricians with a claim to natural heredity, this sociopolitical rhetoric glorifying Venetian *libertà* captured the imaginations of Renaissance philosophers, politicians, and literati from the fourteenth to the end of the sixteenth century. Even newly settled foreigners, conquered subjects and arrivé citizens, supported the humanists' belief that for the benefit of the state, individual passions must be restrained.[1] And yet, upon closer inspection, not all sixteenth-century Venetians tolerated this insistence on social conformity when dictated from above, nor believed in the rewards that silence in the face of injustice brings. Some citizens neither benefited from such selfless devotion to an alleged common welfare nor left this discourse unchallenged.

Two female sixteenth-century writers – Veronica Franco (1546–91), the most important *cortigiana onesta* in Venice, and Modesta da Pozzo, alias Moderata Fonte (1555–92), a highly esteemed citizen writer – denounce in their published works the unequal social practices of an authoritarian state that insists on suppressing an individual's needs and desires in the name of rationality and civic decorum. Marshalling new evidence to support their claims that Venetian women of all classes are not allowed to participate in the alleged freedoms the Republic offers its citizens, both courtesan and married (and then widowed) citizen writer advance new definitions for Venetian *libertà* drawn from their respective social and cultural upbringings. Franco does so in her familiar letters, *Lettere familiari a diversi* (Venice, 1580), first by denouncing the subjugation of the woman's body for the pleasures of Venetian men, and

then by privileging a reciprocal sharing of love between the sexes; Fonte, the respectable widow, first rejects the institution of marriage – which, she argues in her dialogue treatise, *Il merito delle donne* (Venice, 1600), enslaves a woman to the rule of a *paterfamilias* – and then favors chastity redefined as *virtù*. Although their views on the rewards of sensual love and female sexuality diverge widely, on one thing they are in perfect accord. Rather than incorporate themselves into a faceless mass of silent and docile citizens, both Franco and Fonte vehemently defend an individual's right to dissent, especially when dissent is summoned to form what Constance Jordan has called, with reference to early modern feminist defenses of women such as that of Moderata Fonte, a "feminized society."[2] This society is harmonious precisely because it is non-hierarchical; it promotes equal relations between men and women. Negative forces such as aggression, envy, and discord, characteristics associated with the male state, are replaced with positive, generative feminine ideals such as charity, temperance, compassion, and true friendship.

That Veronica Franco and Moderata Fonte should find themselves joined in this essay defies the reality of their specific historical situation. Although descendants of the same social order, the *cittadini originarii*, courtesan and married widow occupied very different social milieux. While Fonte was supported in her childhood by male figures (her maternal grandfather and her uncle) promoting her education, Franco was forced into prostitution for economic reasons, as was her mother before her, owing to the absence of a father's financial assistance.[3] In all likelihood, Franco and Fonte come together here for the first time. Indeed, although their lives parallel one another chronologically, and despite the fact that they both pay tribute to Domenico Venier, the most important Venetian patron of letters of the second half of the sixteenth century, neither Franco nor Fonte acknowledges one another's presence in their published works. One of the aims of the following discussion, then, is to try to account for this fact. To read Franco and Fonte together is, as I hope to demonstrate in the pages that follow, to question inevitably the crucial determinants that class, gender, and social privilege play in any cultural, textual production.

Indeed, it is hard to imagine two more different approaches to the issue of achieving freedom for women in Venetian patriarchal society. When Franco and Fonte assert female excellence, they do so by countering such self-acclaiming pronouncements as that of the infamous disgruntled courtier, Pietro Aretino, who rejoiced in his letters in the social privileges and unique intellectual freedom that Venice offered

him. His representation of Venice as a refuge for self-exiled intellectuals uses both the nurturing maternal metaphor of the Serenissima as spiritual provider, and the more negative image of the "harlot's" body as temptress and enslaver, when fending off critics of the Republic. In Venice, he declares, "treachery has no place, here favor cannot conquer right, here reigns neither the cruelty of harlots nor the insolence of the effeminate, here there is no theft, or violence or murder ... O universal homeland! Custodian of the liberties of man! Refuge of exiles!"[4]

When constructing a public literary identity, Fonte and Franco have recourse to a visual symbolism representing Venice as a powerful female ruler. Privileging, however, different aspects of the female icon's sacred and profane attributes heralding the city's legendary foundation, Fonte and Franco reclaim "Venetia" as their protectress, summoning her as witness to their dissenting claims. Prominently displayed in the artistic decorations adorning Venice's government and religious buildings, and in musical settings and occasional patriotic poetry, in ducal pageantry and patrician rituals, this female icon bolsters these women citizens' disapproval of existing social practices unfavourable to women. In Franco's and Fonte's works, they appropriate in self-elevating ways, while always questioning the limits of a female representation promoted by male patricians, the power of the virginal icon who greets all visitors entering the gateway to the city in the piazza San Marco. This icon reminds Venetian citizens that the Serenissima was founded miraculously, according to legend, on the day of the Annunciation to the Virgin (25 March), born from the sea like a Venus Anadyomene, pure and inviolate. Divinely chosen as Christian successor to Ancient Rome, Venice, figured as Justice, successfully combined three forms of government (democracy, oligarchy, and monarchy) into one well-balanced state.[5] Further, Venice is Venus, the powerful secular goddess of love. Hence, a threefold female icon, located at the very heart of Venetian public, commercial, and political life – a domain where all Venetian women citizens are forbidden regardless of social standing – contrasts dramatically with what was, in effect, a highly restricted life for most Venetian women. Only when it served the Republic's need to advertise its unfailing liberality and unselfish delight in public spectacle and splendor for the enjoyment of all its citizens, the elegant noblewoman, distinguished citizen, and sophisticated honest courtesan were paraded as female symbols attesting to Venice's tolerance of social diversity and its dedication to social justice.[6]

My purpose in this essay is to register the specific resonances of the immaculate female icon for Venetian women citizens, and to use this

civic imagery as a way of explaining the female construction of a literary identity in early modern Venice. In the pages that follow, I shall consider the material historical conditions influencing the choices governing women's lives at a time when notions of female chastity and female silence were commonplace. I shall start with the courtesan writer's familiar letters which rework humanist models, and then proceed to a consideration of Moderata Fonte's dialogue treatise published posthumously in 1600. When read together, these texts demonstrate vividly how literature, when used for historical analysis, uncovers and elucidates a complex layering of attitudes regarding female sexuality and literary identity inarticulated in sociopolitical domains. While Franco adopts the symbolic resonances of the profane Venus born from the seas, Fonte aligns herself with the virginal, ruling queen. Fonte prefers chastity, redefined as female learning, to marriage and domestic confinement. And, while Fonte fiercely repudiates female sexuality, Franco aligns her public eroticism with the sea-born Venus, whom she reclaims as her own from the city's ruling *paterfamilias*. For every year on Ascension Day, the doge, Venice's self-appointed secular bridegroom, marries the feminized sea (*la mar*) in what Edward Muir calls a "hydromantic rite" whereby he proclaims his dominion over Venice's maritime empire.[7] In her celebration of the secular Venus, Franco exalts the powers of erotic love when conjoined with the reciprocal pleasures of mutuality between lovers. She refashions Venus to project a public persona, while reminding her reader of the enormous difficulties a courtesan encounters when she seeks access to public arenas traditionally reserved for men. When she refers to female chastity as a virtue, she does so principally to overturn male satirical representations of the vulgar courtesan.

Venus in verse: Veronica Franco, *cortigiana onesta* of the Serenissima

As *cortigiana onesta*, Veronica Franco went beyond the bounds of female social decorum by moving into the intellectual, literary circles of Venetian life. Like Pietro Aretino before her, Veronica Franco employed the familiar letter of self-promotion and to build a successful literary reputation dependent on the acknowledgement, approval, and support of influential male readers. Unlike her occasional verses and the many editions she assembled in honor of Venetian luminaries, Franco's letters, like her *capitoli* in *terza rima* (fig. 21), assume an even bolder

21 Engraved frontispiece portrait of Veronica Franco, originally intended for her volume of
poems, *Terze rime* (Venice, 1575)

LETTERE

F,AMILIARI

A DIVERSI

DELLA S· VERONICA

FRANCA·

ALL'ILLVSTRISS· ET

REVERENDISS· MONSIG·

LVIGI D'ESTE

CARDINALE.

22 Frontispiece of Veronica Franco's *Lettere familiari a diversi* (Venice, 1580)

position with regard to generic conventions than did her contemporaries. By focusing on the kinds of private concerns typically expressed in the vernacular familiar letter, Franco presents a public version of a courtesan's private self that contests male authors' representations of the courtesan as base, duplicitous, and venal. Franco's letters thus blur the distinctions between a public and private voice; her private thoughts are formulated in a public genre, which she uses to represent both the shared principles of her class and specific women's concerns of the period. In addition, Franco disavows the ceremonial flattery and the obsequious pose of much epistolary practice, thereby attempting to disentangle the courtesan from negative charges of calculated dissimulation.

Veronica Franco wrote the epistles included in her *Lettere familiari* (fig. 22) over a long period of time. The content of her letters (they are undated) reveal that a number of them were written before certain of her lyric *capitoli*, while others gloss them retrospectively. Owing to the genre of the familiar letter, these epistles bring into clear relief the kinds of social courtship and independent critical voice at work in Franco's more lyrically inflected *capitoli*. Critics have consistently misread this personal voice in Franco's letters as implying nothing more than a courtesan's confessional autobiography, and in doing so have failed to see how skilfully Franco redirects classical and Renaissance literary genres towards a literary epistolary voice capable of expressing views in favor of Renaissance women, unrelated to the affairs of the heart. They have tended to use her letters to affirm a commonly held view that women record the concerns of the private self and never rework them for different ends.[8] What is most striking about Franco's epistolary texts (both her familiar letters and her *capitoli* in *terza rima*) is precisely the outward-directed artfulness with which she interweaves classical references into her discourse and plays with contemporary letter-writing traditions.

Franco claims the textual persona of "segretario" ("counselor") to a male élite gone astray. To achieve this persona, Franco dons with a feminine twist many of the public roles traditionally employed by male humanist familiar letter writers. Her letters offer the reader a view into the courtesan's multiple personalities as she experiments with, and retailors to her taste, the public, advisory discourses of the Venetian patriciate. Throughout Franco's *Lettere familiari a diversi*, she is moral counselor, writer, and editor of collaborative literary projects, as well as devoted friend, mother uninterested in financial gain, affectionate companion, and partner in love. Franco's conversational style adheres to the rhetorical strictures and social decorum of the familiar letter, which

advocated the use of plain unadorned speech. She uses this rhetorical style to draw attention to her avoidance of rhetorical embellishments. To this end, the language of Franco's letters is impassioned yet restrained; she elects, as she states in letter 38, the concision of thought and "vero affetto" ("honest feeling") that the familiar letter requires.[9]

Further, in many other letters, she works at persuading her correspondents of their wrong-doing or misguided opinions, perhaps in order to deflect away from the courtesan what she calls in letter 18 "artificio dell'adulazione" ("the artifice of flattery"). Rhetorical excess, she proclaims in letter 30, does not signify female deceit or an artfully composed and seductive façade, but rather male trickery.

At the center of the *Lettere familiari a diversi*, Franco vehemently denounces the hypocrisy of a political rhetoric and social practice that advocate individual restraint and collective self-discipline for the proposed common good, while simultaneously denying crucial personal freedoms to many Venetian citizens. In letter 22, Franco writes as a courtesan to another courtesan; she challenges these beliefs indirectly in exposing the difficulties that an impoverished Venetian woman faces when deciding the future for her young daughter. Implied in Franco's letter is that this woman lacks the necessary freedom, economic means, and social status to be able to make correct choices. Social inequities, Franco suggests, are camouflaged by idealizing civic codes that are blind to an individual's needs. Either because of class inferiority or to gender, Franco argues, many Venetian women are placed in morally precarious positions that compromise their human dignity, personal freedom, and individual beliefs. But the most enslaved human condition, in Franco's view, is to be not only subject to another's desires, but, further, to be robbed of one's freedom of choice.

Critics have repeatedly interpreted Franco's letter 22 as proof of her desire to denounce the horrors of her profession and her need to announce her conversion to a life of repentance. Rather, I would argue, this epistle questions the ideological assumptions that have forced an innocent young woman and her mother into a morally compromising situation. What Franco condemns in the letter is the impossibility of choosing one's future freely – a situation in which she, too, must have found herself as a child. Franco paints a cruel and violent picture of female subjugation, inequality, and suffering. Her message is not repentance, I believe, but profound indignation. Using the example of life's "giuoco della fortuna" ("game of fortune") when coupled with the vulnerability of a young girl's virginity, she argues that not all Venetian citizens share equally in the prosperity touted by the Venetian state. She

exposes a serious social predicament that many young sixteenth-century Venetian women – especially if impoverished – faced. This letter also challenges literary judgments of the Venetian courtesan. Franco litera-lizes the ancient misogynist trope that had equated rhetorical excess and epistolary flattery with a dressed-up "whore."[10] She follows the episto-lary prescription for simplicity of style (honesty, brevity, plain speech) when she counsels a mother to strip her daughter of the corporeal embellishments and vulgar finery that might deceive a male suitor. That is, Franco insists throughout the letter that her motivation to write to her friend is dictated by "familiar concern," and that she has chosen to substitute an epistle only because her spoken words have proven insufficient. She calls attention simultaneously to the appropriate decorum of this familiar letter and to her willingness to offer her friend the useful, practical advice of an experienced courtesan. Moreover, she writes in a language relatively free from embellishment. Although she condemns this mother's unwillingness to accept Franco's earlier offer to assist her daughter to enter the Venetian Casa delle Zitelle (a home for young girls "at risk"), Franco intends her harsh words not as a reproof, but rather as an attempt to "rimuoversi dalla vostra mala intenzione in quest'ultima prova" ("remove oneself from your bad intention for this last test," *Lettere*, p. 36).[11] By so doing, Franco points to the immediacy of the familiar letter; it serves as a warning signal to her addressee to prevent falling from the "precipizio nascosto" ("hidden precipice") for which this young woman is dangerously headed.

In this letter Franco recasts the satiric portrait of Aretino's *Sei giornate*, in which a young woman is educated into the courtesan's profession. Nanna, a former prostitute, delights in training her neophyte daughter, Pippa, in the tricks and allurements of the trade. By contrast, Franco's impassioned epistle decries the horrors of the social context which constrains a young woman to choose such a precarious existence in the first place. This letter achieves unusual force by virtue of its location, following a series of letters of counsel in which Franco ridicules the carelessness and moral negligence of male patricians.

Franco vividly depicts the social injustices a poor young woman will endure in the future if forced now to enslave her body to the desires of another, solely to escape the horrors of poverty. Most importantly, Franco cautions this mother that if her daughter should follow such a dangerous path, she will be prevented forever from enjoying one of the few options available to young women who retain their chastity, that is the right to "onestamente maritare" ("marry honestly," p. 36). In an impassioned plea to her friend's moral conscience, Franco vigorously

denounces the greedy commodification of female sexuality, made even more lamentable when a mother merchandises her own daughter's flesh. Implicit, however, in Franco's condemnation of this mother's conduct is her own painful awareness of the hypocrisy at the heart of Venetian social practices: owing to poverty and to the absence of a male protector, women end up being forced to do precisely those things they would otherwise choose to avoid.

The growing number of female prostitutes in sixteenth-century Venice, although certainly tied to the practice of late marriage for men (especially at the upper social levels), and to the increasing mercantile fluidity of an urban, capitalist economy, can also be explained by a government that tended to overlook female prostitution when faced with other sexual crimes, namely adultery, fornication, and rape, which they deemed more serious. But rather than interpret Venetian authorities' acceptance, or rather, tolerance, of prostitutes and courtesans as a sign of an unusually liberal social policy, I would argue, following Guido Ruggiero's lead, that female prostitution was less severely punished because it eased the severe socioeconomic problems facing sixteenth-century Venetian society. In Ruggiero's words, prostitutes and courtesans "created a secondary sexual economy that safely incorporated the sexuality of young women too poor to participate in the primary system" (p. 153). Although officials regarded an illicit sexuality as deviant, they did so "not so much because [it] threatened public morals," as Ruggiero reminds us, "but because [it] undermined society's most basic institutions of marriage and family" (p. 9).[12]

While Franco's avowed purpose is to signal the many dangers lurking behind the seductive façades of courtesanry, she also provides religious advice when she alerts her woman friend to the "certainty of damnation and ruin" that she will "bring not only upon her daughter but also upon herself." She alone will be considered guilty of "squandering her daughter's flesh" (*Lettere*, pp. 38–9), rather than the customers who will eventually consume it. Together with the sexual politics Franco is condemning, she offers spiritual counsel that is both helpful to her woman friend and exonerating for herself.

Franco's advice in this letter (her letters, although undated, would have been writen in the 1570s), also provides an explanation from the female's point of view of a law passed in the Council of Ten in 1563. This ruling attempted to prevent mothers from prostituting their young daughters for the purpose of receiving economic support. On the last day in March, the Senate legislated to punish any person involved in

violating the chastity of an unwed girl, or anyone who received favors from young women, especially if minors.[13]

Rather than punish the young girl, whom the Senate regarded as the innocent victim, the ruling prescribed that the offenders, often mothers, who "per cupidità di danari" ("lust for money") prostituted their own daughters, or relatives, be severely penalized. The penalty, in fact, was by no means inconsequential. As a form of public humiliation, the mother was placed on a platform between two columns in the piazza San Marco, with a crown of ignominy on her head and a herald proclaiming her specific crime. Further, she was banished from Venice and the surrounding area for two years. Similarly, if a father or other male relative was accused, he was to wear a heraldic emblem across his breast publicizing his guilt, and was to serve on the galley ships at the oars for two years; if such a man could not accomplish this latter task because he was physically unfit for strenuous activity, he was to be imprisoned for two years and then banned from the city for another two years.

To appease discontented citizens, and to control the ever-increasing problem of poverty, Venetian patricians found ways of protecting non-noble women by founding charitable institutions, such as the Casa delle Zitelle for poor and unwed maidens. Yet this kind of charitable institution was designed to prevent the social effects of the loss of a young woman's honor and reputation, rather than to end the specific injustices suffered by underprivileged members of society. For if a young woman had already compromised her chastity, she ran the risk of being ineligible for "honest" marriage. Marriage alone placed her within the restricted, but relatively secure, zone of patriarchal protection offered to her by the state, as well as within the insular boundaries of the Venetian family.

Thus in letter 22, Franco exposes the reality not only of a lower-class woman's economic peril, but of the devastating conditions in which an impoverished courtesan might live when menaced by the threat of irrational and retributive male aggression. Much like the courtier's denunciation of a sycophantic court role that enslaves a man's soul, Franco's description of sexual tyranny both literalizes that complaint by stressing the physical horrors of economic destitution and intensifies it by focusing on the woman's fears of physical violence. This kind of slavery is far worse than that of the courtier; for it makes a woman's body, as well as her mind, subject to the will of another. Franco writes eloquently on the horrors of this spiritual and physical bondage:

> Troppo infelice cosa e troppo contraria al senso umano è l'obligar il corpo a l'industria di una tal servitù che spaventa solamente a pensarne. Darsi in preda

di tanti, con rischio d'esser dispogliata, d'esser rubbata, d'esser uccisa, ch'un solo un dí ti toglie quanto con molti in molto tempo hai acquistato, con tant'altri pericoli d'ingiuria e d'infermità contagiose e spaventose; mangiar con l'altrui bocca, dormir con gli occhi altrui, muoversi secondo l'altrui desiderio, correndo in manifesto naufragio sempre della facoltà e della vita; qual maggiore miseria? quai ricchezze, quai commodità, quai delizie posson acquistar un tanto peso? Credete a me: tra tutte le sciagure mondane questa è l'estrema; ma poi, se s'aggiungeranno ai rispetti del mondo quei dell'anima, che perdizione e che certezza di dannazione è questa? (*Lettere*, p. 38)

(It is a most wretched thing, contrary to human reason, to subject one's body and industriousness to a servitude, whose very thought is most frightful. To become the prey of so many, at the risk of being despoiled, robbed, killed, deprived in a single day of all that one has acquired from so many over such a long time, exposed to many other dangers of receiving insult and dreadful contagious diseases; to eat with another's mouth, sleep with another's eyes, move according to another's will, obviously rushing towards the shipwreck of one's mental abilities and one's life and body; What greater misery? What riches, what comforts, what delights can possibly outweigh all this? Believe me, of all the world's misfortunes, this is the worst; but moreover, if to the concerns of the world you add those of the soul, could there be greater doom and certainty of damnation!)

Hence, Franco urges her friend, while she still can, to protect her daughter's virginity by reminding her friend of her original offer: to assist her daughter in entering the Casa delle Zitelle.

Tied to Franco's denunciation of female subjugation is her insistence on upholding social property and artistic decorum. By employing the "plain speech" of the familiar letter in letter 22, Franco emphasizes her own moral decorum. Indeed, part of her rhetorical strategy, as I have already suggested, is to strip down the male trope of the "dressed-up whore," and to expose the grim social realities of prostitution, both issues carefully avoided in male authors' condemnations of the prostitute. In addition, she opposes the erotic *blasons* of courtesans' customers. Just as she urges this mother to forbid her daughter to wear the costumes that will render her flesh marketable rather than chaste, so Franco clothes her own letter in the modest unadorned garments appropriate to the conversational familiar letter.

Where once you had her go about and combed with simplicity in a manner befitting an honest maiden, with her breasts covered and other attributes of modesty, you now encourage her to be vain, to bleach her hair and paint her face and, all of a sudden, you let her show up with curls dangling all around her brow and neck, her breasts exposed and popping out of her dress, her forehead high and without a veil plus all those tricks and embellishments that people use to promote the sale of their merchandise. (*Lettere*, pp. 36–7)

In this section of the letter, Franco switches from a scolding condemnation of her friend's actions to a practical assessment of the daughter's situation. Consequently, her language changes from the eloquent pronouncements of a moral counselor to the simple but wise popular sayings of a friendly advisor: "perché voi gettata in acqua la pietra, gran difficoltà vi sarà a volerne cavarla" ("because once you have thrown the stone into the water, you will find it very difficult when you want to retrieve it," *Lettere*, p. 39). Franco claims that even if this mother were to force her daughter into the courtesans' ranks, she would not succeed, because the young woman is not sufficiently beautiful, graceful, sophisticated, or educated, all requirements necessary for the honest courtesan's advancement. Franco even interjects a note of humor and common good sense when she affirms that the mother would "break her neck" trying to make her daughter "blessed in the profession of the courtesan" (*Lettere*, p. 38). She closes by reminding her friend once again of her offers to assist her. For not too much time will have to pass, she warns, before this woman's daughter will realize the horrible truth of her situation. Paradoxically, she will flee from her own mother, who she will come to see has "oppressed and ruined" her (*Lettere*, p. 39). With this last warning, Franco asks her friend to turn to God for help and to take fortune into her own hands.

This is one of the few letters written to an interlocutor clearly designated as female in which Franco provides moral as well as practical advice. She underscores her ability to see error and to follow correct judgment, reminding her addressee that practical considerations affirm the ability to make right moral choices. Franco emphasizes the extremely difficult emotional, spiritual, and economic demands that a courtesan's customer might inflict upon her.

Franco then turns to the many privileges afforded to male citizens in a number of letters to male patricians. In letters 4, 14, and 18, she manipulates an economic discourse for her own designs by addressing the issue of what can happen to one's spiritual well-being if subject to a sudden reversal of fortune, a theme often addressed in familiar letter collections of the period. But in Franco's version, she uses the commonplace not only to emphasize the question of an individual's spiritual strength in facing adversity, but also to call attention to her correspondent's unhealthy, even immoral, attachment to money and possessions. To overturn the standard accusation of a courtesan's venality, Franco insists in these letters on giving back her interlocutor's counsel precisely as she originally received it. Placing greater emphasis on the equal exchange of advice and on the reciprocal nurturing of friendship than on

an unbalanced struggle of power or authority, Franco's only "debt," as she calls it in letter 18, will emerge from a mutual exchange of "valor." She repays her "clients" solely with their "own coin" (*Lettere*, p. 30). This exchange, following a marketplace economics as Franco redefines it, radically differs from the sexual tyranny she so vehemently repudiates in letter 22. Franco reminds her correspondents that not only does she assimilate the teachings of her aristocratic friends, she lives in accordance with them. Indeed, she presents herself as a courtesan counselling male patricians who have neglected to follow the advice they had given to others; she redirects the terms of exchange away from the physical and venal towards what most people hold as virtuous and wise behaviour.

In letter 4, by refusing to sacrifice her moral integrity for material possessions, she cautions her interlocutor to do the same. As if to demonstrate the virtuous behavior worthy of his social standing, she declares that she will repay his advice with the exact sum awarded to her – no more and no less. This advice, she cautions, is motivated only by profound respect and reciprocity of feeling. He must follow the advice he gives others if he expects them to heed his counsel. If not, his words are meaningless ornamentation, divorced from reality, much like the embellishments of rhetorical discourse:

> Perhaps it is redundant for me to speak to you about this matter, and, as they say, it is the same as carrying water to the sea, because I am talking about things that you understand perfectly well and about which you have in fact enlightened and advised me. Nevertheless a duty born of love and gratitude further compels me to say to you that virtue lies in practice and not in pretense: so when it comes to matters that you so often taught me, you will show that you neither understand them nor own them unless you apply them when the need occurs.
> (*Lettere*, p. 14)

Thus Franco entreats a male patrician to live up to the values of fairness, justice, moderation, and honesty that he merely professes to follow, yet insists that others uphold. Her correspondent, she charges, has had the unique and enviable advantage of being born male rather than female, human rather than animal, and he resides in an immaculate city, free from barbarism and the servility of other beleaguered Italian cities. Franco's patriotic eulogy here, in contrast to her commemorative poems, gives way to philosophical speculation on the negative effects of those unbridled desires that subjugate other people. The "riches" most important to her correspondent should be those that already surround him and of which he should always be proud: he resides in Venice, a city that defies the powers of the human imagination. Further, he can boast

belonging not to the "scum of the common people," but rather to generations of "illustrious nobility."

> A truly maiden city, immaculate and untouched, untainted by injustice ... built as only a miracle could in the midst of the sea, standing aloft with admirable tranquility and forever expanding through endless time. A city full of marvels and surprise such that if described but not seen it cannot be known or understood by the human intellect. *(Lettere, p. 12)*

Follow the noble dictates of your class, she warns, and subscribe to the principles embodied in the civic practices of this virtuous city, unsullied by foreign hands. Only by practicing what he has advised his friends to do will he come to realize the dangers he incurs in desiring or envying another's fortunes: "Vanità delle vanità e tutte le cose che sono, vanità" ("Vanity of vanities; all is vanity," *Lettere*, p. 12) she reproves him, quoting Ecclesiastes 1:2. To covet material wealth is to subscribe to a world already severely "corrupt by overuse" (*Lettere*, p. 13). For if he were to lower his eyes for a moment to the spheres below him, he would see just how little most people actually possess. Why compare his fate with that of the heavens? His quest for "virtue" already sets him apart from life's more lowly pursuits. True wealth consists, she declares, alluding to Seneca's advice to Lucillius, "in securing tranquillity of mind and in pursuing the infinite rewards of learning and wisdom" (*Lettere*, p. 14).[14]

Franco returns to an earlier invective against male deception in letter 30, in which she charges a friend with not living up to the virtuous example he has set for others. By refusing to acknowledge his professed "error" in his dealings with her, he betrays the tenets of friendly and courteous advice. Instead of simply mimicking his counsel, as she has done in response to other letters that she has received from him and presumably from other men, she interjects here a differentiated response. As stoic advisor, she proposes that he "react to adversity with introspection, following peaceful meditation rather than the violence of confused emotions, which can inadvertently victimize innocent people" (*Lettere*, p. 48). While Franco advises the interlocutor of letter 4 on how to endure in a stoical manner the unexpected disasters of economic ruin, she upbraids the male interlocutor in letter 18 for his arrogance in believing that he can acquire love simply by buying it. Once again, a language of economic transaction runs throughout this letter. While in letter 22 she emphasized the realistic mercenary dimensions of courtesanry and its psychic miseries, calling attention to her fear that "some man may steal all your acquired goods from you" (*Lettere*, p. 38), here

Franco ridicules the cost of buying and selling affections as if they were capital freely exchanged, unattached to the weight of human emotion. Franco replies indignantly that love is not a commodity; it cannot be purchased. Her love, as she has disclosed to her correspondent many times before, is already committed elsewhere. While a courtier might make it his profession to learn how to simulate love with an unequal and false exchange of "prizes," she prefers not to conceal true feelings, but rather to uncover them in an honest display of emotion. Although Franco acknowledges that she might have profited more from this man's literary artifice had she indulged in the "artifice of flattery" (*Lettere*, p. 30), she refused to take part in any form of calculated or commercialized deceit. Unwilling to accept her explanations, preferring to adhere to his predefined notion of the venal courtesan, this interlocutor resorts to vicious accusations. He claims that she willfully withholds her love so as to incite him to love her more intensely. It is he, she retorts, who vulgarizes love by insisting on "facendo mercato . . . della mia persona" ("marketing me," *Lettere*, p. 31), especially by increasing the "value" of his offer with the hope of winning her affections while accusing her of avarice.

Franco suggests what her model of proper behavior between the sexes might be in letter 8. She poses as moral counselor in decrying the negative effects that feigned and calculated emotions can have on one's spiritual well-being. She signals to a male patrician the danger of falling into the trap of falsely accusing the innocent: if he persists in doing so, he will condemn only himself, she cautions. Although Franco speaks, in a sense, in defense of all women who are subject to the irrational will of another, here she condemns the injustice of his behavior specifically in relation to herself. Not only is she unworthy of such treatment, but this behavior is unbefitting to his class's most noble and allegedly peace-loving aspirations:

> I do not know which of us deserves greater blame for the malicious rumors spread abroad; I, whom you tax so unduly or you, who – despite the nobility you profess and to which you were indeed born – go about slandering me. There is no doubt that when injustice is done, the one on whom it is inflicted suffers the damage while the one who inflicts it must bear the burden of a wicked deed. The sin of calumny taints me not. (*Lettere*, p. 18)

Her motivation to write to him, she claims, is her desire to follow "the laws of nature and civilization" (p. 19). It is the style and critical acumen with which one applies one's talents that ultimately matters, Franco pronounces, not whether one has the accoutrements of nobility or the benevolent favors of the heavens. Echoing the Venetian humanist ethic

that advocated the restraint of individual human passions in favor of the *unanimitas* produced by a collective harmonious will, Franco advises her interlocutor in letter 17 to check the extremes of his "appetites" before ending in physical and moral ruin.

Franco's self-portrait in these letters necessarily downplays the sexual side of a courtesan's profession in favor of the intellectual activities she defended for all women. Without dismissing eroticism as one of the courtesan's allures, she was careful to dissociate it from the physical slavery of female prostitution. Franco associated herself with the regal female attributes of the city, "dominatrice alta del mare, / regal vergine pura, inviolata" ("royal virgin who dominates the sea, pure and inviolate," *Terze rime*, p. 271) connoting civic freedom.[15] Her aim was to free women, and all people, from the tyrannies that enslave a person's soul: the tyranny of unrequited love, the tyranny of sexual domination, and the tyranny of social hierarchy and political inequality.

A not so moderate fount: domestic conversation in Moderata Fonte's *Il merito delle donne*

Moderata Fonte's highly entertaining dialogue treatise, *Il merito delle donne* (figs. 23 and 24), was published posthumously in Venice in 1600, eight years after it was completed. The work was brought to light as a collaborative effort between Cecilia, Fonte's daughter (Fonte died giving birth to Cecilia in 1592), her son Pietro, who wrote two dedicatory sonnets to his mother which are placed after the formal dedication letter to Livia Feltri della Rovere, duchess of Urbino, and Nicolò Doglioni, her uncle, who includes in the volume a loving narrative of Fonte's life that is to date the most detailed account of her familiar concerns and literary activities.[16]

The known facts of Moderata Fonte's life (her real name is Modesta da Pozzo) can be briefly summarized. Born in 1555, the second child of Hieronimo da Pozzo, a lawyer in the ducal palace in Venice, and Marietta dal Moro, Fonte and her brother were orphaned a year later when both parents died from the plague. Left to her maternal grandmother, Fonte was then placed in the Monastery of Santa Marta for her education. At the age of nine, Fonte returned to her grandmother's home (her grandmother had meanwhile remarried), and her new grandfather, Prospero Saraceni, also an important lawyer, cultivated Fonte's interests in painting, literature, and music. When Saraceni's daughter married the noble Nicolò Doglioni, Fonte joined them in their new

23 Frontispiece of Moderata Fonte's *Il merito delle donne* (Venice, 1600)

VERA MODERATÆ FONTIS EFFIGIES,
ÆTATIS SVÆ. ANNO XXXIIII.

24 Engraved frontispiece portrait of Moderata Fonte, included in *Il merito delle donne* (Venice, 1600)

home and lived with them until she married Filippo de' Zorzi, a financial lawyer, in 1581, in a marriage arranged by Doglioni. That Fonte had often feared dying in childbirth is evident from her first will, set down in 1585.[17]

Despite the extraordinary pressures of domestic life, Fonte, unlike her pen name the "moderate fount," was extremely prolific. The author of counter-reformatory romance epic, occasional poetry, poetic masques, and poetic debates, she was well considered in Venetian literary coteries. In contrast with Franco, who struggled throughout her life to secure patronage because she lacked the support of a father, Fonte enjoyed, while a child, the protection and nurturing of male figures who saw personally to her education and to her financial assistance. Once married to Filippo de' Zorzi, Fonte, unlike many women writers, especially the woman humanists, never abandoned her literary vocation.[18] But her life, like that of many women of her social standing, was a constant struggle to assert her independence.

Published twelve years after Franco's *Lettere familiari a diversi* appeared in Venice, Fonte's dialogue champions female friendship and the pleasure that seven women citizens find in each other's domestic conversation. Unlike Franco's letters and dialogic poems which always invoke a male interlocutor, Fonte's dialogue features only women participants who delight in the absence of men. Removed, albeit temporarily, from the pressures imposed upon them by their fathers, brothers, or husbands, this female *brigata* pass two days until sunset within an urban *hortus conclusus*, in a space somewhere between the internal privacy of the *palazzo*'s garden, facing the Grand Canal, and the external, yet enclosed, public world of the Serenissima. Together they decide to form a woman's tribunal; they divide into two groups to debate contrasting opinions on male superiority (and the reverse), the goodness of women and the vices of men, and on social institutions, principally marriage, especially for women.

Far from the grave description of a plague-infested, socially dissolute city that drives seven women and three men in the opening of Boccaccio's *Decameron* to find pastoral comfort, this dialogue opens instead with a patriotic encomium to the delights of urban life. Indeed, all of Venice's conventional mythical attributes are rehearsed – its unique geographic position and beauty, its freedom and enviable prosperity, its religious autonomy and unparalleled political stability:

> The pomp and grandeur of this land is inestimable, its richness has no bounds, the sumptuousness of its buildings, the splendour of dress, the freedom of life … One cannot even begin to imagine nor describe it … Here there is more

money than in any other place; like the sea it is a free city without laws; it gives laws to others ... here reigns an incredible peace and equality; everything proceeds from the carefully controlled values of the person who rules.[19]

(*Il merito*, pp. 13–14)

This patriotic encomium takes on new meaning, however, when pronounced within Leonora's garden. A female *brigata*, representing the whole spectrum of female experience – a young and an older widow, two matrons and a young bride, an unmarried intellectual and self-appointed leader appropriately named Corinna – quickly dismantle the illusory façade of Venetian tranquillity and social freedom for all Venetian citizens. In their conversations they challenge male prescriptions of women's correct behavior by refashioning the "civil" conversations of male humanists. By the end of the second day, they construct a new social vision of domestic harmony; they combine learned discussions of cosmology, ornithology, zoology, and botany with more popular domestic concerns, such as the medicinal use of herbs, fashion, and the application of cosmetics.

Fearing the imaginary presence of a male intruder, or a hostile reader who might frown upon their criticisms of Venetian patriarchy, Fonte's tribunal speaks cautiously at first, fashioning their pronouncements against male authority with discretion – that is, until Elena, the newlywed, arrives and pronounces with much misgiving that instead of finding freedom in marriage as her family had promised her, she has been imprisoned, until now, within her own home. This gives way to a series of diatribes against the Venetian institution of marriage. Corinna exclaims that "I would rather die than subject myself to any man; too blessed is that life that I am now spending with you, without fearing the bother of a man who wants to command me" (*Il merito*, p. 17), to which the others respond that she should write a book cautioning "le povere figliuole" ("poor young girls") before it is too late and they are already caught in their domestic "prisons" (p. 18). Indeed, all the women present, but especially Adriana, one of the widows, complain bitterly against women's enforced solitude and subjugation from which she has finally escaped. As in Franco's denunciation of the male domination of a woman's body, Adriana proclaims that marriage is tantamount to a woman renouncing any claim to participate in the public world:

Remarry? she answered; I would rather drown myself than subject myself to any man again; I have escaped slavery and punishment, and now you are suggesting that I should go back to getting tangled up in that affair again?

(*Il merito*, p. 21)

Only Verginia, the wealthy young maiden, holds on to her belief in the social bond of matrimony, which she views as a merely practical convenience. Her mother responds that she should marry because this is the only way that her wealth, left to her by her two uncles, will stay in circulation. If she refuses marriage she will in any case be imprisoned within her family's home, deprived of all the clothes and entertainments afforded, albeit in small measure, to married women on the rare occasions when they participate in public rituals. The others remind her, moreover, that not only do women forfeit individual freedom of movement in marriage, they also lose all economic security. For, once married, the husband takes the woman's dowry and invests it as he sees fit. If a woman were to keep her dowry for herself by never marrying, she would live as a "queen" according to her own designs (*Il merito*, pp. 68–9).

Much like Franco's condemnation of the commodification of the woman's body for financial gain, Fonte's criticism of the division of wealth and goods in the marriage arrangement underscores the extent to which all women are stripped of their property and rights:

> By taking a husband ... one becomes a slave ... and in losing one's freedom, one loses also the control of one's things, placing everything within the dominion, and according to the will, of he who has been bought ... think what a beautiful thing it is to marry ... you lose your possessions, you lose yourself, and you acquire nothing in the end except children who only give you trouble, not to mention the tyranny of a man who dominates you according to his desire. (*Il merito*, p. 69)

After much protest, the group concedes that no woman should be bought or sold. Lucrezia declares triumphantly that "it is much better to live well alone than to live in bad company" (*Il merito*, p. 171). Delighting in the arguments that Corinna marshalls in support of her self-appointed freedom, the others feel increasingly comfortable in participating in her accusations. Indeed, female loquacity disrupts the male-constructed virginal icon which watches over female propriety; once male injunctions on female speech are dissociated from unchastity and realigned with learning, these women speak with abandon. Leonora reminds the group, however, not to get swept away by fancy theorizing or by the abstract power of the spoken word, but to keep forever present in their minds the harsh realities governing their daily existence.

Moderata Fonte was not the only Venetian to ridicule the Venetian marriage institution. A century earlier, the rebellious Ermolao Barbaro the Younger published a treatise entitled *De coelibatu* (*On Celibacy*)

(1471), countering Francesco Barbaro's celebrated treatise *De re uxoria* (*On Wifely Duties*) (1416, dedicated to Lorenzo de' Medici). Ermolao, motivated by his unwillingness to serve in Venetian government as was expected of a man of his social standing, rejects the Venetian ideal of domestic life, privileging instead a life of contemplation. Thus, going against the Venetian humanist ethic of subordinating individual desires for a collective civic good, he insists that a wife and children pose insurmountable demands, preventing his pursuit of learning. A plea such as Barbaro's "is one of self-determination in a social context," as Margaret King has noted, "where family and state limited the possibilities for self-determination."[20] Fonte's dialogue, on the other hand, emphasizes the extent to which men protect their signory by restricting women's participation in Venetian civic life and by disallowing them equality in education.

Corinna represents, in her determination to avoid the bondage of Venetian patriarchal society, the rewards that chastity, now defined as learning, can bring. Now in the presence of a group of newly educated listeners who are beginning to see social injustice and female inequality submerged in every example she provides, her erudite observations assume untold profundity.

When the dialogue ends, Fonte's female *brigata* joins together in a kind of Mozartian finale. Corinna, who champions her "libero cor" ("free heart") and independent intellectual pursuits, Verginia, who will marry in the end one of the men criticized by the group, and the others all sing the merits of women. This final chorus is at a far remove, however, from the vehemence of certain of Franco's letters or the anger that will characterize two Venetian women's treatises defending the independence of women. Lucrezia Marinelli and Arcangela Tarabotti no longer deploy the virginal civic icon in their polemical treatises of the early and mid-seventeenth century.[21] Instead they weave together classical and medieval sources on women's excellence with the feminist pronouncements of Moderata Fonte – and of the Italian women humanists on women's ability to overcome their limited training by retreating into booklined cells – when they argue not for female excellence but for female superiority. There is no mention, unfortunately, of the *cortigiana onesta*, Veronica Franco, which perhaps is not surprising. Intent on asserting female superiority, these women advocated, at least in theory, what Marinelli called "the proper purpose of women": that is, "not to please men, but to understand, to govern, to generate, to bring grace into the world." To place an honest courtesan within the ranks of female worthies would not have helped bolster her case.

And yet both Veronica Franco and Moderata Fonte construct literary identities with newly gendered signatures by dismantling and restructuring the female icon of Venice for their individual designs. As women citizens of the Serenissima, albeit from very different social and cultural situations, both Franco and Fonte question just for whom this civic myth of freedom, equality, and tranquillity is intended.

Notes

I wish to thank the University of Southern California Faculty Research Fund and the National Endowment of the Humanities for supporting the research on which this essay is based. All translations from Franco and Fonte are my own.

1 Cf. Margaret L. King, *Venetian Humanism in an Age of Patrician Dominance* (Princeton, 1986), pp. 175–9.

2 *Renaissance Feminism: Literary Texts and Political Models* (Ithaca and London, 1990), p. 253. For a discussion of Fonte's dialogue, see pp. 253–7.

3 For Franco and the paradoxical term *cortigiana onesta*, see my *Honest Courtesan: Veronica Franco, Citizen and Writer of Sixteenth-Century Venice* (Chicago, 1992). The most useful critical studies of Fonte are: Patricia H. Labalme, "Venetian Women on Women: Three Early Modern Feminists," *Archivio Veneto* 152 (1981), 81–109; Beatrice Collina, "Moderata Fonte e *Il merito delle donne*," *Annali d'Italianistica* 7 (1989), 142–64, an essay which includes important archival information regarding Fonte's life; and, in the same volume, Paola Malpezzi Price, "A Woman's Discourse in the Italian Renaissance: Moderata Fonte's *Il merito delle donne*," 165–81. On the privileges associated with the *cittadini originarii*, see Brian Pullan, *Rich and Poor in Renaissance Venice: The Social Institutions of a Catholic State to 1620* (Cambridge, 1971), p. 100 and throughout. The *Catalogo di tutte le principal et più honorate cortigiane di Venezia* lists Paola Franco as a "pieza" or "go-between," and her daughter Veronica, living at her mother's house, at the (presumably satirical) price of 2 *scudi*; see Giuseppe Tassini, *Veronica Franco: Celebre poetessa e cortigiana del secolo XVI* (Venice, 1888), pp. 9 n. 1 and 56 n. 2. On the Franco family, see Teodoro Toderini, *Genealogie delle famiglie venete ascritte alla cittadinanza originaria*, Miscellanea codici, I, 2:6. Both of Veronica Franco's wills are located in the Archivio di Stato, Venice (hereafter cited as ASV), Notarile Testamenti, (hereafter cited as NT), notary Anton Maria di Vincenti, 10 agosto 1564, busta 1019, fol. 806; notary Baldissera Fiume, 1 novembre 1570, busta 420, fol. 870. For Fonte and Franco's tax reports, see ASV, Dieci Savi sopra le decime, Condizione 1581–2; or Fonte, see b. 157, n. 751, 24 agosto, and for Franco, see b. 157, n. 92, 15 febbraio.

4 Letter to Doge Andrea Gritti (*Lettere, il primo e il secondo libro*), in F. Flora and A. del Vita, eds., *Tutte le opere* (Milan, 1960), p. 30. All translations are my own unless otherwise indicated.

5 See David Rosand, "Venetia Figurata: The Iconography of a Myth," in Rosand,

ed., *Interpretazioni veneziane: Studi di storia dell'arte in onore di Michelangelo Muraro* (Venice, 1984), pp. 177–96; Rona Goffen, *Piety and Patronage in Renaissance Venice: Bellini, Titian, and the Franciscans* (New Haven and London, 1987), pp. 139–54, p. 239 n. 2 and p. 240 nn. 6 and 9; King, *Venetian Humanism*, pp. 174–8. On Franco's Venetian patriotism, see also Ann Rosalind Jones, "City Women and Their Audiences," in Margaret W. Ferguson, Maureen Quilligan, and Nancy Vickers, eds., *Rewriting the Renaissance: The Discourses of Sexual Difference in Early Modern Europe* (Chicago and London, 1986), pp. 315–16.

6 On the civic display of courtesans for important rituals such as the Sensa, see Lina Padoan Urban, "La festa della Sensa nelle arti e nell'iconografia," *Studi Veneziani* 10 (1968), 291–353.

7 *Civic Ritual in Renaissance Venice* (Princeton, 1981), pp. 130–1, and see pp. 119–34.

8 This point of view is articulated in Tassini, *Veronica Franco*, esp. pp. 99–105, and Arturo Graf, "Una cortigiana fra mille," in *Attraverso il Cinquecento* (Turin, 1888), pp. 215–351; it continues in Croce's edition (n. 9 below) and Riccardo Scrivano, "Veronica Franco," in *Cultura e letteratura* (Rome, 1966), esp. pp. 204–6.

9 Franco's *Lettere familiari a diversi* (here cited by letter-number) are available in Benedetto Croce, ed., *Lettere dall'unica edizione del MDLXXX con proemio e nota iconografica* (Naples, 1949). A unique copy, most probably published in Venice, survives in the Biblioteca Nazionale Marciana in Venice, which suggests that a limited number were originally printed. The name of the publisher is not recorded, and there is no "privilegio" (copyright). On the distinction between letters designed for publication, letters dispatched, and letters that adhere to formulated "conceits," see Janet Gurkin Altman, *Epistolarity: Approaches to a Form* (Columbus, 1982).

10 See R. Howard Bloch, "Medieval Misogyny," *Representations* 20 (1987), 1–24, and Quintilian, *Institutio oratoria* 2.5, 5.12, and 8.3.

11 On the *supplica* (petition) that Franco drafted for founding the Casa del Soccorso, see Pullan, *Rich and Poor*, pp. 391–2.

12 *The Boundaries of Eros: Sex Crime and Sexuality in Renaissance Venice* (New York, 1985), pp. 153 and 9; see also pp. 17–18, 23–4, 36–9, 49, 109–45, 152–4, and 162–3.

13 Comuni del Consiglio dei Dieci, Registro 26, 1563–4, fol. 10; see L. Menetto and G. Zennaro, eds., *Storia del malcostume a Venezia nei secoli XVI e XVII* (Abano Terme, 1987), pp. 52–3, 57, 61–2.

14 Franco could have encountered Seneca's epistles in Anton Francesco Doni's translation (Venice, 1549).

15 Abdelkader Salza, ed., *Rime: Gaspara Stampa e Veronica Franco* (Bari, 1913), p. 271.

16 On Fonte's father and the paternal protection of Doglioni, see Adriana Chemello, "La donna, il modello, l'immaginario," in Marina Zancan, ed., *Nel cerchio della luna: Figure di donna in alcuni testi del XVI secolo* (Venice, 1983), pp. 106–7 n. 15. I thank Patricia H. Labalme for generously sharing with me her findings and notes on Moderata Fonte.

17 For a full account of Fonte's life, legal documents, and literary output, see the introductory essay in Chemello, ed., *Il merito delle donne. Ove chiaramente si scuopre quanto siano elle degne e più perfette de gli huomini* (Milano–Venice, 1988).

18 On women humananists of the Renaissance in Italy, see, among others, King, "Thwarted Ambitions: Six Learned Women of the Early Italian Renaissance," *Soundings* 76 (1976), 280–300; Labalme, "Women's Roles in Early Modern Venice," in Labalme, ed., *Beyond Their Sex: Learned Women of the European Past* (New York and London, 1980), pp. 137–44.

19 Chemello, ed., *Il merito delle donne*, p. 171; subsequent references will be cited from this edition in parentheses.

20 *Venetian Humanism*, p. 201; for a representative sample of mainstream treatises, see Bernard G. Kohl and Ronald G. Witt, eds., *The Earthly Republic: Italian Humanists on Government and Society* (Philadelphia, 1978).

21 As cited in Ginevra Conti Odorisio, *Donna e società nel Seicento* (Rome, 1979), p. 57; Jordan, *Renaissance Feminism*, pp. 257–61 for a discussion of Marinelli's text.

The ambiguity of beauty in Tasso and Petrarch

NAOMI YAVNEH

ﻉ

In the final stanzas of Torquato Tasso's *Gerusalemme liberata* (1575), the beautiful and evil temptress Armida suddenly converts. After deploying her seductive and decidedly pagan wiles throughout the poem in order to prevent the Christian conquest of Jerusalem, Armida collapses into the arms of the crusader Rinaldo and declares herself his "ancilla," or handmaiden:

> "Ecco l'ancilla tua: d'essa a tuo senno
> dispon," gli disse, "e le fia legge il cenno."[1]

("Behold your handmaiden: dispose of her according to your judgment and your authoritative gesture will be law to her.")

Considered from a mimetic standpoint, Armida's conversion is implausible. Previously, she has caused dissension with the Christian army, transformed crusaders into fish, and kidnapped Rinaldo, bringing him to her enchanted home in the Fortunate Isles to be quite literally her "love slave." By the poem's final canto the temptress has been abandoned by Rinaldo, who has returned to the Christian army; accordingly, at the final battle for Jerusalem, she has gathered the best of the pagan warriors to be her champions, promising to marry the one who will avenge her honor by slaying Rinaldo. Certainly Armida's conduct has suggested only animosity toward the Christian faith and its followers.

Rinaldo, however, slays his would-be assassins, and readers usually infer from Armida's unexpected and submissive declaration that she has agreed to marry him. But we are not permitted even a brief romantic interlude, for as abruptly as Armida converts, the narrative returns to the battle, and the poem ends eight stanzas later when the Christians capture Christ's tomb. Moreover, Rinaldo's vow, just prior to the conversion, to "bring [Armida] to the throne where [her] ancestors

reign" ("Nel soglio, ove regnar gli avoli tuoi, / riporti giuro," xx.135), strongly suggests that he still believes the lie Armida has told in canto IV of her own betrayal at the hands of a treacherous uncle.

Perhaps the most problematic aspect of Armida's abrupt transformation from temptress to handmaiden is her speech, for her words explicitly imitate the Virgin Mary's at the Annunciation. When the archangel Gabriel appears to the young maiden, announcing that she will bear the son of God, Mary declares: *"Ecce ancilla Domini*: Behold the handmaiden of the Lord. Be it unto me according to thy word" (Luke 1:38). Whether or not we find Armida's intentions sincere, her enunciation seems overdetermined and inappropriate.

Yet the temptress' conversion is not, as many critics have suggested, an unsuccessful contrivance or "failure of tone," but is, rather, essential to the poem's program, an attempt by the poet to give the temptress a role more in keeping with the overarching values of his epic. Armida's self-declaration as "ancilla" at the conclusion of the poem signals her recognition of her subservient place in the Christian order restored by the conquest of Jerusalem, and grants her a teleology which transforms the threatening figure of errant sexuality into a Marian emblem of humility and chastity, the "passive vessel" exalted precisely by her willing submission to God's Word.[2]

Through her conversion, Armida does not become an allegorical figure for the Virgin, or for the Church Triumphant. Rather, the echo summons forth a series of allusions, creating an intertextual space of resonances which go beyond the level of plot to illuminate the larger ideological framework of the poem. It is precisely because Armida's words are so shocking that they direct the reader to a sphere of meaning which mimesis excludes. But while the alliance between the converted temptress and the supreme exemplar of Christian feminine humility is a bold stroke, the allusive density is ultimately insufficient to transcend the mimetic: the problem remains that, for the majority of Tasso's critics (and, I would argue, readers), the imitation does not work.

In examining Tasso's use of *petrarchismo* as well as Petrarch's own poetry, we shall see that Tasso's program is ultimately a failure, for Armida's status as idol – as both character and fictive poetic construct – is too strongly confirmed by the Petrarchan allusions which emphasize an alternative, and idolatrous, incarnation. Moreover, Armida's representation is not merely Petrarchan; more specifically, the temptress is the generic *bellissima donna* of sixteenth-century treatises on beauty, and of the sensuous female half-length popular in Venice in the first half of the cinquecento. This genericizing impulse, which renders lady

indistinguishable from courtesan, saint indistinguishable from temptress, undermines the distinctions between good and evil upon which Tasso's program depends. The tension between spirituality and sensuality is not so easily resolved.

The *bellissima donna* and the narrating eye

At the beginning of canto IV, the devil inspires the sorcerer Idraote to send his niece Armida to "perform" before the Christian army. Her appearance in canto IV is a perfect example of the destructive effect of beauty feared by the Church:

> Vanne al campo nemico: ivi s'impieghi
> ogn'arte feminil ch'amore alletti.
> Bagna di pianto e fa' melati i preghi,
> tronca e confondi co' sospiri i detti:
> beltà dolente e miserabil pieghi
> al tuo volere i più ostenati petti.
> Vela il soverchio ardir con la vergogna,
> e fa' manto del vero a la menzogna. (IV.25)

("Go," he tells her, "to the enemy camp, and there employ every feminine art which love makes attractive. Bathe your entreaties in tears, and make them sweet; garble your speech with sighs: your sorrowing and suffering beauty will bend to your will the most obstinate breasts. Veil your excessive ardor with shame, and make a mantle of truth to your lies.")

Armida's charge is to create dissension in the army, using her seductive beauty as a lure to draw the best of the soldiers away from the Crusade. As the temptress walks through the Christian camp, attracting every eye, the threat of her allure is highlighted by the very first comparison:

> Argo non mai, non vide Cipro o Delo
> d'abito o di beltà forme si care. (IV.29)

(The city of Argos never saw, nor Ciprus nor Delos, a form so dear in dress and beauty.)

The reference to Helen, originally from Argos, evokes the death and destruction of the *Iliad*, and the divisiveness of which the beautiful woman was the ostensible cause. But Armida deploys her beauty not only to divisive, but to deceptive, ends. Throughout canto IV and beyond, Armida uses her appearance as an enchanting snare, gaining masculine power through manipulation rather than strength. Arriving in the Christian camp, she literally follows her uncle's injunction to "use

every feminine art which love makes attractive," for although Armida is a *maga*, an enchantress, in canto IV she invokes her considerable charms rather than magic to get her way, and to create dissension in the previously unified Christian forces.

The temptress is first described by her evil uncle as one who "sotto biondi / capelli e fra sí tenere sembianze / canuto senno e cor virile asconde" ("beneath blonde hair and behind a delicate appearance hides white-haired judgment and a virile heart"). Advocating long hair as an emblem of woman's subjugation to man, Saint Paul affirms in I Corinthians that a woman's long hair "is a glory to her . . . for her hair is given to her for a veil" (11:15). But Armida's hair, which should be the visible, outward sign of both her sex and her submission, is a veil to her masculine cunning. The long curls of the temptress are in fact the sign of her dominance, granting her power precisely because they appear to indicate her lack thereof. She is thus diametrically opposed to a *donna guerriera* like Clorinda, who conceals her femininity, her sexual difference, beneath her armor. Clorinda's hair is in fact the only feature described by Tasso: with a "mirabil colpo," a miraculous blow which knocks off her helmet, the fierce pagan warrior is transformed into the beautiful and chaste Clorinda only by revealing her "chiome dorate" (III.21). Whereas the fierce armor of the *donna guerriera* hides the femininity signified by her long hair, Armido's hair, which should be the sign of her submission, hides a "canuto senno" and a "virile" heart.

By suggesting submission, Armida's "chiome lunghe" become the sign of her idolatrous nature; but her hair has a vernacular as well as a scriptural resonance. Golden curls are a standard feature of the traditional Petrarchan *donna*, adorning not only Petrarch's Laura, but virtually every literary beauty of the fifteenth and sixteenth centuries: Ariosto's Alcina, Angelica, and Isabella, Poliziano's Simonetta, and the myriad beloveds of the cinquecento sonnet-craze all sport the same flowing blonde locks, just as their bodies all fit the design made classic by Petrarch.

Before examining Armida's Petrarchan presentation, we should first explore the tradition in which that representation is based. "To immortalize Laura is an avowed purpose of the *Rime Sparse*," as Robert Durling affirms,[3] yet perhaps her most notable feature is that she is not really there. Recent Petrarchan criticism has emphasized Laura's fragmentation; the *Canzoniere* paints a vivid picture not of the Lady, but of her lover, and Laura's powers are clearly presented as the projection of the poet. Indeed, Laura herself is unimportant, for the lesson of the Petrarchan lover is that he can read the Lady as he desires, even

projecting presence into her absence, recreating her image from her hand, eyes, or sometimes only her veil. In the sixteenth century, anyone who sought to display a patina of culture wrote sonnets, or at least carried about a *petrarchino*, a miniature copy of the *Canzoniere*. A popular parlour game of the mid-sixteenth century involved the simple rote learning of parts of the body, as described by an accompanying line from Petrarch.[4] In addition, numerous treatises were published detailing the beauty of a woman whose ideal features were culled from authors such as Ariosto, Bembo, and of course Petrarch himself. Federico Luigini da Udine's *Libro della bella donna*, printed in Venice in the 1540s, is such a dialogue, in which a group of men on a hunting trip, each arguing his own absent lady to be the most lovely, spend three evenings designing the perfect beauty. Whichever lady is at the end judged most like this paragon will be deemed *bellissima*, most beautiful. In a gesture which parallels the fragmenting effect of the Petrarchan tradition, Luigini's *signori* create a verbal portrait of the ideal lady from poetic fragments, citing the various poets of the Italian vernacular tradition, and even classical authors, without distinction.

A lady's hair, according to Luigini, is her most important feature. "Senz'ella sarebbe tale, quale senza fior prato o senza gemma anello" ("without [it], she would be like a field without flowers or a ring without a gem").[5] These locks must of course be "oro," gold.

> Onde in ogni luogo per gli scrittori potete aver letto "aure chiome," "crini d'oro" e sì fatte voci. Il Petrarca ... in mille luoghi chiaramente per mezzo di Laura, che tali gli ai, ce l'ha dimostrato che aurati debbono essere in ogni modo. (p. 230)

> (Throughout the authors, you can read "aure chiome" [golden tresses], "crini d'oro" [mane of gold], and other such expressions. Petrarch in a thousand places demonstrates clearly, through Laura, that hair must be gold.)

Bembo, Ariosto, and Sannazaro are all cited as further authorities. Hair must also be "crespi" (curly), "lunghi" (long), "folta" and "spessa" (luxurious and thick), like that of Alcina, while Vergil's Venus, Camilla, and Dido demonstrate that hair can be worn either up or loose (p. 231). Ariosto's Isabella and Olimpia, as well as Laura herself, illustrate the power of hair to attract the hearts of men (p. 235). Just as Ariosto's *belle donne* are virtually indistinguishable in appearance, despite their quite different personalities (Alcina is an evil enchantress whose ravishing and seductive beauty is the product of magic, while Isabella is a virgin who commits suicide to protect her chastity and the memory of her dead beloved), so Luigini makes no distinction among his various sources.

Each beautiful woman is as worthy as another; her individuality is of no consequence.

But the ideal of Petrarchan beauty encompasses more than hair, and the men of Luigini's *Libro* design the ideal woman from head to toe. Her eyes must be black, like mature olives, pitch, velvet, or coal, for such adorn Laura, Angelica, Alcina, and the beloveds of Propertius, Horace, and Boccaccio (p. 236). They should also be "luminosi" and "sfavillanti," sparkling and shining like stars. The forehead must be "larga, alta, lucida, e piena di divine bellezze" ("large, high, clear, and full of divine beauties," p. 238), while the cheeks must combine the white of lilies with the vermillion of the rose or the purple of the hyacinth ("bianco giglio e vermiglia rosa, purpureo iacinto e candido ligustro," p. 242). According to Bembo and Boccaccio, lips must be "dolci rubinetti" ("sweet little rubies"), while Sannazaro likens them to "matutine rose" ("morning roses"), and Ovid to "porfido" ("porphyry") – these are all different ways, the author suggests, to express the same color (p. 243). The neck should be as white as fresh snow or ivory, and the breasts, aside from their whiteness ("candidezza"), "picciole, tonde, sode e crudette, e tutti simili a due rotondi e dolci pomi" ("small, round, firm, unripe, and completely like two rotund and sweet apples," pp. 248–9). Since ears and chins are not mentioned by the *scrittori*, it is enough, states Luigini, to say that they should be "riguardevolissime e vaghissime in ogni modo" ("most remarkable and delightful in every way," p. 244).

Elizabeth Cropper has described the Petrarchan world as one of "ideal types, beautiful monsters composed of every individual perfection."[6] The discourse of the *Libro della bella donna* carries the fragmenting and even dehumanizing aspect of the Petrarchan tradition to its logical extreme: if the ideal woman must of necessity be represented as a collection of fetishized parts which render present an absent figure, then she can most perfectly be a composite whole – a collection of parts from a variety of ladies, created in the complete absence of women. The composite woman of Luigini's dialogue is presented as surpassing five individual (fictive) women: the beloveds of the five male friends. Thus, the *Libro* presents a double reification: poetry which is meant to represent the lady metonymically (Laura represented as hand, eye, or even veil) is now used for its fragmenting quality, not the part for the (its) whole, but for *another* whole – which in its turn can never be complete. As Roland Barthes suggests, "the blazon expresses the belief that a complete inventory can reproduce a total body, as if the extremity of enumeration could devise a new category, that of totality," and yet such beauty "can only be tautological (affirmed under the very name of beauty) or analytic (if we

run through its predicates), never synthetic."[8] The *locus classicus* for this reifying synthesis, the story of the painter Zeuxis who required no fewer than five beautiful virgins of Croton as models for his Helen, shows that not all such delineations of ideal beauty occur in the physical absence of women. In Agnolo Firenzuola's *Dialogo delle bellezze delle donne* (Florence, 1548), for example, the protagonist, il Celso, verbally dissects the six lovely ladies who join him for a stroll in the Tuscan hills to hear him discourse on female beauty.[9] As in the *Libro*, the effect is one of detachment, or even dismemberment: the lady celebrated is a series of fetishized parts chosen from each of the women.

What is remarkable in so much of the tradition we are considering is its use of a masculine "economy" of description which designates the female body as a means of exchange between men. As Nancy Vickers notes of Shakespeare's *Rape of Lucrece*, "the canonical legacy of description in praise of beauty is ... a legacy shaped predominantly by the male imagination for the male imagination; it is, in large part, the product of men talking to men about women." Vickers reads *Lucrece* as an example of the dangers of descriptive rhetoric, carried to its extreme. By "situating blazon within a story," the critic argues, Shakespeare's narrative "reveals the rhetorical strategies that descriptive occasions generate, and underlines the potential consequences of being female matter for male oratory ... In *Lucrece*, occasion, rhetoric, and result are all informed by, and thus inscribe, a battle between men that is first figuratively and then literally fought on the fields of woman's 'celebrated body.'" Vickers cites Hélène Cixous to question how descriptive rhetoric, "has 'more than confiscated' woman's body, has turned her into 'the uncanny stranger on display.'"[10] In Vickers' reading, Shakespeare's poem problematizes what Gayle Rubin has termed the "'traffic in women": the use of women as "exchangeable, perhaps symbolic, property for the primary purpose of cementing the bonds of men with men."[11] Vickers' thesis is pertinent to the mid-sixteenth-century *bellissima donna* treatises as well as to the late-Elizabethan *Lucrece*, for as in Shakespeare's poem, the description of Luigini's *Libro* is created for male consumption, both within and external to the dialogue. (Luigini's own beloved, given to other men to describe, is aptly named Lucrezia.) The woman designed – a substitute figure both surpassing and standing for the interlocutors' absent beloveds – is a joint creation, a means of creating bonds rather than rivalry between men, and of defusing the potential violence attested to by Lucretia. The story of Lucretia begins, after all, in a situation remarkably similar to that of the *Libro*; the woman is raped because her husband did such a good job of describing her.

Luigini's *Libro* itself is offered to Monsignor Giovanni Manini, its purpose to "farvi vedere una bellissima ... donna, dipinta e perfetta da cinque pennelli di cinque perfetti ed accorti signori" ("to display for you a most beautiful lady, depicted and perfected by five brushes of five perfect and knowledgeable gentlemen," p. 223). The author explicitly states he does not wish to be paid for his "ritratto," although Zeuxis was well paid by many who wished to see his portrait of Helen: "Questa donna, per sì fatto mezo veduta, potrebbe chiamarsi, come l'antedetta Elena, 'femina di mondo': cosa che a me per ogni rispetto non dee piacere" ("This woman, seen by those means, could be called, like the aforementioned Helen, a 'woman of the world,' something which would in no way give me pleasure," p. 224). Moreover, he wishes to repay the debt he owes for "la molta cortesia vostra," his patron's great courtesy. The connection between the author and his creation is telling: the *bellissima donna* is offered as a means of both repaying and sustaining a bond of obligation between himself and a friend of higher station, a bond whose nature would be transformed if a monetary payment were involved. Yet this tension between patronage and payment is projected onto his creation – it is the *donna*, not her creator, who would be dishonored, who would become the courtesan, the "femina di mondo."

This same ambiguity of subjectivity and agency informs the *Gerusalemme*'s representation of Armida, ordered by Idraote to "impieghi / ogn'arte feminil ch'amore alletti" ("to employ every feminine art which love makes attractive") in order to "bend to [her] will" even the most recalcitrant crusader. The description of the temptress in canto IV seems culled from treatises such as those of Luigini and Firenzuola, for she is immediately recognizable as the idealized perfect beauty of the dialogues:

> D'auro ha la chioma ...
> Fa nove crespe l'aura al crin disciolto,
> che natura per sè rincrespa in onde;
> stassi l'avaro sguardo in sè raccolto,
> e i tesori d'amore e i suoi nasconde.
> Dolce color di rose in quel bel volto
> fra l'avorio si sparge e si confonde,
> ma ne la bocca, onde esce aura amorosa,
> sola rosseggia e semplice la rose. (IV.29–30)

(She has golden hair ... The wind makes new curls in the loose hair which nature itself curls into waves; the close-kept glance remains concentered within itself, and hides away love's treasures and her own. The sweet color of roses in that fair face is mingled and sprinkled amid ivory: but on the mouth whence issues her amorous breath, alone and simply reddens the rose.)

Clearly the temptress has been reading her *petrarchisti*, or so we are led to assume, for while Armida is represented in Petrarchan terms, she seems *self-consciously* informed by the tradition. Despite her downcast eyes, the key to a woman's honor, she is fully aware; her appearance is remarkable for its seeming passivity, the lack of subjectivity characteristic of the blazon. This woman is designed to be gazed upon.

Not surprisingly, this self-aware passivity is most developed in the description of the breasts. In the *Dialogo delle belle donne*, where any potential Eros is dissipated by elencation, broken down through the fragmentation of the body, the breasts are distinguished by their sensuousness, by the motion and even eroticism lacking in most of the treatises and the tradition. Consider the enticing qualities of the breasts described by Firenzuola, as the "bel petto" rises up to greet the eye:

Un petto è bello, il quale, oltre alla sua latitudine, la quale è suo precipuo ornamento, è sì carnoso, che sospetto d'osso non apparisce; e dolcemente rilevandosi dalle estreme parti, viene in modo crescendo, che l'occhio a fatica se ne accorge; con un color candidissimo macchiato di rose, dove le fresche e saltanti mammelle, movendosi all'in sù, come mal vaghe di star sempre oppresse, e ristrette tralle vestimenta, mostrando di voler uscire di prigione, s'alzino con una acerbezza e con rigorosità, che sforza gli occhi altrui a porvisi sù, perch'elle non fuggano. (p. 89)

(That chest is beautiful which, apart from its breadth (which is its foremost/ chief ornament) is so fleshy that no suspicion of bone appears; and sweetly revealing itself from its furthermost parts, rises up as if it were growing, so that the eye becomes gradually aware of it. [The chest should be] of an extreme whiteness stained with roses, where the fresh and leaping breasts, moving upward as if unwilling to remain forever oppressed and restrained by clothing, demonstrating their desire to leave their prison, raise themselves with a sharpness/tenderness and a rigorousness which forces the eyes of others upward, so that the breasts cannot escape.)

Firenzuola's description of the chest displays the fragmentation which we have seen is central to the blazon tradition: indeed, the reader is asked to imagine breasts which may or may not have a head above them! Yet these breasts are complicit in their objectification: even as they struggle to escape from their oppressive garments in a gesture of exhibitionism, their "acerbezza" forces the eye to follow and restrain them. The word "acerbezza" is telling, for it signifies not only sharpness, but unripeness or even tenderness: this is the delicate and desirable flesh of a nubile young woman, a meaning that is made more explicit when we turn to the description of Armida's chest with its half-hidden "mamme acerbe e crude."

Looking at those breasts, we see that the lack of personal pronouns conventional in Italian reemphasizes the objectification and fragmentation of such representation. Yet, as in the passage from Firenzuola's *Dialogo*, the "bel petto" is complicitous; the first word of stanza 31 is "mostra," "display."

> Mostra il bel petto le sue nevi ignude,
> onde il foco d'Amor si nutre e desta.
> Parte appar de la mamme acerbe e crude,
> parte altrui ne ricopre invida vesta:
> invida, ma s'a gli occhi il varco chiude,
> l'amoroso pensier già non arresta,
> chè non ben pago di bellezza esterna
> ne gli occulti secreti anco s'interna.
>
> Come per acqua o per cristallo intero
> trapassa il raggio, e no 'l divide o parte,
> per entro il chiuso manto osa il pensiero
> sì penetrar la vietata parte;
> poscia al desio le narra e le descrive
> e ne fa le sue fiamme in lui più vive. (IV.31–2)

(The beautiful chest displays its naked snows, where the fire of love is nourished and aroused. Part appears of the tender and unripe breasts, another part is covered by an envious dress; envious, but if the passage is closed to the eyes, the amorous thought is not arrested, for, being unsatisfied with the external beauty, it insinuates itself into the hidden secrets as well.

As a ray of sunlight passes through water or crystal, leaving it whole without dividing it or parting it, so the thought dares to enter her gathered mantle to penetrate the forbidden region; there it expatiates, there it contemplates the truth of so many marvels, each by each, then to desire it narrates and describes them and makes thereby [desire's] flames more vivid.)

Armida's breasts, half-hidden by an envious dress, are teasingly sensual. Unlike those of the *Dialogo*, they are static, caught between the spectator and Armida's own rivalrous dress. Partially concealed is partially revealed, and far more alluring than either naked or dressed, for it implies an ambivalent innocence, and an invitation to exploration. In a sense, Armida's sensuality comes from the crusaders themselves, for although her appearance extends the promise of greater delights, it depends on the activation of the viewer's imagination. The incomplete vision of the voluptuous woman places the reader in an analogous position to the beholder within the poem: for each, the link between the eyes and the imagination encourages an amplifying and close reading of the restricted image.

Despite their oppressive imprisonment, the "fresh and leaping" breasts of Firenzuola's *donna* are seductive without inviting sexual violence. Even as they seek to escape, the breasts exert their own power by forcing the eye to follow. In contrast, Tasso's description of the crusaders' wandering minds – their ostensible amorousness notwithstanding – is disturbingly violent. In her lying tale of familial betrayal, Armida presents herself as a "damsel in distress" in need of the masculine protection and defense of Goffredo's men. Yet the passage I have cited, with its emphasis on the mental penetration of her "occulti secreti" ("occult secrets") and "vietata parte" ("forbidden part"), suggests that the lure Armida offers is an invitation to rape: "l'amoroso pensier già non arresta ... ne gli occulti secreti anco s'interna ... entro il chiuso manto osa il pensiero sì penetrar ne la vietata parte." Her seeming passivity as her chest displays itself, her partial exposure to view, encourages violation as the *pensiero* "narra," narrates her forbidden parts, rejoins the body parts of the dialogue into a narrative of desire.

Armida's assumed demeanor engenders fiction in the mind of the beholder. Just as in the description of Armida's dress, the line between reader and spectator is very thin, so, too, is the line between Armida and the poet. Armida is conflated with the poet as she opens herself up for display. The threat of the temptress – her means of manipulation – is presented as a conscious version of the figure of woman as male projection, as object, rather than subject. If, as Vickers has argued, Shakespeare's *Lucrece* underlines the consequences of "being female matter for male oratory," Armida presents herself *as* that matter, deployed by the manly "canuto senno" of the poet beneath the blonde hair which is his poetry.

Armida's appearance in canto IV recalls not only the *petrarchismo* which has been the basis of my discussion, but more specifically the sensuous female half-length images which emerged in Venice in the first half of the sixteenth century. Such paintings – for example, Titian's *Flora* (fig. 25), now in the Uffizi – are, as Christine Junkerman has noted, distinguished by "a mode of dishabille ... a side-long glance and, most importantly, an active but ambiguous gesture."[11] Such images deliberately appeal to "the viewer-consumer who in sixteenth-century Italy is, as a matter of course and with only rare exceptions, a male" (p. 19). These women are not naked. Rather, the Eros for the viewer is heightened by the controlled and limited access: "the sitter is located between the extremes of her unadorned flesh, her nakedness, and the necessarily artful, carefully crafted image that constitutes her public self, her presented beauty" (p. 20). Through the use of the drape (as we see in

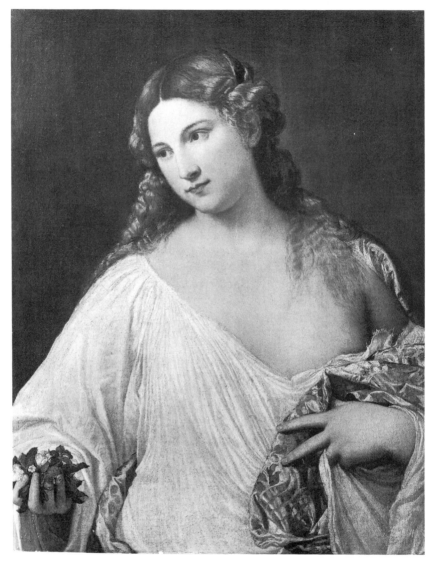

25 Titian, *Flora*

figure 25, for example), the women appear to be caught mid-gesture, in an ambiguous and tantalizing movement that is either covering or revealing. Such a gesture, Junkerman suggests, is designed to engage the viewer; "the objects they display, or may soon withhold, are their own

bodies" (p. 38). And the figure's characteristic glance highlights this engagement with the viewer, "meets the viewer's gaze with a veiled or side-long look, from under partly closed lids ... These sidelong glances suggest mobility and combine with the gestures to create a subtle yet unmistakable level of *active* engagement with the viewer and a seductiveness which is not part of standard portraiture" (p. 38). The significance of such a glance in the sixteenth century should not be underestimated. Junkerman cites numerous conduct books of the period to emphasize the presumed brazenness and thus potential danger implicit in a woman's direct glance. To avoid impropriety, a woman should keep her eyes cast down; the author of *El costume de le* [*sic*] *donne* (Brescia, 1536), for example, views the lady's eyes as the key to her honor as well as the cause of wars and the destruction of Troy (p. 40).

As in those images, Armida's hair is loose, but not completely unbound. Her body is encased in an envious dress which both conceals and reveals. Perhaps even more crucial is her glance, as Armida feigns a modesty designed to control all around her: her eyes are cast down, with the *sprezzatura* that defines her self-presentation as "casta vergine": "'i lumi volse / che dolcemente atto modesto inchina" (IV.34). Yet, as Firenzuola notes, "vaghezza," allure tempered by modesty, is one of the indefinable qualities which enhances a woman's beauty: "Lodata e vagheggiata passa Armida / fra le cupide turbe, e *se n'avede*" ("praised and yearned for Armida goes through the desiring crowds, and *is conscious of it*," (IV.34); my emphasis) with the awareness that characterizes the paintings examined by Junkerman.

Like Armida, whose beautiful breast *mostra*, "displays," its snows, the women in these paintings give an impression of control. Discussing Giorgione's *Laura*, Junkerman argues that: "The significant fiction Giorgione proposes ... is that it is the woman who controls what the viewer sees. It is this innovation that was taken up by Venetian artists in the first quarter of the sixteenth century" (p. 96). According to the art historian, these images raise important issues regarding female power, for while they suggest autonomy, they are in fact controlled. "The woman becomes a seductress, using her power not to act independently, but to act as assigned, to attract men" (p. 96). This is the power of Armida, ordered by her uncle to seduce the Christian army. Armida is a means of manipulation, herself manipulated to control relations between men. Thus she is a property, like these images of seemingly powerful women which were literally possessed by men, and designed for the pleasure of a male spectator.

Petrarch and idolatry

Not only is Armida's appearance described in Petrarchan terminology, her "performance" at the Christian camp is recounted using Petrarch's own poetry. As Armida arrives at the camp to tell the romance tale of betrayal designed to create dissension in the army, her status as idol is reconfirmed: Goffredo's younger brother, Eustazio, addresses her as "Vergine bella" (IV, 37.5), the opening of *Canzoniere* 366, the *Canzone alla Vergine*, directed not to Laura but to Mary. More significantly, when Goffredo finally agrees to allow the princess ten warriors, her triumph is described with lines taken verbatim from two different canzoni:

> Serenò allora i nubilosi rai
> Armida, e sì ridente apparve fuore
> ch'innamorò di sue bellezze il cielo,
> asciugandosi gli occhi col bel velo. (IV.84.5–8)

(Then, clearing the clouds from her sunbeams, Armida shone forth so laughingly that she made the sky fall in love with her beauties, drying her eyes with her beautiful veil.)

As other critics have noted, Tasso here combines, quite shockingly, a second quotation from the prayer to the Virgin with the moment in *Canzoniere* 126 ("Chiare, fresche, e dolci acque") when Petrarch imagines Laura weeping over his death and "asciugandosi gli occhi col bel velo." Walter Stephens, for example, shows how the temptress' transformation from a counterfeit to a legitimate Virgin Mary is effected primarily through Petrarchan echoes and allusions which underscore Laura's "pseudo-Mariological powers"; Armida is "a new, sinister Laura conscious of and willing to manipulate the pseudo-religious sexual fantasies that men spin about her."[12] But in noting that "Armida's art literalizes the Medusan power of Laura's eyes" (*ibid.*), the critic does not explicitly address how Armida's *conscious* manipulation distinguishes her from Laura, and the significance of that distinction.

To understand Armida in the context of this double Petrarchan allusion, we should first examine briefly Laura's role in the *Canzoniere*. As we have seen, Laura is most notable for her absence, for the fragmentation of the Lady by which the poet creates himself. Several critics interpret this literal re-creation of the absent (and uninterested) Laura through the text as a kind of fetishism or idolatry: Petrarch writes in hope of "re-membering the lost body, of effecting an inverse incarnation: her flesh made word"; thereby he creates a "poetics of

idolatry," in which the circular referentiality of Laura and the laurel – Laura/*lauro* – is an attempt to achieve literary autonomy by circumventing any outside referent. But the *Canzoniere* is not, in fact, devoid of referentiality. Indeed, Laura's role as idol is made apparent in part through her implicit comparison with Dante's Beatrice, sent by the Virgin Mary to rescue her admirer from the *selva oscura* and to lead him to salvation.[13]

Armida, too, is an idol, a reified sign. In canto XVI, the knights Guido and Ubaldo discover the hero Rinaldo, unarmed, lying in the temptress' lap in the midst of a labyrinthine and lush garden, his head in her "soft lap," and "his face turned to her face." Without his armor, the knight loses his identity; he becomes Armida's vassal, completely enslaved by her conquering beauty. Yet this seemingly consuming passion is dangerously narcissistic, for each loves the other only as his own reflection:

> Dal fianco de l'amante (estranio arnese)
> un cristallo pendea lucido e netto ...
> ella del vetro a sè fa specchio, ed egli
> gli occhi di lei sereni a sè fa spegli.
> L'uno di servitù, l'altra d'impero
> si gloria, ella in sè stessa ed egli in lei.　　　　(XVI.18–21)

(From the side of the lover [strange armor] hangs a clear crystal ... She looks at her reflection in a glass, while he looks at his own reflection in her serene eyes. He glories in his servitude, and she in her empire; she glories in herself, and he in her.)

Armida's mirror serves both as a symbol of her sexual power, and of Rinaldo's lack thereof, for it replaces his sword at Rinaldo's side. Most significantly, however, Rinaldo's explictly effeminate servitude is a rejection of his political obligations as a member of the Crusade led by Goffredo. Duty to Goffredo is more importantly duty to God, who in the first canto has sent the archangel Gabriel to appoint the captain sole leader of the Christian army. In this religious context, although fornication is a sin, the threat that Armida poses to the hero is not her sexuality *per se*; rather, the temptress is an idol who causes Rinaldo to abandon his crusade and thus his God. The Creator has been *displaced* by his creation, as the temptress gazes at her own reflected glory in an idolatrous inversion of the divinely ordained sexual hierarchy which is part of the religious order. In the first letter of the Corinthians, Paul explains that the man "is the image and glory of God; but woman is the glory of man" (11:7). Armida's narcissistic gaze, however, allows her to see only herself, just as Rinaldo, looking at his own reflection in her eyes, sees himself not in God's, but in Armida's, image.

But if Armida, like Laura, is an idol, of whose creation is she? Her origin is different from Laura's. Let us return to Vickers' description of Laura as the poetic speaker's "reverse incarnation." To incarnate is, of course, to make flesh. But the most universal understanding of this word is in relation to the Christ event, when, as the Nicene Creed declares, God came down from Heaven, became incarnate in the Virgin Mary, and was made man by the power of the Holy Spirit. Petrarch's poet thus imitates and renders idolatrous the "self-referentiality" of the Incarnation: the circular referentiality of the pun Laura/*lauro* makes Laura the false mediatrix – the passive vessel – by which the creator of words, rather than the Word, is ultimately the final referent of his creation. The male poet, created in God's image, attempts to create himself. But Armida, "performing" for the crusaders, goes beyond the passive role of the mediatrix to usurp this masculine incarnational power for herself: whereas the Petrarchan lover creates himself through his own desire, Armida creates herself through the soldiers' desire, so that they perceive in her all that the Petrarchan poet finds in Laura. She is both creation and creator, the uninterested Laura and the "author" of the Petrarchan lover-like projections of Goffredo's men.

Armida's role as poet is emphasized repeatedly in canto IV. Like a poet, the beautiful temptress "compone e finge" ("composes and feigns," IV.91), and her "finto dolor da molti elice / lagrime vere" ("feigned grief elicits true tears from many," 77). Her long and detailed tale recalls the lie told by the Angelica of the *Innamorato*. Indeed, Armida's charge from Idraote to "far manto del ver alla menzogna" is the inverse of the apology of Tasso's narrator to his Muse if he has "ornamented the truth" ("s'intesso fregi al ver"), a narrator who emphasizes the importance of "sweetening the truth" (1.2–4). In this context, then, the citation from "Chiare, fresche, et dolci acque" is particularly telling: Armida, "asciugandosi gli occhi col bel velo" literally acts out the Petrarchan lover's fantasy of Laura. Yet Armida's appearance also makes poets of *others*: as we have seen, the description is designed to inspire the narrating eyes and thoughts of both spectator and reader, drawing attention to, even as it detracts from, its own status as poetic construct.

But Petrarch's canzone has a more specific significance for Tasso's temptress in its evocation of a vision of Laura not merely as a false mediatrix, but as a literally idolized Beatrice. Indeed, the line used to describe Armida presents here with Beatrice's two important physical attributes: her eyes and her veil. The image of Laura, surrounded by a cloud of flowers, quite clearly derives from that of Beatrice in the

Earthly Paradise of *Purgatorio* 30, and just as clearly demonstrates its own distance from the earlier poetic moment. Whereas Beatrice appears always as mediatrix, Petrarch's reference to Laura as "colei che sola a me par donna" ("she who alone appeared to me as *donna*") – as Vickers suggests, "surely a play on [Dante's] 'donna m'apparve'" (30, 32)[14] – underlines her role as his unique and self-created image, replacing all others.

Viewed in this context, Tasso's pairing of lines from *Canzoniere* 126 and the *Canzone alla Vergine* becomes an important locus from which to explore Armida's ambivalent beauty, as well as her problematic conversion. Obviously, to describe Armida with words written in praise of the Virgin reemphasizes the temptress' idolatrous aspect. She presents herself as an idol, in opposition to the Christian goal of the Crusade. But *Canzoniere* 366 raises important questions about the relationship between poetry and idolatry in general. The *Canzone alla Vergine* is the poetic I's *apologia* and moment of conversion (the sincerity of that conversion need not concern us here), in which he renounces the idolatrous love for Laura which has been the theme of the preceding 365 poems. He also rejects the language of those poems: the final poem is a virtual *florilegium* of the Virgin's traditional encomia. Perhaps equally significant is the reference to the Virgin as "vera beatrice," with a lower-case "b" emphasizing the relationship between Laura and Dante's beloved, and, as Freccero has suggested, the problem of reification inherent in all poetry.[15] Yet 366, as the final poem, argues, perhaps, for the necessity of that reification as well: once the idolatry is revealed, what kind of poetry is possible?

Through his imitation of Petrarch, Tasso's use of the thematics of idolatry underscores the threat Armida poses not only to the crusaders, but to the Christian in general. As we have seen, the two Petrarchan allusions suggest the dangers posed by false images, by the ambiguous nature of female beauty. In her conversion, Tasso reunites Armida's appearance with what for him is its proper meaning, and her words, "Ecco ancilla tua," imitate the moment of Incarnation. Yet the evocation of the *Canzone alla Vergine* in canto IV reminds us of the ambiguity of all signs, which may be misread, or misappropriated, just as the statue of the Virgin has been usurped by the pagans in the *Gerusalemme*'s canto II, two cantos before Armida's entrance in the poem, in an episode which further illuminates the problematic of Armida's equivocal allure.

Sofronia and Armida: the temptress as mediatrix

At the beginning of canto II, the king of Jerusalem is persuaded by his advisor, Ismeno, to steal a sacred image of the Virgin, and to place it in his mosque. The next day, however, the beautiful image is missing, and no one – not even the narrator – can say what has occurred. As in the miracles ascribed to the image of the Virgin in the saints' lives popular in Tasso's day, the misused *imago* disappears. But one veiled virgin replaces another; hearing that the king plans to kill all the Christians of Jerusalem unless the image is returned, the beautiful virgin Sofronia, chastely veiled yet fearless, goes before the king, claiming to have burned the icon:

> Vergine era fra lor di già matura
> verginità, d'alti pensieri e regi,
> d'alta beltà; ma sua beltà non cura,
> o tanto sol quant'onestà se 'n fregi.
> È il suo pregio maggior che tra le mura
> d'angusta casa asconde is suoi gran pregi,
> e de' vagheggiatori ella s'invola
> a le lodi, a gli sguardi, inculta e sola. (II.14)

(A virgin there was among the Christians of mature maidenhood, of lofty and queenly thoughts, of lofty beauty; but she cares nothing for her beauty or only so far as it may adorn her chastity. Her greatest merit is that she hides her great merits within the walls of a narrow house, and steals away from the praises and glances of admirers alone and unsolicited.)

Like the traditional virgin martyr, Sofronia exceeds all others in both beauty and chastity. The apparent oxymoron of "matura verginità" recalls the Virgin Mother, in Dante's words' "alta e umile più che creatura," the queen of heaven exalted not only by her beauty, but by her humble chastity. This second virgin, hiding her merits within narrow walls, evokes the traditional iconography of the Virgin as *Hortus conclusus* and Tower of Ivory – both tropes originating in the intensely erotic *Song of Songs*. And her threatened martyrdom likewise evokes the displaced sexuality of the traditional saint's life.

Once she claims to have stolen the sacred icon, the "beautiful lady is seized, and cruelly the king condemns her to be burned to death."

> Già 'l velo e 'l casto manto a lei rapito,
> stringon le molli braccia aspre ritorte.
> Ella si tace, e in lei non sbigottito,
> ma pur commosso alquanto è il petto forte;
> e smarrisce il bel volto in un colore
> che non è pallidezza, ma candore. (II.26)

(Already she is ravished of her veil and chaste mantle, and her soft arms are restrained by cruel bonds. She is quiet, and not dismayed but rather moved, however courageous is her breast; and her beautiful face is blanched by a color which is not pallor, but candor.)

Like Saint Agnes, who in the words of St. Ambrose "went to the place of execution more cheerfully than others go to their wedding,"[16] Sofronia is unmoved as she faces the torture with a masculine courage that paradoxically brings her closer to the ideal of feminine beauty. And Tasso adds a romantic twist to this standard saint's life: Sofronia is beloved not of Christ, but rather the Christian Olindo, who has long admired the beautiful virgin from afar, and now seeks to die in her place by claiming that *he* is the culprit.

Since neither will renounce the claim of having stolen the image, both are condemned to death. Their presence together on the funeral pyre is a literalization and parody of the flames of love, to which Olindo draws attention. In an early draft of the poem, the couple was even placed on the flames tied face to face. Concerned that the scene might be overly erotic, Tasso changed their position to "tergo al tergo, e 'l volto ascoso al volto" (II.32). Olindo's words, however, do not seem to recognize this shift:

> Questo è quel foco ch'io credea ch'i cori
> ne dovesse infiammar d'eguali ardori?
> Del rogo consorte, se del letto non fui ...
> Oh fortunati miei dolci martiri!
> s'impetrarò che giunto seno a seno
> l'anima mia ne la tua bocca io spiri! (II.33, 35)

(Is this then the tie with which I hoped to be coupled with you as my lifetime companion? Is this the fire which I believed must enflame our hearts with equal ardor? I'll be your consort in the fire, if I never was in bed ... Oh, how fortunate my martyrdom, if, joined breast to breast, I can breathe my soul into your mouth!)

Later in the poem, the effeminacy of the hero Rinaldo will be emphasized as he lies in Armida's lap, sighing so profoundly as she kisses him that he appears to have achieved Olindo's goal: "ei sospirar si sente / profondo sì che pensi: Or l'alma fugge / e 'n lei trapassa peregrina" (XVI.19). But Sofronia, unlike the pagan Armida, corrects her recumbent admirer, providing an explication of true Christian martyrdom: "fian dolci i tormenti, / e lieto aspira a la superna sede ... Mira 'l ciel" ("Let the torments be sweet, and joyously aspire to the high seat ... Look at

the heavens," II.36). Whereas Armida, a beautiful idol, distracts Rinaldo from his duty to God and captain, Sofronia is a true mediatrix who literally redirects Olindo's gaze toward heaven.

The couple are saved, however, by the thoroughly ambiguous Clorinda, the *donna guerriera* who dresses as a male, a Christian raised as a pagan, a white daughter born to a black mother. The saint's life is given a fairy tale ending: Sofronia becomes the bride not of Christ, but of Olindo, as they "vanno dal rogo alle nozze" ("go from the pyre to their wedding").[17] Yet despite this happily-ever-after conclusion, the seemingly uplifting episode is not without ambivalence. On the funeral pyre, as in the life of Saint Agnes, the female has greater spiritual strength than the male. Sofronia is not afraid to sacrifice herself for her people, and Clorinda is more moved by the woman's silence than the man's weeping. Although the virgin martyr's body is penetrated and exposed, that one crucial orifice – the origin of her power – remains intact. Virginity, like the temptress' beauty, is a source of strength, and thus, paradoxically, a potential threat to the Christian order in which the man is to be "the head of the woman, as Christ is of the Church" (Ephesians 5:22). Like Armida's conversion at the end of the *Gerusalemme*, Sofronia's marriage to Olindo restores the Christian status quo, reaffirming the traditional male–female hierarchy which her "masculine strength" had threatened to undermine. But more importantly for our discussion, the episode is remarkable for the heightened sensuality, even Eros, of the passive and violated beauty.

The underlying uneasiness evoked by the representation of Sofronia becomes stronger when we compare this episode with Armida's appearance before the Christian army, discussed above: the temptress, walking through the crowd with her eyes cast down, is a hyperbolic version of Sofronia. The similarity between the two episodes is apparent from the start: in canto II, the evil and formerly Christian Ismeno, who confounds the mysteries of both his old and new religions, encourages the king to steal the image, while canto IV begins with a diabolic conference, in which the powers of the underworld decided to use the beautiful *maga* Armida as an idol, a false image, to lure Goffredo's soldiers from the Crusade. Sofronia's beauty and purity attracted Olindo to offer himself in her place in the fire. Eustazio, in turn, is compared to a butterfly, attracted to the spendor of Armida's "beltà divina" (IV.34). But the comparison is more complex than these one-to-one correspondences might suggest: while Sofronia is self-inspired, Armida is a middle figure, appointed by her uncle and Plutone. In Sofronia's narrative, one veiled virgin replaces another; here, Armida is

literally a false mediatrix, an "idol made of a sweet glance and a smile" (IV.17).

Like Armida two cantos later, Sofronia, walking alone through the crowd in Jerusalem, is neither revealed nor exposed:

> La vergine tra il vulgo uscì soletta,
> *non coprì sue bellezze, e non l'espose,*
> raccolse gli occhi, andò nel vel ristretta,
> con ischive maniere e generose.
> Non sai ben dir s'adorna o se negletta,
> se caso od arte il bel volto compose.
> Di natura, d'Amor, de' cieli amici
> le negligenze sue sona artifici, (II.18; my emphasis)

(The virgin walked through the crowd alone. She didn't cover her beauty, nor expose it. Her eyes cast down, she went confined by her veil, with retiring and generous manners. You do not know whether to say her beautiful face is arranged by adornment or neglect, by chance or by art. Her negligence is the artifice of nature, of love, of the benificent heavens.)

Sofronia, neither covering nor exposing herself with a genuine yet ambiguous artlessness, provides a perfect example of the "allure tempered by modesty" which in Armida is a form of *sprezzatura*. In contrast, Armida's demeanor, unlike Sofronia's, engenders a fiction in the mind of her beholder. Feigning modesty, the temptress presents herself as the Petrarchan *vergine bella* of a dialogue. Yet Sofronia's authentic *vaghezza* attracts *vagheggiatori* as well, although she "steals away from their glances." The reader, too, becomes an admirer, for the direct second-person address in canto II ("Non sai ben dir") activates the imagination, forcing a visualization which will be recalled when we encounter Armida's far more sinister breasts in their envious dress. In the passage from canto IV cited earlier, the reader is not addressed directly, but the description underscores the violent and violating role of the spectator's imagination. Whereas Sofronia is ravished of her mantle, in Armida's parodic version the mantle invites us to ravish the woman.

The issues already so troubling to the standard saint's life – sexual violence and gender-transgression – are placed in high relief by canto IV's hyperbole. What is artlessness in Sofronia's narrative becomes, in Armida's version, the product of conscious manipulation: the displaced sexual violation of the saint is transposed into a thinly veiled invitation to seduction. Similarly, the virility of the virgin martyr – Sofronia's "petto forte" which can sustain as much as any man's (II.26) – is, in canto IV, cast in a more sinister light. As we have seen, Armida, too, is a virgin, whose "biondi capelli" and "tenere sembianze" hide the

"white-haired judgment and manly heart" which transform her into an idol. Most significantly, both women are liars. The narrator apostrophizes Sofronia's falsehood in canto II:

> Magnanima menzogna! or quand'è il vero
> sì bello che si possa a te preporre. (IV.24)

(Oh, noble lie, now when is the truth so beautiful that it can be preferred to you!)

Sofronia's noble lie is yet another aspect of the fundamental ambivalence central to both episodes. Whereas Sofronia goes in her veil and cloak to tell her lie, Armida uses shame as a veil, and cloaks her lie in truth, for her order is to "Vela il soverchio ardir con la vergogna / e fa manto del vero a la menzogna." Tasso simultaneously insists upon the necessity of distinguishing between good and evil women, between Sofronia and Armida, and yet blurs that crucial distinction.[18]

The same image, according to Gabriel Paleotti's *Discorso alle imagini sacre e profane* (Bologna, 1582), can produce quite opposite effects. He gives the example of the metal serpent created by Moses:

> Ad alcuni era in loco di cosa sacra e misteriosa, ed altri in vece d'idolo. Onde noi veggiamo che ancor del succo de' fiori nati alla campagna le api ne fanno soave mele e le aragni ne cavano mortifero veneno.[19]

(To some it was a sacred and mysterious thing, and to others, an idol. Whence we see again that from the same wildflowers the bees produce sweet honey, and the spiders extract mortal venom.)

As we have seen, Armida's beauty, while outstanding, is not unusual: the temptress is recognizable both as the idealized beauty of sixteenth-century *petrarchismo* and as a parodic version of exquisite feminine martyrdom; and like the wildflowers described by Paleotti, a woman's beauty, in and of itself, is innocent. But although beauty can be made to serve the good – as we find with a mediatrix such as Dante's Beatrice, or even Sofronia – it can just as easily mislead by suggesting a corresponding inner goodness which it lacks. Out of the same Petrarchan fabric, Tasso creates both a mediatrix and an idol, for while the beauty of Sofronia, imitating a virgin martyr and the Virgin Mary, points not to reification but to heaven, Armida, two cantos later, transforms the saving power of Sofronia's appearance and uses that same force to corrupt ends, just as Petrarch employs Marian and Dantesque elements to create his own unique idol. In the poem's visually ambiguous

universe, how can we distinguish between what leads to grace, and what to idolatry? Armida's beauty is dangerous because it is generic.

Armida is a temptress with a specific role in the poem, but she also suggests the danger of the feminine, the threat of sensuality which, retrospectively, contaminates even Sofronia. Indeed, the tropes which evoke the Virgin Mary in the description of Tasso's virgin are, as we have seen, from the highly sensual *Song of Songs*. Armida, too, is a false Virgin Mary who implicates the reader in her idolatry, for the image used to describe the narrating eye, the *pensiero* which, like "a ray of sunlight through water or crystal," penetrates to forbidden regions while leaving the clothing intact, is a familiar simile in late medieval and early Renaissance poetry to convey the equally penetrating yet uncorrupting power of the Holy Spirit as it enters the passive Virgin of the Annunciation.[20]

The description of Armida, the subject of this essay, is finally recalled just prior to the temptress' climactic conversion: when Armida faints in the arms of Rinaldo, "like a flower cut in half," he supports her, loosening her clothes at the neck to reveal her "bel seno":

> ... ei la sostenne:
> Le fe' d'un braccio al bel fianco colonna;
> E 'n tanto al sen le rallentò la gonna.
>
> E 'l bel volto e 'l bel seno a la meschina
> Bagnò d'alcuna lagrima pietosa.
> Qual a pioggia d'argento e matutina
> Si rabbellisce scolarita rosa;
> Ta' ella, rivenendo, alzò la china
> Faccia, del non suo pianto or lagrimosa.　　　　(xx.128–9)

(He supports her; he makes of his arm a column for her beautiful flank, and simultaneously loosens her gown at the neck. And the beautiful face and the beautiful breast of the poor girl he bathes with piteous tears. As the silver rain of morning rebeautifies the faded rose, so Armida, coming to, raises her inclined face, wet with tears not her own.)

In this revised version of her first appearance in the poem Armida truly is passive, just as eight stanzas later the Incarnation will be evoked without idolatry as the temptress replaces her "canuto senno" with Rinaldo's: "Ecco ancilla tua: d'essa a tuo senno / dispon." But the final recall of Petrarch's "Chiare, fresche, et dolci acque" ("le fe' d'un braccio al bel fianco colonna") serves to reemphasize the ambiguity of her appearance and its significance. By her conversion, Armida abruptly becomes a Magdalene-like figure of redeemed sensuality, and is granted a teleology more congruent with the ideological values of the poem. Yet

the use of *petrarchismo* and Petrarch's own poetry, combined with the ambivalence of Sofronia's martyrdom, suggests that the threat of her beauty remains.

Notes

Much of the research for this essay was facilitated by a Fulbright Dissertation Research Grant to Italy. An earlier version was presented at the University of California, Santa Cruz, in January 1990. I wish to thank Sharon James, Carl Ipsen, Ray Shattenkirk, James Turner, Louise George Clubb, and the members of Paul Alpers' dissertation group at the University of California, Berkeley, for their thoughtful comments on earlier drafts, and Carlo Chiarenza, Renata Guarini, and the *Commissione per gli scambi culturali tra l'Italia e gli Stati Uniti* for their support and friendship in Rome.

1 XX.136. All citations are from *Gerusalemme liberata*, ed. Anna Maria Carini (Milan, 1961). All translations are mine.
2 Walter Stephens, "Saint Paul Among the Amazons: Gender and Authority in *Gerusalemme liberata*," in Kevin Brownlee and Walter Stephens, eds., *Discourses of Authority of Medieval and Renaissance Literature* (Hanover, N.H., and London; 1989), pp. 169–202, and my "The Threat of Sensuality: Tasso's Temptress and the Counter-Reformation," Dissertation, University of California, Berkeley, 1991, ch. 3.
3 "Introduction" to his translation of the *Canzoniere* (Cambridge, Mass., and London, 1976), p. 4.
4 See *Cento giuochi liberali ed d'ingegno ritrovato da M. Innocentio Ringhieri* (1580), cited in Elizabeth Cropper, "On Beautiful Women, Parmigianino, Petrarchismo, and the Vernacular Style," *Art Bulletin* 58 (September, 1976), 385.
5 Giuseppe Zonta, ed., *Trattati del Cinquecento sulla donna* (Bari, 1913), p. 230. Future references to this edition will be found in the text.
6 "Beautiful Women," 376.
7 *S/Z*, trans. Richard Miller (New York, 1974), pp. 113–14.
8 *Opere* (Milan, 1802), vol. 1, pp. 50, 69, 48. Firenzuola goes beyond Luigini's classifications to describe not only the individual parts of the perfect beauty, but also her almost indefinable qualities: *leggiadria, grazia, vaghezza, venustà, aria,* and *maestà*, terms used over and over by the poets to describe their beloveds and which here, reduced to classifications, are as fragmenting and ultimately meaningless as any of the lady's other stock attributes.
9 "'The Blazon of Sweet Beauty's Best': Shakespeare's *Lucrece*," in Patricia Parker and Geoffrey Harman, eds., *Shakespeare and the Question of Theory* (New York and London, 1985), p. 96.
10 "The Traffic in Women: Notes Toward a Political Economy of Sex," in Rayna Reiter, ed., *Toward an Anthropology of Women* (New York, 1975), pp. 157–210.
11 "*Bellissima Donna*: An Interdisciplinary Study of Venetian Sensuous Half-Length Images of the Early Sixteenth Century," Dissertation, University of

California, Berkeley, 1988, abstract, pp. 2–3. Further references will be found in the text.

12 "Saint Paul among the Amazons," p. 196.

13 Nancy J. Vickers, "Diana Described: Scattered Woman and Scattered Rhyme," *Critical Inquiry* 8 (Winter, 1981), 275; John Freccero, "The Fig Tree and the Laurel," in Patricia Parker and David Quint, eds., *Literary Theory/Renaissance Tests* (Baltimore, 1986), pp. 28–9.

14 "Re-membering Dante: Petrarch's *Chiare, fresche, et dolci acque*," *MLN* 96 (1981), 6.

15 "Medusa: The Letter and the Spirit," in *Dante: The Poetics of Conversion*, ed. Rachel Jacoff (Cambridge, Mass., and London, 1986), p. 132.

16 *De Virginitate*, cited in Alban Butler, *Lives of the ... Saints*, vol. 1 (London, 1756), p. 118.

17 11.42. In fact the ending is not so happy; the two are expelled from Jerusalem, for the king is afraid they are too popular with Christians and Muslims alike.

18 A comparable point is made in Sergio Zatti, *L'uniforme cristiano e il multiforme pagano* (Milan, 1983), p. 43. But it is important to note (as Zatti does not) that while Armida is described in elaborate Petrarchan detail, Sofronia's physical attributes are not given; Zatti's ascribing to the two women the same "identifying stilemes" comes partly from his own imagination.

19 In Paola Barocchi, ed., *Trattati d'arte del Cinquecento: fra manierismo e controriforma* (Bari, 1961), vol. 11, p. 172.

20 For example, the jongleur Rutebeuf wrote in the thirteenth century: "Just as the sun enters and passes back through a windowpane without piercing it, so were you *virgo intacta* when God ... made you his mother and lady." Cited in Marina Warner, *Alone of All Her Sex* (New York, 1976), p. 44.

The ladies' man and the age of Elizabeth

JULIET FLEMING

In this essay I shall be investigating the practice of directing a text specifically or "only" to women: the male author of such a work I call a "ladies' man," and the work itself a "ladies' text." Since there are few textual projects either so efficiently engaged with the masculine or so completely indifferent to issues of gender that they can finally resist the production of a special version of themselves for women, the ladies' text is found in the widest variety of contexts and forms, from the Tsenerene (the woman's bible) to the male-authored columns of women's magazines. My concern, however, is with its appearance and deployment in early modern England.

I have argued elsewhere that in formal terms the ladies' text is *supplemental* and fated to address itself to the issue of inadequacy, both in the thing it supplements and in itself.[1] Functionally, we may say it is *appropriative* (embodying and activating a variety of strategies in the struggle to control and deploy cultural meanings), and, more specifically, *transvestite* (for while its author associates himself with a set of attributes that he represents as "female," that association rarely changes or compromises the real and symbolic allegiances he possesses as a male). Fourth, and importantly, the ladies' text is always represented as a trifle or a toy. Marked as being beside the point, the Elizabethan ladies' text may be standing in for that category of the aesthetic that is still absent in early modern England. Fifth, and finally, in representing itself as something women "ask for," the ladies' text both displays and attempts to enact the potential violence that women have to fear from the helpful male. If these qualities are not unique to the ladies' text, if, on the contrary, they attach to a large proportion of English Renaissance texts, I take this as an indication of the extraordinary prevalence and power of the ladies' text in early modern England, where, in consequence, few contemporary works could avoid entering into some sort

of negotiation, either with an implied female reader, or with the ladies' text itself as the dominant type of fiction.

Having received an important early impulse from Boccaccio, who suggested that the *Decameron* "should much rather be offered to the charming ladies than to the men," the English ladies' text developed a tradition within which a wide variety of social, political, and literary tasks were done.[2] This essay concentrates on a discrete set of literary texts published in England between 1576 and 1581, where they comprise an important though unremarked subgroup of what Richard Helgerson has called prodigal fiction: that is, fiction in which the hero, who dissipates his youth before coming to a mature repentance, is understood to be a surrogate for the prodigal author himself.[3] The most famous of the prodigal fictions is John Lyly's two-part romance *Euphues* (London 1579 and 1581), an enormous contemporary success that spawned a school of imitators. Its second volume, *Euphues and his England* (London, 1581), is prefaced by a letter "To the Ladies and Gentlewoemen of England" in which the author ostentatiously consults the pleasure of women:

> It resteth Ladies, that you take the paines to read it, but at such times, as you spend playing with your little Dogges, and yet will not I pinch you of that pastime, for I am content that your Dogges lye in your lappes, so *Euphues* may be in your hands, that when you shall be wearie in reading of the one, you may be ready to sport with the other: or handle him as you doe your Junckets, that when you can eate no more, you tye some in your napkin for children, for if you be filled with the first part, put the second in your pockets for your wayting Maydes: *Euphues* had rather lye shut in a Ladyes casket, th[a]n open in a Schollers studie. (pp. 8–9)

The notoriety enjoyed by *Euphues and his England*, and its enduring critical reputation as a ladies' text, may be attributed in part to this preface. For here the functional characteristics of the ladies' text are summarized within the register of the erotic and made to display the curious logic whereby male self-effacement becomes its own opposite in the company of women. Asking to be remaindered in a lady's pocket, or allowed rather to "lye shut in a ladyes casket, th[a]n open in a Schollers studie," *Euphues* asserts a specific erotic power – the power to give and take pleasure while remaining itself intact – that is easily assimilable to a dream of male potency. The text's repeated request to be "handled" by its female reader has for its expected result not diminishment, but self-enlargement, and the status of Lyly's text is here that of the ostensibly modest "nothing" that Hamlet considered "a fair thought to lie between maid's legs."

George Pettie and the "Pallas in Place"

Anticipating *Euphues* both in the style for which Lyly became famous and in its overt interpellation of a female audience is a collection of short stories published "for the service of [the] noble sex" in 1576. Entitled *A Petite Pallace of Pettie his Pleasure*, the collection is witness to the prodigal phase of its author George Pettie. For it was Pettie's first book, and he followed it three years later with a translation of Stefano Guazzo's *Civile Conversation* which claims to have been intended as reparation or "countervailance" for the former "trifling woorke." For a courtesy book, the *Civile Conversation* is marked by an uncourtly distrust of women. Thus the misogynist persona of Guazzo deliberately misunderstands the phrase that Pettie translates as the "conversation" of women, and offers an apology designed only to administer a further insult: "Pardon mee I pray you, I mistooke you then, for as soone as you began to speake of the Conversation of women: I thought you had ment of those with whom men trie their manhood withall in amorous incounters." According to the *Oxford English Dictionary*, in 1581 the possible meanings of "conversation" included "dwelling," "dwelling with or among", social dealings, the exchange of words and ideas, and the act of sex. The word which now covers these meanings, "intercourse," did not develop its sexual connotation until the eighteenth century; in 1581 it could mean "dwelling with," social dealings, the exchange of words and ideas, and trade communication between countries. (This last meaning is one which Pettie evokes when he expounds his word "conversation" in the phrase "those which make profession of the life, ought to learne the meanes how to traficke together.") "Conversation" and "intercourse" have, then, a complex and mutually involved history; here it is enough to note that in the sixteenth and seventeenth centuries "conversation" was carrying a sexual freight that it later handed over to the word "intercourse." Undertaking to "set down orders" for the conversation of women, Guazzo activates its sexual possibilities so thoroughly that even Annibal, his enlightened interlocutor, is finally unable to distinguish reverential from sexual service to women, and consequently advises the virtuous man to use their company "not for ordinary foode, but for some extraordinary preservative, or some exquisite restorative."

Coming from an author whose only other book is ostentatiously dedicated to the pleasure of women, the misogyny of the *Civile Conversation* may seem surprising. But this apparent contradiction in

Pettie's career is also the enabling logic of the prodigal text itself, which regularly requires its female readers to attend to the story of their own rejection. It is a logic that is also recapitulated in the sequence of tales that makes up *A Petite Pallace*, for as the collection progresses the tales become increasingly misogynist, culminating in the story of Alexius, who grows sick of his wife and decides to save his soul by abjuring women for ever.

A Petite Pallace opens with a prefatory letter "To the gentle Gentlewomen Readers" which I reproduce in its entirety as it can be taken as the credo of the Elizabethan ladies' man.[4]

> Gentle Readers, who by my will I would have onely Gentlewomen, and therefore to you I direct my woordes. May it please you to understand, that the great desire I have to procure your delight, hath caused me somwhat to transgresse the boundes of faithfull freindship: for having with great earnestnesse obtained of my very freinde Master *George Pettie* the copie of certaine Histories by himself upon his owne and certaine of his friends private occasions drawn into discourses, I saw sutch wittie and pithie pleasantnes contayned in them, that I thought I could not any way do greater pleasure or better service to your noble sexe, then to publish them in print, to your common profit and pleasure. And though I am sure hereby to incur his displeasure, for that he willed me in any wise to keepe them secret: yet if it please you thankfully to accept my goodwill, I force the lesse of his ill wil. For to speake my fancy without feiginge, I care not to displease twentie men, to please one woman: for the friendship amongst men, it is to be counted but colde kindnesse, in respect of the fervent affection betweene men and women: and our nature, is rather to doate of women, then to love men. And yet it lyeth in your powers so to thinke of his doings, and to yeeld him sutch courteous consideration for the same, that hee shal have more cause to thank me, th[a]n think ill of my faithless dealing towards him. Which if your courtesies shall perfourme, you shall increase my dutie towardes you, and his good will towardes mee: you shall make me shew my will and him his skill another time to pleasure you: you shall bind both of us to remain ready at your commaundments. For mine owne part, I can challenge no part of praise or thankes for this woorke, for that I have taken no paines therein, neither by addinge Argument, Note, or any thinge, but even have set them forth as they were sent mee: only have I christened them with the name of a *Pallace of Pleasure*. I dare not compare this woorke with the former Pallaces of Pleasure, because comparisons are odious, and because they contain Histories, translated out of grave authors & learned writers: and this containeth discourses, devised by a greene youthfull capacitie, and reported in a manner *ex temporare*, as I my selfe for divers of them am able to testifie. I dare not commende them to you because I am partiall, I dare dedicate them to you Gentlewomen, because you are curteous. And that you may the better understande the drift of these devises, I have caused the letter also which my freinde sent mee with this woorke, to be set downe to your sight. Thus commending mine owne faithles

enterprise, and my freinds fruitfull labour and learning, to your corteous protection, I wish you all, beuty with bounty, and cumlinesse with curtesie, from my lodging in Fleetstreete.

Yours readily to command. R. B. (pp. 3–4)

Although Hazlitt began the tantalizing tradition of regarding "R.B." as the reversed initials of Barnaby Rich (a type of signature for which there is precedent), they are more likely the false mark of Pettie himself. The authorial disavowal which they represent is fairly common in English Renaissance texts, which were regularly "stolen" and "leaked" to the press as a means of avoiding the class derogation that attached to the stigma of "public" print. In this case, however, the use of gender to structure the meaning of the theft is particularly overt; for as it passes from manuscript to print, the text is drawn from a private, enclosed, male domain and displayed in the "common" place of female pleasure.[5] This shift in allegiance from men to women – "I care not to displease twentie men, to please one woman" – and the fracture of male friendship that it implies, is done in the interest of an aggressive heterosexuality: "our nature, is rather to doate of women, then to love men." Looking away from traditional sources of authority (the approval of other men, the example of "grave authors") the ladies' text finds – or at least pretends to seek – its ratification in the approval of women. It thus displays, while making strange, the curious but commonplace logic (a logic we have seen differently inflected in the Lyly preface) whereby the company of women may "make" a man.[6]

R.B.'s letter is followed by one which is supposed to have accompanied the manuscript when Pettie confided it to his treacherous friend. In it "G.P." reminds R.B. that the tales are transcripts of stories "which you have heard mee in sundrie companies at sundrye times report," remarking "yf any seem worse now th[a]n th[e]n, you must impute it to this, that perchaunce there was some *Pallace* in place which furthered my invention. For I am in this point of *Ovid* his opinion, that *Si cupiat sponte disertus erit.*" That is, desire makes a man spontaneously eloquent, or, as I am suggesting here, it is the real or imagined presence of women that enables men to speak. In the printed text Pettie recreates the conditions that gave birth to his story through the deliberately provoking *debats d'amour* with which he ends each tale (summaries which wildly distort the narrative before inviting the reader to judge between male and female interests), and through continual asides to his female audience:[7]

> But here hee aptly ended his talke upon her mouth, and they entred into sutch privy conference, their lips being joyned most closely together, that I can not

report the meaning of it unto you, but if it please one of you to leane
hitherward a litle I will shew you the manner of it. (p. 137)

This may be considered the story's primal scene, the point at which the
narrative is born and to which it must tend. It is a moment whose reali-
zation is endlessly repeated in Pettie's text; making overt that interpel-
lation of the female reader on which the ladies' text – or, for that matter,
all fiction interested to constitute itself as heterosexual – may depend. To
put it another way, it may be the imagined presence of a female reader
that enables early English fiction to appear to be manly enough.[8]

The third and final prefatory letter to *A Petite Pallace*, from "the
Printer to all Readers of this Booke," raises the issue of its potential
sexual impropriety when it reveals that the text as we have it has been
bowdlerized (or as he puts it, "gelded"), and that the best bits – those
that would bring most pleasure – may be missing. Contradicting G.P.,
who had actually asked that the text remain private "for that divers
discourses touch neerly divers of my neere freindes," the printer
pretends to believe that this discretion was motivated by G.P.'s opinion
that the work was "too wanton" to be printed as it was. "Consideryng
that in matters of pleasure, the Prynter may sooner offende in printyng
to[o] mutch, th[a]n in publishynge to[o] litle" he continues, "I have
applyed myselfe to the contrary, hopynge that how mutch the lesse I
have printed, reservynge the discourse perfect, so mutch the lesse I
shalbe blamed for the deede." The tension that clouds this passage
centers on the ticklish subject of the amount that it is appropriate to
"geld": the printer has tried both not to take too much, and not to leave
anything behind. In brief, and to ignore the printer's own anxious
identification with the text (his own fear of punishment), the book that
results is figured as a eunuch. Residue of an act of sexual violence, the
text is now both harmless and improper: fit to keep women in sexual
readiness for other men.

A Petite Pallace may be further explicated in terms of Freud's dirty
joke. For Freud suggests that, while in polite society dirty jokes are not
told in the presence of women, they have their social and historical
origin in male attempts to seduce women with suggestive talk. Where
the actual seduction fails, the suggestive talk itself becomes all-
important, especially if it can be conducted in the presence of "another
man ... a third person" – a scenario which may be so gratifying that it
can function (and in Freud's time and class *only* functioned) in the
absence of women. In her illuminating essay "Why Does Freud Giggle
When Women Leave the Room?", Jane Gallop summarizes Freud's
position as follows: "So the sexual joke which originates in a mythical

scene between a man and a woman, never takes place except between two men."⁹ Although *A Petite Pallace* is energetic in its interpellation of women, there are several significant lapses in the specificity of its female address. Thus G.P. claims that R.B. heard the stories when they were delivered aloud, implying that at least one man other than Pettie was present at their first performance; and the possibility that Pettie's narrative is still catering to, or being overheard by, men is occasionally raised within the body of the text.¹⁰ In the last story the narrator forgets himself so far as to address his closing admonitions to a male audience, – "You Gentlemen may learne hereby not to doate to[o] mutch of wives or women, but to use them as necessary evils" – before turning back to the ladies, "You Gentlewomen may also learne hereby, not to repose any permanent pleasure in practising with your husbands, but only to use their company as a solace." The covert movement through or beyond women to a male audience that stands behind them is a typical effect of the ladies' text, which thus enacts in the register of the literary that process of exchanging women as symbolic property between men which Gayle Rubin has shown to play a crucial role in the formation of a normative, heterosexual, patriarchal order.¹¹

The most telling rupture in Pettie's text – one which serves to underline the significance of its pretence to address an all-female group – occurs at the end of the tale of Scilla and Minos, when Scilla has failed to make Minos love her by presenting him with her father Nisus' "golden" hair. Having offered his usual idiosyncratic summary of the issues at stake, Pettie suddenly registers the pressure of an alien presence, an imagined "father" who constrains him to offer uncharacteristically unexceptionable advice: "But I am by this story chiefly to admonish you that you pull not of[f] your fathers haire that is, that you pul not their harts out of their bodies by casting your selves away in matching in marriage with those that are not meet for you." Briefly relieved of this presence, Pettie begins to offer a more subversive interpretation of events:

> But (Soveraigne) now your father is gone, I will give you more sound advice: I will admonishe you all not to pull of[f] your owne haire, that is not to bind your selves to the froward fansi of your politique parents, but to make your choice in marriage according to your own mindes: for over widowes you see Fathers have no preheminence of power touching their marriages: and the *Rodians* have this law, that onely the mothers have rule over the Daughters. But mum, *lupus in fabula*. I must (I say) admonish you ... (pp. 164–5)

The "father" and Pettie's official voice return together. Pettie's hurried warning, "*lupus in fabula*" – literally, "there is a wolf in the story," but

also, proverbially, "speak of the devil and he will appear" – signals the untimely intrusion of a male presence into the space of the story, where it inhibits the tongue that had been inspired by the presence of women only. At the heterosexual interior of *A Petite Pallace* we are then witnessing the originary moment of Freud's dirty joke, offered by a man to a woman. The sudden penetration of the story space by another man represents an acknowledgment of the men who are waiting outside the narrative action of Pettie's ladies' text – waiting to have its performance recounted to them by Pettie himself. When its prefatory material is included *A Petite Pallace* recapitulates, in a particularly overt phylogenetic display, the evolution and subsequent social functioning of Freud's dirty joke – the telling of which, as Gallop points out, is finally in the interests of the homosocial bond. For while it begins life at the point of heterosexual encounter between Pettie and "some *Pallace* in place," the text which G. P. confides to his friend represents an encounter with women recollected in the tranquility of a manuscript exchange between men.

Thus G.P., confiding his stories to R. B., reminds him "only to use them to your owne private pleasure, and not to impart them to other[s]," and, more especially, to follow the example of his characters Pigmalion and Alexius in their right conversion to heterosexual celibacy. Of course, it is precisely G.P.'s trust in the alliance between himself, his male characters, and his friend R.B. – an alliance which creates a space where women are only a memory – that is dramatically fractured by R.B.'s treacherous decision to publish the text. By redirecting and returning the work to women, R.B. gives it a new status – that of a male discourse betrayed, a dirty joke overheard by the woman with whom it is intimately concerned, but for whose ears it was never intended. Floating the text on the open market is the equivalent of trying, once again, to arouse women with dirty talk – an activity which Freud says is confined to the "lower social levels" of polite society.

A Petite Pallace of Pettie his Pleasure demonstrates the ease with which discussion of the class anxieties attaching to print publication is displaced into the available register of gender. Fear of the class impropriety of printing a text may be disguised as a hesitation about doing it in front of women, and this fact alone could account for the prevalence of the ladies' text in early modern England. On the other hand, the interlock of the languages of print and gender could be read from its other end, so that "print anxiety" stands for a more generalized anxiety concerning the presence of women in the political and linguistic

communities of early modern England. Whatever its applications, the fact that the early English printed text is often structured as a dirty joke, exchanged between men across the evoked but absent figure of a woman, deserves closer attention than it has received, especially since it is something that many of the texts in question are themselves anxious to disclose.[12] For in its most overt form, such as that represented by the ostensible publication history of a *Petite Pallace*, the printer's decision to publish the text, and thus "return" it to women, at once reopens and restages the whole story of the transformation of the dirty joke in the printed text.

Barnaby Rich: self-multilation and the minor mode

A Petite Pallace of Pettie his Pleasure was a popular work. It went through six or seven editions between 1576 and 1616, and may be considered to have dictated many of the subsequent possibilities for the Elizabethan ladies' text. To turn to *Rich his Farewell to Militarie Profession* (1581) is to encounter a work which is at once closely modeled on and deeply resentful of *A Petite Pallace* and its "service" to women. It is the story of this resentment – which is also a story both of self-loathing and of political discontent – that I now trace.

In March 1582, following the suppression of Desmond's rebellion, Queen Elizabeth ordered the discharge of half her troops from Ireland. Among the newly unemployed was Barnaby Rich, who had been on active service there since 1573. Accompanied by Thomas Churchyard and Thomas North, Rich returned to England, where he found waiting for him the recently published book of romance tales which he had composed "in Ireland at a vacant tyme."[13] Entitled *Riche His Farewell to Militarie Profession: conteining verie pleasaunt discourses fit for a peaceable tyme. Gathered together for the onely delight of the courteous gentlewomen bothe of England and Irelande, For whose onely pleasure thei were collected together, And unto whom thei are directed and dedicated*, the book marks Rich's temporary abandonment of his professions of soldier and military theorist, since during the next three years he stayed in England writing and publishing romance. I suggest Rich's sudden concern for the pleasure of women, figured by his surprising turn to the writing of fiction, is deeply sarcastic, and represents an attack, first on a society that he considered to be dangerously effeminized, and then on his queen, whose prevaricating conduct in Ireland and in the international

marriage market seemed to be threatening England's military and imperial ambitions.

According to his biographers, Barnaby Rich (1542–1617) was a "major 'minor' Elizabethan." Living in the reigns of five English monarchs, he was noticed and rewarded by Elizabeth and James, and employed by both Francis Walsingham and William Cecil. He worked variously as a landlord, private adventurer, military theorist, government informer, Irish settler, and soldier in France, the Low Countries, and Ireland. He was also a prolific writer, who produced twenty-six books in forty-three years; was accorded honorable mention by both Harvey and Nashe; enjoyed the patronage of Ambrose Dudley, Christopher Hatton, Robert Cecil, Thomas Middleton, and Oliver St. John; and counted among his friends Lodowick Bryskett, Thomas Churchyard, George Gascoigne, Barnaby Googe, Lodowick Lloyd, Thomas Lodge, Thomas Lupton, and Thomas North. Although the importance of Rich's status as a "minor" Elizabethan appears from this to be a product of the company he kept, the role actually seems to have been constructed for Rich first by himself, and then by his own contemporaries (including and especially Shakespeare), who read, reread, and borrowed from his work, made jokes about his name, represented him on stage, and, in 1616, at the height of Elizabethan nostalgia, honoured him as "the eldest Captain of the Kingdom."[14]

There is an antiquarian tradition that privileges the "minor" as that which is firmly centerd in its own age, undeflected by the impulse of genius, and consequently of great "representative" value.[15] But as a literary practice or effect the minor mode is more usually understood in terms of a failure of will or aspiration, such as that which Ovid represents as the source of his decision to write love poetry: "When in this workes first verse I trode aloft / Love slacked my Muse, and made my numbers soft" (*Amores* I. ii 17–18).[16] Actually, as Ovid's deliberately inadequate excuse is designed to demonstrate, the minor mode is not something which happens to those who lack the energy or skill to avoid it, but is instead a role constructed, chosen, and publicized, often in outspoken opposition to the laureate ambitions of contemporary works. In their study of Kafka, Gilles Deleuze and Félix Guattari identified the three characteristics of a revalorized, deliberative minor literature as "the deterritorialisation of language, the connection of the individual to a political immediacy, and the collective assemblage of enunciation."[17] Rich's oeuvre, which was compiled in close temporal and spatial proximity to that of Spenser, itself fulfills the criteria of a heroically chosen minority. But while Rich's choice of mode was

politically motivated, designed to protest what he saw as the literary and sociopolitical tendencies of Elizabeth's reign, the *Farewell to Militarie Profession* articulates this protest not through refusal and isolation, but through a decision to ally itself with that which it most despised. Embodying in one person the centrism of an antiquarian specimen and the impulses of revolutionary dissent, and dramatizing his possession of both, it may have been Rich who first taught the English that the minor poet is at once victim of, and typical of, his age. It is then of great importance that for Rich, as for several of his contemporaries, the minor mode was first articulated in self-conscious response to the sexual politics of their moment.

The deliberate and spectacular waste of talent, which I shall argue is represented in *Rich his Farewell* in its strongest form, is a common theme and strategy among the writers of Elizabethan England. Helgerson isolates the 1570s and 1580s as a period in which a rising generation of university-trained humanists turned to fiction-writing while they waited for more serious employment (*Prodigals*, ch. 1). The works they produced – Helgerson's prodigal fictions – thematize their authors' frustrations by dramatizing their own triviality: just as the prodigal hero turns away from the sage advice of his humanist counselors to spend his time in the company of women, so the prodigal writer self-consciously wastes his time and talents producing fiction.

Helgerson understands prodigal fiction to represent an act of defiance on the part of its author towards the serious humanist father typified by Burleigh, and towards a patriarchal culture that, in the second half of Elizabeth's reign, was making no room for its youngest sons. However, since a prodigal son always expects and hopes for a final reconciliation with his father, and in the prodigal narratives achieves this at last precisely by turning away from women, prodigal fiction is in the end structured by rejection not of men, but of women, and the female audience to which it is often addressed has thus been invited to assist at the spectacle of its own discountenancing. In the case of *Rich his Farewell to Militarie Profession* – Rich's own prodigal text – this discountenancing is particularly pointed, and marks a rejection not of the father, but of the mother, Elizabeth.

In constructing his scandalous gesture, Rich was able to draw on the latent possibilities of the court text; for having been designed to display their authors' fitness for political office, such texts inevitably remain as witness to the waste of talent which they themselves represent. In the "epilogue at the court" to *A most excellent comedie of Alexander, Diogenes, and Campaspe*, played before Elizabeth on Twelfth Night

1584, Lyly described the radical contingency of the court text, whose worth is entirely dependent on Elizabeth's opinion: "As yet we cannot tell what we should tearme our labours, yron or bullyon, only it belongeth to your majestie to make them fit either for the forg or the mint, currant by the stampe, or countefeit by the anvill." Sole arbiter of worth, it is Elizabeth's opinion that creates both value and dross, and moulds her courtiers "like these torches waxe" into doves or vultures, roses or nettles. Consequently it is only her failure to ratify a court text – by exchanging it for some more tangible currency – that is responsible for the creation of the textual trifle or "toye." Lyly's policy of blaming the reader for the status of a work, which remains more or less latent in the text of *Alexander and Campaspe*, comprises the overt theme of Rich's *Farewell*. And there, in a half-hearted attempt to avoid naming his monarch, Rich makes an abstract female audience stand surrogate for a reader who he feels really *is* to blame for the tales of state corruption that he has to tell.

Rich began his writing career while in Ireland with the publication in 1574 of *A Right Pleasant Dialogue, between Mercury and an English Soldier*, which he dedicated to Ambrose, earl of Warwick. He followed this in 1578 with his *Allarme to England, foreshewing what perilles are procured, where the people live without regarde of Martiall law, with a short discourse conteyning the decay of warlike discipline*, in which he accused England of having been corrupted by the excesses of peace, and warned the English that they ignored the condition and needs of their armies at their peril, for "where Mars is had in no accompt, no state may long endure." The *Allarme*, which is dedicated to Christopher Hatton, has a prefatory poem in which Thomas Churchyard displays his own distrust of the Elizabethan peace, and warns the men of England to follow the drum rather than the tabor, for that "music is not good / That makes men look like girls." Within the text, Rich elaborates the details of the vices bred by peace. He accuses England's merchants of sapping her natural resources through a selfish mercantilist practice that involves the "conveying away [of] commodities, and returning of incommodities, vaine trifles, which are not necessary for humane life, but only to maintaine women and children in pride, pomp, and vainglory." He summarizes the list of "newfangled" luxuries in language, food, and dress that are now being affected at court as reflecting the tastes and rising power of women: "To be short, in *England* Gentlemen have robbed our women of their mindes, and our Women have bereaved us of halfe our apparell." And finally, he suggests that England's devaluation of the military profession is balanced by an over-appreciation of

"Courtiers, Lawyers, or Lovers," a state of affairs that makes many men determine to become lovers too.

It is a marked characteristic of the *Allarme* that the wide variety of behaviors that it stigmatizes are easily reducible to that of service to, or "conversation" with, women; and it is consequently something of a shock to discover that, having published his plea that his countrymen turn from Venus to Mars, Rich himself suddenly turned from Mars to Venus, and spent the next four or five years in a prodigal hiatus, during which he published a poem in the *Paradise of Dainty Devices* (1580), his *Farewell to Militarie Profession*, and a two-volume romance, closely modeled on Lyly's *Euphues*, called *The Straunge and wonderfull adventures of Don Simonides, a gentilman Spaniarde: Conteinyng verie pleasaunte discourse: Gathered for the recreation as well of our noble young gentilmen, as our honourable courtly Ladies*. In 1585 Rich returned to military service in Ireland and to the production of military treatises, social satires, and anti-Irish tracts.[18] In 1592 he did publish one last romance, *The Adventures of Brusanus*, but since this claims in its title page to have been written in 1585, it leaves intact the sharp division between Rich's serious writing and the products of his "prodigal" period.

Rich means his turn from military theory to romance to appear deeply uncharacteristic – and therefore coerced. However, although it is his claim both in the *Allarme* and in the *Farewell* that he had intended to follow the former with a book of military theory, his decision to devote his attentions to Venus instead is not entirely unprepared. For in the *Allarme* Rich represented himself as writing in a country so entirely given over to "wanton" delights that mere self-interest should have prompted him to "frame some conceit according to the time, some pleasant discourse, some strange novell, some amorous historie, some farre fette or unknowen device: this might have purchased me credit: the Printer might have gayned by selling of my booke." *Rich his Farewell* and the two volumes that comprise *The Straunge and wonderfull adventures of Don Simonides* are designed, precisely, to be everything that the *Allarme* was not: the sort of "toys" which, "framed ... according to the time," would at the very least sell. From its bipartite structure to the life-experiences of its protagonist, *Don Simonides* is closely derived from *Euphues*, with Don Simonides himself retracing Euphues' route through Naples to Athens, where he meets his progenitor in person, before going on to London to look up Euphues' old friends. For the *Farewell*, Rich returned to Pettie, creating a collection of

short stories which, like *A Petite Pallace*, has three prefaces: one to women, one to men, and one from the printer to the reader.

It is in his second preface, addressed not to women but to "the noble Souldiers, bothe of Englande and Irelande," that Rich explains his sudden change of career:

> Then, seeyng the abuse of this present age is suche, that follies are better esteemed th[a]n matters of greater waight, I have stept on to the stage amongst the reste, contented to plaie a part, and have gathered together this small volume of histories, all treatyng (sir reverence of you) of love. (pp. 7–8)

The braketed phrase "(sir reverence of you)" has itself the complicated and unstable status that I am attributing the ladies' text. As an apologetic introduction to something which should not be said, the phrase both marks the co-optation of the author's voice to the exigiencies of the reality he describes, and introduces something that he knows will offend his audience. A single space inhabited at one and the same time by an insult and an apology, the phrase predictably generated two common but special meanings: that intended and used by Harington as a noun substantive in his disquisition on excrement, "A thing that I cannot name wel without save-reverence" (*Metamorphosis of Ajax*, London 1596); and that praise-insult of women which I am arguing was the intended effect of *Rich his Farewell*. A sufficient number of the *Oxford English Dictionary* entries under "sir reverence" deal with the improprieties of heterosexual conversation to imply that by 1590 that connotation had become proverbial, "Be it spoken with save the reverence of all women that are or were, save herself" (*Metamorphosis of Ajax*). It is this meaning which Rich's own text may have helped to popularize, for meshed in the double address of the dual preface, his own "sir reverence" asks pardon for mentioning the topic of love before men, and holds promise of the insult that his co-opted voice will offer to women.

The promised sequel to the *Allarme to Englande*, finally published in 1587 as *A Path-way to Militarie Practice*, was dedicated to Queen Elizabeth, and may have been instrumental in earning Rich the small state pension which he enjoyed sporadically from 1587 until his death. The question that concerns me here is why Rich felt in 1581 that a military treatise would not be "accoumpted of," and why he further-more decided to spend the next few years of his career in precisely the sort of literary activity that was clearly distasteful to him.

The *Farewell to Militarie Profession* is a collection of eight tales, three

of which were translated from Italian by Rich's friend L.B. (probably Lodowick Bryskett, who was with Rich in Ireland). The other five stories were "forged onely for delight" from a variety of sources by Rich himself. They "all treat of love," and announce themselves as having been "gathered together for the onely delight of" women. Like the other prodigal texts of which it is a close contemporary, and perhaps with more success than *A Petite Pallace*, the *Farewell* does pay close attention to the pleasures and concerns of women. This is partly because prodigal interests – the interests of younger sons as these are given limited expression before their inevitable repeal – often intersect with those of women, for both parties may stand to gain from a temporary disruption of the patriarchal status quo. Several of Rich's heroines brave the wrath of unsympathetic father figures, and like Valerya (Shakespeare's source for Viola) pledge to follow their lovers "without any regard to the obedience and duetie that I owe to my parents." They are often forced to leave their homes and, in the limited time granted them before their readmittance to the world of their fathers, they wander in disguise, facing dangers, initiating courtship, resisting unwelcome advances, adapting to new circumstances, and working to support themselves. Such freedom is of course circumscribed, contained within the logic of an impending restoration of patriarchal order, and in this careful regulation of disobedience the individual tales of the *Farewell* resemble those prodigal narratives which take men as their heroes, and channel their repentance back into the service of the order which they had temporarily disrupted.

Rich's text as a whole, however, is designed to rearrange and parody the elements of a typical prodigal repentance. In his prefatory address to his female readers, Rich inverts prodigal logic by representing the military service of his "harebrained youth" as his prodigal phase, and service to women as the pursuit of his wise maturity: "I see now it is lesse painfull to followe a fiddle in a gentlwoman's chamber, th[a]n to marche after a drumme in the feeld; and more sounde sleapyng under a silken canapie, cloase by a freend, then under a bushe in the open feelde, within a mile of our foe" (p. 3). Rich represents the decision to cater to the pleasure of women as the choice of a writer who intends to obey, rather than resist, the status quo. Rich borrowed this ironic inversion of the prodigal structure from Pettie's character Alexius, who was commanded by his father to take a wife:

> I see the foolishnesse of my Father (if it were possible there shulde be any in him) to bee far better than all my wisdom and learning. He only knoweth what is profitable, what is pleasant for mee. Hee knoweth and hee told mee, but I

would not then beeleeve hym, that the marryed lyfe is the only life ...
Therefore now farewell *Minerva*, welcome *Venus*, farewell *Aristotle*, welcome
Ovid, farewell *Muses*, welcome maydens, farewell learning, welcome Ladies.

(p. 258)

In having Alexius' father blandly *advise* his son to turn to the company
of women, Pettie makes explicit that social dynamic according to which
the prodigal writer was forced into the service of frivolity by the failure
of the older generation to understand his qualifications.[19]

The pretence of being forced against one's will to write of love was a
common strategy among the Augustan poets, where it both disguises
and figures resistance to a state ideology that required the production of
epic. Thus what Ovid represents at the beginning of the *Amores* as his
unwilling annexation by Cupid, and his direction of book 3 of *The Art
of Love* specifically to women, are decisive acts that mark his refusal to
become an apologist for the state. However, the "Petrarchanization" of
Elizabethan court politics, which made it at least appear that political
preferment and power were dependent on the courtier's ability to wield
the discourses of courtly love, changed and reorganized the various
ways in which a writer could articulate his distance from the official
ideologies of the court.[20] So where Ovid represents himself as having
been compelled to write love poetry by a disobedient Cupid, who
forced him into a frivolity he knows to be subversive, Rich turns to love
in order to "fitte the tyme the better" – that is, to conform to the temper
of his age and the exigencies of a female-headed court.

Rich himself was careful to dramatize the reluctance with which he
chose love over war. The decay of warlike discipline, and the promotion
to office of "fools and sottes ... more fitte to waite in gentlewoman's
chambers, th[a]n to be made captaines, or leaders in the warres," is a
common and important theme in his stories, where it serves as a
constant reminder that Rich's own presence in a gentlewoman's
chamber is not something freely chosen. Like Pettie before him, Rich
constructs his text as an ongoing flirtation between himself and his
female readers. Emphasizing and elaborating the risqué elements that he
found in his sources, Rich explores the possible improprieties of his
own situation as narrator. The women's preface begins by wishing
female readers "all thynges thei should have appertainyng to their
honour, estimation, and all other their honest delights," and thereby
raises the spectre of those "dishonest delights" which it suggests women
also want. Going on to list the rewards that the ladies' man may – and
will – expect, the preface reveals that they correspond to precisely such
"dishonest delights":

> Now contrary to bee of Venus bande, there is pleasure, sporte, joye, solace, mirthe, peace, quiet rests, daintie fare, with a thousand other delites, suche as I cannot rehearse; and a man, havyng served but a reasonable tyme, maie sometymes take a taste at his mistress lippes for his better recompence. (p. 4)

Finally, after more lightly erotic banter, the preface finishes with the ambiguous adieu around which Rich's fame was to crystallize: "wishyng to you all what your selves do like best of, I humbly take my leave, Yours in the waie of honestie, Barnabe Riche." Suggesting that the service of honest Rich dishonours its recipient, this phrase enjoyed extraordinary celebrity, appearing not only in two plays, *Have With You to Saffron Walden* (1596) and *The Weakest Goeth to the Wall* (1600), but also as the code signature of the government spy Michael Moody. As Rich himself remarked in 1606 with some nostalgia: "This olde protestation, Yours, in the waie of honestie ... everie Gull was wont to have it at his tongue's end." The popularity of Rich's unimpressive pun indicates a widespread appreciation of the slipperiness of his text, a slipperiness whose particular function is to ensure that the text will compromize the female audience it serves.

Rich's fifth story, which undertakes to debate "whether a man were better to be married to a wise harlot, or to a foolish overthwart and brawling woman," contains an episode which represents in miniature the carefully constructed ambivalence which I am ascribing to the collection as a whole. It begins by requesting its readers not to take offence, since it was written "onely to make you merrie" and is "such as you maie very well permit," raising once again the question of the propriety of the text and of the female audience that will receive it. The tale concerns the promiscuous Mistress Dorothie, whose repudiation of one of her lovers caused him to write a letter, "whiche ... he left unpointed of purpose, because that in the reading of it it might be poincted two waies, and made to seeme either to her praise or dispraise." The alleged ambivalence of this unpunctuated letter is immediately stabilized by Rich, who transcribes it as he claims Dorothie herself read it – that is, to her serious dispraise. When Dorothie receives another letter from a second discarded lover, Rich represents himself as being reluctantly forced to repeat, and so once again to perpetrate, the abuse of women that it contains:

> Gentlewomen, I beseche you, forgive me my fault in the publishynge of this infamous letter: I promise you, I doe but signifie it accordynge to the copie which this unhappy Lawyer sent to Mistris Doritie; and when I had well considered the blasphemie that he had used against your sexe, I cutte my penne all to peeces wherewith I did copie it out, and if it had not been for the hurtyng

of myself, I promise you, I would have cutte and mangled my owne fingers, wherewith I held the penne while I was writyng of it: and trust me, accordyng to my skill, I could well have found it in my harte to have encountered hym with an answere in your defence, but then I was interrupted by an other, as you shall well perceive. (pp. 140–1)

The figure who leaps to the defence of women is a soldier, which adds a further turn to the complicated duplicity of Rich's address, but whereas Rich has just represented himself as powerless not to record the lawyer's misogynist dispraise, he suppresses most of the soldier's defence: "There were many other speeches pronounced by this souldiour in behaulf of women, whiche I have forgot to recite." By refusing to give equal time to the praise of women Rich lets the earlier insults stand, and thus produces a *concessio*, a text containing a deliberate confutation of its apparent thesis. This deliberate rhetorical instability, according to which any statement may turn into its opposite, may figure Renaissance anxiety concerning the instability of fictional representation; the difficulty, for example, of distinguishing between positive and negative exemplars, between a statement and a critique of an ideological position. However, the "unpointed" nature of Rich's *Farewell*, which results in a single space being filled at one and the same time with praise and dispraise of women, also fulfills another function, which is to display – and perhaps to hide – Rich's own ambivalence about his service to women.

"Why this it is, when men are rul'd by women": Ireland, France, and English discontent

I have argued that Rich's claim to have been prevented from writing or acting in a martial vein is characterized not by Ovidian playfulness, but by a deep bitterness; and that his extravagant obedience to the dictates of female pleasure is intended to witness and protest the waste of his own talents, and his experience of an idleness not chosen but enforced. The most immediate context for this bitterness is of course his own experience of unemployment. Elizabeth's discharge of Lord Grey's troops in the winter of 1581 had left three thousand soldiers stranded in Ireland without means of support, and many died before they could raise money for their passage home. In the *Allarme* Rich had already been outspokenly critical of what he considered to be the mistaken leniency with which Elizabeth conducted the plantation of Ireland: "Where otherwise, if her majestie pretended to rule by rigour over them, who

knoweth not that shee coulde sende suche a power over into *Irelande*, as in verie shorte space, would make quicke riddance of all that ragged rowt, which now so vexeth and molesteth the countrie." There, pretending to praise Elizabeth for her mercy, for the "wholesome" laws which she tried to instigate in her colony, and for the leniency of her lieutenant Sir Henry Sidney, Rich described the disastrous effects of such gentle policy, and strongly advised its abandonment: "There needes no longer circumstaunce nor better triall to prove, that courtesie in the Irish gouvernement, is not the readiest way to winne: but onely by severe justice without mercie, to him that shall offende: for this hope of forgivenesse is the onely marring of all together." Rich's view that Elizabeth's Irish policy was failing through her lack of resolution and her refusal to make any long-term commitment of funds was shared by several of his contemporaries, including Sidney, Spenser, and Raleigh, all of whom wrote on the topic. In 1595 Spenser, who had been secretary to Lord Grey, finished *A View of the Present State of Ireland.* Suppressed until 1633, the book followed Rich in deploring the waste of time, money, and men that had been spent without result in Ireland, and in advocating the deployment of a strong armed force, which properly administered would cost the queen no more than "in the last two years has been vainly expended."

Critical interpretation of book 2 of *The Faerie Queene* (1591, but which may have been composed while Spenser was in Ireland after 1579) has centred around the description of Guyon's violent destruction of the Bower of Bliss. But while Stephen Greenblatt reads the episode as symptomatic of Spenser's own attraction to and fear of Ireland itself, Patricia Parker has more recently suggested that the scene which spurs Guyon to his act of violence, the sight of Verdant asleep in Acrasia's lap, figures the male poet whose voice has been disempowered or emasculated by its service to a powerful queen:

> His warlike armes, the idle instruments
> Of sleeping praise, were hong upon a tree,
> And his brave shield, full of old moniments,
> Was fowly ra'st, that none the signes might see;
> Ne for them ne for honour cared hee,
> Ne ought, that did to his advauncement tend,
> But in lewd loves, and wastefull luxuree,
> His days, his goods, his bodie he did spend:
> O horrible enchantment, that him so did blend. (2.12.80)

Parker suggests that Verdant's arms, "the idle instruments ... hong upon a tree," signify not only the erasure of his martial honor, but also,

like the harps of psalm 137, hung on willows as a sign of the Israelites' resistance to a power that sought to co-opt their voices, the deliberate abandonment of his poetic gift.[21] The different readings of this stanza produced by Greenblatt and Parker could and should be assimilated one to the other; for the dangerous pleasures of colonialism and the emasculation of the Elizabethan poet-courtier are issues that are always intricately involved – both at the level of representation, where one signifying system is used to amplify, complicate, or stand in for the other, and in the historical facts of Elizabeth's conduct of Ireland and her other colonies.

After he has described his intended apostasy from the military profession, Rich continues his preface to the soldiers of England in familiar terms:

> But I trust I shall please gentlewomen, and that is all the gaine that I looke for, and herein I doe but followe the course of the worlde, for many, now adaies, goe about, by as great devise as may bee, how thei might become women theimselves ... And my good companions and fellowe souldiours, if you will followe myne advise, laie aside your weapons, hang up your armours by the walles, and learne an other while (for your better advauncements) to pipe, to feddle, to synge, to daunce, to lye, to forge, to flatter, to cary tales, to set ruffe, or do any thyng that your appetites beste serve unto, and that is better fittyng for the tyme. (p. 8)

Shakespeare borrowed from this preface for the opening speech of *Richard III*, a play which explores the corruption of male energies in a society "when men are rul'd by women," where "bruis'd arms" are "hung up for monuments," and where the warrior has learned to "caper nimbly in a lady's chamber / To the lascivious pleasing of a lute." Counselling the men of his generation to lay aside their weapons, Rich expresses the frustrations of a warrior class whose growing redundancy had been made more visible by the long summer of the Elizabethan peace; but since this redundancy is articulated in the context of a concern with female power, the abandoned weapon figures the sexual as well as the political disgrace of Rich and his contemporaries. This is to say that in *Farewell to Militarie Profession*, as in the works of many other Elizabethan poet-soldiers – including Bryskett, Lodge, Churchyard, Spenser, Markham, and Harrington, all of whom had served in Ireland, and Sidney, Gascoigne, Pettie, Gosson, and Lyly, who had served in the army elsewhere – the production of fiction is often represented as an enforced service to women, and therefore becomes a point at which the poet both fears and can express his fear of emasculation.

The years 1578–81, when Rich was putting the *Farewell* into its final

form, were further trying to the nerves of patriotic Englishmen. For having ignored over two decades the urgent request of commons and council that she find a husband, in 1578 the forty-five-year-old Elizabeth seemed to be seriously considering marriage to the duke of Alençon, a French Catholic more than twenty years her junior. In 1579, Jean Simier, "a most choice courtier exquisitely skilled in love toys, pleasant conceits and court dalliances," arrived at court with full powers to conclude the marriage contract. Elizabeth's council was divided over the match, though agreed that whatever she did must be done without further delay or prevarication. In the country at large, however, opposition to Alençon reached dangerous proportions. Two attempts to assassinate Simier were made during the summer of 1579, and the Spanish ambassador Mendoza noted that "the people in general seem to threaten a rebellion about it."[22] In August 1579 Philip Sidney, apparently deputed by Leicester's faction, wrote to the queen begging her not to "take to husband a frenchman and a papist ... the sonne of that Jezebel of our age [Catherine de Médicis]"; and in the same month John Stubbs published *The Discovery of a Gaping Gulf whereunto England is like to be swallowed by another French marriage, if the Lord forbid not the banes, by letting her Majestie see the sin and punishment therof.*[23] Having suggested that Alençon was a syphilitic opportunist, and Elizabeth surely barren, Stubbs claimed that the queen had allowed herself to be misled by corrupt counsel and her own feminine lusts; and he warned his contemporaries that

> In times past the noble Englishmen delighted rather to be seen in France in bright armour than in gay clothes and masking attire; they did choose rather to win and hold by manly force than by such effeminate means. Yea, when they did obtain anything by marriage, it was not that England was married to France, but by marrying France to England, wherein is great difference, if a man have the wit to mark of it ... But in this marriage our Queen is to be married, and both she and we poor souls are to be mastered, and which is worse, mistressed too.
>
> (pp. 57–8)

But for Stubbs the greatest danger facing the "mistressed" land was that from Rome, which he saw harboring in France and Ireland, dangerously invigorated by the presence of the Catholic claimant Mary Queen of Scots on English soil. Thus Stubbs persistently maintains that both the French proposal and the wars in Ireland are part of a Catholic plot: "we may see that it is a very French Popish wooing to send higher smooth-tongued Simiers to gloss and glaver and hold talk of marriage ... Is it possible for the breath of marriage well meant in England and war performed in Ireland to come out of one mouth?" (p. 80). The savagery

with which the pamphlet was suppressed is an indication of the extraordinary anxiety it aroused in the government: Stubbs, his printer Hugh Singleton, and William Page, who was convicted of distributing the work, were sentenced to lose their right hands under an act reactivated from the reign of Philip and Mary. Two lawyers who protested the illegality of the proceedings were removed from office; and the queen issued a proclamation to be read in guilds and churches refuting the book and ordering the surrender of all copies.

1579 is then a moment in which the dangers and frustrations of a Petrarchanized court politics must have been felt particularly acutely; ranged against it was a coalition of interests that variously represented themselves as masculine, English, anti-Catholic, and martial. Spenser, who spent these crucial months in London, seems to have lent his own voice to the cause, for both the November eclogue of *The Shepheardes Calendar* (1579), and "Mother Hubberd's Tale" (a complaint poem published and immediately suppressed in 1591) contain covert criticism of the French match, and may have been instrumental in Spenser's departure for Ireland early in 1580.[24] The fact that the coalition against the match found its headquarters-in-exile in Ireland, main arena for the English colonialist enterprise, may be taken both as a symptom of, and as a partial explanation for, the interpenetration of its interests not only with each other, but with an embryonic British imperialism in whose aftermath we still live.

It has been my contention that in displaying their fictions as products of a prodigal phase Elizabeth's poets intended their writings first to explore, and then to reject, female power and its most alarming consequences. This procedure is nowhere more visible than in the epilogue to Rich's *Farewell to Militarie Profession*. Marked "Conclusion," it tells the story of the devil's marriage to a woman called Mildred who wore out his patience with her increasing demands for "newe fashions." The devil finally sought refuge in Scotland, possessing the king of Scots himself until he was dislodged by Mildred's arrival at court. That James I recognized himself in this story is suggested by the fact that he made Rich replace the king of Scots with the emperor of the Turks in those editions of the *Farewell* published after his accession; Mildred is thus a figure for Elizabeth, before whose frivolous and thankless demands the subject flees to the court of her male successor.

Notes

1 *Ladies' Men, the Ladies' Text, and the English Renaissance* (London, forthcoming).

2 For an early, influential exploration of Boccaccio's female audience, see Giuseppe Mazzotta, *The World at Play in Boccaccio's Decameron* (Princeton, 1986).

3 *The Elizabethan Prodigals* (Berkeley, 1976).

4 Quotations are from Herbert Hartman, ed., *A Petite Pallace of Pettie his Pleasure* (London, 1938), to which page numbers refer.

5 My argument here is indebted to the work of Wendy Wall; see, for example, "Disclosures in Print: the 'Violent Enlargement' of the Renaissance Voyeuristic Text," *Studies in English Literature* 29 (1989), 35–59.

6 On the strangeness of the heterosexual bond and on the tremendous cultural work that is necessary to keep it even shakily in place, see Eve Kosofsky Sedgwick, *Between Men: English Literature and Male Homosocial Desire* (New York, 1985), especially pp. 1–20 and 28–48.

7 See, for example, Pettie's summary of "Curiatus and Horatia," which blames its heroine for the disasters of which she is the victim, and exonerates her murderer as having done her a favour (pp. 183–4). The sadistic frisson produced by such comments in the space between Pettie and his female audience is also present in those places where Pettie thanks his readers for their "quiet forbearance" of the insults that he has been forced to administer to them through the exigiencies of his narrative (see, for example, pp. 102, 257).

8 Pettie is, after all, able to imagine a different, more serious "discourse": one which, having nothing to prove, does not need to take its origin in the company of women: "And surely the consideration of this our miserable estate doth so resolve mee into sorrow, that if your presence did not sprinkle mee with some deawe of delight, I should hardly frame my wittes to procure you pleasure by any pleasant history, but rather continue a dolorous discourse of our calamity" (p. 42).

9 In Richard Feldstein and Henry Sussmann, eds., *Psychoanalysis and . . .* (New York, 1990). p. 49.

10 For example: "I have hytherto (Gentlewomen) done you some wronge in framinge my talke to the condition and capacitie of these Gentlemen, who, as you hard at dinner, helde so hotly that learning was not necessarie for a captaine" (p. 257).

11 "The Traffic in Women: Notes Toward a Political Economy of Sex," in Rayna Reiter, ed., *Toward an Anthropology of Women* (New York, 1975), pp. 157–210.

12 But see Nancy J. Vickers, "'The Blazon of Sweet Beauty's Best': Shakespeare's *Lucrece*," in Patricia Parker and Geoffrey Hartman, eds., *Shakespeare and the Question of Theory* (New York, 1985), pp. 95–115.

13 Shakespeare Society Reprint, in *Eight Novels . . . of the Reign of Queen Elizabeth* (London, 1846), sig. B1v. Rich dates his tales, "before the coming over of James FitzMorice," that is, before the hostilities that erupted in 1570. As we shall see, Rich cannot be trusted to give the correct date for the composition of his works. But even if this date is accurate, the subsequent arrangement of the tales in a

certain order, the addition of prefaces and an epilogue, and the decision to publish the whole, is, I am arguing, the work of the late seventies.

14 Thomas M. Cranfill and Dorothy Hart Bruce, *Barnaby Rich: A Short Biography* (Austin, 1953), p. ix, ch. I, and Rich's own *Faultes, Faultes and Nothing Else but Faultes*, ed. Melvin H. Wolf, (Gainesville, Fla, 1965), p. 47.

15 For example Carlo Ginzburg, *The Cheese and the Worms: The Cosmos of a Sixteenth Century Miller*, trans. John and Anne Tedeschi (Harmondsworth, 1982), p. xx.

16 Anon., *Ovid's Elegies* (London, 1635?). The original is as follows: "cum bene surrexit versu nova pagina primo / attenuat nervos proximus ille meos."

17 *Kafka: Towards a Minor Literature*, trans. Dana Polan (Minneapolis, 1986), p. 18.

18 One of Rich's later works, *The Excellency of good women. The honour and estimation that belongeth to them. The infallible markes whereby to know them* (London, 1613), has itself the marks of a ladies' text, for it is dedicated to James' daughter Elizabeth, and has a prefatory letter "To the Numberles Number of Honourable Ladies, vertuous Gentlewomen, and to all the rest of the mild, modest, and worthy sexe of womankinde." It is, however, like most conduct books, more *about* women than to or for them; and its writing could not be considered a prodigal act.

19 Alexius holds the fields of learning and literature to be the province and work of men, and feels that he must abjure them all *except Ovid* if he is to become a ladies' man: a distinction which once again speaks of the perceived existence of a mode that is at once frivolous, minor, and the province of women.

20 See Louis Montrose, "Eliza, Queene of shepheardes,' and the Pastoral of Power," in Arthur Kinney and Dan S. Collins, eds., *Renaissance Historicism: Selections from 'English Literary Renaissance'* (Amherst, 1987), pp. 34–63.

21 Greenblatt, *Renaissance Self-Fashioning from More to Shakespeare* (Chicago, 1980), ch. 4; Parker, *Literary Fat Ladies: Rhetoric, Gender, Property* (London, 1987), ch. 4.

22 William Camden, *The History of ... Princess Elizabeth* (London, 1630), book 2, p. 90; Alison Plowden, *Marriage With My Kingdom: The Courtships of Elizabeth I* (London, 1977), p. 187; *Calendar of State Papers, Spanish, 1568–1579* (London, 1894), p. 63.

23 Quoted in Lloyd E. Berry, ed., *John Stubb's "Gaping Gulf" with Letters and Other Relevent Documents* (Charlottesville, 1968), p. xlix. Subsequent quotations from Stubbs are from this edition.

24 See Berry, ed., *Stubbs's "Gaping Gulf"*, p. lv. *The Shepheardes Calendar* was printed in London by the same Hugh Singleton who risked so much to publish the *Gaping Gulf*. On the November eclogue as an expression of England's grief over the French match, see Paul E. MacLane, *Spenser's Shepheardes Calendar: A Study in Elizabethan Allegory* (Notre Dame, 1961), pp. 47–60.

Troping Utopia:
Donne's brief for lesbianism

JANEL MUELLER

૪✿

The corpus of Donne's love poetry contains one poem that is neither elegy, nor song, nor sonnet. This anomalous item is "Sapho to Philaenis," which appeared under the heading "Heroical Epistle" following the twenty-odd love elegies in Grierson's edition of the complete poetry in 1912 – a crucial event for the growth of Donne's twentieth-century reputation. Grierson's heading was a compact exercise of literary scholarship. The rhymed pentameter couplets, the epistolary genre, the feminine writer, the eroticized longing for an absent beloved all mark "Sapho to Philaenis" as Donne's sole entry in a once-modish category: vernacular imitations of Ovid's *Heroides*. Ovid's own "Sappho to Phaon" is the last of fifteen single verse epistles – that is, unanswered letters – which supply the bulk of his collection by working variations on a stock situation; in each, an abandoned female pleads with her faithless male lover to return to her. In the vogue of Renaissance Ovidianism, the *Heroides* – and particularly "Sappho to Phaon" – could exert a determining force; Joan DeJean, for example, finds the fiction of Sappho central to the emergence of both the epistolary and the historical novel in France.[1] The English response to the Ovidian Sappho, in contrast, takes the form of comedy or verse epistle – the genre that includes Donne's poem.[2]

In one respect, however, the English imitators do confirm DeJean's reading of the Renaissance Sappho (*Fictions of Sappho*, pp. 28–9). In her view, Sappho's personification in "Sappho to Phaon" registered as a masterly Ovidian *fait accompli* that legitimated a primal act of literary violence – the appropriation and assimilation of female erotic experience and expression by male authors. DeJean asserts also that the implied plot of this verse epistle did duty as erotic biography for the historical person and poet, Sappho, fixing her not only in her tragic situation, but also in a normatively heterosexual construction. I concede that these claims hold

for Renaissance English adapters of the Ovidian Sappho, but with one conspicuous exception, which is the subject of this essay: Donne in "Sapho to Philaenis." My aim is to make the exceptionality of Donne's poem at once evident and historically intelligible.

Right from the outset, Donne's intervention in the genre of *Heroides* imitations constructs the psychology of Sappho differently by reworking Ovid's epistolary opening. Donne frees his Sapho from the degrading Ovidian compulsion to name herself in the verse she is writing because it may not otherwise be recognized as hers. This Sapho lacks all such self-doubts. Engulfed in her memories and longing, she struggles with only an ordinary difficulty in personal letter-writing, a shaky start, from which she recovers with the resumptive construction, "Thou art so faire," and introduces the first of her two main subjects – her beloved's all-sufficiency – by the midpoint of line 15. Donne's ensuing revisions of Ovid show more markedly in the implied plot than in the representation of Sapho's psychology. Ovid's Sappho is an aging ex-lesbian crazed by the desertion of her boyfriend, Phaon the ferryman, whose lovemaking makes her renounce her past, and whose departure renders her suicidal. Donne's Sapho steps forward by degrees in her verse epistle to figure finally as an ardent, active lesbian in full experiential and emotional career. She declares outright against the inferior attractions of Phaon, a figure she firmly locates in her bygone past, while pronouncing Philaenis her love for all time in a panoply of tenses: "As thou, wast, art, and, oh, maist be ever" (line 26).[3] In "Sapho to Philaenis," one woman first confronts the trauma of separation from her beloved, whom the text gradually reveals to be another woman; she then passionately recounts for them both the erotic bliss they have experienced together. They are one another's ideal complement, two selves made one through the reciprocal identity of their knowing, desiring, and pleasuring. While Donne's Sapho is both transported with desire and separated from her Philaenis – the convention of a verse epistle could scarcely make sense otherwise – she looks forward steadily to the fullness of life and (re)union, not, as in Ovid, to a death that alone can vacate the devastation of a romantic, heterosexual betrayal.

Does any twentieth-century reader escape surprise at Donne's figuration of lesbian erotics in "Sapho to Philaenis" – and his positive figuration at that? This is, after all, the vaunted (or reviled) poet of "masculine perswasive force" ("Elegie: On his Mistris," line 3). Helen Gardner's reaction in her 1965 edition of Donne's love poetry was perhaps the most extreme. She removed "Sapho to Philaenis" from the roster of Donne's authentic works, although in so doing she defied the

evidence of the best manuscripts recorded in her own critical apparatus. Subsequent editors have restored "Sapho to Philaenis" to Donne's canon, printing it, as Grierson had, to follow the love elegies.[4] The editorial crisis met, the interpretive challenge remains. What was Donne doing, within a Renaissance literary context and network of associations, by figuring a utopian – by which I mean, an ideally satisfying – love as lesbianism? How may we best read his "Sapho to Philaenis"?

I propose to motivate and develop a constructive reading of "Sapho to Philaenis" despite the cross-winds of the present critical climate. While current methodologies being applied to Donne – moralizing humanism, psychobiography, deconstruction, feminism, and new historicism – are disparate enough in other ways, they tend toward reductivism by cutting Donne down to a size manageable within their own categories and procedures.[5] Against such maneuvers, certain passages in Donne's texts set up tough resistance – not just in the poetry, but in the prose tracts and sermons as well. I would describe these typically Donnean passages as commingled thought experiments and flights of fancy – in the Renaissance sense of fancy. Their dynamic is the trajectory of their subject's "what if" imaginings; it takes these imaginings to the utmost limit that desire will carry within language. And the generative source of verbalized desire in "Sapho to Philaenis" is the figure of Sappho herself, made concrete and hence available to Donne. He informs himself about her – specifically about her sexuality and her poetry – through any of a number of outlets in his Renaissance cultural inheritance. What he learns arouses his imagination, whatever does or does not occur in the imaginary of his unconscious. Donne bonds with Sappho across gender difference as a subject of otherwise unimagined or unimaginable possibility, both in the writing of celebratory lesbian poetry and, I think even more, in the ideality of what lesbian love comes to signify for him. In the course of this verse epistle, lesbianism transmutes to utopianism as a figuration of all-sufficient love in its economic, no less than its erotic, aspects. In Sappho's name Donne writes his way beyond the confines of a Renaissance social context by imagining a synthesis of love and friendship that she and her Philaenis alone seem to make possible.

Re-membering Sappho: doxography and citation in humanist scholarship

What prompted Donne's interest in Sappho? What knowledge of her poetry, what associations with her name can plausibly be ascribed to

him? As the vogue of *Heroides* imitations demonstrates, questions of interest and information are inseparable. Ovid's "Sappho to Phaon" provided Donne with an incentive for composing in (or against) this vein and with a source of putative knowledge about Sappho. DeJean has shown that the stock conception of Sappho among sixteenth-century writers was that of a poetic genius who gave consummate lyrical expression to intensely personal erotic experience (*Fictions of Sappho*, pp. 29–42). The core text for this conception was Sappho's celebrated four-stanza fragment in sapphics that anatomizes her lesbian longing in a charged situation where she triangulates with her beloved and a male rival. Because editorial titlings and numberings of her poems vary, I shall refer to this fragment as *Phainetai moi* (its opening words in the Greek). I also offer a prosaic but literal translation that will suffice at least for the purposes of this discussion:

> He seems to me equal to the gods, the someone who sits closely facing you, and listens to your sweet tones of speech, your pleasurable laughter, which make the heart in my rib-cage beat so fast and high. As I look at you, Brochea, my voice goes to nothing, my tongue is broken, and subtle fire runs in courses through my body; my eyes see nothing, my ears ring; sweat pours from me as trembling seizes me completely; I become green, like grass, and death seems to me only a little way off. But impoverished now, I must dare all [or, alternatively reconstructing a textual lacuna, "I must be contented withall"].[6]

One of only two substantially complete lyrics from her corpus to survive and circulate in the interval between classical antiquity and the late nineteenth century when more texts came to light among the Oxyrhinchus papyri, *Phainetai moi* supplied the core of Sappho's reputation through repeated citation and adaptation alike. Both the treatise *On the Sublime* (*Peri Hypsous*) long ascribed to Longinus and Plutarch's dialogue *The Lover* (*Erōtikos*) in the *Moralia* had quoted *Phainetai moi* in full, to document their authors' great admiration for Sappho's fiery nature and expression, as well as her artfulness in selecting and portraying the symptoms of her love-seizure.[7] "Longinus" and Plutarch were accessible by the late sixteenth century in multiple editions, several with parallel Latin translations. Also in the course of the sixteenth century, *Phainetai moi* began to be printed in gatherings of Sappho's poetic remains that first appeared as appendices to the Stephanus editions of Anacreon (1554 *et seq.*; *Phainetai moi* first in 1556) and later in other anthologies like Fulvio Orsini's compendious *Carmina novem illustrium feminarum* (Antwerp, 1568).[8]

But due to the difficulty of Greek for many Renaissance poets (Donne is typical in this regard), Latin translations and adaptations of

Phainetai moi proved more potent cultural disseminators than the original text. This is notably true of Catullus' *Carmen* 51, a masterful adaptation of Sappho's Greek sapphics into Latin that also assimilates her lesbian passion to heterosexual expression by the simple expedient of altering the gender of the lyric "I"; thus Catullus supplants as he salutes Sappho. *Carmen* 51 was familiar currency in the Renaissance; Montaigne, for example, quotes two stanzas in "De la tristesse."[9] In the opening section of "Sapho to Philaenis," Donne serves notice not only that he is revising Ovid, but also that he knows Sappho in and through (some version of) *Phainetai moi*. His English recovers her characteristic reliance both on oblique pronoun references and on common lexical primaries (heart, fair) as well as her imagery of fire, immediate sensations, and absence felt as physical depletion. The introductory impulsion of the verse epistle rounds itself off by fixing and dilating upon her phrase, "equal to the gods" or "like the gods are":

> Thou art so faire,
> As, *gods*, when *gods* to thee I doe compare,
> Are grac'd thereby; And to make blinde men see,
> What things *gods* are, I say they'are like to thee.　　(lines 15–18)

This phrase Donne wittily translates from the male rival to the female beloved – outsapphizing, at this juncture, Sappho herself.

It can be safely assumed, I think, that Donne's interest was first attracted to Sappho by what he had learned of her surpassing reputation as a poet of the physiological and psychological effects of erotic possession. Although "Sapho to Philaenis" cannot be dated with certainty, it probably belongs to Donne's youthful, loosely Ovidian phase as an Inns-of-Court student in the London of the 1590s, a milieu where, as Arthur Marotti shows, his readers would "understand the literary-historical vicissitudes of various genres and modes and ... appreciate his inventive reformulation of them in ways that called into question both familiar conventions and their usual ideological and social affiliations."[10] Accordingly, the Petrarchan overlay given by Donne to the Sapphic images in lines 5–6 and 9–12 – the oxymoronic simultaneity of fire and water, passion and tears, the waxen image melted from the heart but deeply imprinted in the memory – strengthens the inference that, as an amorist of some sophistication, he looked to Sappho as a source of renewal and intensification for the stock-in-trade counters of Renaissance love poetry. But this inference, taken only thus far, fails to differentiate Donne from DeJean's Ovidianizing male poets who conformed Sappho to their norms and expressions of heterosexual love.

Donne, however, distanced himself from the masculinist appropriation that had already been sealed in antiquity by Catullus and Ovid. Both his dismissal of Phao's importance and the lesbianism of his Sapho are proof of that; the name of Philaenis is further proof. In shaping "Sapho to Philaenis" as a poetic antitype to "Sappho to Phaon," Donne must have drawn on sources beyond the accessible ones cited above for conceptions of Sappho, of women poets, and of lesbian erotics.

Donne made characteristically independent use of the reservoir of humanist scholarship that accumulated throughout the sixteenth century in annotations on the *Heroides* and in treatises on poetry. His affirmative representation of lesbian sexuality, in particular, contrasts starkly with the insistent homophobia of the commentaries and poetic histories in which the text of the *Heroides* and the myth of Sappho were transmitted to Renaissance readers. A chief instance in point is what Helmut Saake has called "the defamation of Sappho" by the "humanists' conjecture about line 19 of *Heroides* 15" – that is, Sappho's reference to the women who were her lovers before Phaon.[11] The earliest editions give the reading of a majority of the manuscripts that contain this poem: "quas hic sine crimine amavi" ("them" – feminine plural – "have I loved without blame in this"). But textual scholars in the later Renaissance emend line 19 to accord with a variant reading from a different manuscript source: "quas non sine crimine amavi" ("them have I loved, not without blame").

The latter, self-incriminating, reading of Sappho is the one adopted in the 1594 London edition of the *Heroides*, circumstantially the volume in which Ovid would have been most accessible to Donne. This edition parades its humanist credentials – a "most accurate" text from Andreas Navigerius and prose arguments by Guy Morillon (no less a personage than Emperor Charles V's secretary). Morillon's prefatory note or "argument" to "Sappho to Phaon" (pp. 76–7) distinguishes two poets named Sappho. There was a much earlier woman of Lesbos who, on the authority of Aelian (200 AD) and Suidas (950 AD), was renowned as a lyric poet and inventor of the plectrum, a pick for playing the lyre; this Sappho was a contemporary of Alcaeus and Pittacus. We have lost all of her work. The later Sappho of Lesbos, according to Morillon, was also a gifted lyric poet who wrote many excellent poems – so gifted that Plato hailed her as the tenth Muse and praised her wisdom. But this Sappho was a whore ("meretrix") whose lasciviousness nothing could allay, as Ovid demonstrates in "Sappho to Phaon." This Sappho made love with girls, frowns Morillon, taking the superior position with them and rubbing them in a fashion different from what men do. Hence she was

termed a "tribas" ("one who rubs," from the Greek verb *tribein*, "to rub"), and Horace for this reason called her "mascula" – "manly" – Sappho. Morillon's misapplication of Horace continues when he cites *Odes* 4.9.11: Horace wrote "spirat adhuc amor / vivuntque commissi calores / Aeoliae fidibus puellae" ("the love still breathes, the flames still live, which the Aeolian girl confided to her strings"), but Morillon picks up the quotation after the first clause, silencing the breath of love and adducing the living flames only as witnesses to Sappho's poetry of passion.

The character of humanist commentary on Sappho – both its constant tonalities and its variable details – can be fleshed out somewhat by considering Politian's notes for a series of Latin lectures he delivered to the Florentine Academy in 1481 on Ovid's "Sappho to Phaon." Politian recognizes in Ovid's choice of Sappho as a subject just one more tribute to her eminence in antiquity as a poet. He lists a number of ancient testimonies to Sappho's poetic genius and lyric innovations, including her invention of the plectrum and of sapphic meter, and correctly notes that Horace offered admiration, not slander, in hailing the mastery of lyric shown by "mascula Sappho" (*Epistolae* 1.19, line 28). But Politian also allows himself remarks on her "shameful loves" (for which he uses the Greek phrase *aiskhras philias*) and invokes Apuleius' far from laudatory notice of "a Lesbian woman, indeed a lascivious one, who by her charm of language rendered agreeable the insolence" (*insolentiam*) – alternatively, "excess" or "unusual character" – "of her songs."[12] Such instability on the expository plane correlates elsewhere with spates of moralistic disapproval in Politian's lectures, as emerges clearly in his commentary on lines 17–19 of Ovid: Sappho's reflections on her former lesbian loves.

At first Politian strains to hold the high ground, citing Maximus of Tyre to the effect that, as Socrates loved young men like Alcibiades, Charmides, and Phaedrus, so Sappho loved Gyrinna, Atthis, and Anactoria. Intimating that Socrates and Sappho were adepts in an exalted understanding of love, Politian then lists a series of what he takes to be consonant expressions in Sappho's lyrics, and in the speech on love attributed by Socrates to the prophetess Diotima in the *Symposium*.[13] With the next step, however, the high ground breaks apart beneath his feet. At line 19, where he adopts the reading "non sine crimine," Politian acts as if he were deep in dirt. He mucks about, not least with Horace's phrase "mascula Sappho," which he now reads altogether differently. His comment on Ovid's line runs in full as follows:

"Blame" I hear, not wrongly. In Lucian's fifth *Dialogue of the Courtesans* Clonarion is introduced, speaking thus of Leana: "They say there are such masculine-looking women in Lesbos, who are unwilling to put up with men but are intimate with women as though they themselves were men." Whence Horace's "masculine Sappho" – since, as Porphyry says, "she was one who rubs" [*tribas fuerit*]. Martial: "Philaenis, you champion of women who rub" [*Ipsarum tribadum tribas, Philaenis*]. And Horace elsewhere: "to Aeolian strings / Sappho confiding her plaints about the girls of her city." And Aristophanes on "to lesbianize": "Now they are about to lesbianize the drinking party." Whatever this is, Suidas expounds: "They dirty their mouths," and he adds: "The Lesbians are denounced for shameful things."[14]

Here, without even venturing beyond the compass of sixteenth-century commentaries on Ovid's *Heroides*, we find the names of Sappho and Philaenis paired in the context of lesbian erotics.

As we have seen, the humanists recognize Sappho as a major poet, although all such tribute is rendered equivocal by their manifest revulsion at her sexuality. Philaenis too might have been left only the degraded and attenuated image given her by Martial, if the celebrated humanist polymath Lelio Gregorio Giraldi had not compiled his encyclopedic *Historia poetarum* (1545) and included accounts of her and Sappho as poets. Giraldi's entry on Philaenis of Leucas – the site of the Ovidian Sappho's death leap – is relatively brief. It is found in an excursus on ancient Greek poet-prostitutes who reportedly wrote verses on the postures and techniques of lovemaking. Philaenis is the second such mentioned by Giraldi and, according to him, the second most notorious, ranking only after Elephantis in this erotic-poetic vein. As far as Giraldi can tell, the libertine poet Philaenis seems to have been heterosexual. He cites two Lucianic dialogues, *The Sham Sophist* and *Erotics*, that attribute to her "most lascivious" verses, adding that Suidas reports Philaenis to have been a disciple of the poet Astyanassa, who was a chambermaid to Helen and Menelaus. The Philaenis whom Martial branded "tribade" must have been another woman, Giraldi concludes roundly.[15]

In his long entry on Sappho (11:457D–459C) Giraldi intensifies both her sexual transgression and her poetic eminence. Through promiscuous behavior with boys and girls (after her husband had died), Sappho became known as a "tribas." But Horace and Ausonius labeled Sappho "mascula," according to Porphyrion among others, because of her deep studies of poetics: "she was turned manlike by them" ("in quibus studiis ut vir versata est"). Others say she acquired this epithet through her temerity in leaping from the Leucadian cliff, and Giraldi adds to it that Strabo the geographer (and Menander his commentator) were of the

view that the heat of oestrus precipitated Sappho's death leap. As he continues to select and marshal his authorities, in fact, Giraldi locates the heart of Sappho's achievement in her blending of lyric artistry with erotic intensity. Thus he cites Plutarch, quoting Aristoxenus, on Sappho's invention of the sensuous and emotional mixolydian mode. He reports Demetrius (?50 AD) and Hermogenes (200 AD) as praising Sappho's lyrics especially for what they reveal of the poetic force of figures of repetition. And, in his undiminished stature as an authority for the Renaissance, Aristotle figures for Giraldi at some length as an admirer of Sappho's poetry, particularly of the artistry with which she creates an *ethos* of unabashed candor for herself in a verse exchange with Alcaeus (*Rhetoric* 1.9). For Aristotle, Sappho delivered a stroke of *pathos* by manipulating syntax and verse form in an elegant reflexive construction where one half of a couplet answers the other both argumentatively and poetically. Three influential fragments conclude Giraldi's poetic biography. Stobaeus (?450 AD) reports Sappho on the ages of persons to be matched – "If you love me, choose yourself a younger bedmate, for I cannot bear to live as the older with someone younger than I" – and her snub to an uncultivated woman: "When you die you will lie forever unremembered, for you have no part in the roses that come from Pieria [blooms gathered at the Muses' spring]; but, unremarked in Hades' halls you will flit up and down among the obscure dead." And Aristides (170 AD) records Sappho's retort to certain wealthy women: "But I have genuinely received wealth from the golden Muses, and when I die I will not be forgotten." Confirming Sappho's own reflections on her lyric gifts and achievements, Giraldi ends by remarking that all the cities of Lesbos erected public statues in her honor, exceptional recognition for a love poet even earlier than Anacreon (the originary figure in Renaissance eyes).[16]

The humanist commentaries of Morillon, Politian, and Giraldi suggest well enough what the available Renaissance source materials on Sappho and Philaenis were like.[17] Yet, in regard to all these materials, Donne's revisionism remains the salient, distinguishing feature. "Sapho to Philaenis" undoes the Ovidian portrayals in "Sappho to Phaon" by picking out elements from the humanist commentary that can be set to work against the grain of Ovid's poem. Close attention to both Ovidian and non-Ovidian sources may be required to follow what Donne is doing. For example, it looks at first as if the doxographical tradition will not help to account for Sapho's object of passion, Philaenis, since it specifies a number of women other than Philaenis as Sappho's lovers. But in conjunction with *Heroides* 15, Leucas gains significance as a

catalyst – the site of Sappho's death leap in Ovid, and Philaenis' home in the commentary. Thus a glimpse opens into Donne's recasting of Ovid's tragic plot. On arrival in Leucas, Donne's Sapho does not end her life in thwarted lust for Phaon. Instead she meets the libertine love poet Philaenis and falls so deeply in love with her that Phaon becomes a relic of Sapho's past ("Such was my Phao'awhile," line 25). The moment of Donnean composition – the writing of his heroical epistle – ensues upon Sapho's separation from Philaenis, not Phaon.

Having fixed this point of departure, Donne appears to work steadily, though selectively, from the Sappho doxography and its quotations from her poetry. His Sapho's utterance is sensuous and emotional, as befits the inventor of the mixolydian mode in lyric. As Demetrius and Hermogenes had noted in her prototype, figures of repetition exert force in the verse of Donne's Sapho: "But thy right hand, and cheek, and eye, only / Are like thy other hand, and cheek, and eye," "All, all that *Nature* yields ... So may thy cheekes red outweare scarlet dye ... So may thy mighty, 'amazing beauty move" (lines 24–5, 44, 59, 61). Additionally, as in the reports of several of her responses to other women, his Sapho's tone rings pridefully in affirming the conjoint superiority of the feminine refinement and lesbian erotics that she enjoys with Philaenis: her "body is a naturall *Paradise*" containing "all pleasure," with no need of any "perfection" conferred by men (lines 35–8). In keeping, moreover, with one of the Stobaeus quotations, Donne's Sapho insists on the equality of her sexual partner while casting this insistence into binary responsions of poetry and argument – the form of the couplet that Aristotle had admired so greatly:

> My two lips, eyes, thighs, differ from thy two,
> But so, as thine from one another doe;
> And, oh, no more; the likenesse being such,
> Why should they not alike in all parts touch? (lines 45–8)

Donne's Sapho also defies death, though more explicitly through the strength of a love union and more implicitly through her poetic powers than does her prototype in the quotations preserved by the doxographers: "And so be *change*, and *sicknesse*, farre from thee, / As thou by comming neere, keep'st them from me" (lines 64–5).

Thus far I have argued as if breaking the hold of Ovid's poetic denigration and heterosexual recasting of Sappho's figure were project enough for Donne in this verse epistle. But to put the matter this way obviously makes for an incomplete account. Donne's personifications and thematics call into question the conventions of heterosexuality that

ruled love poetry, erotic behavior, and social arrangements in his own day. What can be said of Donne's lesbian design and its implications even for an élite Renaissance readership in this singular poem? The question urged recently by William Kerrigan returns upon us here in full force.[18] What *was* Donne doing in "Sapho to Philaenis"?

Lesbian erotics and economics: Donne's utopian trope

The sixteenth and earlier seventeenth centuries in Europe have left very little witness to lesbian relationships from any quarter whatever. The historian Judith Brown reports "references to a few prosecutions" in Spain, "four sketchily known cases in France, two in Germany, one in Switzerland, [and] one in the Netherlands," besides the transcript that she discovered of formal ecclesiastical proceedings against an Italian abbess, Benedetta Carlini.[19] From within the literary sphere, Lillian Faderman reached an identical finding in her survey history of "romantic friendship and love between women from the Renaissance to the present." Faderman's handful of literary examples, almost all French, consists of verse epigrams or vignettes in prose romances. The epigrams, manifestly modeled after Martial's on Philaenis and Bassa, are obscene process descriptions that heap scorn indiscriminately on female masturbation and homoerotics. Rather more coy in their language and selection of details, the prose vignettes represent and finally place such lovemaking as foreplay for the superior satisfactions that women are to gain from male penetration, a sequencing observed in pornography even today. Faderman generalizes as follows: "Writers who attempted to deal with lesbianism regarded it primarily as a sexual act and were unwilling to give it the dimensions they might attribute to a serious male–female love relationship: admiration, concern for the beloved's welfare, tenderness, total involvement in the beloved's life."[20]

From what I have to add to these findings from English materials, Donne emerges with a double first. He is (as far as we know) the first writer to treat the subject of lesbianism in English, and he goes to lengths unparalleled in his time to personify the lesbian love of his Sapho as both sexually active, and emotionally and morally positive. Two of Donne's most eminent contemporaries retreat on one or both fronts as they skirt lesbian subjects. The straight humanist line of viewing female homoerotics with disgust finds expression in two epigrams written between 1600 and 1609 by Ben Jonson. One, in print in a poetic miscellany by 1601, refers moodily to the Graces as "tribades" with whom Venus

might be found inventing "new sports"; the other, Johnson's "Epigram on the Court Pucell," Cecelia Bulstrode, denigrates Bulstrode's poetry-writing as lesbian rape: "What though with Tribade lust she force a Muse?"[21] Shakespeare, by contrast, takes a sanitizing approach in *Two Noble Kinsmen*, a late collaboration with John Fletcher (*c.* 1613; 1st ed. 1634), where the heroine Emilia rhapsodizes about her girlish attachment to a certain Flavina's company and person. The passionate inseparability of the two girls, "I / And she (I sigh and speak of)," involved "things innocent" in a "fury innocent": "The flower that I would pluck / And put between my breasts, oh (then but beginning / To swell about the blossom) she would long / Till she had such another, and commit it / To the like innocent Cradle." Emilia ends this speech by voicing her conviction that "the true love 'tween Maid, and Maid, may be / More than in sex individual," and she concludes the scene by announcing "I'm sure I shall not ... Love any that's call'd Man."[22] Notwithstanding her declared homoerotic fidelity, in this stage adaptation of Chaucer's *Knight's Tale*, Emilia is married off in due course to her surviving suitor, Palamon. Lesbian attachment and a woman's resolve never to marry can find dramatic expression only as transient states falsified by the play's ending, which confirms anew the force of social convention.[23]

Shakespeare's ultimate bestowal of Emilia upon Palamon illustrates the attitudinal frame that Faderman finds consistently enclosing the uncensorious treatments of what, in any case, was a very rare Renaissance subject. In the mere condescension exhibited by the few male authors who treated lesbianism, she detects a twofold rationale, which I label "economic" and "erotic" respectively. These authors project the "phallocentric confidence" of their sex "that they could not be unnecessary to women," for, "first of all it was universally acknowledged that women had to form bonds with men in order to survive," and, "secondly ... it was inconceivable that a woman's sexual pleasure could be significant if the male were absent" (*Surpassing the Love of Men*, pp. 28–9). Nonetheless, it is just such phallocentric confidence that Donne renders null in the "what if" imaginings of "Sapho to Philaenis." Conventional social implications are worlds removed from the erotics and economics of lesbian union that energize his thinking and writing in this poem. How was a union on such terms even conceivable? How might Donne have been prompted to project the utopian love of his two women principals?

Donne's thought experiment proceeded, I suggest, along such lines as these: What if one were to synthesize the unitive perfections of the

Reformation ideal of marriage and the Renaissance ideal of friendship between equals? What might the resulting relation look like? Any answer he might give to such questions, however, would inevitably be implicated in historically specific social productions of gender and rank. "Sapho to Philaenis" demonstrably trades on a Renaissance understanding of friendship: a relation between two persons so alike in age, means, education and upbringing, interests, tastes, and values that they bond in mutual joy and constancy at finding another self with whom to share both experience and intimacy. Our prime source for this understanding is Montaigne's celebration of his relation with Estienne de la Boétie in his essay "De l'amitié." In phraseology that repeatedly registers the sexual charges he will later disclaim, Montaigne evokes minds that "sounded, even to the very bottome of each others heart, that I did ... know his, as well as mine owne," in a "commixture, which having seized all my will, induced the same to plunge and lose it selfe in his, which likewise having seized all his will, brought it to lose and plunge it selfe in mine." "All things were with us at halfes," Montaigne continues, so that after the friend's death, "me thinks I am but halfe my selfe."[24] Donne's Sapho's repeated reciprocals and assertions of "likenesse" (lines 47, 51) sustain by similar means the key motifs of this intense mutuality, even merger, of identities: "Me, in my glasse, I call thee" (line 55). Sapho can also be found conflating a still larger literature of friendship within a single couplet: "O cure this loving madnesse, and restore / Me to mee; my *halfe*, my *all*, my *more*" (lines 57–8). The aetiological myth that Aristophanes relates in Plato's *Symposium* is the oldest as well as the best-known Western source for the image of lovers as one another's halves. In the *Confessions*, Augustine had called his friend half of his soul, and in "Of Friendship," Bacon declares the friend not merely "another Himself," but "farre more than himselfe."[25]

Despite this language of union and mutuality, "Sapho to Philaenis" does not challenge the Renaissance construction of gender implicit in the stress on friends as equals. Since gender was bound in hierarchical relations, men and women could not be equals; hence, men and women could not be friends in the then specially charged and specially regarded sense of friendship. A battery of institutions that imposed separate socialization and education on the two sexes set period limits on how human equality and mutuality could be conceived. Donne manifestly accepts the single-sex definition of the friendship literature. However, he accepts neither the male chauvinism nor the compulsory heterosexuality that bedevil Montaigne's weighing of friendship against marriage. Perhaps just cognizant enough of his earlier sexual undertones

(the echoes of the *Symposium* myth, the images of plunging and penetration) to disclaim them on returning to the subject of la Boétie, Montaigne firmly enunciates a negative dichotomy as he struggles to characterize his relationship with his friend. Marriage cannot yield such perfect friendship, since women are too weak to secure "a knot so hard, so fast, and durable." Logically male friendship should lead to physical consummation –

> Truly, if ... such a genuine and voluntarie acquaintance might be contracted, where not only mindes had this entire jouissance, but also bodies ... and a man might wholy be engaged: it is certaine, that friendship would thereby be more compleat and full –

but Montaigne emphatically rejects "that Greeke licence ... justly abhorred by our customes."[26] Donne's "what if" in "Sappho to Philaenis" consists precisely in closing Montaigne's negative dichotomy and uniting friendship and marriage through homoerotics – the "truly ... more compleat and full" engagement of bodies as well as souls. And he chose, not male homoerotics, but lesbianism, as if to counter Montaigne's slur on women's incapacity for "this sacred bond."

This choice may have been influenced by the inequality of age and rank that (except in Aristophanes's *Symposium* myth) remained a conspicuous feature of classical Greek homosexual love and its type figures – an older male lover of superior social standing and a youthful male beloved whose social standing was yet in formation.[27] Donne's project and projection required equality, and in the humanist scholarship he could find Sappho declaring that "I cannot bear to live as the older with someone younger than I" – a clear alternative to male hierarchy for embodying homoerotics. But a further and probably weightier factor in Donne's representational choice arose from hardy Judaeo-Christian theological traditions that tended to ignore lesbianism as a species of (more or less venial) pollution in contrast to what was viewed as the far graver perversion of male–male sexual relations. When the contrast was drawn – by no means consistently – it turned on the understanding that male–male relations, unlike female–female ones, involved contrary-to-nature disposition of the essential element in human reproduction, that is, the semen.[28] Accordingly, in Donne's time and circumstances, it looks as though only a marriage–friendship synthesis gendered female could achieve poetic representation – and this itself would have been constrained to manuscript circulation among coterie readers.

In noting these situational constraints I do not mean to imply that

Donne treated lesbianism as a trope merely dealt to him by the limits set in his age on how unitive perfection might be figured between two lover-friends. Through the personages of Sapho and Philaenis, Donne really undertook to explore how utopian erotics and economics might be gendered all-female. And for this exploration, Sappho's own fragmentary corpus but surpassing reputation as a love poet provided catalytic impetus at key points in Donne's text. We have seen, for example, how he transfers Sappho's "equal to the gods" simile from her male rival to their conjoint object of desire, the female beloved (lines 15–18). To be godlike fair in "Sapho to Philaenis" is to be beauty's defining instance; divine perfection in fairness is known by being embodied in Philaenis, so that even "blinde men see" how to proceed from a perfect human embodiment to an appreciation of divine perfection. This beauty is then proclaimed by Sapho as a challenge to the rationale of androcentric commonplaces that image cosmic wholeness in terms of the male body: "For, if we justly call each silly *man* / A *litle world*, What shall we call thee th[e]n?" (lines 19–20). This question will be answered presently from a standpoint of triumphant gynecentrism that Philaenis, again, authorizes by being its embodiment: her body is a paradisal economy "in whose selfe, unmanur'd, all pleasure lies," and she has no need to "admit the tillage of a harsh rough man" (lines 35–8). The woman possessed of a paradisal body has no need of a mere little world, a male as her would-be cultivator and inseminator.

Between the question of the relative value of gendered bodies and this "paradisal" answer, which translates the determination of value into erotic practice, an intervening passage seeks a basis on which to perform an evaluation of binary sexual difference. Donne's Sapho locates this basis by working from a premise that appears to me more identifiable with the historical Donne than the historical Sappho – the premise that, in matters of love, stability is superior to change.[29] But the figure of Sappho and the representation of lesbian erotics as transmitted in humanist scholarship still set the course of this section of the poem. Compounded with the self-esteem that is such an emphatic aspect of the Sappho fragments cited in the doxography, the passionate self-analysis and sexual jealousy that infuse *Phainetai moi* find new expression here. "*Griefe* discolors me" (line 28), she says, distantly echoing "I grow green, like grass":

> And yet I grieve the lesse, least *Griefe* remove
> My beauty, and make me'unworthy of thy love.
> Plaies some soft boy with thee, oh there wants yet

Donne's brief for lesbianism

A mutuall feeling which should sweeten it.
His chinne, a thorny hairy'unevennesse
Doth threaten, and some daily change possesse. (lines 29–34)

"Mutuall feeling" will register in retrospect as a richly multivalent pun that signalizes the acts as well as the emotions of lesbian erotics. More immediately remarkable at this point is another image transfer by which Donne intensifies rather than diminishes Sapphic fire: his Sapho reassigns from self-reference to the male rival the lack confessed in the last line of the *Phainetai moi* fragment ("But impoverished now, I ... "). What the youthful male rival lacks is the stable physical beauty of the female body, consummately exemplified by Philaenis. Given the popularity and accessibility of Lucian in the Renaissance, Donne may here be drawing on a passage from the dialogue *Erotics* (as Politian had in his lectures on *Heroides* 15) and giving the material a typically freewheeling twist. In this dialogue a speaker for heterosexual love presses his case against a pederast, who may even be found making "attempts on a boy of twenty": "Then ... the chins that once were soft are rough and covered with bristles, and the well-developed thighs are as it were sullied with hairs ... But ever does her attractive skin give radiance to every part of a woman and ... the rest of her person has not a hair growing on it."[30]

Boldly discarding the heterosexual thrust of the original, "Sapho to Philaenis" adapts the Lucianic case *against* male homosexuality to a case *for* female homosexuality, and rationalizes the turn by invoking a calculus of sexual difference. In so doing, Donne also runs against the grain of a celebrated passage in Plato's *Symposium*, much in currency in the Renaissance (quoted, as we have seen, in Politian's lectures on *Heroides* 15 and reechoed in Montaigne). Aristophanes' myth in this dialogue had represented all gendering, all erotics, as indifferently chancy and contingent. No sexual arrangement is privileged or disparaged in this myth, since all stem equally from Zeus' punishment of humans doubly-sexed at their origins in three possible combinations – male/female, male/male, female/female: heterosexuals are subdivided from the androgyne sex, "the woman who is a slice of the original female is attracted by women rather than by men ... while men who are slices of the male are followers of the male ... and take delight in lying beside them and being taken in their arms."[31] Donne's Sapho counters Plato's Aristophanes by converting a Lucianic tribute to embodied female beauty into an argument for what, with her, is the distinctive superiority of lesbian erotics. Female beauty has a prelapsarian self-containment and stability that male beauty lacks: "Such was my *Phao* awhile, but shall be never, / As thou wast, art, and, oh, maist be ever" (lines 24–5). To stress

the stability of the female body is to challenge a longstanding and influential formulation in the ideology of gender: the antithesis of the male body, the locus of domestic and political authority in its steady self-identity, and the female body that slowed its movements and distended in pregnancy, that emitted blood in menstruation and milk in lactation, and that ran the repeated danger of death in childbirth – the site of variability and disorder.[32]

Any counter-representation like that made by Donne's Sapho would need a counter-image to quell the objection that the stable beauty-in-symmetry exhibited by Philaenis' body is not intrinsic, but requires maintenance – indeed, economic management. Hence the argumentative and emotional turning point of the poem comes with the contrast between male "tillage" and female "*Paradise*," male artifice and female nature. No longer voicing emotion that might be expressed by any lover of a woman, male or female, Donne's Sapho begins to write specifically in the vein of lesbian erotics as she offers her prudential grounding for the logic of lesbianism and then moves skillfully to naturalize it:

> Men leave behind them that which their sin showes,
> And are as theeves trac'd, which rob when it snows.
> But of our dallyance no more signes there are,
> Th[a]n fishes leave in streames, or *Birds* in aire.　　(lines 37–42)

This argument on behalf of just that species of erotic pleasure by which a woman can insure against pregnancy dates this text to the long pretechnological era of contraception in women's history. It also expresses more local Renaissance concerns, as demonstrated by the affinities between this passage and a first-person love elegy in rhymed pentameter couplets (like Donne's), written by a male poet of the French Pléiade, Pontus de Tyard, to image the experiences and feelings of "a lady enamoured of another lady." This elegy, printed among Tyard's poetical works in 1573, celebrates the moral superiority of a lesbian attachment for an honorable gentlewoman who abhors the low sexual designs constantly made upon her person by the gentlemen with whom her rank obliges her to associate at court: love would be "softer" because "honor is not wounded," the beloved retains her beauty unscathed (by pregnancy, presumably), and the lover experiences an especially intense enjoyment of beauty loved in "an identical subject." "There is not," the writer concludes, "a richer treasure in love's empire than the love of one woman for another." But a punitive plot on the model of *Heroides* 15 brackets these effusions. The elegy ends in vengeful, hopeless imaginings about a disdainful, unresponsive beloved. Perhaps the writer will

undergo (an Ovidian) transformation into an echo voice, a weeping stone, or a fountain; perhaps her beloved will fall in love with someone unworthy of her and not have her love returned.[33]

Tyard's "Elégie" proves most suggestive by comparison with Donne's "Sapho to Philaenis" in its revelation of a feminist *mentalité* that refuses to submit to the contemporary sexual mores of gentlemen courtiers and proposes a full-scale alternative of being and loving. This alternative is the logic of lesbianism, but there are, Tyard's speaker finds, no takers for it beyond herself. Donne tallies with Tyard in several particulars of the case for lesbianism, but he articulates the issues of honor, sexual pleasure, and the threat to honor posed by pregnancy more distinctly (in the images of robbing and being robbed), and brings them into tighter conjunction as an argument for lesbian erotics. Up to the midpoint, then, of "Sapho to Philaenis," as my discussion has been indicating, Donne could and did pursue his "what if" imaginings about a perfect union of marriage and friendship by working permutations on materials that came his way as a generalized cultural inheritance.

However, after the midpoint of Donne's poem, a qualitative difference begins to open between his Sapho and her poetic counterparts in Tyard and Shakespeare – a difference that does not reduce simply to degrees of explicitness or reticence or to the level of success they reach in affirming lesbian love. The quantum leap that Donne, and only Donne, is found making occurs on the plane of love theory. Donne theorizes lesbianism as an *ars erotica* – that unattested genre in Western society, according to Michel Foucault, where *scientia sexualis* has held discursive sway at least since the sixteenth century. Not expecting fellow Westerners to be able to recognize an *ars erotica*, Foucault explains that "in the erotic art, truth is drawn from pleasure itself, understood as a practice and accumulated as experience."[34] Donne's Sapphic "Art" addresses the truths – that is, the experiences and practices – of female sexual pleasure. The poem seems strikingly knowledgeable in the arts of female sexual gratification, even to late twentieth-century readers. Sapho knows the self-empowering pleasures of narcissism, of autoeroticism, of mirror-gazing, as means by which an acculturated female invests her body and her psyche with a sense of worth and gains the confidence to be a subject, not merely an object, of desire.[35] She confides to Philaenis the "strange selfe flatterie" of "Me, in my glasse" and of "touching my selfe": "My selfe I embrace, and mine owne hands I kisse, / And amorously thanke my selfe for this" (lines 51–5). By further implication in these same lines on the autoerotic play of hands for which she amorously thanks herself and with which she

fails to compensate for Philaenis' absence, Sapho's is a self-cognizant clitoral sexuality.

Donne's Sapho, moreover, knows the asymmetry between male and female orgasm in the closeness of their respective ties to the mechanics of reproduction. She argues from the facts of female bodies to her lesbian *ars erotica*. It is not necessary to get pregnant or even to risk getting pregnant in order to experience climactic pleasure, as she assures Philaenis: "betweene us all sweetnesse may be had; / All, all that Nature yields, or Art can adde" (lines 43–4). Focused tactility figures prominently in exhortations that their body contact and caresses be multiplied to an implied climax: "And oh . . . the likeness being such, / Why should they not alike in all parts touch? / Hand to strange hand, lippe to lippe none denies; / Why should they brest to brest, or thighs to thighs?" (lines 48–50). Gender difference, moreover, makes all the difference in this realm of "mutuall feeling" (the pun in line 32 is now fully in play). Sapho declares that knowledge of female sexual pleasure can best be transmitted experientially to a woman from a woman, who inhabits and experiences just such a body. Again, the link between female knowing and female pleasuring is very clearly articulated. Emphasis is laid repeatedly on "touch" and "touching" (lines 48, 51), and on prolongation of actions and effects: "As thou, wast, art, and, oh, maist be ever," "And so be change, and sicknesse, farre from thee, / As thou by comming neere, keep'st them from me" (lines 26, 65). Most emphatically, in this lesbian erotics, the joy of binariness figures as primary in pleasure. Earlier, Donne's Sapho had grounded her claim for the stability of the female body in the symmetry of its correspondent parts, the identity of right and left in Philaenis' "hand, and cheek, and eye" (lines 24–5). She now represents that symmetry as redoubling and ramifying through erotic union with a lover who is also a woman. Sapho's expostulation to Philaenis not only repudiates the "phallocentric confidence" in the sexual indispensability of males to females that is commonly taken to identify Donne as a love poet, but cuts through the cumulative shroudings of cultural repression to utter the unspoken and unspeakable knowledge of total female competency in female sexual pleasure. It is preposterous to suppose that the clitoral site of orgasm was known only to women as historical subjects.[36] Males too surely knew – and among them I do not hesitate to number that subtle amorist, Donne. What sets him apart is no special erotic knowledge, but what he could imagine and image as alternative possibility in the erotic knowledge that he had.

Remarkable enough as a utopian figuration on the erotic plane,

Donne's Sapho's image of the paradisal plenitude of a female body "unmanur'd," refusing to "Admit the tillage of a harsh rough man," carries utopian connotations onto an economic plane as well. Emotively this image works to ballast the connotations of feminine all-sufficiency that proliferate later in the poem: "All, all that Nature yields, or Art can adde," "thee, my *halfe*, my *all*, my *more*" (lines 44, 58). But argumentatively the image mediates the conversion of erotics into economics, by one of the inside-out turns of reasoning patterns that are so omnipresent in Donne's poetry. The reasoning pattern that Donne subverts is the prop to the phallicism that has traditionally secured the dependence and repression of females in patriarchal Western societies. Patriarchy argues thus: he who holds property and purse strings also effectively possesses the woman's body, whether sexually or by power of disposition. The woman with the body has to eat and be housed and clothed; she also has to find her social place in some fashion, by some means. Historically in all these matters she has been at the disposition of males. Donne's Sapho, however, argues this way: the inhabitant of the woman's body effectively holds all that endows property and purse strings with their value and power to sustain life. Having begun her verse epistle in near despair over her lines' inability to portray Philaenis in all her beauty and desirability, Donne's Sapho takes control of her subject and expression alike with the question in line 20, "what shall we call thee then?" She offers answers in two climaxes of lyricism: the imperious centering of Philaenis' value in "Thy body is a naturall *Paradise*" (lines 35 ff.), and the communication of Philaenis' value in the simultaneously promissory and incantatory close of the poem: "So may thy cheekes red outweare scarlet dye," "So may thy mighty, amazing beauty move . . . And so be change, and sicknesse, farre from thee" (lines 59, 61, 63).

The effect of these local inversions performed on the traditional hierarchical construction of sexual difference is to free the other who has always been there – the female, actualized as Sapho – so that she can speak and figure as other than silenced, preempted, yet tacitly essential to the male-dominant system. However, the effort required of Donne to work such inversions in a resistant cultural context is severe enough to leave some signs of strain within his poem, and to recall the reader to a sense of its historical circumstances and date. The final situation envisaged for the two lesbian lovers lacks temporal or spatial concreteness. There is, significantly, no present for Sapho and Philaenis' perfect mutuality; all hangs in suspension between Sapho's memories of the past and anticipations of the future. Then, too, the imaging of Philaenis' "mighty, amazing beauty" as the object of female envy and male love

(lines 61–2) recalls the conventional Petrarchan love-worship accorded the pair of heterosexual lovers in Donne's "The Canonization." This intertextual echo seems to relegate the pair of lesbian lovers to an indistinct locale as marginalized (albeit idolized) curiosities for a larger heterosexual world.

That economic aspects of lesbianism are addressed at all remains for me a compelling index to the seriousness and rigor of Donne's "what if" in "Sapho to Philaenis" – the attempt to imagine friendship and marriage as a conjoint relation of equality. But eventual complications in the handling of these economic aspects clash with the assured, even triumphant, handling of its erotics. Sapho takes an enthymemic argument through a typical Donnean course in lines 58–64. In outline this argument holds that, once the lovers reunite and become "all" and "more" than all to each other, Philaenis' "mighty, amazing beauty" will be eternally self-sustaining; that her beauty will also become everyone's locus of erotic value, thus presumably legitimating the lesbian lovers' cohabitation as a social arrangement; and that Sapho and Philaenis will be physically sustained as well by this secured and legitimated cohabitation. What typifies Donne in this poetic argument is the extension of a notion from one semantic field into another, with the specious implication that meaning has been preserved. The key notions here are greatness and sustenance. By the lines' implicit logic, what sustains great beauty must be great sustenance – great enough to sustain not only Philaenis, but also the whole society's system of eroticized value, and Sapho too, and for always. My flat paraphrase voids the wit, but exposes the unstable meanings of the synonyms for greatness ("my *all*, my *more*," "mighty, amazing," "farre from," in lines 58, 61, 64), and for sustenance ("outweare," "keep," in lines 59, 64). Sapphism, when carried to the economic plane, thus appears to end in sophism. As the poem concludes, common sense nags at the heels of the superbly hyperbolic logic. Who could draw life-sustenance from enduring beauty, we muse? What beauty, when it comes to that, is enduring? Thus, if we do print "Sapho to Philaenis" among Donne's works as a heroical epistle, using Grierson's heading, we might be advised to place it at no great distance from the youthful Donne's paradoxes as well. Nonetheless, when all necessary concessions are made, the power of a poetic representation that innovates by configuring self-sufficiency – economic as well as erotic – for a pair of lesbian lovers remains. Here Donne put in play intimations of experiential alternatives that we twentieth-century readers have only lately come to see actualized to any significant degree. As envisioned, affirmed, defended, and celebrated in

Donne's brief for lesbianism

Donne's lines, the lesbianism of "Sapho to Philaenis" opens a utopian dimension in the history of sexuality, not merely for the Renaissance, but equally for the present and future that we call ours.

Notes

I am grateful for discussion with my University of Chicago colleagues at a departmental colloquium in May 1989 as well as the follow-up critiques I received from Lauren Berlant, Joshua Scodel, and Tom Stillinger. Claire McEachern and Mary Beth Rose – also Chicago associates – gave me further helpful criticism. At the John Donne Society conference in February 1990, Diana Benet, George Klawitter, Ted-Larry Pebworth, Michael Schoenfeldt, Jeanne Shami, Gary Stringer, and Claude Summers had helpful questions and period references for me; portions of an earlier version of this essay appeared in Summers' guest-edited issue of the *Journal of Homosexuality* (1992). A session organized by James Turner at the annual meeting of the Renaissance Society of America in April 1990 provided me with more stimulation and help, especially from Joseph Cady, Elizabeth Harvey, and Domna Stanton. As only he can, James Turner has performed an exhaustive, incisive, and witty editing job on this final version; I owe several new points and references to him.

1 *Fictions of Sappho, 1546–1937* (Chicago, 1989), pp. 29–115, revising and extending an interpretation advanced by Lawrence Lipking in *Abandoned Women and Poetic Tradition* (Chicago, 1988).

2 For example, John Lyly's *Sapho and Phao* (1584), Michael Drayton's *Englands Heroicall Epistles* (1597), subsequently enlarged and revised (1619). Harriette Andreadis briefly surveys these developments in "Sappho in Early Modern England: A Study in Sexual Reputation" (unpub. paper), 3–7; I am grateful to her for sharing her work with me.

3 I cite "Sapho to Philaenis" from John T. Shawcross, ed., *The Complete English Poetry of John Donne* (Garden City, N. Y., 1967), pp. 75–7. All citations from this edition will be incorporated in my text and identified by line numbers in parentheses.

4 See John Donne, *The Elegies and the Songs and Sonnets*, ed. Helen Gardner (Oxford, 1965), pp. xlvi, lxvii–lxxi, 119, 158, 160–1, 177, 212, 216, 218, 223. On Gardner's own showing, the authenticity of "Sapho to Philaenis" is as well supported as that of "The Comparison," "The Computation," "The Paradox," and "The Dissolution," and it is better supported than that of "A Jet Ring Sent," "Negative Love," "Farewell to Love," and "A Nocturnall upon S. Lucies Day" – all poems that no one has dreamed of detaching from Donne's canon. Shawcross's lead (see n. 3 above) was followed by A. J. Smith (1971) and by C. A. Patrides (1985).

5 James Holstun's "'Will You Rent Our Ancient Love Asunder?': Lesbian Elegy in Donne, Marvell, and Milton," *ELH* 54 (1987), 835–78, recognizes a number of positive aspects, but ends by recuperating Donne's poem into full ideological

alignment with Ovid's: "Though 'Sappho to Philaenis' does consider lesbian eroticism with considerable imaginative sympathy, it finally masters this eroticism by subordinating it to a patriarchal scheme of nature, history, and language" (p. 838). A comparable strategy informs Elizabeth D. Harvey's "Ventriloquizing Sappho: Ovid, Donne, and the Erotics of the Feminine Voice," *Criticism* 31.2 (1989), 115–38. She recognizes Donne's superiority to Ovid in sympathizing with female authorship and female homoerotics, and she explicitly signals utopian images and moments. Yet Harvey's argument ignores both Donne's revisions of Ovid and the potential in the epistolary genre for complexities of representation. It quite simply projects the relation of Donne to his Sapho as an Ovidian battle of the sexes played out on the male poet's terrain. Harvey finds Donne overmastering his Sapho by locking her in solipsism, thus establishing a vantage point from which he can explore and possess her through "a process … mediated both by ventriloquism and by voyeurism" (p. 126). Holstun and Harvey's readings of "Sapho to Philaenis" exhibit a categorical neatness that compounds with the appeal of an absolute regard for gender difference. According to them, a male poet cannot do other than assimilate, dominate, and silence the self-expression of a female predecessor or a female character whom he incorporates in his work (it remains an important feature of Sappho in literary history that she figures both as person and persona). What place does this leave for Flaubert's famous declaration, "Emma Bovary, c'est moi"? Is the sole proper domain of a male dramatist or novelist the portrayal of male characters? Can love lyrics and verse epistles adopt only the gender perspective that matches that of the poet writing? Such implications should leave us uneasy enough to rethink our critical premises about the literary construction of sexuality.

6 I translate from the text of Sappho's *Phainetai moi* in J. M. Edmonds, ed., and trans., *Lyra Graeca: Being the Remains of All the Greek Lyric Poets*, Loeb Classical Library (London and New York, 1922), vol. I, p. 186; the index to this edition provides my parenthetical dates for sources.

7 Edmonds, ed., *Lyra Graeca*, vol. I, pp. 185–7; Edwin L. Minar *et al.*, ed. and trans., *Plutarch's Moralia*, Loeb Classical Library (London and Cambridge, Mass., 1961), vol. IX, pp. 389–91. Cf. Aristotle, *The "Art" of Rhetoric*, ed. and trans. John H. Freese, Loeb Classical Library (Cambridge, Mass., and London, 1975), pp. 120–1.

8 For sixteenth-century French editions of Sappho, see DeJean, *Fictions of Sappho*, pp. 30–5, 37. Presumably because the compiler was not French, DeJean does not mention Orsini's superbly scholarly and compendious assemblage of sixty-nine fragments (in Greek only, however) plus a large doxography in the Sappho section of his *Carmina*. I have Betsy Karlberg and Bret Baker of the rare book collection of the library of the University of Illinois, Urbana, to thank for access to Orsini as well as to the 1554 and 1556 Stephanus editions of Anacreon.

9 Pierre Villey, ed., *Les Essais de Michel de Montaigne* (Paris, 1930), vol. I, p. 17. For Catullus' *Carmen 51*, see F. W. Cornish, ed., and trans., *Catullus, Tibullus, and Pervergilium Veneris*, Loeb Classical Library (Cambridge, Mass., and London, 1950), pp. 58–61.

10 *John Donne, Coterie Poet* (Madison and London, 1986), pp. 67, 70. Gary Stringer has informed me (personal communication) that Donne does not seem

to have used such astronomical terms as "galaxy" in his writings before about 1612, unless line 60 of "Sapho to Philaenis" is a piece of counter-evidence.

11 *Sapphostudien: Forschungsgeschichtliche, biographische und literarästhetische Untersuchungen* (Munich, Paderborn, and Vienna, 1972), p. 14; my translation. A fuller and more recent account of continental commentary is provided by Marie-Jo Bonnet, *Un choix sans équivoque: Recherches historiques sur les relations amoureuses entre les femmes, XVI–XXe siècle* (Paris, 1981). The Victorian editor of the *Heroides*, Arthur Palmer, adopted the defamatory emendation of line 19 (1898), but the prestigious Teubner edition (1916) did not; instead, the German editors denied Ovid's authorship of "Sappho to Phaon" altogether.

12 Angelo Poliziano, *Commento Inedito all'Epistola Ovidiana di Saffo a Faone*, ed. Elisabetta Lazzeri (Florence, 1971), pp. 3–7; the translations of Politian's Latin, and of his Greek quotations, are my own.

13 Abrupt transposition from homosexual erotics to the rarefied reaches of Diotima's speech seems to have been a standard move among Florentine humanists; cf. Agnolo Firenzuola's *Dialogo delle Bellezze delle Donne, intitolato Celso* (1541), in *Opere* (Florence, 1763), vol. I, pp. 267–9. The move, however, can be documented at least as early as Maximus of Tyre (*Dissertations*, book 24, ch. 18).

14 *Commento*, pp. 31–2. For uncertainty whether "lesbianize" refers to *cunnilingus* or *fellatio*, see J. N. Adams, *The Latin Sexual Vocabulary* (Baltimore, 1982), pp. 134, 202. Politian clearly associates Martial's savage and circumstantial epigrams on the *cunnilingus* practiced by the lesbian Philaenis with Horace on Sappho and with "lesbianizing"; cf. Martial 7.67 and 70, and Horace, *Odes*, book 2, no. 13, lines 24–5.

15 *Poetarum historia, graecorum et latinorum* (1545), dialogue 3, in Lilius Gregorius Gyraldus, *Opera omnia* (Leiden, 1696), vol. II, p. 171D. Translations from the Latin are mine.

16 Vol. II, p. 259D–F. Sappho's Greek for the fragments cited by Giraldi, together with English translations and full references, can be found in Edmonds, ed., *Lyra Graeca*, vol. I, pp. 266, 260, 168 (plus 186), 254, 233, 192.

17 It should be noted, however, that the so-called *Greek* [or *Palatine*] *Anthology* contains several epigrams and epitaphs whose ostensible aim is to restore both Sappho and Philaenis to respectability firstly as women, and secondly as poets. See, on Philaenis, W. R. Paton, ed. and trans., *The Greek Anthology*, Loeb Classical Library (London and New York, 1919), vol. II, pp. 186–7, 244–7; and, on Sappho, Edmonds, ed., *Lyra Graeca*, vol. II, pp. 158, 162–6. Donald L. Guss offers evidence of Donne's acquaintance with this compilation in "Donne and the Greek Anthology," *Notes and Queries*, n.s. 10 (1963), 57–8. For contemporary knowledge of the doxography, see Thomas Heywood, *Gunaikeion: or, Nine Bookes of Various History concerninge Women; Inscribed by the names of the nine Muses* (London, 1624), pp. 394–5 (for accounts of Sappho and Philaenis that accord in numerous specifics with Giraldi's).

18 "What Was Donne Doing?" *South Central Review* 4 (1986), 2–15.

19 *Immodest Acts: The Life of a Lesbian Nun in Renaissance Italy* (New York and Oxford, 1986), p. 6.

20 *Surpassing the Love of Men: Romantic Friendship and Love Between Women from the Renaissance to the Present* (New York, 1981), esp. p. 37.

21 C. H. Herford, Percy and Evelyn Simpson, eds., *Poems and Prose Works* (Oxford, 1925–52), vol. VIII, pp. 107–22. I thank Claude Summers for the latter reference. Jonson's editors note regarding the former, "Must I Sing?," that the lines were first printed among the "Diverse Poetical Essaies" appended to Robert Chester's *Love's Martyr* (1601).

22 A. R. Waller, ed., *Works of Francis Beaumont and John Fletcher* (Cambridge, 1910), pp. 303–4.

23 Similar themes, affectivity, and implied plot are found in a mid-sixteenth-century Scots protestation addressed in stanzaic verse by one gentlewoman to another, in a manuscript written and owned by Mary Maitland and dated 1586. The speaker yearns for a "band of hymen" to bind her and her beloved, but can envisage this only as an Ovidian myth – an intervention by "michtie Jove" to "metamorphos" her. See "An Address of Friendship," in W. A. Craigie, ed., *The Maitland Quarto Ms.*, Scottish Text Society, n.s. 9 (1920), 160–2.

24 J. I. M. Stewart, ed., *The Essayes of Montaigne: John Florio's Translation* (New York, 1933), pp. 150, 149, 153–4.

25 Plato, *Symposium*, 189d–193b; Augustine, *Confessions*, book 4, ch. 6 ("dimidium animae suae" – itself an allusion to Horace, *Odes*, 1.3.8); Francis Bacon, "Of Friendship" (1625 version) in Edward Arber, ed., *A Harmony of Lord Bacon's Essays* (Birmingham, 1871), p. 181. For England, the fullest study is still Laurens J. Mills, *One Soul in Bodies Twain: Friendship in Tudor Literature and Stuart Drama* (Bloomington, 1937), esp. pp. 214–304.

26 *Essayes*, p. 147. References at this point to Plato's Academy, Achilles and Patroclus, Harmodius and Aristogeiton, make clear that Montaigne is repudiating male homosexuality – and specifically, perhaps, pederasty as a relation between unequals. However, in the later essay "Sur des vers de Vergile" (III.5), Montaigne adverts with equanimity to male homosexuality.

27 See K. J. Dover's account of the culturally formalized, unequal roles of *erastēs* (lover as superior) and *erōmenos* (beloved and subordinate) in *Greek Homosexuality* (New York, 1980), pp. 42–68, 81–109.

28 See Brown, *Immodest Acts*, pp. 6–20, but contrast Louis Crompton, "The Myth of Lesbian Impunity: Capital Laws from 1291 to 1791," *Journal of Homosexuality* 6 (1980–1), 17. For a more general account, see John Boswell, *Christianity, Social Tolerance, and Homosexuality* (Chicago and London, 1980), pp. 163, 201–2, 288–93, 295, 303–34.

29 The force of Eros in Sappho has been widely equated with ceaseless vicissitude by twentieth-century readers and critics; see DeJean, *Fictions of Sappho*, pp. 25–7. Donne writes notable lyrics on changefulness in love ("Womans Constancy," "The Indifferent," "Loves Usury," "Communitie," "Confined Love"), but also evokes love in terms of permanence ("The Good-morrow," "The Canonization," "The Anniversarie," "Lovers Infinitenesse," "Loves Growth," "A Lecture upon the Shadow").

30 Pseudo-Lucian, *Erōtes*, under the title "Affairs of the Heart," in M. D. Macleod, ed. and trans., *Lucian*, Loeb Classical Library (Cambridge, Mass., and London, 1987), vol. VIII, p. 191.

31 *Symposium*, 191e, trans. Michael Joyce, in Edith Hamilton and Huntington Cairns, eds., *Collected Dialogues of Plato* (Princeton, 1961), p. 544.

32 See Peter Brown, *The Body and Society: Men, Women, and Sexual Renunciation in Early Christianity* (New York, 1988), pp. 11–17.

33 *Pierre de Ronsard et la Pléiade*, vol. I of Louis Perceau, ed., *Le Cabinet secret du Parnasse* (Paris, 1928), pp. 182–7.

34 *The History of Sexuality – Volume I: An Introduction*, trans. Robert Hurley (New York, 1980), p. 57.

35 Cf. Sarah Kofman, "The Narcissistic Woman: Freud and Girard," *Diacritics* 10 (1980), 37–8: women know "how to safeguard their narcissism, their independence, their nonchalance, and their high self-esteem by repelling everything that might be capable of depreciating them." Hence Kofman construes a woman's "taking of narcissistic pleasure in herself" not "as a compensation for a natural deficiency, but rather as a compensation for social injuries" that accordingly comes to constitute "the ground of all desire." There are in fact multiple points of accord between Donne's "Sapho to Philaenis" and twentieth-century lesbian feminism. On "similarity in *volupté*" produced by "the lover ... caressing a body whose secrets she knows, whose preferences her own body has taught her," see Colette, *Ces plaisirs* (Paris, 1932), pp. 155, 161; on the binariness by which a woman derives tactile pleasure from her own genitals and defies "a civilization that privileges phallomorphism," see Luce Irigaray, *This Sex Which Is Not One*, trans. Catherine Porter and Carolyn Burke (Ithaca, 1985), pp. 26, 208, 214.

36 Thomas Laqueur, *Making Sex: Body and Gender from the Greeks to Freud* (Cambridge, Mass., 1990), ch. 3, and Stephen Greenblatt, *Shakespearean Negotiations* (Berkeley, 1988), pp. 83–5, 181 n. 27.

Staging gender: William Shakespeare and Elizabeth Cary

MAUREEN QUILLIGAN

ह≫

The power of money, of name, of race, and of gender intermixed fluidly in the seas of more mutable social place to fix subjects at the time of Shakespeare. We remember Iago's professed concern: "Who steals my purse steals trash ... But he that filches from me my good name ... makes me poor indeed" (*Othello*, iii.iii.157–61). Iago is a shaman of the social world and clearly speaks for the preeminent power of social report in the time of Elizabeth and James; he sneers at Cassio: "I thought you had received some bodily wound; there is more sense in that than in reputation. Reputation is an idle and most false impression; oft got without merit, and lost without deserving. You have lost no reputation at all, unless you repute yourself a loser" (ii.iii.266–71). In this tragedy, of course, loss of reputation proves as dangerous as a bodily wound. His occupation gone, Othello is turned into a "dog"; having been stripped of her reputation for chastity, Desdemona is murdered. Iago's speech, and, indeed, his actions, indicate how complicatedly intertwined the relationship between body, reputation or name, and gender becomes in defining what seems (both to him and to us) to be somehow opposed to it, the "private" character, what an earlier age with a theological discourse called the soul, what used to be the "self," and what is now termed the "individual subject." The lack of coherence between text and body is even more crucial in questions of gender; as Gayle Rubin has most usefully argued, gender is society's appropriation of sexual bodi-edness, its transformation of biology into social codes which have no necessary relation to biological facts. Women are thus constituted as different from men by virtue of being signs passed "between men"; they are not, in themselves, capable of inhabiting their own subjectivity.[1]

If we take Iago at his word and look first at the cultural code of reputation in early modern Europe, we may be in a better position to unpack the interconnections between the body, gender, and economic

concerns specific to the construction of subjectivity at Shakespeare's moment. If we then investigate these interconnections not through their tragic outcome in *Othello*, but by their more comic and presumably more socially successful interactions in *The Taming of the Shrew*, we may be on firmer historical ground for understanding the relationship of gender to subjectivity and how Shakespeare's theater not only staged female obedience for the visual pleasure of its male auditors, but also outlined the parameters of discursive possibility for its female spectators. By briefly juxtaposing Kate's final speech in *The Taming of the Shrew* with the problematically disobedient speech of the self-sacrificing wife in Elizabeth Cary's *Tragedie of Mariam*, we may be better able to apprehend the part pure power plays in gender determinations. Seen from the perspective of Cary's female-authored tragedy, the shared verbal play and sheer slipperyness of language in communication between a husband and wife is less *jouissance* than the old game of dominance.

"Civil conversation" and *The Taming of the Shrew*

The Renaissance is preeminently marked by its recognition of the power of language to shape culture, though of course it also tried to hide from itself this radical knowledge. In the late twentieth century, we have taught ourselves to be remarkably sensitive to the way language constructs reality, even, and especially, our sense of the human body, which other ages have understood to be immutably physical. Thus, for example, in a book titled *Essentially Speaking: Feminism, Nature and Difference* (London, 1989), Diana Fuss argues for the ideologically constructed character of any experience, including one's personal identity. So too, Teresa de Lauretis chooses not to differentiate between the terms "sex" and "gender," because using "gender" for both allows the concept to be susceptible to the "grasp of ideology."[2] And recently, in *Making Sex: Body and Gender from the Greeks to Freud* (Cambridge, Mass., 1990), Thomas Laqueur has argued that our sense of the body is driven less by physical fact than by our "needs in speaking about it" (p. 115). Following Foucault, our special concern has been to realize the extent to which language constructs our sense of even the most natural phenomena.

While the Renaissance may have remained naive about the power language has to shape our conceptions of the body, writers of the time came close to our own suspicious awareness that formerly immutable

truths were highly susceptible to verbal manipulation. A case in point is the testimony of conduct books about the problem of class position; a good example is Castiglione's *Courtier* (1528; trans. Hoby, 1561), specifically Federico Fregoso's defense of the importance of reputation. Fregoso cautions that the courtier, "when he has to go where he is a stranger and unknown, [should] see to it that a good repute precedes him ... for a fame that is thought to result from many judgments generates a certain firm belief in a man's worth, which then, in minds already disposed and prepared this way, is easily maintained and increased by actual performance."[3]

The control of one's reputation – sending letters of introduction in advance, so to speak – is part of the elaborate program of self-presentation marked by *sprezzatura* (Hoby's "disgracing"). The underlying assumption of sixteenth-century conduct books such as *The Courtier* – insofar as they become commodities to be bought – is that it is possible by industrious study to learn those "natural" behaviors formerly thought to have been inborn, which are innately appropriate to one's class or family of origin.[4] In essence, these books assume that those (men) who can play the part convincingly become the part they play. The pervasive theatrical metaphor displayed everywhere in the culture subtends the improvisatory freedom for self-creation. Thus, George Pettie's translation of another Italian conduct book, Stefano Guazzo's *Civile Conversation* (1575; trans. London, 1581), builds on the theatrical foundation to make a claim for the power to create new class positions:

> Another used likewise to saye, that this world was a stage, we the players which present the comedie, and the gods the lookers on ... I will propose unto you a kinde of conversation not to stand us chiefly in markets, comodities, and other outward things subject to fortune, but to the end that we may thereby learne good manners and conditions, by means whereof the giftes of fortune are distributed and conserved and the favour and good will of others obtained.
>
> (C5v)

The frame story of Guazzo's conversation may prove useful by its contradiction of another of Iago's distinctions – that between physical and social wounds, fundamentally speaking, between the body and the psyche. The conversation is therapeutically aimed at helping one of the interlocutors recover from a battle wound. The wounded soldier, Guazzo's brother, has slowed his recovery because he has lost his healthy taste for society and gained a perverted taste for solitariness – just as, a simile explains, a pregnant woman gains an aberrant taste for unusual food. In order to get well of his physical ailment, he needs to be

talked out of his melancholy humor. This sixteenth-century version of conversational psychotherapy (a talking cure) is designed not to bring the patient into harmony with himself (there being as yet no distinguishably private "self" in this text), but with society.[5] Such social harmony will cure his physical wound. The content of such "conversation" includes all the discourses of society, that is, all the proper codes of behavior for all social roles, and the very frame of the dialogue sets up a close interconnection between the physical and the social self.

Such a connection makes modern medical sense. But when we introduce the question of gender into the discussion, the connection between physical health and social role becomes more intricate, because gender is one social role ideologically grounded in the physical body. Ruth Kelso has pointed out the fundamental ideological stress on the single element of chastity in conduct books for Renaissance women.[6] Suzanne Hull has shown how the triple injunction to be "Chaste, Silent, and Obedient" is the fundamental tenet for social control of the female; sexual order is ensured by policing language.[7] It would seem that a female body must be silent in order to be chaste.

But perhaps not. Kate may not be silent or obedient, but she is chaste. This fact, one of the larger differences between the tragedy of Desdemona and the comedy of Kate, helps to clarify the vital question: upon what basis is the social role of female grounded in this play? Do the discourses of role-playing, of social mobility, of individual choice for self-presentation that we see operating in contemporary conduct books for men work in any way to shape or constrain the social identification of women as women? Or is the concept of "woman" grounded in this play (as it is in the bestial imagination of Iago) on physiology or on some other physiological fact (such as family identity or birth, which includes the inherited station of class)? Poised at the threshold between two of the three major stages of social life for an Elizabethan woman – turning from unmarried girl to wedded wife – is Kate's changed role defined by physical difference, a sheer loss of virginity? To enter into the social role of wife is to change status physically, legally, economically. Tracing Kate's changes will help us to see the forces at work shaping gender. As farce, with its generic emphasis on the physical, (movement, timing, and pace), the play is an ideal text about which to ask: is gender grounded in the body, or is it defined otherwise?

The frame of the Induction to *The Taming of the Shrew* immediately suggests that the answer to this question, at least as female gender interacts with class, is that it is not grounded in the body. As many commentators have noticed, the Induction metadramatically frames the

presentation of the play as theatrical artifice nested within a huge practical joke about the role-playing of social class; but it also presents the drama as a diversion that may have a salutary impact on the realm of the physical. Within the Lord's practical joke to convince the lowborn drunkard Christopher Sly that he is a great lord, one of the Lord's men argues that seeing a comedy performed will have the same beneficial physical effect as the conversation in Guazzo's book:

MESSENGER: Your Honor's players, hearing your amendment,
Are come to play a pleasant comedy.
For so your doctors hold it very meet,
Seeing too much sadness hath congealed your blood.[8]

Not only will the play itself lengthen life by its diversionary pleasures, it will postpone (so the fiction of the practical joke goes) the moment of physical exertion in sexual intercourse that may bring on the former melancholy. Sly submits to seeing the play, because the boy who pretends to be his wife tells him that his doctors

have expressly charged
In peril to incur your former malady,
That I should yet absent me from your bed.
I hope this reason stands for my excuse.
SLY: Ay, it stands so that I may hardly tarry so long,
but I would be loath to fall into my dreams again. I will therefore tarry in despite of the flesh and the blood. (Induc.ii.121–8)

The play as a whole necessarily takes up the question of masculine desire both as a social need and as a phallic drive, implicit in the punning on "stands," a reference to Sly's physical erection. Such clever bawdy does more than evoke a laugh; it pinpoints the physical substratum of the play's analysis of the sex–gender system within the larger issue of class, here appropriately spoken by the carnivalesque and low-born Sly. My argument is not merely formal, but if we appreciate the play for the intricate social document that it is, we may also be able to guess why the Christopher Sly Induction frame should not reappear at the end of the play.

When the wife-taming Petruchio brings his baffled bride home to his country house, he beats his servants, throwing out the dinner they have prepared, and explains himself thus:

PETRUCHIO: I tell thee Kate, 'twas burnt and dried away
And I expressly am forbid to touch it,
For it engenders choler, planteth anger;
And better 'twere that both of us did fast,

Since, of ourselves, ourselves are choleric,
Than feed it with such over-roasted flesh. (IV.ii.173–8)

So begins Petruchio's politic "reign," as he "kills [Kate] in her own humour," starving her into submission, denying her food, sleep, clothes, and (most significantly) sex, training her as if she were a beast, all the while pretending that he does it in "reverend care" of her: "This is the way to kill a wife with kindness" (IV.ii.211). The pun on "kindness," meaning both loving tenderness and "nature," puts the humors theory of physiological disturbance in such close conjunction with the discourse of elective behavior – for Petruchio's gentleness is a chosen strategy – that we are forced to ask about the connection between the two. If Kate is a shrew because her humors are imbalanced, she needs only to fast to become more tractable; and indeed the thirteenth-century folk version of the shrew plot insists on just this – the wife only has to be bled by a surgeon to become instantly amenable to husbandly authority.[9] Very differently from this medieval wife, Kate is being "gentled" by the discourse of "gentility" – by the strength such a social language has to coordinate Kate's and Petruchio's sense of their appropriate roles.

The text of the play asks questions about the connection between the two such "kinds" – the connection being not merely the relationship between nature in all its phenomenal manifestations and the more arbitrary human behavior that may have no real causal connection to it; the drama highlights the unreferentiality of language. This slippery language figures prominently not only in the scenes of bawdy badinage between Kate and Petruchio, but also generally throughout the entire text.[10] The power of language to oppose its referential operation is presented most emphatically in the opening of the wintry country-house scene. Grumio reports to Curtis the farcical drama of the wedding party's disastrous journey home through the winter landscape:

CURTIS: Is she so hot a shrew as she's reported?
GRUMIO: She was, good Curtis, before this frost; but thou knowest, winter tames man, woman, and beast; for it hath tam'd my old master and my new mistress and myself, fellow Curtis. (IV.i.22–6)

Grumio calls for fire, that physical element analogous to the choleric humor, itself a physiological force in nature. However much the scene deals in real physical effects of weather, talk of Kate's "hot" shrewishness is fundamentally a figure of speech and, finally, only a figure of speech; what Curtis' question actually demonstrates is that report of Kate's bad reputation has preceded her to her country quarters. What the scene stages is not how the natural force of winter has begun to tame

her physical humor (we do not see the couple shivering in the cold). Instead we are treated to Grumio's report, and the scene actually stages the process by which Grumio's report of her tames her social reputation for shrewishness, especially when he recounts her attempts to stop Petruchio from beating him. Putative spokesman for the natural, Grumio suggests that in Petruchio's country house Kate may not be as vulnerable to her own reputation as she was in her father's house; significantly, this potential new freedom for her is voiced in terms of a misunderstanding between the figurative and the literal meaning of words.

GRUMIO: Call them [the other servants] forth.
CURTIS: Do you hear, ho? You must meet my master to countenance my mistress.
GRUMIO: Why, she hath a face of her own.
CURTIS: Who knows not that?
GRUMIO: Thou, it seems, that calls for company to countenance her.
CURTIS: I call them forth to credit her.
GRUMIO: Why, she comes to borrow nothing of them. (VI.i.99)

Grumio's insistence on the literalness of "countenance" and "credit" locates value in a different discourse than that of gentility and honor. Kate, of course, has come with plenty of money; Petruchio has succeeded in his plan of wiving it wealthily in Padua. When Grumio posits her possession of her own literal face different from any countenancing the servants might grant her in doing her honor, he demarcates her potential possession of her self (and body) by outlining her class as distinct from theirs. In this central scene, Petruchio beats his servants (as he has constantly beaten Grumio in the Padua scenes). Such beatings are generically necessary to the farce. Petruchio, however, never beats his wife. In their initial encounter Kate hits him, "to try if you're a gentleman ... If you strike me, you are no gentleman." He does not strike her then, or ever, demonstrating his own class position. Throughout the late sixteenth and seventeenth centuries, actual scolds were routinely treated to community-authorized physical abuse, as in punishments by ducking stool; such publicly mandated physical violence directed at unruly women was, according to David Underdown, at an unusual high during the years 1560 to 1640.[11] There is thus every reason to suppose that Shakespeare's audience would have noticed Petruchio's restraint in the face of Kate's provocation – and her argument about class position might therefore have had greater force. Guazzo had argued that a refusal to beat one's wife not only demonstrates gentility, but "when the wife knoweth that all the beames of her husbands love,

faith, and loyaltie shine upon her onelie … you shall see her consume cleane away in burning flames of love, and cast all her care in thinking and doing that which she knoweth will please him" (*Civile Conversation*, K3). Although Kate compares herself in her final speech to one who, like a servant, is bound to "serve, love, and obey," his treatment of her gives the lie to Petruchio's claim that she is his "chattel." The whole thrust of the play is to make this new class position of the wife (and husband) absolutely clear.

Grumio's literalization of the word "credit" has further reverberations: the staff comes to honor Kate by doing her "credit." The word as Grumio understands it does not function in the old discourse of social deference – of honoring a social superior – but in the newer arena of social currency. A money economy is based on credit, and borrowing needs to have reliable markers of social identity. Will a debtor be able to pay back the debt? Creditors are those who quite literally "believe" in the trustworthiness of their debtors' identities. We recall that Sly in his initial resistance to his new class position claims to be able to establish his identity (his reputation) not only by traditional heritage, but by an appeal to one of his creditors:

> Am I not Christopher Sly, old sly's son of Burton Heath, by birth a pedlar, by education a card-maker, by transmutation a bear-herd, and now by present profession a tinker? Ask Marian Hacket, the fat ale-wife of Wincot, if she know me not. If she say I am not fourteen pence on the score for sheer ale, score me up for the lying'st knave in Christendom. (Induc.ii.17–24)

In this carefully catalogued progress through life, Sly is a peddler who is now by profession a tinker – that is, he remains what he was at birth. Against the Lord's "practicing" to make him think that he is a great lord, we have the conservative assurance that no social change happens: Sly's identity is to remain in debt (if not always to Marian Hacket, an entrepreneurial female). While Sly may be talked into thinking that he is a Lord, he cannot be talked out of a natural preference for ale over sherry (this "bodily" taste is resistant to change). He cannot be changed by the Lord's joke. Quite differently from Sly, Kate's class *will* be changed by her lord's practicing.

The Induction makes clearer than the inner play the essential question posed by both: are actual social class and gender-role "play acting," or are they immutably bound to some "natural" ground (as, seemingly, Sly's taste for ale over sherry could never be changed)? In order for any change in role to occur, new speeches must be conned. Kate and Sly both need to learn the new language appropriate to their roles. Thus Sly

acutely asks to be instructed in how to act the husband Lord to his pretend Lady. What is the script?

SLY: What must I call her?
LORD: Madam.
SLY: Al'ce madam, or Joan madam?
LORD: Madam, and nothing else: so lords call ladies. (Induc.ii.11–14)[12]

If the Lord here offers a quick conduct-book lesson in how to "lord it," we may still see in this carefully staged representation of class code a sly critique of upper-class identity. The discourse of gender names class here quite literally. The prejudice of this play – a bourgeois city comedy, one of the few Shakespeare wrote – is tipped against the aristocracy, who will remain nameless. Lower-class women with no titles have names. Any individuality there might be for an upper-class woman, at least as seen from this lower-class perspective, fades into social title. Thus, when Sly tells his "wife" not to call him "Lord" but "goodman," since only servants should call him "Lord," the boy-actor playing the lady corrects him: "My husband and my lord, my lord and husband, I am your wife in all obedience."

In order to tame Kate, Petruchio needs not only to confront her reputation as a shrew and transform her by transforming it, he also needs to make her speak the new language of her role. He does so in part by renaming her, giving her a name that sounds more like the class rank of "Joan Madam" or "Alice Madam." Petruchio's language reassigns Kate not only a new social identity, but a new social class, somewhere between Joan and Madam:

PETRUCHIO: Good Morrow Kate, for that's your name I hear.
KATHERINE: Well have you heard, but something hard of hearing.
 They call me Katherine that do talk of me.
PETRUCHIO: You lie, in faith; for you are call'd plain Kate,
 And bonny Kate, and sometimes Kate the curst;
 But Kate, the prettiest Kate in Christendom,
 Kate of Kate Hall. (II.i.183–9)

The class syncopation of the complicatedly King Hal-like plainness of "Kate" (which includes a parodically baronial "Kate Hall") is analogous to the "honest mean habiliments" Petruchio insists they wear to her sister Bianca's wedding. For Petruchio, clothes (one of reputation's currencies) do not make the man, nor the woman either: "Our purses proud, our garments poor, / For 'tis the mind that makes the body rich" (IV.v.173–6). To see an upper-class "honor" peering through the meanness of a lower social class is to see here the discourse of a new class and

subject position (for Petruchio) appearing in the creation of a new gender-role. John Gillis argues that in artisanal family structures, which comprised a good fifty percent of the population in 1600, "marriage was a highly privileged status," one not to be entered into lightly, but only after the means to support an independent household had been accumulated: it was the major rite of passage for both men and women of this society. Only thirty percent of the population were married at any given time, and in Sheffield in 1615 only twelve percent of the population were classified as householders – and these were married men to whom the rest of the city was supposed to defer.[13] The subject of this new class bases himself in money, especially its accumulation, not its aristocratic dispense, and he measures himself by his ability to marry.

Petruchio counts it no "shame to his estate" to be so unprovided with wedding garments, but argues for some less external, some more private measure of relation in the marriage he is going to make: "To me she's married, not unto my clothes" (III.ii.119–22). It is the same argument he later makes to Kate when decreeing what they are to wear to Bianca's wedding:

> ... neither are thou the worse
> For this poor furniture and mean array.
> If thou account'st it shame, lay it on me;
> And therefore frolic. (IV.v.181–4)

All the external markers of social identity and class status that the Induction introduces as essential to the definition of a lord – clothes, food, furniture – Petruchio does not so much ignore as strategically manipulate in order to define himself and Kate's relationship to him as one supervening class. By inviting her to lay all her class shame on him, he constitutes himself as the sole arbiter of her social identity.

In the same way that Petruchio dresses against the codes others would impose upon him, he speaks against the language that has been erected around Kate to make her Katherine the cursed, and for the same motives. Hortensio, for instance, immediately depreciates Kate's worth by saying that while she is young, wealthy, beautiful, gentle, and chaste,

> Her only fault, and that is fault enough,
> Is that she is intolerable curst
> And shrewd and froward, so beyond all measure
> That, were my state far worser than it is,
> I would not wed her for a mine of gold.

Petruchio responds:

> Hortensio, peace! thou know'st not gold's effect. (iii.85–92)

The effect of gold is to make Petruchio discredit reputation and to reevaluate Kate to herself: " 'Twas told me you were rough and coy and sullen. / And now I find report a very liar" (ii.i.245–6). When Petruchio further corrects the slanderous world for reporting that "Kate doth limp," we begin to see his policy. If report – by which all judge her and through which her behavior will be interpreted – has lied about her body, it is also capable of misinterpreting her behavior. If there is, however, no direct connection between social discourse and physical fact, Kate may be free to be changed by a different language: Petruchio simply presents his as an alternative authority for defining her behavior. The false report that "Kate doth limp" enacts the way civil conversation constructs even bodily facts. If her father told all the world she was a froward daughter, all her husband needs to do is tell the world she is a perfect wife. For an actress to limp, or for a producer to stage the scene so that Kate does, in fact, limp before she hears of the false rumor, is to miss the play's point about the construction of social reality through language (though if she limps after hearing about the report, as if she had only just noticed that, in fact, she does limp a bit, the point is well made). Kate's first appearance on stage announces her concern for her own reputation; she argues with her father for letting Bianca's suitors taunt her:

> KATHERINE: I pray you sir, is it your will
> To make a stale of me amongst these mates?
> HORTENSIO: Mates, maid! how mean you that! No mates for you,
> Unless you were of gentler, milder mould.
> KATHERINE: I'faith, sir, you shall never need to fear.
> Iwis it is not half way to her heart. (i.i.57–62)

Referring to herself in the third person, and acting out the part assigned to her, Kate fulfills her father's script. Petruchio names this script immediately, "Father, 'tis thus; yourself and all the world / That talked of her, have talk'd amiss of her." When the assembly points to the obvious failure of his wooing (Kate has berated him in public) he establishes the "truth" of Kate's character by removing it from their public appraisal into the arena of the private relationship between husband and wife:

> Be patient gentlemen; I choose her for myself.
> If she and I be pleas'd, what's that to you?
> Tis bargain'd 'twixt us twain, being alone,
> That she shall still be curst in company. (ii.i.304–7)

To say that what is instituted here by Petruchio's claim for the primacy of his private compact with Kate is the newly private, companionate marriage, is to perceive not much that is new.[14] But to perceive how it happens through a careful adjustment of social discourse – the rewriting of a single woman's reputation – is to see displayed the construction of a new subject position for the husband by the construction of a reclassed role for the wife.

Having won Kate's consent to be wed, Petruchio must continue to seduce her into accepting his discourse (in contrast to that of her father and society) as definitive. He has redefined her against the authority of her father and his associates; now he must make her accept that her nature is in fact transformable. The fact that he can teach her "How-to" stop being a shrew reveals the same social premise that underlies the courtesy books: social behavior is not a natural, biologically determined fact; it can be learned (and unlearned).[15] Petruchio educates Kate in self-restraint by the proper Renaissance method of doctrine by example rather than by rule. To say that he demonstrates to Kate how to practice self-restraint may seem wildly to mistake his character in the play, where everyone else notes that, compared to his shenanigans, Kate's are tame. However, in the country-house scene, she and he will "fast for company." Petruchio eats no more than she. If she is kept from sleep by his brawling, Petruchio, no more than she, can satisfy this instinctual need. He waits on her at table to bring her to say "thank you," demeaning himself to the level of servant. On Curtis' testimony, his restraint would appear to include as well the curbing of sexual desire: Petruchio makes a "sermon of continency to her" on their wedding night. It is important to acknowledge that the marriage has not been consummated until after Bianca's wedding ceremony and the gambling match. If Kate is changed physically into a wife before she accepts the role on its own purely social terms, the clear separation of social discourse from physical fact would be blurred, as it can be blurred in the regimen of starvation and sleeplessness.

Petruchio offers his discourse as definitive, but he also insists that it be seen as arbitrary; its currency derives from the value his authority gives it, and only from that. The conversation they have on the way back to Padua as they retrace the steps of their earlier farcical journey through the natural wintry landscape reveals the essential arbitrariness of the language of his authority. When Petruchio calls the sun the moon ("I say it is the moon") and Kate contradicts him ("I know it is the sun"), he insists upon absolute obedience. It is not what she "knows," but what he says that determines reality. Suddenly, she decides to "humour" him.

KATHERINE: Then God be blessed, it is the blessed sun.
 But sun it is not when you say it is not,
 And the moon changes even as your mind.
 What you will have it named, even that it is,
 And so it shall be so for Katherine.

<div align="right">(IV.v.29–33)</div>

The sun and the moon are two forces in nature, themselves often gendered – the one giving light and promoting growth, the other ruling the sea with its monthly, natural tides and the monthly seasons of female physiology. Petruchio's insistence enacts the quintessential arbitrariness of the sex–gender system, as he renames natural (and by extension biological) facts however he will, organizing them to serve his own masculine authority. Kate's continued reference to herself in the third person betrays the similarity of the scriptedness of this speech to her earlier acceptance of her father's authority. One may see in the more formal name some resistance to his authority, perhaps, but it is hardly massive room in which to maneuver and to speak a self.

On the immunity language here claims from the fixed laws of nature rests what freedom Kate has to authorize her own name, and readers are quick to insist on the way in which Kate's hyperbolic embellishments of Petruchio's antics present her own share in the play between them.[16] The further joke Petruchio plays on the true Vincentio, father to Lucentio, fortuitously appearing at this moment, makes more emphatic his power over her – "Tell me sweet Kate, and tell me truly too, / Hast thou beheld a fresher gentlewoman" – and also emphasizes that this joking concerns gender-roles primarily: "[He] will make the man mad, to make a woman of him." Not only a woman of a man, but a young woman of an old man, a maid of a father. When Petruchio calls an end to the joke, we see in Kate's apology to Vincentio not only her quick wit, but also her character's insistence on a naturalistic discourse:

Pardon, old father, my mistaking eyes
That have been so bedazzled with the sun
That everything I look on seemeth green.

<div align="right">(IV.v.45–7)</div>

Such a joke, shared as it is between an ideal Elizabethan couple who now speak the same discourse, enacts the divorce between language and nature (it does not change the "facts"); it is no less arbitrary than the Lord's tricking Sly, or Tranio's disguise, or the pedant's pretense to be Vincentio – and no less potentially powerful. Though Vincentio is momentarily thought to be a madman when he arrives in Padua, the patriarch is protected, the usurper is soon unmasked, and the son immediately asks forgiveness of the father.

Petruchio's insistence that social behavior takes shape in a realm divorced from the natural could have had the potential for freeing femaleness from the constriction of the formula that "anatomy is destiny." For Shakespeare's text to posit a conduct-book-like freedom in going beyond "naturally" prescribed roles and class opens a potential arena for women as well as men to move beyond the prescriptions society assigned them at birth. As we have seen, however, this freedom is only put to the use of reassigning Kate another male-defined social role. She merely moves from behaving like a shrew to behaving like an obedient wife. However, for the text to have demonstrated to its audience the liberating powers of language at all, utterly arbitrary and thus potentially free, also frees up some potential room in which Kate might identify herself. But before we can see how this freedom is immediately recontained and explicitly regrounded in biology, we need to see how the play continues to reinforce the arbitrary assignment of value to gender role.

The wagering at the bridal banquet that closes *The Taming of the Shrew* reappraises the women in it. What Petruchio is betting on in crediting his wife's "new built virtue and obedience" is authority for behavior more reliable than the training, position, and reputation upon which Bianca and Hortensio's widow have grounded their behavior. It is important to remember that Petruchio not only bets on Kate, he bets against Bianca and the widow. Bianca has had an educational experience analogous to Kate's and one which has given her her own authority: with scholars she has studied languages (including, very specifically, Greek and Latin), music, and poetry. However empty its charade, her instruction had at least some pretenses to humanistic enterprise. The widow, at least before she remarries, has had her own dowager wealth; her authority rests upon her financial independence. Kate's obedience is revealed to be of much greater value than either Bianca's humanist education or the widow's money – two of the few means by which individual women in the early modern period could have accrued some sense of self-worth. Kate's value is greater, and further measured not only in the one hundred crowns she wins for Petruchio, but in the twenty-thousand crowns Baptista promises to give his son-in-law: "another dowry to another daughter, / For she is chang'd as she had never been." Petruchio thus gets not only a twentyfold, but a two-hundred fold return on his original wager. In the gambling, an activity where money is made to function in its most obviously arbitrary manner, the homosocial relations of the traffic in women are specifically enacted. Women pass in exchange from one man or group of men to

another at any marriage feast: the gambling explicitly asserts the financial nature of the exchange, and recalls the bartering Baptista has earlier instituted in the bidding match between Bianca's suitors.

However, Kate does not merely come back to the banqueting room in obedience, winning the bet; she stays to make a "public" speech. Her final oration about woman's duty is a tour de force of Renaissance sententia about the naturalness of female submission. In grounding her arguments about women's appropriate behavior in the female body, she would seem to be authorizing a script that is masculinist at its most regressive. "Why are our bodies soft and weak and smooth, / Unapt to toil and trouble in the world, / But that our soft conditions and our hearts / Should well agree with our external parts?" (v.ii.165–8). The language of the natural body, kept so carefully distinct from the authorizing terms throughout the play until this moment, returns with full force.

> Thy husband is thy lord, thy life, thy keeper,
> Thy head, thy sovereign; one that cares for thee,
> And for thy maintenance commits his body
> To painful labour both by sea and land . . .
> And craves no other tribute at thy hands
> But love, fair looks, and true obedience. (v.ii.146–54)

It is important to note that Shakespeare has radically rewritten this whole speech as it appears in "A Shrew" (xvii, 16–43), specifically substituting the argument from the body in the place of scriptural citation. While such a substitution of bodily difference for biblical authority suppresses the anti-female bias of the Genesis text and refounds female submission not on commanded obedience to a divine power, but in the "free" choice of domestic economics, it also regrounds hierarchy in the biological. The social institution installed by Kate's speech is a very forward-looking family – where the non-productive wife pays feudal fealty to her merchant husband. Also subtly indicated in Kate's notion of "debt" is the sexual duty of marriage. The marriage "debt," at least for such as the Wife of Bath, had meant specifically the sexual intercourse due the wife by the husband. Here Kate's discourse on the debt of wifely submission and obedience earns her immediate payment of this marriage debt: "Come Kate, we'll to bed. / We three are married, but you two are sped" (v.ii.185–6). Kate's language suggests that the last gesture is a physical rendering of the metonymic wifely hand that pays tribute to the husband. She tells the women to

> place your hands below your husband's foot;
> In token of which duty, if he please,
> My hand is ready; may it do him ease. (v.ii.177–9)

The text of her speech vehemently naturalizes obedience by the language of the body. If we acknowledge the possibility that the play makes clear Petruchio's restraint of his physical appetite (and right) until this moment, the text might seem to grant Kate the exercise of her own biologically gendered sexual desire at the moment of her most freely chosen obedience (just as Guazzo had promised); in Renaissance theories about female sexuality such a move makes sense, for reproductive biology at the time held that female orgasm, conceived as a parallel to male ejaculation – that is, both pleasure and active desire – was necessary for conception.[17]

At the end Kate conforms to social role-playing in direct contrast to the witness of her "mistaking" all social categories on the road to Padua.[18] Any return of the Christopher Sly frame would have completely undercut the discourse of the body in Kate's speech, because Sly's wife would have to be revealed to be no wife but a boy. The successful playing of the Induction's trick depends on restraint; it will work, according to the Lord, "if it be husbanded with modesty" (Induc.i.68). The players act, as they put it, "naturally" specifically when they "act." And so too, the Lord chooses to explain Sly's very unlordly behavior to the players (who are not in on the joke) by telling them that Sly has never seen a play before, as if classed behavior were synonymous with the learned cultural experience of play-going. For his part, the Lord's page boy, although not a professional player, is able, like a woman, "to rain a shower of commanded tears," playing the role the way a woman would play it (and if he cannot, an onion will help).

The return to Sly would necessarily have called attention to the institutional artifice of the sixteenth-century theater, an artifice predicated on the boy-actor's ability convincingly to transgress the physical reality of gender.[19] Kate would also have been played by a boy (perhaps the same boy), no more suitable for the representation of real female desire than Sly's page. Without the return of the frame, the fiction of Kate's femaleness is left intact and the audience can imagine that what it sees is a "real" woman choosing her own role as wife, speaking her own physical desire within that role, and not a wholly masculine fantasy played out by a male of what a wife ought to be. Shakespeare's plays often call attention to this artifice, especially as a means of closure. Here, however, because in order to work gender ideology needs to be regrounded in the body it defines, it is not appropriate to call attention to the disembodiedness of gender-role – that, in fact, a boy can do it as well as a girl, so eminently playable is it.

Karen Newman has recently argued that the "bisexual aspect of

representation" in the *Shrew* "deconstructs its own mimetic effect," the "indeterminateness of the actor's sexuality" finally "subvert[ing] the patriarchal master narrative ... by exposing it as neither natural nor divinely ordained, but culturally constructed."[20] While this is in fact true – hence the play needs to suppress the facts by neglecting the frame – the celebration of gender instability such an argument winningly purveys perilously neglects the social effect of the reasons for the boy-actor's presence on the stage. When Kate's new social role of wife needs immediately to be grounded in the body, the play comes up against the limits of its own theatrical conventions. If it is forced to let the constructedness of sexuality be represented by the indeterminate boy-actor's gender, it is also forced to try not to call attention to the fact – not because the theater as an institution recognized the freedom and fluidity of social role, but because women were not allowed on stage. The final paradox of the last speech is not merely that patriarchy cannot naturalize its proscription in the female body because that body is not present on stage, but that the body's absence was decreed by the very proscription such naturalization would hope to serve.

Giving voice in Elizabeth Cary's *Tragedie of Mariam, Faire Queen of Jewry*

To turn to a female-authored closed drama, Cary's *Tragedie of Mariam* (printed in 1611), is immediately to confront the limitation placed on female behavior which necessitated the use of boy-actors in Shakespeare's theater: proper women did not speak in public. Mariam's first question to herself – "How oft have I with publike voyce runne on?" – states the initial problem undertaken by the play: how thorough-going must obedience – and silence – be?[21] What we see at once in Cary's play about the wife of Herod, king of the Jews, and sister-in-law to the infamous Salome, is that the proper policing of the physical basis of appropriate wifeliness is insignificant when compared to transgressions at the verbal part of the "chaste–silent–obedient" triad. Differently from Shakespeare's farce, in Cary's drama being a wife is distinctly not role-playing. Mariam is a wife exemplary in her chastity, but, distinct from Ruth Kelso's argument, in having that virtue she does *not* possess sufficient power to claim any freedom for herself to define what her role will be. Cary's text provides a useful contrast to Kate's speech because it provides at least another response to the discourses defining wifeliness, voiced from one who had experienced subjectivity in the terms society

decreed for a woman moving from the middle to the gentried class. In Cary's place we may trace the complicated effects Kate's speech may be supposed to have had on women who attended the all-male theater. The very choice of closet drama would, at the very least, seem to underscore the fact that the public theaters barred women.[22]

Although Herod does in fact listen to Salome's malicious gossip that Mariam has fallen in love with another man, Mariam is condemned to death by her husband Herod not so much because she is unchaste, as because she will not conform to his demands upon her mind. In Cary's drama, the wife's role demands that she not merely play the obedient echo to her husband's soul, but *be* that unreverberant echo. A hard, and virtually impossible, task, especially when, as Mariam makes clear, she hates her husband for having murdered her father and her brother. Her bitterness has turned her critical, and she has, as she confesses in the opening line of the play, presumed to make that criticism public. Having run on with "publick voice" against Herod, she half regrets how critical she has been of her husband. She thus laments what she quite erroneously assumes is his death, a false rumor having reached Jerusalem that the king has been executed by the Romans. When Herod in fact comes back in the best of health, Mariam cannot make herself be happy at his return. The chorus of this classicizing closet drama makes clear the extreme form of the ideal which Mariam will not meet:

> That wife her hand against her fame doth reare
> That more then to her Lord alone will give
> A private word to any second eare,
> Though she may with reputation live.
> Yet though most chaste, she doth her glory blot,
> And wounds her honour, though she kills it not.[23]

Any speech beyond the ear of her own husband gains the wife an ineradicable taint. Speech, even to a second person, is to take the hand away from where it belongs – where Kate would put it, beneath the husband's foot – and to raise it against one's own fame as virtuous wife.

In a bit of role-playing Herod demonstrates for Mariam what she must do: while he temporizes and excuses, explaining that he did not murder her brother, but actually promoted him to the priesthood, he expects her either to believe him or to pretend that she does:

> Did not I shew to him my earnest love,
> When I to him the Priesthood did restore?
> And did for him a living Priest remove,
> Which never had been done but once before? (iv.iii; p. 41)

Unlike Kate, Mariam does not pick up her cue. Instead she states the tragic truth: her husband murdered her brother:

MARIAM: I know thee mov'd by importunitie,
You made him Priest, and shortly after die. (*ibid.*)

The remarkable sillepsis on "made," which makes equal both pro-motions – to Priesthood and to death – parodies the kind of taciturnity required of Mariam as a good wife. She accuses him in as few words as possible, making "made" do double duty, thereby condemning her husband's hypocrisy.

Herod's outburst makes his power-play absolutely explicit: "I will not speake, unles to be beleev'd" (IV.iii; p. 41). Similar to Petruchio's "crossed and crossed and everywhere crossed," Herod insists that she take his lie for the truth. Here, however, while the process is uncannily the same, the stakes are far different. What Herod asks for is not merely play with notions of the sun and the moon, but Mariam's obsequious pretense that she does not know he murdered her brother.

Mariam can no more play her part than can Hamlet – thus when Herod asks "Yet smile my dearest Mariam, doe but smile, / And I will all unkind conceits exile," Mariam stubbornly answers, "I cannot frame disguise, nor never taught / My face a look dissenting from my thought" (IV.iii; p. 41). Cary's heroine, unlike Shakespeare's, must enact her own thought. She will not be betrayed into a Bianca- or Kate-like charade. And like Hamlet, she pays for her sincerity with her life.

Wifeliness is not merely a role one may play; Cary's insistence in the play is that Mariam must conform her innermost thoughts to the role. The heroine is not allowed the escape modern readers might wish for Kate when they assume that she is only joking. So too, for Cary, wifeliness is far more than a thing of the body: Mariam is chaste, but her chastity is no protection for her independence of mind. In her final soliloquy, before she goes to her death, Mariam acknowledges that, unlike Petruchio, she has wagered too much on Herod's love for her. Although not even Cleopatra could seduce Herod away from his love for wife Miriam, she herself could make him turn from her:

> Had not my selfe against my selfe conspirde,
> No plot, no adversarie from without
> Could Herods love from Mariam have retirde,
> ...
> But now though out of time, I plainly see
> It could be drawne, though never drawne from me:
> Had I but with humilite been grac'te,
> As well as faire I might have prov'd me wise:

> But I think because I knew me chaste,
> One vertue for a woman, might suffice. (IV.viii; p. 53)

Chastity is not all; it is finally no more sufficient for Mariam than it is for Desdemona. Such remarkable explicitness makes clear what *The Taming of the Shrew* hints at; the injunction against speech and against publicness is not a means to secure sexual control. Rather, the terms of sexual control are there to ensure the verbal blankness – so to speak – of the other, the conformability of the will of the wife to her husband.[24] The role of wife is one in which a woman exercises her self only to erase her self so that her husband may have a self. She is not to be mute, but to provide a "conversation" out of which he will construct his self. What she says, she says *only* to him.

As Mariam goes to her death, her mother follows along railing upon her daughter. When Herod asks the messenger "What answer did her princely daughter make?" he is informed that Mariam was silent:

> She made no answere, but she lookt the while,
> As if thereof she scarce did notice take,
> Yet smilde, a dutiful, though scornful smile. (IV.viii; p. 57)

Scornfully dutiful to her mother and silent, the last thing that Mariam actually says is, in fact, for Herod's ear. When the Nuntio tells him that she called to him by name, Herod pleads to know what her last words were: "But what sweet tune did this faire dying Swan / Afford thine eare: tell all, omit no letter" (IV.viii; p. 58). What the text has Mariam say is a very slippery statement: "Tell thou my Lord thou sawst me loose my breath" (IV.viii; p. 58). The spelling of "loose" allows the text to have it both ways: Mariam not only "loses" her breath by dying, she sets her speech "loose," finally free from Herod's control in death. Herod's remark, with its own double meaning, underscores the doubleness of Mariam's: "Oh that I could that sentence now controule." This ambiguous sentence conveys both the wish that he could recall his sentence of death upon her, and also the wish that he could continue to exercise control over the conversation she now willingly goes to her death to keep free from his command. Her last act is Samson-like, both prayerful and silent. The Nuntio finally reports that

> After she some silent praier has sed,
> She did as if to die she were content,
> And thus to heau'n her heau'nly soule is fled. (IV.viii; p. 58)

The pun on "lose/loose" allows Mariam's double meaning to escape Herod's ability to impose a single sense on her sentence. In order to do that he would have to recall his sentence of death. Such wordplay enacts

in malo the play we enjoy *in bono* between Petruchio and Kate when he, for example, takes her "tale" and turns it into a sexual "tail." Inside an all-male theater, Shakespeare's play presents such puns as verbal wittiness between men enjoying a joke about women being forced to talk dirty.[25] Outside that institution, in a "closet drama" quasi-anonymously authored by a woman, but printed for public consumption, Cary exposes the bodily costs of female public speech. While Karen Newman is right to insist that Kate at least continues to speak (p. 98), we must balance that textual fact against the historical understanding that what the boy-actor says on her behalf contributes to the silence of women.

The difference between Cary's and Shakespeare's versions of such play between spouses is fundamentally generic to be sure, but because Cary's version also speaks to the historical actualities of the suppression of women's speech (especially "public" speech), we are forced to see it as a gendered difference as well. Even so authorized a female speech as that of Elizabeth I, who spoke both as woman and as sovereign, aroused very complicated cultural responses, and the burgeoning critical literature on the representation of Elizabeth witnesses the depth and reach of these cultural complications.[26] David Underdown repeats Alice Clark's guess that the move to repress women's social agency, which reached a peak in the years 1560 to 1640, was due to fears aroused by social dislocations caused by the slow change to a capitalist society.[27] So too, Susan Amussen outlines how proscriptions about class order could be questioned in complaints to justices of the peace, but also demonstrates that the strict social code governing gender was seldom questioned in theory, though often breached in practice.[28] Amussen in particular points out that when they went to court, women sued to protect their sexual reputations, further guessing that "while the refusal to focus on the non-sexual aspects of their relations with men was not disruptive, it provided a covert critique of relations within the family" (p. 209). Given the silence of women in court on the question of submissiveness, it is all the more interesting that Cary's Mariam is so concerned to criticize herself for her wifely failings.

If we return most briefly to *Othello*, we may see how the command of wifely silence and obedience is not merely part and parcel of chastity, but is the overriding issue of marriage. When Emilia comes upon the strangled Desdemona and her murdering husband, she asks: "O, who hath done / This deed?" Desdemona lives long enough to say:

Nobody – I myself. Farewell.
Commend me to my kind lord. O, farewell! (v.ii.122–4)

Her speech shows the kind of control Mariam had yearned for and
Herod prized. Desdemona is perfect. But what does that perfection
mean? The wife is nobody, what she does is nobodiness. Her very self
consists in not being a self, not being even a body, but a bodiless
obedient silence.

This is an impossible ideal, and one not even Shakespeare's theater
chooses to enforce, for there is, of course, another wife on stage. Emilia
confesses that she is the one who will speak – "I must needs report the
truth" – and, were Othello not to confess, the truth would be that Des-
demona had killed herself. What the truth becomes is that wives finally
must speak. When Iago tells her to keep quiet, she makes a careful choice:

Good gentlemen, let me have leave to speak.
'Tis proper I obey him, but not now. (v.ii.192–3)

And again:

'Twill out, 'twill out! I peace?
No, I will speak as liberal as the north.
Let heaven and men and devils, let them all,
All, all cry shame against me, Yet I'll speak. (v.ii.216–19)

In the end, Emilia, no less than Mariam, is murdered for her speaking;
Iago finally himself does what he makes Othello do: "Sure he hath killed
his wife" (v.ii.233). So too Emilia's final words are "So speaking as I
think, alas, I die" (v.ii.248).

What makes Othello wish to kill Desdemona is the power of report,
the social language spoken and manipulated with such mastery by Iago,
by such as Petruchio, and also by such as Salome who tells Herod that
Mariam has been unfaithful. Petruchio's control over Kate's reputation
is no less complete than Iago's over Desdemona's – both women are
chaste, as is Mariam. But chastity is not enough. What is newly
necessary in the close confines of modern marriage is the wife's
self-restraint, so that she does not require beating in order to be
obedient. If Kate learns to be a new wife by exercizing the public silence
that is her true calling, limiting herself to a companionable conversation
conformable to her husband's newly absolute authority, it is that silence
which allows the discourse of the male self. In *Othello*, we may see that
social ideal cracking and shattering along the lines of its internal
contradictions. Were Emilia not to go against her evil husband's
commands to return home, keep silent, the truth would not get told, and

the back of his evil plot would not be broken. In the tale from which Shakespeare took the plot, the wife of the Iago character never speaks out to save Desdemona, although she knows more of what is necessary to save her. Shakespeare's "wife" speaks as soon as she understands what the matter is. The source wife lives long after all the principals are dead – indeed she lives to tell the tale, for she is its "author." On stage Emilia dies, for like Mariam she must pay the price for breaking wifely silence, for speaking out in public against her husband.

Such moments of wife-murder are to be sensed as tragic versions of such theatrical self-references as Rosalind's epilogue or Cleopatra's decision to commit suicide so that she would not be presented in Rome by someone "boying her greatness." The masculine limitation of Shakespeare's theater does not in fact lame the presentation of female characters so much as it continuously indicates how female character (like male character) is prescribed and constructed by the very social practices which require that women must pay the price of absence in an all-male theater. If actual women do not speak on Shakespeare's stage, the boy-played women who do necessarily spend a great amount of time dealing with the fact that they should not. Paradoxically, it is when Shakespeare's text would enforce a reality beyond the artifice of his theater that his plays becomes most time-bound. At the moment when Kate attempts to moor the ideology of wifeliness in the body, the theater must forget the boy-actor beneath, so that Kate's appeal to the physical proof offered by the female body is to a substratum which can only be metaphorically present at that moment. Cary's unacted drama displays the social deformation at work in the crucial fact of Shakespeare's stage: boys had to be female impersonators because women were not allowed to appear on stage. For Cary, the loosing of female breath in an imagined public spectacle was simultaneously authorial freedom and sexual shame. But that act of transgression was also a play, the first to be published in English by a woman.

Notes

1 "The Traffic in Women: Notes on the 'Political Economy' of Sex," in Rayna Reiter, ed., *Toward an Anthropology of Women* (New York, 1975), pp. 157–210. For the problem of women posed as a class question, see Peter Stallybrass, "Patriarchal Territories: The Body Enclosed," in Margaret W. Ferguson, Maureen Quilligan, and Nancy J. Vickers, eds., *Rewriting the Renaissance: The Discourses of Sexual Difference in Early Modern Europe* (Chicago, 1986), pp. 123–44, and Jordan's essay in this volume.

2 *The Technologies of Gender: Essays on Theory, Film and Fiction* (Urbana, 1987), p. 9.

3 *The Book of the Courtier*, trans. Charles Singleton (New York, 1959), p. 129.

4 See Frank Whigham, *Ambition and Privilege: the Social Tropes of Elizabethan Courtesy Theory* (Berkeley and Los Angeles, 1984).

5 For a critique of assumptions that place the arrival of the modern "self" too early, see Francis Barker, *The Tremulous Private Body: Essays on Subjection* (London and New York, 1984), esp. p. 38.

6 *Doctrine for the Lady of the Renaissance* (Urbana, 1978), pp. 24–5.

7 The title of Hull's bibliographic study of all the books printed in England during the Renaissance aimed at a specifically female readership indicates the main burden of their advice: *Chaste, Silent, and Obedient: English Books for Women, 1585–1640* (San Marino, Calif., 1982).

8 *The Taming of the Shrew*, ed. Robert B. Heilman (New York, 1966), Induc. ii.129–32; all references hereafter cited in the text are to this edition.

9 Cited in Geoffrey Bullough, *Narrative and Dramatic Sources of Shakespeare's Plays* (1957; repr. New York, 1961), vol. I, p. 62.

10 See Joel Fineman, "The Turn of the Shrew," in Patricia Parker and Geoffrey Hartman, eds., *Shakespeare and the Question of Theory* (London, 1984), pp. 141–4.

11 "The Taming of the Scold: the Enforcement of Patriarchal Authority in Early Modern England," in Anthony Fletcher and John Stevenson, eds., *Order and Disorder in Early Modern England* (Cambridge, 1985), p. 119. Underdown argues that this period coincided with increasing accusations of witchcraft, and both, he speculates, may have been tied to social dislocations caused by rapid economic change. He locates the greater incidence of ritual disciplining of scolds in wilder, less settled wood-pasture communities, and notes, further, their distinctly theatrical tinge (p. 129).

12 In the source play, "A Shrew," Slie never gets an answer to his question about the lady's name; instead he is given the names of his lower-class servants whom he treats as equals. See Bullough, *Sources*, p. 72 ("Shrew," I.i.35–41).

13 *For Better, For Worse: British Marriages, 1600 to the Present* (Oxford, 1985), p. 15.

14 Cf. Lawrence Stone, *The Family, Sex, and Marriage in England, 1500–1800* (New York, 1977), and *The Crisis of the Aristocracy, 1588–1641* (Oxford, 1965).

15 Tita French Baumlin argues that Petruchio "cures his wife's linguistic illness more with language than with physical brutality toward her," in "Petruchio the Sophist and Language as Creation in *The Taming of the Shrew*," *SEL* 29 (1989), 238–9.

16 A representative argument is John C. Bean, "Comic Structure and the Humanizing of Kate in *The Taming of the Shrew*," in Carolyn Lenz, Gayle Greene, and Carol Neely, eds., *The Woman's Part: Feminist Criticism of Shakespeare* (Urbana, 1980): "Kate is tamed not by Petruchio's whip but by the discovery of her own imagination, for when she learns to recognize the sun for the moon and the moon for the dazzling sun she is discovering the liberating power of laughter and play" (p. 72).

17 Laqueur, *Making Sex*, pp. 99–103.

18 On the interpretive difficulty in assimilating Kate's last speech to the play as a whole, see Jean Howard, "The Difficulties of Closure: An Approach to the Problematic in Shakespearian Comedy," in A. R. Braunmuller and J. C. Bulman, eds., *Comedy from Shakespeare to Sheridan: Change and Continuity in the English and European Dramatic Tradition* (London and Toronto, 19), pp. 113–28.

19 See Coppélia Kahn, *Man's Estate: Masculine Identity in Shakespeare* (Berkeley, 1981), pp. 104–18, and Fineman, "The Turn of the Shrew," esp. p. 159: "Sly's metatheatrical desire for the pageboy defines the essence of femininity as masquerade."

20 "Renaissance Family Politics," *English Literary Renaissance* 16 (1986), 100.

21 For a discussion of the problematic question of public speaking fundamental to the whole drama, see Margaret W. Ferguson, "'How oft haue I with publike voyce runne on?" in Florence Howe, ed., *Tradition and the Talents of Women* (Urbana, forthcoming).

22 Closet drama was, of course, a favored genre of the women (and men) in the Sidney circle; see Mary Ellen Lamb, *Gender and Authorship in the Sidney Circle* (Madison, 1990), pp. 129–33.

23 *The Tragedie of Mariam, The Faire Queene of Jewry. Written by that learned, vertuous, and truly noble Ladie, E.C.* (London, 1613), available from The Women Writer's Project, Brown University; III.iii, p. 37.

24 Milton's definition of marriage in the divorce tracts makes a similarly extreme demand for conversational "fitness"; it is possible that Milton knew Cary's play and might well have found it interesting for its discourse about divorce (Salome considers arrogating to herself the rights offered men by Jewish law). It may well have formed one part of the context of Milton's own closet drama, *Samson Agonistes*, where similar issues are taken up.

25 Cf. Juliet Fleming, *Ladies Men, the Ladies Text, and the English Renaissance* (London, forthcoming), and her essay in this volume.

26 See Marie Axton, *The Queen's Two Bodies* (London, 1977); Leah Marcus, "Shakespeare's Comic Heroines, Elizabeth I and the Political Uses of Androgyny," in Mary Beth Rose, ed., *Women in the Middle Ages and the Renaissance* (Syracuse, 1986), pp. 135–53; Louis Montrose, "*A Midsummer Nights Dream* and the Shaping Fantasies of Elizabethan Culture," in Ferguson, Quilligan, and Vickers, eds., *Rewriting the Renaissance*, pp. 65–86; Patricia Parker, "Suspended Instruments," in *Literary Fat Ladies: Rhetoric, Gender, Property* (New York and London, 1987); and my "The Comedy of Female Authority," *English Literary Renaissance* 17 (1987), 156–71.

27 "Taming of the Scold," p. 126. Antonia Fraser outlines the remarkable social categories in which women exercised agency in seventeenth-century England, but her title acknowledges the ideological assumptions against which they all worked: *The Weaker Vessel: Womenn 17th-Century England* (New York, 1984). For a discussion of the remarkable power women were able to exercise in the face of patriarchal ideologies, see Margaret Ezell, *The Patriarch's Wife: literary Evidence and the History of the Family* (Chapel Hill, 1987).

28 "Gender, Family and the Social Order," in Fletcher and Stevenson, eds., *Order and Disorder*, esp. p. 210: "The general acceptance of the gender order stands in marked contrast to the attitudes toward the class order."

The semiotics of masculinity in Renaissance England

DAVID KUCHTA

ঌ

In her classic article "Did Women Have a Renaissance?" Joan Kelly speculates on the dynamics of gender relations in Renaissance court life, arguing that the male courtier began to "adopt 'woman's ways' in his relations to the prince."[1] In Kelly's reading of Castiglione, the Renaissance courtier's dependence on the prince was signified by the "accommodation of the sixteenth- and seventeenth-century courtier to the ways and dress of women" (p. 44). Femininity was identified with the manipulation of appearances, as noblewomen lost all forms of power other than charm. The courtier was thus feminized when he used courtly display to attract the favor of the prince. "To be attractive, accomplished, and seem not to care; to charm and do so coolly – how concerned with impression, how masked the true self. And how manipulative . . . In short, how like a woman – or a dependent, for that is the root of the simile" (p. 45).

Kelly's analysis raises important questions about the relationships between gender and power – gender as a form of power, to be sure, but also the similarity, the "simile," between political and gender ideologies. This essay will take up Kelly's analysis by considering the semiotics of masculinity in the English Renaissance court. It will analyze the relationship between political ideals of masculinity, and attitudes to display and attraction. How was masculinity represented, and what was the connection between the phenomenon of courtly display and the political construction of masculinity? Was there a "simile" between political dependence and gender dependence? Was the courtier feminized?[2] This chapter will argue that, although Kelly was correct in linking the phenomena of attraction, charm, and display to political dependence, political dependence and display themselves were not inherently gendered. As will become clear, men's use of sartorial splendor was seen as compatible with dependence on the crown. More importantly, élite

masculinity was defined in part as properly sumptuous display, as living up to the sartorial expectations of the crown. What this chapter will analyze, then, is the semiotic regime which defended sumptuous masculine attire in the Renaissance court.

Noble privileges of sumptuous male display did not go unchallenged during the Renaissance. Elizabethan and Jacobean England was sufficiently fluid in its social structure to challenge any aristocratic monopoly on conspicuous consumption.[3] Elite prerogatives to sumptuous dress were undercut by new wealth, destabilizing a seemingly natural association between the display of wealth and claims to élite status. This challenge from below may have encouraged traditional élite groups to solidify their claims to sartorial splendor. Yet sumptuous male display was not without its critics either. Puritans, mercantilists, and country gentlemen opposed the import of Italian ideals of courtesy and the Italian (and later French) fashions which accompanied them. Critics helped shape an image of the court as the locus of vice, luxury, tyranny, and effeminacy – an image which would be an important element in the outbreak of the Civil War. In country ideology, following fashion was a sign of effeminacy and servitude, while the freeborn gentleman's virtue was signified by "simplicity and wholesome pleasures based on religion and respect for tradition," as Perez Zagorin has written.[4] Country gentlemen linked effeminacy with sumptuous display and political dependence: manly simplicity signified political autonomy; restraint symbolized freedom. In this politicized vision of masculinity, fashion was merely an external imposition by tyrannical and arbitrary custom.

Courtiers and gentlemen thus stood uneasily between challenge and criticism. The desire for a visible social order did not mesh easily with claims to a visible moral order. Faced with this ambivalence, defenders of the crown and court constructed a definition of masculinity which argued for the morality of male display, yet made it theoretically inaccessible to all but the nobility. In assertive language meant to gloss over fluid boundaries, they defined high expenditure as the exclusive prerogative of the nobility, yet justified it as liberality not prodigality, as magnificence not extravagance, and as manliness not effeminacy. What critics saw as debilitating softness, defenders saw as honorable bravery. Two public definitions of masculinity competed with each other in Renaissance England, and we can trace this competition in courtesy manuals, sermons, and literary sources. Of course it would be difficult to claim that either definition captured the reality of sartorial practices in Renaissance England – rather, they provide insight into the ways in which ideals of masculinity were constructed and contested by religious,

political, and cultural factors (to name but a few), and warn us against ahistorical speculation about the true nature of masculinity in Renaissance England. This chapter will analyze the way in which a semiotics of masculinity was constructed to justify élite male display during the English Renaissance.

Beauty adorns virtue

As is well known, Castiglione and other Italian courtesy writers had an immense impact on English courtesy theory. English writers influenced by Italian courtesy rhetoric include Henry Peacham, Thomas Elyot, Francis Bacon, Francis Osborne, William Higford, and the author of *The English Courtier*.[5] In this discursive tradition, dress and manners were not mere externals: they were manifestations of internal worth, graceful supplements to nobility. Thomas Adams wrote: "Oh how comely are good cloathes to a good soule, when the grace within, shall beautifie the attire without."[6] Adams echoed Castiglione's formula: "therefore is the outward beauty a true sign of the inward goodness, and in bodies this comeliness is imprinted, as it were, for a mark of the soul."[7]

In this semiotics of masculinity, the hypothetical "true sign" consisted of an identity between outward beauty and inward goodness, between material signifier and social signified, between appearance and status. Noble dress and noble status were meant to resemble one another. In effect, this clothing regime worked by a hierarchy of analogies, by the resemblance between social standing and clothing expenses. Silk and satin were noble, flannel and fustian were humble. This accords with Michel Foucault's characterization of Renaissance semiotics: "it was resemblance that organized the play of symbols, made possible knowledge of things visible and invisible, and controlled the art of representing them."[8] (Foucault later refers to this episteme as a "hierarchy of analogies" [p. 55].) Dress was meant to make status visible by the one-to-one correspondence between social level and level of expenditure. The poet Barnabe Barnes opined that "all garments should be ... in worth and fashion correspondent to the state, substance, age, place, time, birth, and honest custome of those persons which use them."[9] The higher the status, the richer the fabric; wealth should correspond to worth. "The use of soft cloathing" and fine fabrics, as the archbishop of York, John Williams, argued, is confined "to those due circumstances to which they are designed. They are not for every sole

and private man, to gather about him a gaping multitude, but for magistrates and other remarkeable persons, imployed in governing estates, and serving of Kings."[10] Material fabric and social fabric resembled one another; beauty adorned virtue: riches well bestowed were "a great ornament, and setting foorth to a gentleman;"[11] in rich apparel and ornaments "the beames of magnificence shine, which is numbred amongst the principallest vertues heroicall."[12]

The hierarchical resemblance between clothing and status, like the social order itself, was considered to be natural, though (and this will be a key point in this semiotics) the clothes themselves were not seen as inherently endowed with status. In the abstract, it was considered natural for noble men to wear noble clothes, and in this sense the hierarchy too was deemed natural. The resemblances, however, were not. There was much more ambivalence in determining which men, and what clothes, were themselves noble. In this discourse, it was the state's role, not nature's role, to determine nobility by legal means. The crown should legitimate claims to nobility, in men as well as in clothes, and thus help naturalize the relationship between clothing and status. The natural icon, then, was socially naturalized, arbitrarily motivated. It is this oxymoron which defined the semiotics of élite masculinity in the Renaissance court.

Since costly apparel naturally graced the courtier, he had to fashion an unaffected attitude towards it. He needed to feel at home in the sumptuous trappings of his station, a naturalness and nonchalance which Castiglione called *sprezzatura*. *Sprezzatura* meant displaying ease, whereas affectation meant a mismatch between appearance and social status in a hierarchy which itself was considered natural. "Men's behavior should be like their apparel," Francis Bacon advised, "not too strait or point device [precise], but free for exercise or motion." Likewise, Bacon argued that "if he labor too much to express [good forms], he shall lose their grace, which is to be natural and unaffected."[13]

To the modern reader, this created appearance of nonchalance seems like deceit, manipulation, and effeminacy: "how masked the true self . . . how like a woman," as Joan Kelly quipped. It was, however, precisely the opposite. To be sure, nonchalance was self-consciously created, but it was a created naturalness – with all the instability and ambivalence that this implies. It meant cultivating a political image which accorded with a natural order, acting and dressing according to one's sexual and social station. It meant being truthful in one's appearances, neither feigning a false modesty nor affecting an unearned extravagance. Affectation and impersonation were condemned because they drew attention to the

theatricality, the self-fashioning, the created image – not because the image was false, but because the immediacy of signification, the affiliation between appearance and reality, the correspondence between signifier and signified, was lost. In this semiotics, affectation was the misuse of signs, the loss of transparency, the loss of their proper, noble significance. It is in ceremonies and appearances, Stefano Guazzo wrote, "that the inward love may bee knowne, as well as the outwarde honour is seene, other wise ceremonies are lothsome unto us, and shew that the hearte is faigned" (p. 166). When outward honor manifested and resembled inward love, display was a true sign. Otherwise, when outward honor was merely purchased by upstarts, the signifier lost its graceful relationship to what it signified. It was worshipped for itself rather than for its referentiality. As a legal status (rather than an economic class) nobility could not be purchased or affected, but it nonetheless had to be displayed and proclaimed.

Apparel proclaims the man

Sprezzatura, "the master trope of the courtier,"[14] was thus also the master trope of this semiotics of masculinity: the display of a one-to-one correspondence between appearance and social position, the image of a due proportion between fabric and rank. No statement better captures this semiotics than Polonius' advice to his son Laertes:

> Costly thy habit as thy purse can buy,
> But not expressed in fancy; rich, not gaudy,
> For the apparel oft proclaims the man.[15]

Laertes' dress should be as costly as his purse could buy, and thus correspond to his status. He should express this status through richness not gaudiness, though Polonius does not tell us how to distinguish between the two. The difference was determined more by attitude than actual garment. The difference was not how much money one invested in clothes, but how much symbolic value. The difference, then, was one which relied on the semiotic status of the garment. Apparel, as Shakespeare neatly summarized, "proclaims" the man (not "makes" him, as is often incorrectly quoted). Rich clothing proclaimed gentility, represented it, and made it conspicuous. Proclaiming is an act of attribution, ascription, while making is an act of creation, production. In this semiotics, sumptuous dress did not make or create gentility, as upstarts desired. If defenders of this semiotic regime argued that the higher the

status, the finer the fabric, they accused upstarts of believing that the finer the fabric, the higher the status. This double standard meant that the correspondence between material fabric and social fabric was not iconic, but arbitrary.

In this discourse, then, there was nothing inherent in clothes themselves which gave them nobility or masculinity. Henry Peacham quoted Plutarch: "gold and silver, worn by martial men, addeth ... courage and spirit unto them; but in others effeminacy, or a kind of womanish vanity."[16] The relation between signifier and signified was arbitrary, dependent upon the context, and upon the wearer. Clothes were considered to be arbitrary not in the sense of being random, but in the sense of being conventional, historically determined, rather than ahistorically and naturally fixed in their meaning. The signifier only secured its proper meaning when it corresponded to a preexisting social station. Gold added courage only to "martial men" – that is, men of the aristocracy. "Womanish vanity" was this loss of correspondence, the misappropriation of signs by those who did not merit their noble significance. In themselves, clothes were innocent, arbitrary, conventional: it was their connection with nobility which made them noble. Only within their hierarchical correspondence did they become naturalized. Count Annibale Romei praised "costly garments, pretious jewels, sumptuous pallaces, magnificent furniture," yet warned that "neither riches, nor sumptuous vestimentes make a man noble" (pp. 246, 187). The clothes did not make the man.

To assume otherwise was effeminacy. For Renaissance courtesy writers, gender and semiotics were linked. Effeminacy was found in the affected misuse of signs by vain upstarts. Effeminacy meant dressing out of place, thus calling attention to one's dress in a kind of "womanish vanity." Effeminacy was idolatry: treating arbitrary signifiers like idols endowed with inherent meaning, mistaking signifier for signified. William Rankins condemned those "self-soothing sots" who

> have no firmer vertue than a name:
> But who so thinkes the signe the substance is,
> Erres, and his wit doth wander much amisse.[17]

Effeminacy meant semiotic instability, as signs lost their grace, the natural affiliation between clothing and status:

> Grace is nothing else but something akin to a light which shines from the appropriateness of things that are suitably ordered and arranged one with the other, and in relation to the whole ... Thus, a man must not embellish himself like a woman, for his adornments will then contradict his person, as I see some

men do, who put curls in their hair and beards with a curling iron, and who apply so much make-up to their faces, necks, and hands that it would be unsuitable for any young wench, even for a harlot who is more anxious to hawk her wares and sell them for a price.[18]

Overdressing was a form of semiotic prostitution, an impure traffic between signifier and signified, an exchange muddled by an immoderate attention to materiality. Elsewhere, della Casa linked immoderate dress with homosexuality: "Your garments should not be extremely fancy or extremely ornate, so that no one can say that you are wearing Ganymede's hose."[19] Courtly masculinity was defined in opposition to a series of "wanton and sensual imperfections,"[20] which were themselves linked with materiality: prostitution, homosexuality, and effeminacy. Effeminacy was a loss of moderation, "an effeminate spruceness, as much as a fantastic disorder," as the royalist and Anglican Owen Felltham wrote.[21]

Clothing, then, was a dangerous supplement to masculinity. Masculinity sat ambivalently between the extremes of homosexuality and prostitution, differentiated from them only by its moderate attitude to materiality, by its nonchalance toward the signifier. To presume that material signifiers made the man was to destroy the hierarchy of analogies so central to Renaissance masculinity. Effeminacy involved misappropriating the symbols of the warrior class. Aristocratic masculinity rested on "bravery" both in battle and in dress. Adornments should moderately embellish a nobleman, but not to the extent that they "contradict his person," as della Casa wrote. Moderation, of course, was a relative term, one which stood precariously between modesty and prodigality, simplicity and extravagance. Men should apply makeup, but not "so much make-up." Effeminacy was found not in display and adornment, but in excess. Properly used, the material sign should bring grace and shine; improperly used, materiality might lead to debauchery and sensuality. There was thus a fine and invisible line – called moderation – between the proper and improper use of signs. The difference between virtuous magnificence and vicious prodigality existed not in the garment itself, nor in the eye of the beholder, but in the station and attitude of the wearer. James I advised his son to be "moderate in your raiment; neither over superfluous, like a deboshed waister; not yet over base, like a miserable wretch; not artificiallie trimmed and decked, like a Courtizane; nor yet over-sluggishly clothed, like a country-clowne; not over lightly, like a Candie-souldier, or a vain young Courtier; nor yet over gravelie, like a Minister."[22] Moderation was not artificial vanity, but it was not precise modesty or gravity either.

Such were the sins of debauchees, courtesans, country gentlemen, upstarts, and puritans. James I repeated the major formulae of courtesy advice on dress when he counselled:

> In your cloathes keepe a proportion, as well with the seasons of the yeare as of your age: in the fashions of them being carelesse, using them according to the common form of the time, some-time richelier, some-times meanlier clothed as occasion serveth, without keeping any precise rule therein. For if your minde be founde occupied upon them, it will be thought idle otherwaies ... But speciallie eschewe to be effeminate in your cloathes, in perfuiming, preening, or such like: and faile never in time of warres to be galliardest and bravest, both in cloathes and countenance. (p. 151)

Distinguishing between bravery and artificiality was a difficult task, especially since courtesy literature argued that there were no "precise rules" for dress other than conformity to custom. One form of consumption signified bravery, the other clownishness. One led to a proper display of aristocratic masculinity, the other led to debilitating effeminacy. The difference between the two was precisely one of attitude, of displaying a certain carelessness, of not being "found occupied upon" fashions. The internal sensibility of moderation – a semiotic sensibility – was compatible with the external display of being galliardest and bravest.

That James I rejected effeminacy but advocated bravery in dress should lead us to question the long-standing association between homosexuality, effeminacy, and male display in Jacobean England. Diana de Marly has flatly asserted that "King James I of England and VI of Scotland was a homosexual and this changed the character of the court considerably," leading England into an "effeminate and wanton age."[23] The historical association between homosexuality and effeminacy is best known in Lawrence Stone's account of the crisis of the English aristocracy in the century prior to the Civil War. Stone has speculated: "It was the Court that led the fashion, and a philandering queen followed by a homosexual king no doubt gave an added incentive to the movement: both Elizabeth and James had an eye for the well-dressed young man."[24] Stone's musings are not mere errant remarks in his classic work: for Stone, the aristocracy's abnormal adoption of conspicuous consumption was "led by the monarch themselves [sic]" (p. 562), contributed to "the general downward trend of aristocratic fortunes" (p. 197), and exacerbated the crisis of confidence in aristocratic society which culminated in the Civil War. The corrupting influence of homosexuality thus seems to play an important role in Stone's account of the crisis of the aristocracy. Yet as we have seen, conspicuous male display

was compatible with aristocratic masculinity, and Stone provides no evidence to suggest that James I encouraged men to dress beyond their means. Certainly James adopted standard courtesy tropes to defend the elaborate dress of his noble courtiers – but this defense was not specifically linked with sexual preferences, except in the homophobic minds of his critics.

It should be clear from this evidence that much courtesy literature written and read in Renaissance England rejected considering male display in itself as effeminate, even when it was meant to attract the attention of the prince. Defenders of the courtier saw conspicuous male display not as a lesser form, but as a different definition of masculinity. In much courtesy literature, the courtier was not feminized when he used display, contrary to Kelly's claim. The ethics of attraction and the aesthetics of display were not inherently gendered. Gender was certainly displayed – "all garments should be neat, fit for the body, and agreeable to the sex which should wear them," as Barnabe Barnes argued (p. 15) – but the phenomenon of display itself was not gendered. The manipulation of appearances was not "woman's ways," nor, for that matter, was it specifically "man's ways," as similar strictures and prerogatives applied to court ways, a subject beyond the scope of this chapter. For the English courtier, then, bravery in dress was justified by bravery in battle. Conspicuous consumption was considered a rightful and manly honor bestowed upon him by his noble status and position at court. Rich clothes proclaimed high status. Conspicuous consumption made the social order conspicuous. Effeminacy, on the other hand, was the misuse of these arbitrary status symbols, and thus a threat to the social order by the base materiality of the nouveau riche.

The crown proclaims the clothes

How, then, was effeminacy to be prevented in an age which saw a growing number of nouveaux riches, an increase in social mobility, and the relative decline of aristocratic fortunes? Who was to arbitrate between the proper and improper use of arbitrary signs? Who regulated the correspondence between signifier and signified? Courtesy writers here called upon the crown. If clothes were arbitrary signifiers, and their meaning determined by social custom, then it should be the prerogative of the crown to control such custom. Since there was nothing inherent in clothes, nothing natural which gave them nobility, it was only the constant reenforcement of the hierarchy of analogies which might

guarantee their proper signification. Only an explicit and frequent repetition of their intended meanings could assure that fine fabrics remained the signs of nobility. If silk was noble, it was only because royal proclamation made it so. Signifiers took on social meaning because of state policy, not natural affiliation. To be sure, fine fabrics had intrinsic material qualities – softness, rarity, craftsmanship, shine – but it was considered that these properties only took on sexual and social meaning through social convention. Richness in fabric corresponded to high social status only because the crown limited the purchases of the untitled wealthy. An economic order defined by wealth corresponded to a legal order defined by worth only through royal proclamation. In this hierarchical order, the crown distributed clothes to each according to their social "needs."

Improperly distributed, arbitrary signifiers might be misused arbitrarily: their excessive dissemination could lead to riot and disorder. In this semiotic regime, nothing was greater feared than polysemy. It was thus the crown's role to guarantee the hierarchy of analogies, to regulate the proper correspondence between fabric and rank. It did this by sumptuary law, which reached its zenith under Elizabeth.[25] Sumptuary proclamations were often issued, though rarely enforced. Since the frequency of their issue, and the lack of cases prosecuting infringements, suggests that sumptuary laws were futile, they are testimony more to a social thought about dress than to any actual practice.

Through the declarative power of sumptuary law, the crown attempted (apparently unsuccessfully) to legislate the nation's habits of consumption and thereby regulate the general economy of signs. In this great hierarchy of analogies, no one under the degree of earl, for example, was permitted to wear cloth of gold, silver, or tinseled satin. No one under the degree of husbandman was allowed to wear hose made of cloth costing more than 2s. per yard.[26] Attempting to assure a direct traffic between signifier and signified, the crown tried to guarantee that the misuse of signs would not dilute their noble value: a sort of Gresham's law of semiotics. The increased frequency of royal proclamations against excessive dress under Elizabeth may testify to the increase of new wealth during her reign, as is often argued, but it also suggests that Elizabeth, more than her predecessors, saw the monarchy as the guardian of semiotic stability. It was considered a royal prerogative to ensure conformity to fashion. The political regulation of the display of social distinctions, then, was primary in Elizabethan sumptuary policy. Sumptuary proclamations, in theory if not in practice, were the legal guarantee of the hierarchy of analogies, the arbiters of the economy of signs.

If clothes proclaimed the man, then it was the crown which pro-claimed the clothes. Royal proclamation made sumptuous court dress merely a uniform to be donned without affectation, one which should gracefully correspond to station, one for which there was no precise rule other than court custom itself. Castiglione offered no exact rules for fashion, "but that a man should frame himself to the custom of the most" (p. 126). Clothes should not make an impression on a man's heart, for that was affectation and effeminacy: rather, they should be worn in due obedience to the crown. Archbishop Williams considered that princes "express their magnificence ... in their outward garment, whether it were gown, cloak, or mantle of estate, which they might be said to bear only" (p. 26). Conformity to fashion signified nothing more than a man's position at court and his fidelity to the crown. The entire hierarchy of analogies which guaranteed the courtier's claims to sump-tuous apparel depended upon the support of the monarchy. Thus the protean courtier should be able to adapt himself to current court fashions. "For clothes," wrote the MP Sir William Cornwallis, "he that shunnes singularity (for from singularity comes eyther disdaine, or envy) let his attire be conformable to custome, and change with company ... In many things (as in this) custome is a thing indifferent, and things indifferent receyving their life from light grounds; every countrey hath some peculiar to it selfe by which when we are there, we ought to be ruled."[27]

For the courtier, conspicuous consumption was the rightful honor bestowed upon him by his position at court, by the good will of his monarch. Fine dress was a "thing indifferent," an arbitrary court convention to which noblemen should conform with nonchalance. In themselves, costly garments were innocent, gender neutral. Properly used, they were noble; improperly used, they were affected, vain, and effeminate. Though richly apparelled, the nobleman ultimately should treat clothing as a thing indifferent. For the courtier, donning sump-tuous dress was, in theory at least, merely an act of uniformity.

As is by now clear, the resemblance between material fabric and social fabric was arbitrary, not motivated by any natural properties of the signifier-fabric. In themselves, clothes had no intrinsic social or religious worth, only one which derived from their position within a social hierarchy. On this point, my analysis differs from Michel Foucault's account of Renaissance theories of the sign. For Foucault, Renaissance knowledge considered signs as natural icons whose signifying power "resides in both the mark and the content in identical fashion" (p. 30). This is the basis of the resemblance between signifier and signified, a

resemblance which, in Foucault's account of Renaissance thought, was inherent in the sign, whether that sign was a natural object or a linguistic form: "In its raw, historical sixteenth-century being, language is not an arbitrary system" (p. 35). From the evidence presented here, however, one can argue that although signs were considered to be based upon resemblance, that resemblance was established by convention: though based on physical resemblance, the icon was seen to be dependent upon convention. The arbitrary icon, a notion alien to traditional semiotics, had natural properties intrinsic to it, but the relation of those properties to their referent was established by custom.[28]

Thus we have seen a social doctrine of conspicuous consumption, a political doctrine of crown prerogative, and a semiotic doctrine of the arbitrary icon merge into an episteme of masculinity. The Renaissance semiotics of masculinity was based on a hierarchy of analogies, a system of resemblances between clothing and social position. Material fabric corresponded to social fabric. Rare and gentle fabrics signified gentility, while cheap and coarse cloth denoted commonness. This hierarchy was determined and guaranteed by royal proclamation, which commanded conformity in such "things indifferent" as court dress. The courtier needed to cultivate an indifference to his clothes, as they were merely a state-instituted uniform. Any attitude to clothing other than indifference was affectation, pride, vanity, or effeminacy. Noble liberality merged with nonchalance. In this semiotic regime, then, conspicuous consumption among the nobility was socially necessary, politically commanded, and semiotically arbitrary. It is this notion of the arbitrary icon which justified sumptuary inequalities, and which allowed conspicuous consumers not only to ward off accusations of effeminacy and immorality in dress, but to accuse upstarts of precisely the same thing. A social order was – at least in their own eyes – discursively compatible with a moral order. Upper-class masculinity was compatible with fashionability. Thus although display at court was "an art of conduct tailored to the social and political exigencies of Renaissance despotism," as Daniel Javitch has argued,[29] there was no "simile" between political dependency and gender dependency. In this semiotic regime, display itself was not gendered, while masculinity, not effeminacy, was defined as conformity to court custom.

Of course, this Renaissance semiotics of masculinity would not last. It collapsed in the general political, economic, and religious crisis of the seventeenth century. Court critics would criticize the idea of the arbitrary signifier in the same language that they criticized arbitrary rule. Inspired by puritanism and country ideology, a new, iconoclastic

discourse considered courtly signs not as arbitrary signifiers, but as evil icons with inherent sinfulness and intrinsic effeminacy. Court-sponsored dress was "polutid openly with popishe supersticion and idolatry," as the puritan Anthony Gilby wrote.[30] Court dress was semiotically over-determined, and in itself caused corruption and effeminacy. "Soft cloathes introduce soft mindes. Delicacy in the habit, begets an effeminacy in the heart," warned Richard Brathwait.[31] In this iconoclastic discourse, vanity and effeminacy originated in the clothes, not in the heart. Outward beauty was no longer a true sign of inward goodness, but led to moral corruption. Delicacy begat effeminacy. The clothes made the man: such was the danger inherent in court dress. The freeborn Englishman, however, was autonomous and self-sufficient, and did not need the dangerous supplement of display. True masculinity would be displayed by a condemnation of the signifier, a fashion which disdained fashion – with all the instability that this implied.

It was this iconoclastic discourse, this anti-fashion, which ended the Renaissance episteme and gave birth to a new, "classic" regime (in Foucault's terms) in the second half of the seventeenth century. It was this discourse which gave us as well a new masculine appearance: the relatively modest three-piece suit, introduced in the late seventeenth century. Historical analysis of Renaissance courtesy and Renaissance masculinity has long borrowed much from the metaphysics of Renaissance court critics, a gendered metaphysics with its own historically produced privileging of the signified over the signifier. For it is this discourse, finally, which looks at the display, ornamentation, and manipulation of appearance by the Renaissance courtier and exclaims, "how like a woman."

Notes

1 (1977), repr. in *Women, History and Theory: The Essays of Joan Kelly* (Chicago, 1984), p. 44.
2 I would like to thank Randolph Starn for originally posing this question to me.
3 Lawrence Stone, *The Crisis of the Aristocracy* (Oxford, 1965), p. 123.
4 *The Court and The Country* (New York, 1971), p. 34.
5 For further data, see Frank Whigham, *Ambition and Privilege: The Social Tropes of Elizabethan Courtesy Theory* (Berkeley, 1984), p. 199 n. 99, and the essays by Quilligan and Schoenfeldt in this volume.
6 *The Gallants Burden* (London, 1614), p. 54.
7 *The Book of the Courtier*, trans. Thomas Hoby (1561; repr. New York, 1907), p. 347.

8 *The Order of Things* (New York, 1973), p. 17.

9 *Foure Bookes of Offices: Enabling Privat Persons for the Special Service of all Good Princes and Policies* (London, 1606), p. 15.

10 *A Sermon of Apparel, Preached before the Kings Majestie and the Prince his Highnesse at Theobalds, the 22. of February, 1619* (London, 1620), pp. 24–5.

11 Stefano Guazzo, *Civile Conversation*, trans. George Pettie and Bartholomew Young (1581; repr. New York, 1967), p. 188.

12 Count Annibale Romei, *The Courtiers Academie* (1598; New York, 1969), p. 253.

13 Gordon Sherman Haight, ed., *Essays and New Atlantis* (1597; New York, 1942), pp. 215, 213.

14 Whigham, *Ambition and Privilege*, p. 93.

15 William Shakespeare, *The Tragedy of Hamlet Prince of Denmark* (1600–1), ed. Edward Hubler (New York, 1963), p. 51.

16 *The Worth of a Penny* (1647) (London, 1669), p. 28.

17 *Seven Satires* (1598), ed. A. Davenport (London, 1948), p. 5.

18 Giovanni della Casa, *Galateo* (1558), trans. Konrad Eisenbichler and Kenneth R. Bartlett (Toronto, 1986), pp. 53–4.

19 *Galateo*, p. 54.

20 Robert Greene, "A Quip for an Upstart Courtier" (1592), in *Harleian Miscellany*, vol. v (London, 1745), p. 372.

21 *Resolves Divine Moral and Political* (1620) (London, 1840), p. 275.

22 "Basilikon Doron. Or, His Majesties instructions to his Dearest Sonne, Henry the Prince" (1606), in Henry Morley, ed., *A Miscellany* (London, 1888), p. 150.

23 *Fashion for Men: An Illustrated History* (London, 1985), p. 45.

24 *The Crisis of the Aristocracy* p. 564.

25 Reed Benhamou, "The Restraint of Excessive Apparel: England 1337–1604," *Dress* 15 (1989), 27–37.

26 Act of 24 Henry VIII, cap. 13 (1532), in *A Collection in English, of the Statutes nowe in force, continued from the beginning of Magna Charta, made in the 9. yeere of the reigne of King H.3 untill the ende of the Session of Parliament holden in the 23. yeere of the Reigne of our gratious Queene Elizabeth* (London, 1583), pp. 13–16. This Act was frequently renewed under Elizabeth.

27 *Essayes* ([London,] 1600), essay 24, fo. Va54.

28 For a review of recent literature on "iconicity" which shares this notion of the arbitrary icon, see Paul Bouissac, "Iconicity and Pertinence," in Bouissac, Michael Herzfeld, and Roland Posners, eds., *Iconicity: Essays on the Nature of Culture* (Tübingen, 1986), pp. 193–213.

29 "*Il Cortegiano* and the Constraints of Despotism," in Robert W. Hanning and David Rosand, eds., *Castiglione: The Ideal and the Real in Renaissance Culture* (New Haven, 1983), p. 17.

30 *To My Lovynge Brethren That is Troublyd Abowt the Popishe Aparrell, Two Short and Comfortable Epistles* (n.p., 1566), p. 451.

31 *The English Gentleman and Gentlewoman* (London, 1641), p. 278,

Recuperating women and the man behind the screen[1]

DOMNA C. STANTON

෧෨

In *Rabelais and his World*, Bakhtin cites *Le Caquet de l'accouchée* (*The Cackle of the Confined Woman*), a set of short, anonymous texts published sequentially in 1622, to illustrate the "degeneracy" of grotesque realism.[2] Though he concedes that "a tiny spark of the carnival flame is still alive" in these "fashionable" writings (pp. 105–6) – eight of which were collected in the *Recueil général des caquets de l'accouchée* (1623) and reprinted seven times before 1650 – he highlights their differences from the "very old" tradition of "female gathering[s] at the bedside of a woman recovering from childbirth ... They were marked by abundant food and frank conversation, at which social conventions were dropped," Bakhtin continues: "The acts of procreation and eating predetermined the role of the material bodily lower stratum" (p. 105). By contrast, in the post-Rabelaisian *Caquets de l'accouchée*

> the author eavesdrops on the women's chatter while hiding behind a curtain. However in the conversation that follows, the theme of the bodily lower stratum ... is transferred to private manners. This female cackle is nothing but gossip and tittle-tattle. The popular frankness of the marketplace with its grotesque ambivalent lower stratum is replaced by chamber intimacies of private life, heard from behind a curtain. (p. 105)

Bakhtin perceives the importance of the eavesdropper, but the binary oppositions that structure his comparative discussion of the "traditional" female gathering and the *caquets* reveal the ideological agenda and the gender blindspots of his study. His paean to the ambivalent grotesque realism of the carnival, which subverts dominant beliefs and affirms the devalued or denied, finds its crowning expression in Rabelais, but is then, according to his Marxist scheme, recuperated by the serious, official culture of the absolutist state and reduced to a low literary genre with monologic meaning. In the process, marketplace frankness about the "lower bodily" organs of ingestion, excretion, and

reproduction, which represent openings to the world, for Bakhtin, was suppressed by civilized manners; and the body was bounded, closed off, privatized with the rise of the bourgeoisie. Exemplifying these shifts from the lower bodily stratum to manners, from the popular, public marketplace to the private, bourgeois chamber, *Les Caquets de l'accouchée* thus set the stage for the "alcove realism" of the nineteenth century (p. 106), and subtextually throughout Bahktin's critique, the official, sexually repressive homogeneous culture of the Stalinist state.[3]

However, Bakhtin's vision of carnivalesque folk culture seems nostalgic, utopian, religious when juxtaposed with early modern scenes of the lying-in.[4] As de Lincy showed in the introduction to his 1855 edition of the collected *Caquets de l'accouchée* – their most recent edition – fifteenth-century texts by Aliénor de Poitiers and Christine de Pizan highlight the luxurious chambers of recuperating aristocratic and bourgeois women.[5] In what became a topos of the genre, Pizan's *Trésor de la cité des dames* (1405) inveighs against the pretensions and upward mobility of wealthy bourgeoises who act like queens at their lying-in (pp. xxxiii–xxxv). Already in medieval texts, then, Bakhtin's mythical marketplace frankness is conspicuous by its absence. At the same time, the enclosed upper-class setting contextualizes important social issues that undermine the reductive Bakhtinian dichotomy between public space and private life.

Even more significant, however, is Bakhtin's failure to consider the sex–gender system at work in representations of the lying-in as an integral aspect of that "ideological environment, which forms a solid ring around man."[6] Concerned with the privatizing implications of eavesdropping on chamber intimacies, he does not consider the masculine subject position of the narrator of the *caquets*, much less examine gender ideology in scenes of recuperating women, which are already appropriated by male authors in sixteenth-century texts. Coquillart's *Les Droits nouveaux* (1513), for example, uses the lying-in to satirize women's rivalrous squabbles over the beauty of their face, or the shape of their ass ("Each one has hers touched to see / If it's ill-formed, if it's fine / If it's tucked, if it's tight / If it's thin, how, and how much / If it's long or round, or square"); to chastize women's criticisms of men ("That's where they discuss our minions. / And spare neither the deaf man nor the fool."); above all, to ridicule their "jargon" and "jumble." The devaluation of female discourse, and the androcentric notion that women only talk about and compete for men, recuperate and assuage the phantasmatic fear of being excluded, or becoming targets of criticism by the second sex, and thus of reversing roles in the sex–gender

system. The anonymous sixteenth-century satire *Les Quinze Joies de mariage* dramatizes these fears. In the third joy, or more accurately tribulation, of marriage, a henpecked husband, become cook and housekeeper to his lazy, extravagant, and duplicitous wife, is eaten and drunk out of house and home by the stream of women at the lying-in who nevertheless denounce his domineering manner. "He is so tamed," bemoans the male narrator, "you could lead him by the chain to tend the sheep ... [he] will end his days miserably."[7]

The phantasmatic fears and the gender ideology inscribed in these (re)constructions of the lying-in can be identified with the misogynistic pole of the early-modern *querelle des femmes*, but they cannot be dissociated from the carnival or its grotesque realism, Bakhtin to the contrary notwithstanding. As historians and literary critics have shown in recent years, the carnival was a multivalent phenomenon that provided a temporary release from established hierarchies, but also served to reinforce dominant ideologies. And as Davis and others have argued, the carnival may have widened behavioral options for women, and affirmed their excessive life-giving powers, but it also redeployed "taboos around the female body as grotesque ... and as unruly when set loose in the public sphere." That the masquerade of the fierce virago was often donned by men, and incited popular uprisings in the early modern period, suggests the power of this misogynistic representation, just as its enactment of role reversals dramatizes women's subordinate status.[8]

In his quest for a transhistorical oppositional context, however, Bakhtin ignores the gendered specificity of the grotesque, embodied by the "senile, decaying and deformed flesh" of pregnant hags in Kerch terra-cotta figurines (p. 25), even though it points to men's fear and loathing of female reproduction and aging. And he claims that, in his greatness, "Rabelais took the most advanced and progressive positions" in the political conflicts of his time (p. 452), thus revealing, as Booth put it, "a comfortable acceptance of ... open misogyny and covert sexism" (p. 167). Indeed, Bakhtin strains to ascribe early modern misogynism exclusively to Christian asceticism, insisting that the popular or Gallic tradition "obviously" does not offer "a negative, hostile attitude toward woman" as the incarnation of the lower bodily stratum, because "the image is ambivalent" (pp. 240–1). So saying, Bakhtin does not see the ideological implications of identifying females only with the material body. And he hides behind the screen of a curiously unambivalent ambivalence, like those insurgent men who donned women's skirts.

Not surprisingly, then, Bakhtin ignores the phallocractic implications of the term *caquet* when he declares tautologically that in the *Caquets*

de l'accouchée "female cackle is nothing but gossip and tittle-tattle" (p. 105). If the term denotes "the hen's clucking when she lays an egg" (Robert, under *caquet*), its early modern synonyms were "pratling, tatling, babbling, tittle tattle, much talking," as Cotgrave confirms. By analogy, the term generated verbs, adjectives, and other nouns, including *caquetoire*, "a place where women meet and pratle together" (Cotgrave); or, as Henri Estienne explained in 1583, *caquetoire* "designated the chairs ... on which the ladies were seated (especially about a recumbant woman) when each one wanted to show her mouth wasn't frozen-stiff" (Huguet, under *caquetoire*). By extension, a man can be disparaged (and feminized) as *caqueteux* for his "boring, backbiting, simpering, sugary prattle" (Huguet, under *caqueteux*). But as late as 1694, as the *Dictionnaire de l'Académie Française* illustrates, the primary association for *caquet* was "*le caquet de l'accouchée*, the discussion of trifles that usually occurs at the home of women in childbed."[9]

Aside from being trivialized as *bagatelles*, women's conversations in the absence of men have traditionally been denigrated as gossip. And the connection between a gossip, a term that first designated a godparent, and *le caquet* is highlighted by Doctor Johnson's definition, "one who runs about tattling like women at a lying in."[10] As Spacks has observed, gossip is identified with women, more broadly, with subordinates, whose "idle" talk betrays the secrets of the dominant, and can both challenge their powerful public image, and create cohesion among the unempowered group. Woman's "loose tongue," with its erotic connotations, can constitute a threat to the superordinate image and interests of men, and thus the perpetuation of the sex–gender system.

Beyond their devaluation of women's talk, *Les Caquets de l'accouchée* recuperate the exclusive femaleness of the lying-in through the presence of the voyeuristic male narrator. By penetrating this space, he symbolically avenges the excluded male, for instance, the henpecked husband of *Les Quinze Joies de mariage*. The re-presentation of the scene through the male gaze frames, controls, degrades the gathering and loose bantering around fertile women. This textual construction assumes special significance during the period 1550–1650 which, as Merchant and Bordo have shown, was obsessed with the untamed generativity of nature and/as woman, and mobilized religious, legal, scientific, and medical institutions to control it.[11]

The desire to contain the threat of women assumes even more specific meaning in the context of early seventeenth-century France. The proliferation of *caquets* in 1622, and the publication of the *Recueil général* in 1623, edited to create a uniform narrative frame and chron-

ology, follows upon the troubled and unpopular Regency of Marie de Médicis (1610–17), and her struggles for power with her melancholy and suspicious son, Louis XIII (1601–43), which led to her first exile and subsequent military confrontations with him until their tenuous reconciliation in 1620. And the publication of the *caquets* coincides with the king's absence from Paris to fight minor battles against the protestants in the Béarn – Louis XIII is said to have preferred soldiering and hunting to ruling the kingdom – while Marie, reinstated in the ruling State Council, commissioned Rubens to glorify her life and reign in nine monumental paintings. That Marie incarnated the woman on top in deviation from Salic Law, the virago who tries to usurp the place of her rightful ruler, may explain in part why the end of her regency coincided with the onset of the first and perhaps most virulent of the *querelles des femmes* of the seventeenth century. The debate was reignited by Jacques Olivier's *Alphabet de l'imperfection et malice des femmes* (1617), which denounces women's faults from A to Z, supported by classical and biblical references: *Regnorum Ruina* ("the ruin of kingdoms"), *Truculenta Tyrannis* ("cruel tyranny") and *Garulum Gutter* ("chatterbox"), the "idle words" of "shameless women." Put four women in the same room, says Olivier, and "while cackling and chattering [*caquetant et jasant*], they go ... from insults to blows with such rage and frenzy you could call them Hell's furies."[12] In this phantasmatic ambiance, the cackling woman at the lying-in may function as the ludicrous correlative of Marie, the maternal virago; in the phallic imaginary, women's license – discursive and/as political – threatens male rule(s). Far from being a trivially private text, as Bakhtin claims, the male-narrated *Recueil général des caquets de l'accouchée* recuperates the "loose talk" of women at the lying-in, and then uses it as a screen to denounce social disorder and to proclaim the cure of rigid, patriarchal rule.

The placental text

The narrator's infiltration of the lying-in is motivated by a symptomatic desire to recover from "a great and painful illness," one of those "cold and dank maladies" that casts a melancholy humor over the imagination, and to govern his life by better regimen (pp. 7, 45–6). Heeding an old doctor's advice to find curative pleasures and diversions, the unnamed narrator first goes to the theater, but ends up at the carnivalesque Pont-Neuf, in the hands of charlatans, all the worse for his health, humor, and finances. Better by far, insists the old doctor, to get

permission from *une accouchée*, "slip into the bedroom alcove after dinner to hear the latest news from the many women who come to see her, and to keep a faithful record ... it will rejuvenate you and restore your health" (pp. 9–10). While denying any prurient curiosity about women, the narrator thus seeks out a cousin, in childbed at her home on the "rue des Mauvaises Paroles" ("the street of nasty words"), and is readily allowed to eavesdrop on what constitutes the first *caquet* (pp. 11, 46). By the second, his sickness is "much diminished"; by the fourth, he can exclaim: "Gone all melancholy!" (pp. 45–6, 125). His daily return to record women's prattle until the final *Relèvement de l'accouchée* links the production of his corpus to the women's room and the womb, the return of the postnatal female body to its pristine state – a variation on the topos of female generativity as a metaphor for male creativity.[13]

On one level, the implicit connection between penetration of the lying-in and the end to melancholy lies in the titillation of hearing and seeing the forbidden without being discovered and punished. From one text to another, the narrator shifts his hiding place – behind the curtains of his cousin's *ruelle* (pp. 12, 191), the cabinet at her bedhead (pp. 94, 128), the corner of a tapestry (p. 216), and in a little room behind her bed gained through a little door (pp. 46–7). These details set the stage for the suspenseful moment when a woman warns that "the walls have ears," and another declares, in one of the texts' numerous self-references:

> I was told the other day that while a respectable, polite company came to visit milady in childbed, a certain someone hid behind the bed and kept a register of everything that was said; which only makes us look bad, for everybody is calling us prattlers [*chacun nous appelle caqueteuse*]. If he were here now, we'd let *him* have it. (p. 63).

The threat of discovery and punishment is heightened when the indignant females search the room to make sure no man has intruded: as "a wrinkled old woman" approaches the alcove, the narrator gleefully relates that "she found the nest but the bird had flown away. And I ... split my sides laughing" (p. 63). That the male outfoxes the pursuing hens compounds the pleasure of the secret, and of the joke at their expense.[14]

Even more than the secret pleasure of transgression, laughter cures melancholy in these texts, an echo of the remedy proffered in the prologue to Dr. Rabelais' *Gargantua*. Here, however, the narrator's guffaws at the women's gossip marks a triumphant reversal of the fear of their mockery of men, what Cixous has called "the laugh of the Medusa." On the fifth day, for example, the women's laughter sets off

his uncontrollable, lower-bodily laugh at them: "Each of these bourgeois women ... began to laugh with such pluck that it sounded as if female donkeys were in a field braying to be covered by males. And I who speak, though hidden in the alcove, I had to loosen my codpiece, for fear of pissing in my breeches" (pp. 191). Aside from their asininity, he derides their deafening barnyard cackling and the unceasing mobility of their tongues (pp. 153, 182, 231). It is as natural, he explains, "for women to chatter with their upper and lower dentures" (*caqueter à double rattelée*) as it is for birds "to shit everywhere" (p. 231).[15]

The narrator's laughter is especially satisfying because it is shared with another, intratextually – with his complicitous cousin in the texts' narrative frame. "We roared with laughter," he states at the beginning of the fourth day, and at the end, "you can well imagine how we laughed" (pp. 126, 154). In effect, *l'accouchée* functions as the narrator's double and alibi, undermining the solidarity of the female gathering, though "she wouldn't want it discovered for anything in the world" (p. 12). Differentiated from the women of all ages and classes who visit her chamber, she remains conspicuously silent throughout the texts, perhaps because she accepts her objectification ("confinement") under his gaze. According to the narrator, she is offended not only by their "deafening talk" and nasty gossip, but also by their discussion of serious subjects, which she deems fit only for men (pp. 100, 242).[16]

As the exception that proves the rule of women's "nature," and as the narrator's female alibi, *l'accouchée* is recuperated by the text. In this way, she also assuages men's phantasmatic fear of – and repulsion from – the fertile maternal body at the birth-giving scene, which Kristeva describes in *Powers of Horror* as the ultimate abjection, "something horrible to see at the impossible doors of the invisible."[17] Indeed, the "great" flow (p. 93) that issues from the "lower bodily" parts of the woman in childbed is appropriated as the emblem of the narrator's own "ample" production, which he disparagingly dubs his excremental or placental text. "What I'm doing here," he explains,

> has the form of an AFTERBIRTH [*en forme d'ARRIERE-FAIX*] ... If we want to consult Mme Perrette, midwife [*sage-femme*] of the faubourg Saint-Martin, [the afterbirth] is nothing but a superfluity of matter that is evacuated from the womb after childbirth; since it is excremental, and is retained in the cavities of the womb and stuck in its membranes, this superfluity could have greatly inconvenienced the mother; it must be thrown out so that she may regain [(*être*) *reintegrée dans*] her original health.[18] (pp. 214–15)

Like the birthing maternal body, whose form he assumes, the narrator throws out the superfluous matter of the placental text, but only to offer

it up to the reader, with whom he shares the best laugh. His alliance with *l'accouchée*, and his awareness that she will be furious when he tells the secrets confided in her home, are minor considerations before his need to expose and profit from what he heard. After all, a secret becomes valuable the very moment it is given away; or, as Chambers puts it more paradoxically, "only divulgence makes a secret ... because a secret exists only as discourse ... the discourse which 'realizes' the secret is that which destroys it as a 'secret' (something unspoken)." And the narrator, etymologically, "the one who makes it known," can use its secret matter to establish a complicitous bond with readers, onto whom he projects his fascination with the trivial. As the narrator-become-author says of the *caquets* in the prefatory verses to the *Recueil général*: "Ready your open throats to laugh / At all that I tried to describe / In these cackles of confinement; / Because the matter's so trivial; / No subject matches it, / To gain one's satisfaction" (p. 5).[19]

At the same time, the author/narrator recasts his eavesdropping as the efforts of a faithful secretary to "please those whose curiosity sparks the mind," "to bring satisfaction to the curious" (pp. 178, 180). Ascribed to his ideal readers, this curiosity serves to distinguish him from the curious women whose *caquet* he has been recording, an activity that threatens to feminize him. After all, curiosity was Pandora's crime, and as seventeenth-century misogynistic texts of the *querelle des femmes* never fail to emphasize, the sin of Eve that caused the downfall of man. The instant he incorporates women's speech under his pen, however selective their volubility forces "the best secretary" to be (p. 178), he can be feminized as *caqueteux*, degraded, and derided. This fear may account for the defensive prefatory remarks in the *Recueil général* where the author acknowledges that some critics "will roar with laughter at the secretary who collected such a sterile thing to share it with the public, and will strive to tarnish his reputation" (p. 3). (The backbiting "cawing crows" [p. 3] to whom he proclaims indifference may encompass the virulent author or authors of the 1622 *Anti-caquet* [pp. 249–60], a text that the narrator of the fourth *caquet* brands the work of idiots written in most improper French [p. 126].) Not surprisingly, then, the author's preface strains to assure the reader that his own rank "separates me from the common herd" (p. 4). So doing, he aims to sever all ties to his cackling objects of representation. Simultaneously, he valorizes his text by linking it to Rabelais', confident that those who wish "to consume the pithy part of writings, do not stop with the bark ... under lowly appearances there are lofty effects worthy of satisfying the most demanding minds" (p. 4). The low, dirty gossip of curious women is

thus reframed as the superficial envelope that contains "something fit to satisfy the appetite" of his lofty addressee, a desired male double who can profit from his labor and his text's essential purpose: "it was published only to reform morals, regulate actions and eliminate abuses" (p. 4).[20] Through this traditional definition of satire, the author cuts the cord connecting him to the birthing female body and the placental text, reaffirms his identification with superior men, and can ultimately become the doctor who would cure society's ills and the disorder of the body politic.

Sex and state in (dis)order

The *Caquets de l'accouchée* appropriate women's disorderly talk at the lying-in as the vehicle or screen for exposing to the author's distinguished male addressees societal licenses and abuses. In this process, the texts make little reference to what would conventionally be called "women's themes": a few remarks on children's education and behavior (pp. 69, 82–3, 187–8); some specific comments on daughters who lack dowries (p. 129), are forced to become wives or nuns against their will (pp. 76, 90), and are exploited by parents and husbands (pp. 119, 244–5); and a couple of exchanges on unwanted pregnancies. Thus *l'accouchée* of the fourth *caquet* is stuck with five tormenting brats, and determined to forgo the conjugal bed to have no more (p. 129); elsewhere, her mother quips that if she had known her daughter would become so pregnant so quickly, "I would have let her scratch her private parts until the age of twenty-four without getting married" (p. 13, and see pp. 62, 175).

Such earthy talk dots the *caquets*. Although premarital sex is discussed, and there is even gossip of incest, adultery predictably preoccupies the sex considered insatiably lascivious in seventeenth-century medical and moralistic texts.[21] A young woman married to an old geezer wants a lover (p. 19); an old woman would pay a young fellow to keep her juices going (p. 29); an overburdened wife desires, but has no time, to sleep around (p. 20), as the many women do whose affairs are disclosed in bits and pieces and longer anecdotes throughout the *caquets*, in part by the narrator himself (pp. 61–2, 179, 244). If adultery is occasionally condemned, especially when it serves to better one's station and wealth (pp. 179–80, 247), the women mostly ridicule the phantasmatic cuckold of male writing since the Middle Ages. In three different versions of the same tale, two husbands follow their wives to

trysts, "hear them making hay [*faire la feste*] like a two-backed beast," but meekly take consolation in the communality of their plight; "I ask you whether these husbands don't deserve it," asks a lawyer's wife in the third *caquet* (p. 112). And in the seventh, the husbands, disguised as monks, see through a keyhole "what wood the horns about to be planted on their forehead were made of"; once they become members of the "most populated brotherhood in Paris" they have understandable difficulty putting their monacal hoods on their horny heads (p. 219). In the narrator's version of the tale, the "loose" women are punished, which prompts *l'accouchée*'s objection that he is telling it like a man and that "these fools clearly deserve to wear antlers" (p. 127). Echoing a topos of the early modern *querelle des femmes*, they finally agree that cuckoldry may be the unavoidable fatality of marriage, but is still preferable to abstinence (p. 128). For the cuckold, a term derived from the Old French for "cuckoo," woman as cackling hen becomes what Bakhtin would call the "bodily grave" of man.

And yet the theme of sexuality in the *Caquets* pales by comparison with the depiction of social corruption that dominates the women's gossip. Money, far more than sex, makes the world go round in the words of these predominantly bourgeois, but also upper- and lower-class, women, who cite names and places that create "libellous" *effets de réel*. "Everything is corrupt today, money is everything," declares the wife of a law clerk (p. 76). From the salt sellers who rob their clients, to "the fraud and embezzlement committed by the army's chiefs and leaders" and the Tartuffian greed of men of the cloth, "there is deceit everywhere" (pp. 54, 71–2, 90, 165). Usurers, financiers, and treasurers are targeted, but above all, the clerks, attorneys, magistrates, and judges, whose wives populate the *caquets*:[22]

> What purpose do so many bailiffs and sergeants serve? to rob the peasant; what good are so many marshals' provosts? to hang those who have no money; so many criminal judges? to take from others so they can cancel the debts they incur buying their offices; so many commissioners of Chastelet? to get pensions from tarts, pimps, bakers and all those who sell flesh, for today everything is allowed. (pp. 37–8)

Beyond individual professions, the attacks center on the recently created *noblesse de robe* as a symbol of the power of money to wreak havoc on traditional class distinctions. But as one woman remarks: "If emperors, by their own appointments and tidings, intended to proclaim lawyers noble, even though they were of low birth, why would we want to correct their actions, since we owe them our own advancement? ... if lawyers now wear cassocks of damask, instead of serge, it is not any

more inappropriate than for a simple procurator who has no shame doing the very same thing" (pp. 237–8).

Though the unchecked ambitions of powerful men of the period are exposed,[23] the backbiting women never fail to chastise the pretensions and upward mobility of their own sex. The clothmaker's daughter struts about like a peacock in her finery, disdaining her peers to seek the judge's son in marriage (pp. 246–7); the wives of artisans, merchants, and attorneys, "whose silks trail from head to toe," try to ape ladies of high birth and breeding (p. 179); the widow who sold jam three days ago is now married to a nobleman, and wears "high collars with four and five layers of lace ... I don't know how that's tolerated," says the draper's wife of such pretensions and misalliances (p. 22). In this climate, substance counts for nought, appearance is all, an "invention" that women have perfected, says the narrator in the fifth *caquet*, "if vice is to be called perfection" (p. 179). The impoverished nobility, who represent true quality, and the virtuous *gens de bien*, have become society's pariahs.

Used to criticize the proverbial materiality of their gender's ambitions, women at the lying-in are more fundamentally recuperated as the vociferous opponents of a pervasive corruption caused by class confusion and "dis-order." This discursive move assumes particular significance in the period 1550–1700 when political, juridical, scientific, and religious forces converged to eliminate the radical "dis-order" attributed to women as witches. Moreover, that both proponents and opponents of woman's emancipation in the seventeenth-century *querelle des femmes* stressed her role as an agent of social mobility – in the salons she created, for example, as Lougee has shown – highlights the threat she posed to traditional class distinctions. And it helps to read the women's condemnation of licence and corruption in the *caquets* as a symptom of reaction-formation. "Today, everything is permitted and tolerated," bemoans the wife of a counselor, while another woman deplores "the reign of confusion that now waxes bright" (pp. 145, 238). Accordingly, the women look back nostalgically to a time when rigid distinctions existed: "in the past the linnet and the goldfinch were apart in different cages; but now, everything is in the same aviary" (p. 33). Money has obscured the traditional signs of class difference beyond any recognition: "today you no longer know anything from a person's clothing; everything is allowed, provided there's money" (pp. 106–7). To counteract this widespread confusion and to recreate the old idealized order, the women advocate the rule of law, urging archers, the police, courts, and the *parlement* to survey and punish, "to prevent disorder" (p. 23). Extending this repressive patriarchal law to the most

marginal segments, a wealthy bourgeoise wants to regulate "the disorder" created by vagabonds, tramps, and beggars, so that they will be usefully employed in public works or isolated from the rest of society (pp. 69–70). In more global terms, the cackling women believe optimistically that "the great disorder that now exists will engender a good order; edicts will be passed that will regulate everything; and we will then know the merchant from the noble, the man of justice from the mechanic" (p. 31).[24]

Ultimately, however, only the king can restore order to the realm. His often-mentioned absence from Paris, because of the war against the "vicious" protestants who have "ruined the kingdom" (pp. 53, 84–5), however, compounds the magnitude of the present disorder. Indeed, the king is exploited by his closest counselors, and his financial and military officers profit from the civil war to line their pockets. "Oh God, what disorder!" exclaims one woman, "I don't think the king knows the half of what goes on," a situation that leaves the monarch no better off than the cuckolded husbands of the *caquets* (p. 37). Nevertheless, the women project beyond the war's end to proclaim their faith that the king, become true patriarchal sovereign and society's ultimate doctor, "will bring such good order to the disorders which have crept among the people that the law-and-order regime [*la police*] he will institute, following his ancestors' example, will guarantee that every person is known for what he is" (p. 238).[25]

In purportedly recording the women's *caquet*, the narrator explicitly hopes to "notify" all those "who can impose order," king and counselor, judge and archer (p. 43). The texts thus confirm the prefatory aims of the *Recueil général* "to reform morals, regulate actions, eliminate abuses" (p. 4), and in so doing, display what Paulson calls the structural goals of satire: to depict the corruption of the ideal order because of the massive presence of a false society; to affirm the return to that past order as a corrective; and to ensure some mode of punishment for the cause of this upheaval. As the symptom of a disordering reversal in the sex–gender system, women at the lying-in are first punished by the narrator's comic degradation of their "cackling." In turn, their gossip punishes the sexual license and social pretensions of their own sex. But they are also "reintegrated," as Bergson would say, indeed recuperated as the proponents of a rigid monarchic order.[26] The threatening, disorderly other is brought in from the margins, and used to bolster the dominant discourse, becoming the spokesman for repressive phallic rule. In the *Caquets de l'accouchée*, women cackle like a superordinate man in drag.

The doctor's recuperation and the *sage femme*

The voyeuristic narrator and the satirical author count among the male "doctors" who, in various guises and through various practices, over-determine the recuperation of women. Symptomatically, the old doctor can prescribe the lying-in as a curative diversion to the ailing narrator only because of his own infiltration of the gathering and, more generally, as historians of medicine confirm, of his profession's appropriation of women's bodies through the displacement of the midwife. Indeed, in the third *caquet*, a doctor and a surgeon come to care for l'*accouchée*, thereby forcing the women to silence their attack on the greedy and pretentious doctors who disguise "the herbs we often rake in our gardens" in fancy Greek and Latin names (pp. 103–4). These herbs, "which we could surely benefit from and use for our health if we were acquainted with them" (p. 103), as one woman puts it, were the special province of the female healer and the midwife. However, those women were denounced, by doctors from Rabelais on, as ignorant fools who harmed their patients. Moreover, like witches, midwives were branded the devil's allies. As the *Malleus Maleficarum*, the foremost treatise on demonology, stated: "the greatest injuries to faith as regards the heresy of witches are done by midwives." Thus Louise Bourgeois, midwife to Marie de Médicis' six children, warns her own daughter in 1626 never to keep the "membrane amnios," reputedly used in black masses, for fear of being accused of witchcraft. And she deplores the loss of prestige of the midwife and the enormous popularity of male accoucheurs, surgeons, and doctors among birthing women. More accurately, however, it was the Church and the legal profession which ensured the doctor's power and prestige. Despite the widespread view that it was indecent for an unknown man to penetrate a woman's body and become her accoucheur, prelate and magistrate placed the doctor on the side of God and law in the witch hunts. Along with the seventeenth-century monarchy's belief in the doctor's competence and greater ability to save women's lives, the Church and the law gave him the authority to displace the midwife.[27]

Like these good doctors, seventeenth-century editors and publishers of the period suppressed or recuperated opposition voiced by women to the "libellous" *Caquets de l'accouchée*. To be sure, the *Recueil général* includes "la Response des dames et bourgeoises de Paris au Caquet de l'accouchée" ("The Response of the Ladies and Bourgeois Women of Paris to the *Caquet de l'accouchée*") (1622), purportedly written by Mademoiselle E.D.M., and published "under the sign of the three Maidens" (p. 195). In this text, the women vigorously object to being

the eternal butt of the insulting satires of men, who are powerful and thus impervious to their own faults. "A female philosopher" then propounds a defense of women – an intertextual echo of Marie de Gournay's *L'Egalité des hommes et des femmes* (*Equality of Men and Women*) (1622) – which reaffirms their inherent equality to men, and documents their achievements by historical and literary exempla. Despite the oppositionality of this piece, its setting at the baths, where the women undress and swim naked under the constant fear of being observed, implies the presence of a titillated male gaze. In turn, and in his efforts to standardize the narrative frame, the editor of the *Recueil général* systematically replaces the first-person female narrator with the overseeing third-person male narrator; and he suppresses the closing "letter of repudiation," which denounces the *caquets* as foundless calumny, and calls upon women of all classes to cease and desist from reading "a piece so pernicious to our sex" (p. 211).[28]

No less significant is the omission of the *Essais de Mathurine* from the *Recueil général*, a short piece purportedly written by "mad Mathurine," the female jester of Marie de Médicis' court. Never reprinted before de Lincy's 1855 edition, this earthy first-person narrative derides *Le Caquet de l'accouchée* as the fiction of a sex-starved "rapacious bird" (p. 269), who is rejected by the Rabelaisian number of females he pursues, and who knows no women's secrets: "there isn't a single woman who is so foolish as to reveal it to her confidante if she had let the cat have the cheese … there isn't one so young who wouldn't prefer to do it twenty times than to talk about it once" (p. 274). Affirming female sexuality and her own *jouissance*, Mathurine traces the narrator/author's contempt for women to the hideous old whore who promised him great potency with the "classiest, most crested ladies," but who gave him, instead, a venereal "love sickness" and turned him into "an eviscerated falcon" (p. 272). "Would to Saint Fiacre," the patron saint of gardens and of venereal diseases, "that his arse be full of boiling water," exclaims crazy Mathurine (p. 269), who sends forth the call for communal female action: "Let every woman smear his face with cow dung! let every girl soil his moustache with spit, and let all women together heap so many curses upon him he can only shit after a good thrashing, and prowl about like a werewolf all the rest of his days!" (p. 274). Though he reprints this "grotesque" text, in which Mathurine becomes the "bodily grave of man," as Bakhtin would say, de Lincy prudishly remarks in his 1855 introduction: "It contains several racy and witty strokes, but they are ruined by a type of verbal cynicism that cannot even be excused by the madness of the character who utters it … this piece cannot possibly compare with the *caquets* that it tries to censure" (pp. xxiii–xxiv).[29]

The fear of women's mockery of men thus strikes the Doctor of Letters no less than the editor of the *Recueil général* or the narrator of the *caquets*, and prompts the degradation, recuperation, and/or the suppression of discourse ascribed to women. And this includes Bakhtin, with whom I began. For the proponent of frank marketplace humor and the lower bodily stratum never mentions the *Essais de Mathurine*, the most "Rabelaisian" of the *caquets* and *anti-caquets*, in his dogmatic exposition of official seventeenth-century culture. And beyond this omission, the misprision in Bakhtin's reading of the *caquets* as "female cackle [that] is nothing but gossip and tittle-tattle" (p. 105) symptomatically reproduces the phallocentric views of the voyeuristic narrator. This would suggest a homosocial identification, a phallic bond with the dismissive, derisive male. Like the narrator, moreover, Bakhtin uses the body of women to produce his own excremental, placental discourse on grotesque realism, which, as Booth observed, is addressed only to men (p. 163). And like the talking cure recommended by the doctoral author of the *Recueil général*, Bakhtin proclaims the healing properties of male laughter at women's expense. To be sure, the seventeenth-century author(s) of the *caquets* promoted the kind of order that Bakhtin systematically opposes and aims to subvert. And yet, both look back nostalgically to an idealized past whose return would remedy the ailing body politic of their own era, by hiding behind the screen of loose-talking women.

Of course, these are not exceptional instances of the textual harrassment and recuperation of women. As one of the nude women of the unpublished sixth *caquet* remarks: "Men always lay us on the carpet, and then afterwards we serve as their plaything and the topic of their conversation [*nous servons de jouet et d'entretien aux hommes*]" (p. 198). Even more important, women have been used to engender male discourse and critical speech. As a metonymy of doctoral male talk, theory has often been founded, notes Jacobus, on the specular appropriation of women by men, from which self-regard and narcissistic self-assertion are never far away.[30]

"Mad Mathurine" can thus serve to remind Bakhtin-as-male-critic of the gendered inflection and self-interest of his own discourse. Until that self-conscious subject position is embedded in its texture, criticism cannot be radically oppositional or meaningfully dialogic, Bakhtin notwithstanding – nor Booth, who excuses the "failure of Bakhtin's imagination," because his work is "counter ideological"[31] and because, inevitably, all discourse excludes some others or reflects the "deep dogmatism" of a system of language. And yet, as Bakhtin recognized, though he failed to dramatize it in his own text, a "self-criticizing"

impulse (p. 171) is crucial to ideological radicalism, and thus, in my view, to the possibility of seeing beyond the horizon of one's gendered gaze. Such an impulse is integral to the critical science or critique of science that Kristeva called *semiology*:

> [Semiology] is, each time, a reevaluation of its object and/or its models, a critique of its models (and thus the sciences from which they are taken) and of itself (as system of constant truths) ... it is an open path of research, a constant critique that turns back on itself, in other words, an autocritique.[32]

A difficult, perhaps utopian, practice, autocriticism or autodialogicalism must of course also be embodied in the cackling exposure of phallocentric texts by Mathurine feminists. It is the only potent remedy – or am I being too much the *sage femme*? – perhaps, the only ambivalent brew that can begin to cure the monologic dogmatism of men *and* women, and help to engender a healthily disordered world.

Notes

1 For a longer version of this essay, with full transcripts of the French passages cited, see my *Women Writ, Woman Writing: Gender, Discourse, and Difference in Seventeenth-Century France* (Chicago, forthcoming).

2 Mikhail Bakhtin, *Rabelais and his World*, trans. Hélène Iswolsky (Bloomington, 1984), pp. 104–5. Bakhtin also cites the *Caquets des poissonnières* (1621–2) and *Caquets des femmes du Faubourg Mont-Martre* (1622?), which do not use the setting of the lying-in, but underscore the popularity of the *caquet* as a genre. *Le Caquet des marchandes poissonnières et harangères* (1649), which Bakhtin does not cite, seems to be the latest seventeenth-century text entitled *caquet*.

3 Contemporary critics who have emphasized the anti-Stalinist subtext and impulse of Bakhtin's work include Katerina Clark and Michael Holquist, *Mikhail Bakhtin* (Cambridge, Mass., 1984), pp. 304–14; Richard M. Berrong, *Rabelais and Bakhtin: Popular Culture in Gargantua and Pantagruel* (Lincoln, Nebr., 1986), pp. 105–20; and Peter Stallybrass and Allon White, *The Politics and Poetics of Transgression* (London, 1986), pp. 11ff.

4 For these interpretations of carnivalesque folk culture, see Julia Kristeva, "Mot, dialogue et roman," in *Semeiotike: Recherches pour une sémanalyse* (Paris, 1969), p. 144; Michael André Bernstein, "When the Carnival Turns Bitter: Preliminary Reflections Upon the Abject Hero," in Gary Saul Morson, ed., *Bakhtin, Essays and Dialogues on His Work* (Chicago, 1986), p. 113; and Stallybrass and White, *Transgression*, pp. 9, 18 – though they argue, unconvincingly, in my view, that Bakhtin's work is "consciously utopian and lyrical" (p. 9). The only documentation for early modern scenes of the lying-in cited by Bakhtin is that "Etienne Pasquier and Henri Estienne mention them in the sixteenth century" (p. 105).

5 *Les Caquets de l'accouchée*, ed. Edouard Fournier, introduction by Le Roux de Lincy (Paris, 1855), pp. vii–ix; all references to the *Caquets* are taken from this edition and all translations are my own. *Les Caquets de l'accouchée* were published in seven different editions in the seventeenth century (see pp. xxx–xxxi); de Lincy cites one inaccurate 1847 Metz edition. He is the first and only editor to reprint the three texts written in opposition to the *Caquets* – *L'Anti-Caquet*, the *Essais de Mathurine*, and the *Sentence par corps*, which were published separately in 1622.

6 P. N. Medvedev and Mikhail Bakhtin, *The Formal Method in Literary Scholarship: A Critical Introduction to Sociological Poetics*, trans. Albert J. Wehrle (Baltimore, 1978), p. 14.

7 Guillaume Coquillart, in M. J. Freeman, ed., *Oeuvres* (Geneva, 1975), pp. 233–5, lines 2130–4, 2100–1, 2143, 2085; *Les Quinze Joies de mariage*, ed. Jean Rychner (Geneva, 1967), 19, 25–26.

8 On the carnival's reinforcing of dominant ideologies, at least as one if its functions, see Roger Chartier, "Discipline and Invention: The Fête in France, XV–XVIII Century," *Diogenes* 110 (Summer, 1980), 44–65; Peter Burke, *Popular Culture in Early Modern Europe* (New York, 1978), pp. 200ff; Stallybrass and White, *Transgression*, pp. 13–54; Natalie Z. Davis, *Society and Culture in Early-Modern France* (Stanford, Calif., 1986), pp. 123, 130–1. I discuss recent interpretations of Bakhtin and carnival at greater length in *Women Writ, Woman Writing*.

9 Paul Robert, *Dictionnaire alphabétique et analogique de la langue française* (Paris, 1979); Randle Cotgrave, *A Dictionarie of the French and English Toungues* (1611), intro. William S. Woods (Columbia, S.C., 1950); Edmond Huguet, *Dictionnaire de la langue française du XVIe siècle* (Paris, 1925).

10 Patricia Meyer Spacks, *Gossip* (New York, 1985), p. 26.

11 Carolyn Merchant, *The Death of Nature: Women, Ecology, and the Scientific Revolution* (San Francisco, 1980); Susan Bordo, "The Cartesian Masculinization of Thought," *Signs* 11. 3 (Spring 1986), 439–56.

12 On Marie de Médicis' regency, which was unprecedented except for that of Catherine de Médicis (1559–64) and required the convocation of a special assembly called the *lit de justice*, see Michel Carmona, *Marie de Médicis* (Paris, 1981). On Rubens' cycle, see Jacques Thuiller *et al.*, *Rubens, La Galérie Médicis au palais du Luxembourg* (Paris, 1969), but especially Deborah Marrow's *The Art Patronage of Maria de Medici* (Ann Arbor, Mich., 1982). Marrow argues (p. 74) that Marie is the figure on the frontispiece of Olivier's *Alphabet de l'imperfection et malice des femmes*, which I cite here from a later edition (Rouen, 1683), pp. 79–81.

13 The narrator's "cold and dank" malady, which evokes the cold and wet humors of the female in early modern thought, heightens the link between him and the birthing female. On this literary topos, see Susan Stanford Friedman, "Creativity and the Childbirth Metaphor: Gender Difference in Literary Discourse" (*Feminist Studies* 13.1 [Spring 1987], 49–82): the male metaphor actually "reinforces the separation of creation and procreation" (p. 58).

14 Although he is never discovered, the narrator intimates in one passage a fear of being punished for his transgression. In an intertextual echo of an anecdote in

Rabelais' *Gargantua* (*Oeuvres complètes*, "Intégrale" edn., Paris, 1973, p. 56), the *caquet*'s narrator imagines sharing the fate of the devil, who, "hidden behind a church pillar to register everything that three or four women said, and trying to lengthen the sheet of paper with his teeth, unhappily struck his head against the pillar" (p. 92).

15 The *Caquets*' doctor dubs the laughter generated by his patient's text a "balm" (pp. 37–8). For specific metatextual references to laughter in Rabelais' work, see *Oeuvres complètes*, pp. 4, 145, 231, 265. Cf. Hélène Cixous, "The Laugh of the Medusa," trans. Keith Cohen and Paul Cohen, *Signs* 1.4 (Summer, 1976), 875–93.

16 The primary narrative function of *l'accouchée* seems to be to change the subject: see pp. 20, 31, 53, 100, 110, 118.

17 Julia Kristeva, *Powers of Horror: An Essay on Abjection*, trans. Leon Roudiez (New York, 1982), pp. 155–6.

18 Although medical texts of the period, including the midwifery treatises of Louise Bourgeois, speak of *l'arrière faix*, the suggestive image of the placental text does not seem to appear in other works. Montaigne's *De l'oisiveté* (*Essais* I, viii) contains a related image, but one that stresses female deficiency as epitomized by menstruation and false conception.

19 Ross Chambers, "Histoire d'Oeuf: Secrets and Secrecy in a La Fontaine Fable," *Sub-stance* 32 (1981), 67.

20 The narrator uses heroic images to "virilize" his efforts: he will "enter the lists and put the lance of discourse [*la lance de discours*] in the stirrup of an admirable course, where I can pursue the career of eloquence" (p. 215).

21 On gossip of incest, see pp. 88–90, 108, 118–19, 174, 246–7. On women's stronger sexual appetites, see, for example, Dr. Nicolas Venette's influential *Tableau de l'amour conjugal* (1687; Coulommiers, 1813), vol. II, pp. 14–22.

22 The *caquet* is dubbed *un libelle*, or defamatory text, on pp. 180, 185, 249; on the popularity and political significance of the *libelle*, see Erica Harth, *Ideology and Culture in Seventeenth-Century France* (Ithaca, 1983). On the theme of deceit and corruption, see also pp. 64, 80, 165, 221. The presence of magistrates' wives at the *caquets* may justify the women's extensive knowledge of the legal profession, its administration, and recently enacted laws (see pp. 32–7), but such knowledge is unconvincing in the wives of jam, glove, jewelry, and perfume makers who attend the lying-in, as well as the housemaids.

23 The *caquets* seem to target public figures around Luynes, the falconer who became Louis XIII's closest and wealthiest advisor, and who had died in 1621 (pp. 66–8, 156); his secretary, Monsigot (pp. 148–53), his cohort, Deplan, a laquais who became marshal of France (pp. 160–1); and his wife, the future Mme de Chevreuse, who was to play a role in the Fronde (pp. 148–9, 222). There are also references to Concini, Marie de Médicis' closest and most hated Italian advisor, more commonly known as the Maréchal d'Ancre, who was assassinated on the king's orders, and whose wife was burned at the stake for witchcraft.

24 On woman as agent and symbol of disorder, see Davis, *Society and Culture*, and Merchant, *Death of Nature*. On women as agents of social mobility through the salons, see Carolyn Lougee, *Le Paradis des Femmes* (Princeton, 1976). On the theme of law and order see also *Les Caquets*, pp. 26, 61, 142, 238–9.

25 On the theme of disorder, see also pp. 64, 95–7, 163, 165. The publication of *Les Caquets* coincides with the onset of Richelieu's rise to power, first as the ally, then as the enemy of Marie de Médicis.

26 See Ronald Paulson, *The Fictions of Satire* (Baltimore, 1967); Henri Bergson, *Le Rire: essai sur la signification du comique* (Paris, 1961).

27 The difficult birth of Gargantua is ascribed to the ignorance of *les sages femmes*, especially to their misguided use of a horrible astringent (Rabelais, *Oeuvres complètes*, p. 56); and Gargamelle, Pantagruel's mother, dies in childbirth, while the midwives "prattled ... about petty matters amongst themselves" ("caquetaient de ... menus propos entre elles," p. 225). For attacks on French midwives, see Jacques Gélis, *La Sage femme ou le médecin* (Paris, 1988), pp. 306, 350–1, 386, 470, 473, 484. The *Malleus Maleficarum* (1489) is quoted from Barbara Ehrenreich and Deirdre English, *For Her Own Good* (New York, 1978), p. 32. For Bourgeois, see *Instruction à ma fille* (Paris, 1626), pp. 25–6.

28 This response was apparently catalyzed by the publication of the second and third *caquets* (pp. 207, 210). "People speak of nothing but the women's prattle," remarks one of the women at the baths. "Never was the bed of the woman in confinement more shaken up; they keep turning it inside out and skimming it" ("on ne parle que de caquet des femmes. Jamais le lict de l'accouchée ne fut mieux remué; il est souvent retourné et feuilleté," 197).

29 Although this intriguing character apparently never wrote any texts, several "libelles" bear, or more accurately appropriate, her name, including *la Cholère de Mathurine contre les difformez réformateurs de la France* (1616); *Le Feu de joye de madame Mathurine* (1609); *La Sagesse approuvée de madame Mathurine* (1608). In 1622 she was still living on a king's pension, according to Louis Battifol, *La Vie intime d'une Reine de France au XVIIe siècle* (Paris, n.d.), p. 146.

30 Mary Jacobus, "Is There a Woman in This Text?" *New Literary History* 14 (1982), 117–41.

31 Wayne C. Booth, "Freedom of Interpretation: Bakhtin and the Challenge of Feminist Criticism," in Morson, ed., *Bakhtin*, pp. 161, 166–7, 171. It could be argued that Rabelais' work was not counter-ideological with respect to the sex–gender system of his time, and more specifically to the *querelles des femmes*, in light of the works of a Christine de Pizan, for instance. And, in Bakhtin's own era, there were of course such notable feminists as Alexandra Kollontai.

32 "La Sémiotique: Science critique et/ou critique de la science," in *Semeiotike*, pp. 27–42.

A womb of his own: male Renaissance poets in the female body

KATHARINE EISAMAN MAUS

ु≫

Sandra Gilbert and Susan Gubar begin their groundbreaking book on the Victorian novel, *The Madwoman in the Attic*, by remarking that literary creativity is often construed as a masculine attribute.

> The poet's pen is in some sense (even more than figuratively) a penis ... the patriarchal notion that the writer "fathers" his text just as God fathered the world is and has been pervasive in Western literary civilization.[1]

Writing from a different theoretical standpoint, such French feminists as Luce Irigaray, Hélène Cixous, and Catherine Clément have emphasized a Lacanian connection between linguistic representation and the phallus.[2]

For feminist critics, then, problems of authorship become acute when the writer is female. "If the pen is a metaphorical penis," Gilbert and Gubar inquire, "with what organ can females generate texts?" (p. 7). Irigaray, Cixous and Clément, Margaret Homans, Susan Gubar and others have tried to chart the literary development of a "woman's language" that eschews or subverts "male," phallic forms of representation.[3] While disputing a phallocratic connection between virility and good writing, these critics share the important assumption that writers naturally imagine their creativity in terms of their own bodies, their own genders. The analogies are essentially celebratory, or at least positive ones. Men think of their literary creativity as a form of sexual potency because they value both attributes, even though a Lacanian distinction between penis and phallus may complicate the relationship between bodies and processes of signification. Women, heroically asserting the importance of culturally undervalued female experiences, must redeem both their bodies and their creative energies for themselves, if they are not to succumb to neurosis or bad faith.

In this essay I examine a different metaphoric connection, one that

challenges some of the assumptions underlying this important account of creativity. In the English Renaissance, the creative imagination is commonly associated with the *female* body. In the first sonnet of *Astrophil and Stella*, Philip Sidney describes himself as "great with child to speak, and helpless in my throes" (p. 12). Ben Jonson, often described as the most aggressively "masculine" of English Renaissance writers, nonetheless frequently depicts his own creativity as maternal. In *Poetaster*'s "apologetical dialogue," for instance, he represents his "long-watched labours" as "Things, that were born, when none but the still night, / And his dumb candle saw his pinching throes" (pp. 217–19). In the Cary-Morison ode, the turn of the infant of Saguntum, "half got out" but already retreating back into a womb that will become its tomb, rehearses the "turns" and "counterturns," the strophes and antistrophes, of a poem generated to commemorate the dead. Shakespeare burlesques the figure in *Love's Labour's Lost*, in which the would-be poet Holofernes boasts that his effusions "are begot in the ventricle of memory, nourished in the womb of *pia mater*, and delivered upon the mellowing of occasion" (IV.ii.68–70).[4] Milton, phallic poet *extraordinaire* in Gilbert and Gubar's account, makes anti-censorship arguments in *Areopagitica* that rely upon analogies between "the issue of the brain" and "the issue of the womb."

For the English Renaissance writers who employ this analogy, it hardly follows that women make better artists than men. The relative scarcity of women writers in the English Renaissance contrasts vividly with the unprecedented literary activity of late sixteenth- and early seventeenth-century English men, with the emergence of important women writers on the continent, and with the explosion of important female talent into the English literary marketplace in the Restoration and eighteenth century. Nor would this scarcity have seemed surprising to many Renaissance intellectuals. Sixteenth- and early seventeenth-century medical authorities explain women's unfitness for serious intellectual pursuits on physiological grounds. Citing Galen, they claim that a woman's body in general and her womb in particular is cold and moist:

> Were it not so, it would fall out impossible, that her monthly course should flow, or she have milke to preserve the child nine moneths in her bellie, and two years after it is borne; but that same would soone wast and consume.[5]

By contrast, bodily heat and dryness are qualities associated with, indeed constitutive of, maleness. They are also, not coincidentally, the qualities associated with intellectual exertion generally, and imaginative creativity in particular:

To think that a woman can be hot and drie, or endowed with wit and abilitie conformable to these two qualities, is a very great errour; because if the seed of which she was formed, had been hot and drie in their domination, she should have been borne a man, and not a woman ... She was by God created cold and moist, which temperature, is necessarie to make a woman fruitfull and apt for childbirth, but an enemy to knowledge. (p. 274)

What makes women fertile – what makes them *women* – also makes them stupid.

Why should men imagine their poetic and intellectual endeavors in terms of a sex to whom those endeavors were proscribed – in terms, moreover, of the very organ that is supposed literally to chill and dampen the female intellect? The apparent anomaly sharpens rather than diminishes when we recall how exclusively female was the experience of giving birth in the late sixteenth and early seventeenth century, when midwives and female "gossips" rather than male physicians attended women in travail, and husbands were excluded from the birthing chamber.[6] The easiest explanation is that men envy women's ability to give birth; but if this is true, it merely raises further questions. For "womb envy," whatever it is, is surely no more a fact of nature than "penis envy." Rather, it is a cultural construct, and the cultural mechanisms involved are what should really interest us. Moreover, what these poets manifest is not "envy," understood as a consciousness of lack and a search for substitutes. In Freud's account, the woman who suffers from "penis envy" eventually resolves her complex by making her child stand proxy for the missing penis. But Sidney, Jonson, and Milton do not indicate any sense of inadequacy. Their bland appropriation of what does not seem "appropriate" is not a search for a substitute, but a claim that they already possess the real thing. In this essay I shall argue that the female body provides a risky but compelling model for the structure of male poetic subjectivity in the English Renaissance.

Pregnant wits

Analogies between mental creativity and bodily fecundity are not new to the English Renaissance, nor do they require the exaltation of a female function. In the *Theaetetus*, for instance, Socrates informs his interlocutor that his mother was a midwife and that he has inherited her gift. He does not have ideas himself, but his interrogative technique helps others bring forth theirs:

So great, then, is the importance of midwives, but their function is less important than mine ... mine differs from theirs in being practiced upon men, not women, and in tending their soul in labour, not their bodies ... Now I have said all this to you at such length, my dear boy, because I suspect that you, as you yourself believe, are in pain because you are pregnant with something within you ... Remembering that I am the son of a midwife and have myself a midwife's gifts, do your best to answer the questions I ask as I ask them. And if, when I have examined any of the things you say, it should prove that I think it is a mere image and not real, and therefore quietly take it from you and throw it away, do not be angry as women are when they are deprived of their first offspring.[7]

Even while deriving his talents from his mother-midwife, Socrates discards her specific skills and attributes. He not only differentiates male from female and mind from body in a familiar hierarchical arrangement, but also aligns both pairs of terms, so that the superiority of the male over the female is equivalent to the superiority of mind over body. The male must possess in the mind some creative gift analogous but superior to the fruitfulness of the female body: Socrates flatteringly contrasts the young man's sensible readiness to relinquish unsatisfactory ideas with a woman's irrational attachment to her doomed infant. The very similarity between thinking and childbirth clarifies their differences, excluding women from philosophy by a principle that seems as natural as the principle which precludes men from giving birth.

English Renaissance versions of the topos, however, complicate such neat distinctions. In the prefatory letter to his sister in *The Arcadia*, Sidney alters the Socratic paradigm even while invoking it:

For my part, in very truth (as the cruel fathers among the Greeks were wont to do to the babes they would not foster) I could well find in my heart to cast out in some desert of forgetfulness this child which I am loath to father. But you desired me to do it, and your desire to my heart is an absolute commandment. Now it is done only for you, only to you; if you keep it to yourself, or to such friends who will weigh errors in the balance of goodwill, I hope, for the father's sake, it will be pardoned, perchance made much of, though in itself it have deformities ... In sum, a young head not so well stayed as I would it were ... having many fancies begotten in it, if it had not been in some way delivered, would have grown a monster, and more sorry might I be that they came in than that they got out. But his chief safety shall be the not walking abroad; and his chief protection bearing the livery of your name.[8]

Pregnant with his fancies, Sidney produces an issue which, like Theaetetus' inadequate ideas, would, in the Greek scheme of things, deserve a quick death. The birthing is, however, therapeutic, apparently both for parent and for child. The word "grown" in the phrase "would have

grown a monster" could mean "become" – in which case Sidney's head is threatened with monstrosity – or "generated," in which case the work is itself deformed: a monster if it were not delivered, and monstrous even now that it is.

Fortunately, the fate of the child-work depends here not upon the authority of the "cruel" father-writer but of the compassionate female reader; more changes between Socrates and Sidney than intuitions about the morality of infanticide. In Sidney's witty reformulation, the child-birth metaphor makes the genders cross. The man submits to the woman's will ("your desire to my heart is an absolute commandment"), and she in turn provides the child with shelter and a name. This blurring and interchange of gender-roles seems an appropriate prelude to a romance in which a prince assumes a transvestite disguise in order to pursue a heterosexual agenda, thoroughly disrupting the familial and erotic loyalties of the two women and one man who fall in love with him. The tone of the prologue is playful; Sidney seems unconcerned about the authorial masculinity that his deliberate scrambling of mater-nal and paternal attributes might seem to compromise.

To other writers such reversals can seem more immediately threaten-ing. Milton's description of the birth of Truth in *The Doctrine and Discipline of Divorce* suggests uneasiness:

> Though this ill hap wait upon her nativity, that shee never comes into the world, but like a Bastard, to the ignominy of him that brought her forth: till Time the Midwife rather than the mother of Truth, have washt and salted the Infant, declar'd her legitimate, and Churcht the father of his young *Minerva*, from the needlesse causes of his purgation.[9]

Truth comes forth from her originator as if from a mother, but, like Sidney, the author swiftly regains a specifically male identity: it is as Truth's *father* that he must, scandalously, be "churcht." Milton repre-sents this obligation as preposterous not only because left-wing Prot-estants considered the ceremonial purification of new mothers a Popish superstition,[10] but because his topsy-turvy version of the ritual outrage-ously subjects the male writer to the female authority of Time, and moreover identifies the male intellect with an unclean childbearing body. The incoherence of Milton's trope originates in an ambivalent wish to conflate intellectual originality with childbearing, while simul-taneously implying that to identify the two processes is to confuse carnal and spiritual in a typically Catholic error. But Socrates' clear separation of male and female, mind and body, seems impossible.

So when English Renaissance poets imagine themselves inhabiting

women's bodies – as possessors of wombs, or as undergoing intellectual childbirth – two different but related questions arise. The first is: given the vigor with which the masculine prerogative was asserted in the early modern period, why are these writers attracted to such analogies at all? The second is: if they employ these terms, why not use them with the confidence of Socrates in the *Theaetetus*, to reinforce rather than to confuse the demarcations between male intellect and female carnality?

Contemporary evidence suggests that connections between the womb and the imagination, and between completed works, speeches, or actions and babies, were not merely poetic topoi in early modern England. After the failure of the earl of Essex's coup in 1601, for instance, many of his friends faced trial for high treason. Henry Neville protested in court that he had not taken part in Essex's insurrection itself, but merely participated in a conference planning the rebellion: this, he maintained, "was no more Treason than the childe in the mothers bellie is a childe."[11] Neville's defense is curious: he claims that the child in the mother's belly is not a child, but he calls it a child nonetheless. Neville only makes sense if he is saying that before a certain point, "treason" is not public, therefore not prosecutable by the courts.

In this respect Neville's analogy is extremely suggestive. He stresses less the womb's fecundity than its hiddenness, or rather a fecundity dependent upon hiddenness. The womb becomes the private space of thoughts yet unuttered, actions yet unexecuted. It is a container, itself concealed deep within the body, with something further hidden within it: an enclosed, invisible organ, working by means unseeable by, and uncontrolled from, the outside. Sixteenth-century anatomists go into great detail upon the stratified membranes that constitute the womb, "tunicles" and "panicles" layered one inside another like a set of Chinese boxes; some insist, moreover, that the womb is additionally divided into two, five, or seven cells like a honeycomb or labyrinth. Galen had insisted that women's reproductive organs are exactly parallel to men's, but inside-out, or rather, outside-in:

> All the parts, then, that men have, women have too, the difference between them lying in only one thing ... namely, that in women the parts are within the body, whereas in men they are outside ... Consider first whichever ones you please, turn outward the woman's, turn inward ... and fold double the man's, and you will find them the same in both in every respect.[12]

Or, as the sixteenth-century French physician Ambroise Paré echoes him, "that which man hath apparent without, that women have hid within."[13] The anatomical reticence of the female body can be a source

of embarrasment for Renaissance obstetrical writers, whose writing and diagrams indecorously display what seems to demand concealment. Thus Jacques Guillemeau's English translator assures his readers that "I have endeavoured to be as private and retired, in expressing all the passages in this kind as possible I could."[14] Both men and women have "secret parts," but women's are genuine secrets.

The female body imagined in these terms modifies rather than departs from a familiar misogynist topos. Antifeminist texts from classical satire to *film noir* complain that the woman's visible body, a fascinating surface further elaborated by cosmetic enhancements, has nothing to do with the essence concealed within – if, indeed, there is anything inside at all. In *The Araignment of Lewd, Idle, Froward, and Unconstant Women* (London, 1616) Joseph Swetnam rehearses this topos:

> [Women] are also compared unto a painted shippe, which seemeth fair out-wardly, and yet nothing but ballace within her; or as the Idolls in *Spaine*, which are bravely gilt outwardly, and yet nothing but lead within them. (p. 3)

The anonymous author of *A Discourse of the Married and Single Life* (London, 1621), similarly explains:

> Sometimes at marriages Walnuts are scattered up and downe; which sheweth, that a woman is like unto a Walnut, that hath a great shell, but a little kernel; faire without, but rotten within. (p. 96)

The outside is no clue to the inside. A notion of women as deceptive or hollow surfaces produces paranoid complaints about female hypocrisy and vacuity.

At the same time, differences between inside and outside can be exhilarating under different circumstances. Anticipating an invasion by the Spanish Armada, Elizabeth I rouses the courage of her troops at Tilbury by telling them that she has "the body of a weak and feeble woman, but ... the heart and stomach of a king, and a king of England too."[15] Elizabeth's claim apparently reverses the metaphors I have been considering here, since it involves a woman appropriating male bodily parts, but it relies upon an identical intuition: it is never obvious what a woman has inside her.

The possibility of such a hidden space appeals to those who want to shield some aspect of themselves from public scrutiny or control. Renaissance advice literature for aspiring humanists and courtiers, full of exhortations to concealment of one's true motives, fosters precisely this kind of self-protective impulse. Bacon is repeating an old Renaissance saw when he tells his readers in "Of Simulation and Dissimulation" that

"The discovery of a man's self by the tracts of his countenance is a great weakness and betraying," or praises the inhabitants of Bensalem for seeking to be "hidden and unseen to others, and yet to have others open and as in a light to them." Jonson likewise does not pretend to originality when he writes in *Discoveries*:

> It was excellently said of that Philosopher ... that the rashnesse of talking should not only bee retarded by the guard, and watch of our heart; but be fenced in, and defended by certaine strengths, placed in the mouth it selfe, and within the lips. (pp. 333–9)

The ability to exploit the difference between invisible private thoughts and visible public actions is one of the important Renaissance meanings of the word "politic." Even Martin Cognet's *Politique Discourses Upon Trueth and Lying*, which makes the lie the basis of all sin, concedes that "if a man woulde ... discover to everie man the secrete of his minde, he shoulde be counted but a dizard."[16]

The woman's body, then, incarnates some of the particular privileges and paradoxes of Renaissance subjectivity. On the one hand she is constituted as something preeminently *seen*; the paradigmatic focus, as numerous feminist writers have pointed out, of the male gaze. At the same time her interior "difference," her lack of visibility, can become a topos of a *resistance* to scrutiny, of an inner truth not susceptible to discovery or manipulation from the outside. In *Astrophil and Stella* (*c.* 1580), Sidney gets over his labor pains when he eschews external aids and begins to trust his depths: "Look in thy heart and write" (sonnet 1, line 14). Jonson often associates his claims to a womb with quasi-Stoic assertions of independence: he gives birth to his work in proud solitude, his labors unattended. In *The Revenge of Bussy d'Ambois* (1613), Chapman's Stoic hero Clermont suggests the advantages and disadvantages of a subjectivity formed upon this model:

> The garment or the cover of the mind
> The human soul is; of the soul, the spirit
> The proper robe is; of the spirit, the blood;
> And of the blood, the body is the shroud. (v.v.170–3)

The mind is elaborately insulated by layers of increasingly material substance – soul, spirit, blood, body – which provides necessary shelter for the true, vulnerable center of human identity, even while precluding any direct communion between the interior subject and exterior objects. Perhaps, then, the womb is another of those small enclosed spaces in which so many seventeenth-century poets discover their poetic identity and freedom; like Donne's little room, Carew's hidden garden,

Lovelace's prison cell. The clearly bounded and delimited body is the space of freedom.

While it might seem that the calculated cultivation of a hidden space within would be incompatible with misogynist paranoia, the reverse is in fact the case. The unreadability that seems so attractive in oneself seems sinister in others; one man's privacy is another woman's unreliability. The female interior encloses experiences unappropriable by an observer: adultery, orgasm, and so forth are both unseeable and possible. This dilemma, essentially a version of the "problem of other minds," produces the paradoxes or oxymorons of antifeminist rhetoric: women's silence conceals their true thoughts, women talk too much; women are inscrutable, women disclose everything. Hamlet boasts to his mother that he has "that within which passes show," but her own unforthcomingness drives him, literally, nearly crazy. In books 3 and 4 of *The Faerie Queene*, Spenser's exaltation of Britomart, the armed figure of chastity, militantly closed to penetration, coexists with much more disturbing portraits of female figures who exploit their inscrutability, like Helinore or the false Florimell. The Renaissance male appropriation of the womb as a figure for the imagination is perfectly consistent with an ideology that prescribes the strict supervision of female sexual behavior, and the exclusion of actual women from literary endeavors. Thus, as we have already seen, in *Doctrine and Discipline of Divorce* Milton's daring mixture of metaphors relies upon an ultimately conservative notion of woman's subjection to man's authority. For men, the womb can become a figure for a kind of freedom, however limited; but the very hiddenness of that freedom can preclude allowing it to the actual possessors of those wombs, whose bodies, unreadable from the male point of view, suggest a kind of anarchy.

This way of thinking about women's bodies, however, is extremely tendentious. The appeal of the woman's body, for a man who wants a subjective refuge, is the way it is closed in upon itself, the way her interiority is protected by opaque bodily perimeters. But as an emblem of a "closed" subjectivity, the female body is defective insofar as it is penetrable, insofar as it is, in fact, a sort of paradigm of penetrability.[17] Moreover, the birth process, both in reality and as a metaphor for rhetorical production, involves the permeability of boundaries in the other direction, the sensational transfer from inside to outside through an orifice that ordinarily, in Jonson's phrase, ought to be "fenced in, and defended by certaine strengths." That favorite King James Bible word "knowledge" has both a carnal and spiritual significance; men "know" their wives, but the expression is not reciprocal. When Donne in *Holy*

Sonnets 14 asks to be raped by God, takes on a position that seems "feminine" or passive, the point is that his position is already feminine, insofar as God is always already inside.

But if the mechanics of impregnation are repudiated, then some of the chief attractions of the female body as a metaphor for poetic creativity – its receptivity and fruitfulness – seem endangered too. Sidney and Jonson both identify themselves with a pregnant female body, struggling to "deliver," to "express," an interior fullness. The act of poetic creation seems to require a reference to an inside even as that inside is being externalized, as the difference between inside and outside is transgressed or annihilated. But this is pregnancy without impregnation. At the end of the first sonnet of *Astrophil and Stella*, Astrophil's pregnancy is revealed to be essentially self-generated: something comes out, but nothing came in. He becomes able to give birth when he recognizes his own self-sufficiency, stops relying upon externals, and looks within his own heart. The Muse gives him advice, but she does not give him the poem: she is a midwife, not an origin or even a co-begetter. Likewise Jonson manages simultaneously to employ and disavow the childbirth metaphor in *Timber, or Discoveries* (1640), when he writes that language "springs out of the most retired, and inmost parts of us, and is the Image of the Parent of it, the Mind" (lines 2032–3). He wants to emphasize an interior space in which the creative imagination works, without stipulating how language got in there in the first place. So the mind, although it functions like a mother, becomes merely a "parent," divested of its gendered specificity.

It would seem that Renaissance poets could avoid these awkwardnesses by imagining themselves in terms of the female body, but at the same time making clear – as Socrates had – that the figure was an analogy, that processes of mind and body cannot be confused or conflated. Instead such metaphors become, for English Renaissance writers, the sites of gender disorientation rather than of clarification. In vernacular sixteenth- and early seventeenth-century speech and writing, the whole interior of the body – heart, liver, womb, bowels, kidneys, gall, blood, lymph – quite often involves itself in the production of the mental interior, of the individual's private experience. Humors psychology is perhaps the most systematic working-out of this premise, but often it is invoked more casually. "When I am dead and opened," Mary Tudor puns to her counselors, "you shall find Calais [callous] lying in my heart."[18] Edward Coke, presiding at the trial of the Gunpowder conspirators, describes to the prisoners the rationale behind the punishment that awaits them: the traitor's "bowels and inlay'd parts [are] taken

out and burnt, who inwardly had conceived and harboured in his heart such horrible treason."[19] The traitor comes to the scaffold quite literally to spill his guts, to have the heart plucked out of his mystery.

None of this ought to suggest anything like consistent materialism on the part of early modern Europeans. There is considerable philosophical dispute in the Renaissance among neo-Stoics, neo-Platonists, Galenists, Paracelsans, Aristotelians, and others about the relation of bodily and mental phenomena; theologically, philosophically, psychologically, and medically oriented discourse compete, coexist, and sometimes blend in surprising ways. But the patterns of speech I am discussing here are largely subphilosophical, suggesting habits of mind rather than carefully articulated systems of thought. Except in the case of philosophers like Descartes, few attempt to sort out the implications of their own linguistic practices, which bring the carnal and the spiritual into frequent but unstable intimacy.

Consequently when a sixteenth- or seventeenth-century man lays claim to a womb, the precise character of his assertion is sometimes difficult to assess. Renaissance speech habits can make it difficult to know when we are dealing with a bodily metaphor and when with a bare statement of fact – and whether, many times, this kind of distinction is even germane. Moreover, even given a general lack of clear distinctions between bodily and mental processes, the womb seems a particularly indefinite organ. Although early sixteenth-century anatomists had disproved Aristotle's claim that the uterus wandered about the body, and discredited Galen's notion that it constituted a separate animal, notions of its errancy and autonomy persisted in the popular imagination and undoubtedly suggested comparisons with the idiosyncratic itineraries of fantasy. Rhetorical treatises elaborate the similarities. Thomas Wright claims that hasty and imprudent speakers "commonly are with childe with their owne conceits, and either they must bee delivered of them, or they must die in child-bed."[20] Words such as "conception," "issue," and "delivery" imply affinities between childbirth and thinking or speaking. Patricia Parker has discussed many of these punning affinities between the pregnant woman and the text of *corpus* – for instance the pun on *mater*, matter, mother, the connection between the copious, amplified text and the enlarged, fertile female body, the traditional association of women with a loquacity that lacks any "point" – while Lisa Jardine has described the implications of the common Renaissance association between sexual promiscuity and female speech.[21]

These half-analogical, half-literal relationships could only have been

reinforced by intimate, casual connections between the brain, in which Galen had located mental functioning, and the womb. Huarte writes: "the member which most partaketh the alterations of the bellie, all Phisitians say, is the braine, though they have not set downe the reason whereon they ground this correspondence" (p. 273). Gynecological writers, following Aristotle and Galen, invariably warn that a pregnant woman's mental state affects the physical and psychological disposition of the fetus, that the developing child is likely to be imprinted by the images that come before the mother's eyes or are entertained in her imagination. Conversely, disorders that originate in the womb – hysteria, greensickness – produced, and were diagnosable by, primarily mental symptoms.

These medical beliefs complicate the neat contrasts Socrates makes in the *Theaetetus*. The most significant difference between the midwife and the philosopher, in Socrates' account, is the ability of the latter to tell true from false, a talent irrelevant to the delivery of babies: "for women do not, like my patients, bring forth at one time real children and at another mere images which it is difficult to distinguish from the real" (150B). In Renaissance obstetrics however, the close links between mind and body made malformed children as likely as malformed ideas; in fact, the former were a consequence of the latter. "Monstrous creatures of sundry forms are also generated in the wombs of women," writes Paré, "somewiles alone, otherwiles with a *mola*, and sometimes with a child naturally and well made, as frogs, toads, serpents, lizzards."[22] The monstrous birth, transgressing categories, becomes not merely a tragic instance of deformity, but an intriguing intellectual puzzle. The fascination with misleading evidence evinced in these treatises seems part of the same pattern: the instructions on how to tell a tumor from a fetus, a genuine conception from a psychosomatic pregnancy, a male from a female child before delivery. The Renaissance midwife needs to be able to tell true from false, monster from human, *mola* from embryo, in a way Socrates had reserved for the philosopher.

Body and mind in Milton's *Comus*

All of these complexities surrounding the difference between male and female, mind and body, converge upon the poetry of the young Milton, for whom both oppositions are crucially important. The association of intellectual creativity with the fecund female body is extremely attractive to him, as we have already seen. But it is also more problematic than

it is for Sidney and Jonson, since at this point in his life his poetic gift, he insists, is predicated upon sexual renunciation.

Milton devises a solution which preserves many of the advantages of the trope of the poet-in-childbirth while adapting it to the decorum of his particular situation. As many critics have noted, the author of *Comus*, whose sexual fastidiousness had earlier earned him the nickname "Lady" from his contemporaries at Cambridge, invests himself in the character of the Lady, speaking from the place of the virgin. In a university rhetorical exercise, written six years before *Comus*, Milton suggests how he may have imagined this investment:

> Have I by killing a snake suffered the fate of Tiresias? Has some Thessalian witch smeared me with magic ointment? . . . From some I have lately heard the epithet, "Lady" [*Domina*]. But why do I seem to those fellows insufficiently masculine? . . . Doubtless it was because I was never able to gulp down huge bumpers in pancratic fashion; or because my hand has not become calloused by holding the plow-handle; or because I never lay down on my back under the sun at mid-day, like a seven-year ox-driver; perhaps, in fine, because I never proved myself a man in the same manner as those gluttons [*Ganeones*]. But would that they could as easily lay aside their asshood as I whatever belongs to womanhood.[23]

Here, as in *Comus*, Milton imagines an individual threatened by a metamorphic power, but here the metamorphosis is false – both because, of course, he is not actually the victim of a Thessalian witch, and more importantly because he embraces rather than denies the ascription of effeminacy. The Lady, here as in *Comus*, advertises his/her rejection of indiscriminate sensuality and withdrawal from coarsely physical toil and pleasure. For his adversaries, Milton uses the word *Ganeones* – a word that means not only "gluttons" but "perverts" – turning the homosexual implications of his nickname back upon his hypermasculine opponents and conflating, just as he will in *Comus*, sexual profligacy with dietary intemperance. But Milton also imagines that his own occupation of a feminine position is a matter of choice; that he is free to lay aside whatever belongs to womanhood as one cannot lay aside an immutable characteristic like stupidity. His imaginative identification with the Lady in *Comus* might be seen as the same kind of gesture, an attempt to assume a role that, while deeply self-expressive, can nonetheless be discarded when it becomes inconvenient.

Milton's identification with a virginal character allows him to enjoy the advantages of the secure interior space associated with the female body without suggesting, even by the studious omissions of Sidney and Jonson, that the interior need be compromised in order to obtain a

poetic result. At the same time, of course, he affiliates himself with a rich classical and Christian tradition of thinking about the virgin female body in terms of what Theresa Krier has recently called, in Spenser's case, a fascination with "warmly eloquent surface and protected interior." But as Krier points out, Spenser's "creative impulse ... is to honor the otherness of feminine bodily life."[24] He maintains a certain distance between his virgin characters and the experience of the male author or reader, who occupies the place of a spectator. Milton, by contrast, follows Sidney and Jonson in *identifying* himself with the woman. He thinks of his poetic vocation in terms of inhabiting the Lady's physical position.

Comus explores the implications of that identification with unprecedented boldness and rigor. Versions of the Lady's body, a perfectly enclosed, strictly delimited interior space, pervade the masque. The Attendant Spirit tells us that the gods live "insphered / In regions mild of calm and serene air" (lines 3–4); Echo, in the Lady's song, is "unseen / Within thy airy shell" (lines 230–1); the lost brothers are imagined as hidden in a "flowry cave" (line 239); the sheep are "folded flocks pen'd in their watled cotes" (line 344); the Attendant Spirit refers to "the litter of close-curtained sleep" (line 554). These lovely, reassuring images have their nightmare counterpart in terrifying visions of involuntary confinement: mortals are, the Attendant Spirit announces, "confin'd and pestered in this pinfold here" (line 7); the night is a "Dragon woom of Stygian darknes" (lines 131–2); the woods a "close dungeon of innumerous bowes" (line 349); Comus and his followers, "within the navel of this hideous wood", perform "abhorred rites to Hecate / In their obscured haunts of inmost bowres" (lines 520, 535–6).[25]

For Comus, invisible space is the place of transgression; if, as he says, "'Tis only daylight that makes Sin" (line 126) then he can do anything he likes as long as no one sees him. His unspeakable concealed enormities recall the gynephobic anxieties of misogynist writers such as Joseph Swetnam; his male power (the power to rape) is magically dependent upon evil women – his mother Circe and the witch-goddess Hecate. The virtuous Lady, by contrast, thinks of herself as always fully displayed before an omniscient divine eye, a spectator that both keeps her safe and evaluates her, that by observing her provides her with her own capacity of observation. "Eye me blessed providence," she prays (line 329), asking both to be watched and to be given eyes, granted vision. Similarly the Elder Brother contrasts the transparent interiority of the virtuous with the opacity of the bad:

He that has light within his own cleer breast
May sit i' th' center, and enjoy bright day,
But he that holds a dark soul, and foul thoughts,
Himself is his own dungeon. (lines 380–4)

Complicating this distinction is the fact that the virtuous individual
maintains a well-lit interior only by strictly policing its boundaries,
whereas Comus, who exploits the sinful potential of the hidden refuge,
does so by insisting upon the necessity of penetrating, violating that
space.

Thus not only is the enclosed female body simultaneously fortress
and trap, but how one experiences the space inside depends upon one's
moral perspective. The virtuous person's freedom exactly resembles the
vicious person's confinement, and vice versa. The issues become
especially vivid when Comus attempts to intimidate the Lady:

COMUS: Nay Lady sit; if I but wave this wand,
 Your nervs are all chain'd up in alablaster,
 And you a statue; or as *Daphne* was
 Root-bound, that fled *Apollo*.
LADY: Fool do not boast,
 Thou canst not touch the freedom of my minde
 With all thy charms, although this corporal rinde
 Thou hast immanacl'd, while Heav'n sees good. (lines 659–65)

This recalls the Ovidian text:

> Hanc quoque Phoebus amat positaeque in stipite dextra
> sentit adhuc trepidare novo sub cortice pectus
> conplexusque suis ramos ut membra lacertis
> oscula dat ligno; refugit tamen oscula lignum.

> (Phoebus loved her even now, and his right hand, placed upon the trunk, felt
> the heart still trembling under the new bark. Embracing the branches as if they
> were human limbs, he bestowed kisses upon the wood; but the wood shrank
> from his kisses.) (*Metamorphoses* I, 553–6; my translation)

Forced to endure Apollo's unwanted caresses, Daphne is nonetheless
protected from rape. The moment contains both threat and promise,
paralysis and liberation. Comus' attempt at intimidation can become the
very material of the Lady's defiance. When the Lady asserts that Comus'
power over the "corporal rind" cannot extend to "the freedom of her
mind," she insists that what is inside her is of a radically different kind
than what is on the surface. Ovid's text is pointedly ambiguous on this
issue. On the one hand the heart still beats under the bark, and the wood
shrinks from Apollo like flesh beneath a garment. On the other hand,

the wood he kisses (*ligno*) is the same wood that shrinks (*lignum*); so by the end of the passage, as the metamorphosis completes itself, the difference between surface and depth seems meaningless.

The exchange between Comus and the Lady thus puts tremendous pressure on the ambiguities in Renaissance analogies between body and soul. If the universe of *Comus* is dualist, then the Lady's intuition of the safety of her mind within her body, her "corporal rind," is correct. If it is not, she is not. The rest of the masque gives us little help in deciding the issue. On the one hand, Comus can imagine the Lady residing within her body as a person within a house:

> Sure somthing holy lodges in that breast,
> And with these raptures moves the vocal air
> To testifie his hidd'n residence. (lines 246–8)

But the emblematic function of the Lady's virginity depends upon assuming that the body and the mind are of the same substance, or at least that the body is in some intelligible relation to the mind. Moreover, moral issues are persistently figured in corporal terms:

> When lust
> By unchaste looks, loose gestures, and foul talk,
> But most by leud and lavish act of sin,
> Lets in defilement to the inward parts,
> The soul grows clotted by contagion. (lines 463–6)

What is the difference here between carnal impurity and mental sin? Another way of putting this is that *Comus* combines an Ovidian discourse with Augustinian and Stoic ones that are at odds with it. In Ovid, especially as he was interpreted in the Renaissance, physical transformations represent psychological ones. When Comus' victims drink his potion

> their human count'nance,
> Th'express resemblance of the gods, is chang'd
> Into some brutish form. (lines 68–70)

The pun on "express" – external, exact – suggests that the body's form reproduces the form of the soul, a point the Attendant Spirit makes later in the masque when he describes Comus' potion as "unmoulding reason's mintage / Character'd in the face" (lines 529–30). The power of this identification of body and soul is intensified in the traditionally allegorical masque form in which Milton is working, in which the whole point of the genre is to personify abstractions and make them visible,

devising ways to present what Jonson had called "more removed mysteries" to the eyes of the spectators.

Contradicting this kind of figurative procedure is the Augustinian claim that the condition of the body is irrelevant to moral worth – a claim made most vigorously, not coincidentally, in a discussion of rape victims in *The City of God* I.xvi–xix. Women who suffer rape, Augustine insists, are in no sense defiled, because they do not consent to the action. Even if in the course of the act their bodies have, against their will, helplessly experienced sexual pleasure, their souls – the only things that finally matter – remain pure. Likewise the "budge doctors of the Stoic fur" (line 707), derided by Comus and quoted approvingly by the Elder Brother, strive to separate moral worth from bodily accidents.

In the way *A Mask Presented at Ludlow Castle* represents the body as both separable and inseparable from the soul, dispensable and indispensable for the practice of virtue, it resembles much of Milton's early work; in the divorce tracts, for instance, James Turner describes him "torn between materialist monism and hierarchic dualism."[26] In this particular instance, however, the specter of rape exacerbates difficulties produced by the relationship between the tenor and the vehicle of the metaphor mind = female body. By equating, even symbolically, the free mind with the impenetrable body, Milton makes rape a highly problematic issue. The Elder Brother, describing the unassailability of "true virgins," manages to reassure his younger brother by insisting that his sister possesses a "hidden strength" that controls the fate of the body:

> 'Tis chastity, my brother, chastity:
> She that has that, is clad in complete steel.
> . . .
>
> No goblin, or swart faery of the mine,
> Hath hurtful power o'er true virginity. (lines 420–1, 436–7)

Our problem in assessing the Elder Brother's claims is that it is unclear whether or not they are meant to be evaluated apart from their generic context. In the magical world of romance, in which aggressors quail from "sacred vehemence" (line 795) and river goddesses hurry to the rescue, the Lady has nothing to worry about. But in real-world Renaissance Britain, a woman's moral worth was inevitably involved with the fate of her vulnerable body, and the Elder Brother is close to suggesting that since "true virgins" are unassailable, rape victims are responsible for their own fate: they must have asked for it.

This would hardly have been an academic issue for the earl of Bridgewater's family. Their notorious relative, the earl of Castlehaven,

had recently been executed for various sexual crimes, one of which involved encouraging his servant and homosexual lover, Skipwith, to rape his twelve-year-old stepdaughter, Elizabeth Audley, while he watched. Elizabeth – first cousin and agemate of Alice Egerton, who played the Lady in *Comus* – had been married the year before the rape to Castlehaven's seventeen-year-old son, but the marriage had evidently not been consummated; although the earl provided Skipwith with "oil to open her body," he was at first unable to penetrate her. After Skipwith confessed, Elizabeth was convicted of adultery, fornication, and incontinency. Her grandmother, who took in the rest of the Castlehaven children in this time of crisis, refused to provide refuge for Elizabeth: "some sparkes of my grandchilde Audlies misbehaviour remaining ... might give ill example to the young ones which are with me."[27] Clearly this child, whom modern sensibilities would see as a victim of outrageous abuse, was held responsible both by legal authorities and by her own family for the sexual assault committed upon her.

And Milton keeps the pressure on by emphasizing the corporeality of the Lady, by making it difficult to idealize her virginal body too completely. One such moment occurs when, surprisingly, she responds to Comus' seductive language with the phrase, "I had not thought to have unlockt my lips" (line 756). But what seems like capitulation turns out to be resistance: the Lady unlocks her lips in order to refute Comus' argument, not to drink his potion or allow him any other kind of access. Another moment has provoked more critical discomfiture; after the brothers enter, the Lady proves to be stuck to her chair by "gumms of glutenous heat" (line 917). Phrases like these force attention upon the Lady's body as a body, not as an emblem for something else, highlighting the ambiguous metaphoricity of Renaissance mind–body relationships. If the body is expressive of the soul, then line 917 suggests that the Lady is saying no while meaning yes. Hugh Richmond writes that "the Lady's ... body acknowledges [Comus'] authority"; John Carey that

> there are ... elements in the masque which suggest some spiritual deficiency [on the Lady's part]. She does, after all, get glued to Comus' chair, and the chair "smeared with glutinous heats" brings to mind the sexual heat for which Comus' enchantments are allegories.[28]

If the body is distinct from the soul, on the other hand, then it is necessary to insist with Augustine that involuntary physical responses, even sexual ones, are morally inconsequential.

Problems like "the vulnerability of the body" or "the problem of the

existence of other minds" or "the relation between mind and body" might seem, in other words, to contain no explicit reference to gender, but their solutions are likely to seem different when the minds and bodies are male, rather than when the minds and bodies are female. By explicitly gendering such questions in the confrontation of Comus and the Lady, Milton renders them acute and troubling, especially given the fact that Milton is imagining himself as *inhabiting* the Lady's body, whatever that may come to mean in a work that calls into question the difference between mind and body. For if mind and body are inseparable, then it is a sheer impossibility for a male poet imaginatively to occupy a position physically designated as female, even while retaining the intellectual qualities associated with masculinity. The fantasy Milton elaborates in Prolusion 6 of occupying a feminine position temporarily, like an article of clothing, seems in this light to involve a confusion about, or denial of, that inseparability. But if, on the other hand, mind and body are entirely discrete categories, then it is unclear why one kind of body should seem an especially appropriate structural model for creative subjectivity – that is, why Renaissance poets should want to imagine themselves as women at all.

At the crucial moment, Milton uses masque conventions to obscure the issue further. The Lady insists that she has the power to bring Comus' castle down around his ears, and he – while granting that fact – moves forward to "force" her nonetheless. What is about to happen? Will the Lady's virginity, as a figure of the free mind, prove a source of magical power, or at least something unassailable from the outside? Will Comus turn out to be able to rape her after all, and if so, would he be committing merely an insignificant assault upon the body, the "corporal rind," or would he be more seriously compromising a virginity that has been represented throughout the masque as a moral virtue?

Although the Lady is saved at the last moment, Milton does not depict the Lady as rescuing herself from rape, nor does he show the brothers as able to solve her problem. He wants to preserve virginity – the unpenetrated body – as the emblem of incorruptible poetic creativity and the wellspring of moral virtue, but he is, realistically, aware that actual bodies are indeed penetrable, suffering not only rape, but disease, death, and decay. In *Lycidas*, written four years later, Milton is obsessed with a somewhat similar problem: the swollen, rotten bodies of the Anglican communicants, forsaken by their pastors, have an unfortunate affinity with the presumably swollen, rotten body of the drowned Edward King, with whom the corrupt churchmembers are supposed to be contrasted. In the elegy the solution is to deny the relevance of the

material, accidental world to spiritual and moral truths: the material King may be sunk low, but the "real" King is mounted high. In *Comus* the same option is available to Milton, but he does not quite take it. Perhaps the allegorical form of the masque forbids him to take it. Or perhaps, as in the passage cited earlier from *Doctrine and Discipline of Divorce*, Milton wants to insist both upon the proximity *and* the distance between mind and body. At any rate, the resolution of the Lady's dilemma represents a deflection in emphasis, a shifting of the terms in which it has been constructed. At the end of her ordeal, still fastened to Comus' chair, the Lady requires the supernatural salvific agency of the nymph Sabrina. As the Attendant Spirit informs us, Sabrina was herself an innocent victim of intolerable persecution who was rescued by sympathetic powers, the water nymphs and their father Nereus, at the crisis of her fortunes. Sabrina's story, and her intervention in the Lady's case, addresses less the poem's tense mind–body problematic than what might seem its isolating consequences. The Lady's steely continence, and her insistence upon mental freedom in the face of physical peril, has seemed as much Stoic as Christian. In order to assimilate the virtue into a Christian framework, Milton must emphasize its ultimate dependence upon a charitable external power, a saving grace that simultaneously allows the Lady's reincorporation into both her family and her social context.

I have several concluding observations. In the case of *Comus*, the ambiguously metaphorical female body becomes a site of anxiety about symbolization, about the status of emblem – obviously an important issue in a masque, especially a masque written by an iconoclast. In the case of the more general issues, I would suggest that the equivocal and anxious cross-gender identification implied by these metaphors might provoke a rethinking of the way feminist theorists have discussed literary creativity in a patriarchal society. In the cases I have been examining, the use of bodily metaphors suggests no "natural" or "healthy" tie to one's own physical structure, and the analogies are extremely intricate and shifty (women are closed, women are permeable; women are full of interesting things; women are hollow inside; men are boring inside; men have real inner lives which women either do not have or have only in grotesque ways). I wonder too if the problems of ambiguous figuration that I have been discussing with respect to Renaissance poets also haunt us today, especially in psychoanalytically oriented kinds of feminist theory. The question, just how much is a poet like a pregnant or virgin woman? may resemble questions like: how different is the phallus and the penis? what does the Law of the Father

have to do with ordinary everyday fathers? what is the difference between sex and gender? It may resemble, in other words, just those questions which are so troubling for French and Anglo-American feminist theorists today.

Notes

A National Endowment for the Humanities Summer Stipend facilitated completion of this essay. I presented versions at the University of Virginia Faculty Colloquium, the 1989 Modern Language Convention, the 1990 Renaissance Society of America Conference, and a seminar on Renaissance concepts of privacy at Berkeley. I thank the audiences at these events, and James Turner, Fred Maus, James Ferguson, Clare Kinney, Daniel Kinney, and James Nohrnberg for their helpful comments.

1 *The Madwoman in the Attic* (New Haven, 1979), p. 4. As Gilbert and Gubar indicate, Harold Bloom's powerful Oedipal account of poetic influence and originality in *The Anxiety of Influence: A Theory of Poetry* (Oxford, 1973) is premised upon this "more than figurative" analogy. See also Barbara Johnson, *A World of Difference* (Baltimore, 1987), pp. 184–99.

2 Irigaray, *Speculum of the Other Woman* (1974), trans. Gillian C. Gill (Ithaca, 1985); Cixous and Clément, *The Newly Born Woman* (1975), trans. Betsy Wing (Minneapolis, 1986).

3 See above, and Margaret Homans, *Bearing the Word: Language and Female Experience in Nineteenth-Century Women's Writing* (Chicago, 1986); Susan Gubar, "'The Blank Page' and Issues of Female Creativity", in Elaine Showalter, ed., *The New Feminist Criticism* (New York, 1985), pp. 292–313.

4 Elizabeth Sacks enumerates Shakespeare's use of similar metaphors in *Shakespeare's Images of Pregnancy* (New York, 1980), and gives further examples from Nashe, Harvey, Whetstone, Skoleker, Dekker, Lyly, and Daniel.

5 Juan de Dios Huarte Navarro, *Examen de Ingenios. The Examination of Mens Wits*, trans. R. C[arew] (London, 1604), p. 270.

6 See Audrey Eccles, *Obstetrics and Gynecology in Tudor and Stuart England* (London, 1982), and Adrian Wilson, "The Ceremony of Childbirth and Its Interpretation," in Valerie Fildes, ed., *Women as Mothers in Pre-Industrial England: Essays in Memory of Dorothy McLaren* (London, 1990), pp. 68–107.

7 Plato, *Theaetetus* 150B–151C, trans. Harold North Fowler (London, 1977).

8 *The Countess of Pembroke's Arcadia (The Old Arcadia)*, ed. Jean Robertson (Oxford, 1973), p. 3. The prefatory letter is published in the first printed edition of the work ("The New Arcadia") in 1590, and in subsequent editions as well.

9 *Complete Prose Works*, ed. Don M. Wolfe *et al.* (New Haven, 1953–82), vol. II, p. 225.

10 For Puritan hostility toward "churching," see Keith Thomas, *Religion and the Decline of Magic* (New York, 1971), pp. 59–61, and Wilson, "Ceremony of

Childbirth," pp. 78–82. In *An Apology for Smectymnuus* (1642), Milton comments sarcastically upon "errors, tautologies, impertinences" in the ritual (*Complete Prose Works*, vol. II, p. 939).

11 Francis Bacon, *A Declaration of the Practices and Treasons Attempted and Committed by Robert late Earle of Essex and his Complices* (London, 1601), K2r. For some implications of this conception of treason, see my "Proof and Consequences: Inwardness and its Exposure in the English Renaissance," *Representations* 34 (1991), 26–49.

12 *On the Usefulness of the Parts of the Body*, trans. and ed. Margaret Tallmadge May (Ithaca, 1968), p. 628. For a full account of these theories, see Thomas Laqueur's *Making Sex* (Cambridge, Mass., 1990).

13 *The Anatomy of Mans Body*, in *The Workes of that famous chirurgeon Ambrose Parey*, trans. Thomas Johnson (London, 1649), p. 128.

14 *Child-birth, or, the Happie Deliverie of Women* (London, 1612), p. 3.

15 George P. Rice, ed., *The Public Speaking of Queen Elizabeth: Selections from the Official Addresses* (New York, 1951), p. 96.

16 Trans. Sir Edward Hoby (London, 1586), p. 13.

17 Gail Kern Paster and Peter Stallybrass remark that women often feature in Renaissance texts as "leaky vessels" requiring girdling or enclosure (Paster, "Leaky Vessels: The Incontinent Women of City Comedy," *Renaissance Drama* 18 [1987], 43–65; Stallybrass, "Patriarchal Territories: The Body Enclosed," in Margaret Ferguson, Maureen Quilligan, and Nancy Vickers, eds., *Rewriting the Renaissance* [Chicago, 1986], pp. 123–42).

18 John Foxe, *Acts and Monuments*, ed. George Townsend (London, 1839), vol. VIII, p. 625.

19 *State Trials* 2.184. The rationale, like the punishment, is traditional; see John Bellamy, *The Law of Treason: England in the Later Middle Ages* (Cambridge, 1970), pp. 39, 47, 52.

20 *The Passions of the Minde in Generall* (1604), ed. Thomas O. Sloan (Urbana, 1971), p. 110.

21 Parker, *Literary Fat Ladies: Rhetoric, Gender, Property* (New York, 1987), pp. 17–35; Jardine, *Still Harping on Daughters: Women and Drama in the Age of Shakespeare* (Brighton, 1983), pp. 103–40.

22 *Works*, p. 763. This passage comes from a treatise on smallpox, measles, and worms; Paré's fascination with anomaly is more fully displayed in *On Monsters and Prodigies*, later in the same collection.

23 Prolusion 6, trans. Bromley Smith, in *The Works of John Milton*, vol. XII (New York, 1936), pp. 240–1.

24 *Gazing on Secret Sights: Spenser, Classical Imitation, and the Decorums of Vision* (Ithaca, 1990), pp. 129, 139.

25 All quotations from *Comus* are from Helen Darbishire, ed., *The Poetical Works of John Milton* (London, 1958).

26 *One Flesh: Paradisal Marriage and Sexual Relations in the Age of Milton* (Oxford, 1987), p. 200.

27 Cited from Barbara Breasted, "*Comus* and the Castlehaven Scandal," *Milton Studies* 3 (1971), 201–24; to my mind Breasted is too willing to accept Skipwith's claim that Elizabeth's participation was voluntary. Leah Marcus, in "The Milieu

of Milton's *Comus*: Judicial Reform at Ludlow and the Problem of Sexual Assault," *Criticism* 25 (1983), 293–328, draws attention to a rape case that the earl of Bridgewater was investigating in his judicial capacity as Lord President of Wales, in the months before *Comus* was performed; in this case, the initial response of the authorities was to imprison the raped woman.

28 Richmond, *The Christian Revolutionary: John Milton* (Berkeley, 1974), p. 72; Carey, *Milton*, (London, 1969), p. 46. Critical debate on the gums is summed up in Edward Le Comte, *Milton and Sex* (London, 1978), pp. 1–4.

The geography of love in seventeenth-century women's fiction

JAMES F. GAINES AND JOSEPHINE A. ROBERTS

෧ം

Michel Foucault has observed that, even as Western culture was suppressing the most overt depictions of sexual relations, it was engaged in a widespread exploration and promulgation of every imaginable psychic aspect of human sexuality: "What is peculiar to modern societies, in fact, is not that they consigned sex to shadow existence, but that they dedicated themselves to speaking of it *ad infinitum*, while exploiting it as *the* secret."[1] Since this process was condoned by religious institutions, which relentlessly dissected the forces of desire in their pastoral and confessional literature, it is hardly surprising that the ever-evolving story of sexuality should find a still more accommodating outlet in the medium of worldly prose. Two of the most outstanding examples of the intensive examination of sexual means and motives may be found in the first work of original prose fiction by an Englishwoman, Lady Mary Wroth's *Urania*, and in Madeleine de Scudéry's *Clélie*, the final pinnacle of the French heroic romance.

Both Wroth and Scudéry were aware that the fictional quest for amorous discovery was inseparable from the fundamental reassessment of physical space that was sweeping through Europe, led by the cartographers Mercator, Ortelius, and Plancius, who developed the art of map-making.[2] Under similar inspiration, writers began to incorporate highly detailed imaginary maps or voyages into their works, ranging from More's *Utopia* or the Voyage to the Oracle of the Bottle in Rabelais' *Pantagruel* to the diagrams of moral conduct composed by such seventeenth-century authors as John Bunyan and John Hall.[3] A striking characteristic of early women writers, both in England and France, is their interest in creating a different type of cartography, one which would attempt to map the *terra incognita* of the human heart. A comparative approach to two of the most outstanding geographic allegories in seventeenth-century fiction, Wroth's Throne of Love

sequence in the *Urania* (1621) and Scudéry's Carte de Tendre in *Clélie* (1654–60), offers an illuminating perspective on both texts: Wroth's work can be better understood in relation to later models of literary cartography, while Sapho's famous map of desire can be studied in the light of another spatial construct, sprung from the experience of an often embattled *romancière*, and not deriving directly from her own model, as did most subsequent French love-maps.[4] Although Wroth's romance antedates *Clélie* by more than thirty years, they share a common attempt to explore the nature of love relationships and gender differences and to respond critically to the classical and medieval traditions of amatory geography which preceded them. Because both books present a double projection of sexual discourse as verbal narrative and pictorial landscape, they place particular emphasis on the self-conscious plotting out of the sexual adventure as an organizing force in the emerging modern *episteme*. Even the allegorical mechanisms of deferral which govern this discursive overflowing into the realm of graphic metaphor do nothing to diminish its epistemological value, for as Foucault has demonstrated, erotics always entail the question of truth (*History*, 1.243), especially when, as in the case of Wroth and Scudéry, the focus changes from the object of love to the guidance of the lover.

Lady Mary Wroth's inaccessible Throne of Love

The importance of the Throne of Love in *The Countesse of Mountgomeries Urania* is visually evident, since the episode furnishes the material for the frontispiece, engraved by the Dutch artist Simon van de Passe, for the first, printed half of the work (fig. 26). A company of knights and ladies, about to land at the court of Naples, is carried away by a violent tempest, which, after a harrowing night, leaves their unmasted ship off the coast of Cyprus. Constrained by lack of provisions, the travelers no sooner alight on the shore than their vessel bursts mysteriously into flames, as had another they observed during the landing. Although they do not encounter any of the dreaded barbarians said to inhabit Venus' enchanted island, they soon discover a splendid palace, constructed of black marble and adorned with statues of the Olympic pantheon, which is the abode of the goddess herself, the Throne of Love. It sits high on a hill, dominating the featureless plain, and the only approach involves crossing a river over a very peculiar bridge. This edifice contains three towers, which, as they learn from an old priest whom they interrogate, are also prisons, and belong to Cupid

The
Counteſſe
of Mountgomeries
URANIA.

Written by the right honorable the Lady
MARY WROATH.
Daughter to the right Noble Robert
Earle of Leiceſter.
And Neece to the ever famous, and re-
nowned Sr Phillips Sidney knight. And to
ye moſt exelt Lady Mary Counteſſe of
Pembroke late deceaſed.

LONDON
Printed for IOH MARRIOTT
and IOHN GRISMAND. And
are to bee ſould at theire ſhop-
pes in St Dunſtons Churchy-
yard in Fleetſtreet and in
Poules Ally at ye ſigne of
the Gunn.

26 Title page of Lady Mary Wroth, *The Countesse of Mountgomeries Urania* (London, 1621)

(Desire), Love, and Constancy. After refreshing themselves with water from the stream, the group falls prey to a plague of emotional derangement, with the result that some members are trapped in the first two towers, others stray off into the countryside, and only three are left with sufficient reasonable control to consider saving themselves and their comrades.

The Throne of Love episode takes its inspiration from a rich tradition, extending from Ovid through to Petrarch and the prose romances, especially *Amadis de Gaule*. Classical authors regarded Cyprus as the habitation of Venus, where Ovid locates her temple and the tree of golden apples (*Metamorphoses* x.644–8). The influence of the classical tradition was so strong that when Abraham Ortelius described Cyprus, he characterized its inhabitants as servants to Venus:

> The people generally do give themselves to pleasures, sports, and voluptousnesse: the
> women are very wanton, and of light behavior. The fruitfulnesse of it is so great, that in old time they called it Macaria, that is, The Blessed Iland; and the lasciviousnesse of the nation such, that it was supposed to have been dedicated to Venus the goddesse of love.[5]

At the end of Petrarch's *Trionfo d'Amore* the narrator describes his journey to the island, where Cupid leads a procession before the great triumphal arch of Venus' palace. The narrator discovers that the palace is actually a prison entered by wide-open gates, but from which it is impossible to escape: "dentro confusione turbida e mischia / di certe doglie e d'allegrezze incerte" ("within, a turbulent mingled confusion of certain sorrows and uncertain joys").[6] Wroth's account of the Throne of Love borrows particularly from Petrarch's description of the narrator's sudden shock at becoming entrapped in a structure that is outwardly majestic, but inwardly torturous. Release from Wroth's enchantment will occur only when "the valiantest Knight, with the loyallest Lady come together" (p. 40) and open the gate to the third tower of Constancy. Wroth may have derived the mechanism of release from the romance *Amadis de Gaule*, where the knights Amadis, Galaor, Florestan, and Agraies gather before the Arch of Loyall Lovers, through which "no man that hath falsified his first love may passe."[7] Only Amadis is able to reach the innermost chamber of the Palace of Apollidon; the others are driven back by various fiery torments. The Palace, described in detail as "one of the most sumptuous buildings in all the world" (book 4, p. 4), is constructed with a

high wall of black marble, and its enchantments may cease only when the "matchless beautie" (Oriana) enters the inner chamber. It is significant that Wroth combined the separate journeys of Amadis and Oriana into a simultaneous arrival of her heroic lovers at the Throne.

Several structural features are clear from the outset. Not only are Wroth's travelers neophytes in the country of love, like most subjects of moralistic cartography in Louis Van Delft's study, but they are also literally thrust into the strange land by events unforeseen and beyond their control. If the exploration is involuntary, parts of it are irreversible as well: one does not have to burn one's bridges in love's landscape, for the means of transport (in this case the ships) incinerate themselves, and the bridge is more apt to immobilize those who attempt to cross it than to facilitate their passage. Thus, the problem is not so much where to go, for the Throne is the only possible objective and can be reached by only one path, but how to overcome the redoubtable obstacles that lie in the way.[8]

What Wroth's geography lacks in length and breadth, it gains in height, for hers is clearly a relief map, and the notion of altitude is vital to her sense of personal values. The Palace itself is hierarchically removed from all that surrounds it. Crown-like in aspect, it is topped by the statues of the lordly Olympian deities, and sits exactly on the top of a hill which has room for no other structure. Even the gardens surrounding it on three sides and the woods occupying the remaining quadrant are terraced into the hillside. (In the engraving, the Dutch artist obviously had so much difficulty reconciling this vertical aesthetic with the usual pattern of the Renaissance formal garden that he depicted the geometric beds, espaliers, and quincunxes below the hill, at ground level, and was even obliged by the constraints of two-dimensional space to locate one on the opposite side of the river.) The rest of the Cypriot landscape seems to have been designed deliberately to be dull and ordinary, so as to enhance the *éclat* of Venus' castle. Love implicitly reigns supreme, incomparable, and elevated above the banal level of most human experience.

Elaborate and mysterious geographic traps await all those who wish to pass the bridge and enter the tower of Constancy. The psychic disarray caused by such an arrangement is evident in the frontispiece engraving, where the heterogeneous structure resembles none of the contemporary types of bridge architecture. This cannot be due to lack of familiarity, since fortified bridge-towers were familiar to city-dwellers all over Europe and to anyone who had crossed the Thames between

London and Southwark. Van de Passe's tower seems to have no ramps or doors, and instead of a passageway, it features a sort of elevated promenade far above both the river and the normal crossing level. Faced with the irresolvable problem of immobility, the artist created a building that is neither fish nor fowl. Although Wroth's geography is ostensibly simple in arrangement, this appearance is deceptive, and the moral multidimensionality of her amorous landscape is reflected in the immediate distress encountered in any physical or imaginative plotting of the description.[9]

Of course, the concept of a prison tower contains nothing new in itself. It has innumerable prototypes in Arthurian literature, in popular tales, and, perhaps most importantly, in the allegorical masterpiece, *Le Roman de la Rose*. However, such towers are usually *donjons* rather than bridge-towers, and generally contain the sought-after object of love (the Rose) rather than the questing lover (Amant). Wroth reverses the medieval imagery of Guillaume de Lorris and Jean de Meung by luring the active lover into the tower with the vain prospect of mobility toward a farther, higher goal – Venus' Throne. Instead of fighting against legions of allegorical warriors, each clearly identified by personifying arms, Wroth's questing lovers can only deal with their own isolated consciences and with a chaotic universe for which they were totally unprepared, against which conventional chivalry cannot contend.

Three in number, the towers still embody the concept of geographical displacement as a progress through clearly demarcated stations. To some extent all Renaissance travel was subject to this framework of regular incrementation, inasmuch as the realities of coaching necessitated regular changes of horses and frequent stops for refreshment, shelter, and rest. Even at sea, coastwise travel consisted still of a series of anchorages, since night navigation in or near shoal waters was considered nearly suicidal. Yet, the moral allegory of the towers in Wroth's landscape suggests another analogue – the stations of the cross and other regular prayer stages in religious pilgrimages and devotions. The rapprochement between love's journey and religious symbolism is so explicit in the early modern mind that it resulted in the popular Italian amusement called the *pellegrinaggio d'amore*, where the "shrines" bear names of allegorical states of the heart.[10] Equally suggestive are the stations of the cross in the Holy Week devotions, for each stop involves, like Wroth's towers, a specific ordeal, with deliverance only coming through a miraculous agency at the end of the progress. Venus' palace looms over the Cypriot plain like the kingdom of heaven, inviting those

who attain the equivalent of grace – that is, constancy – to enter into its sacred precincts.

The geographical plan of the *Urania* is very much what Van Delft would call *une carte-instrument*, not simply a series of locations, or even a centralized ordering of disparate places, but a plan in the sense of volition, offering a path to the accomplishment of a quest, and a series of problems that must be solved by the individual before he or she can reach the hierarchical goal ("Cartographie morale," 95). Without it, the questing lover is not only lost, but in imminent danger, and it is no coincidence that Wroth evokes the dilemma of Theseus against the Minotaur when she describes those newly arrived in Cyprus "as in a Labyrinth without a thrid" (p. 39). The author herself plays the role of Ariadne, offering her privileged creatures a distinct spatial and moral teleology: the desired goal can only be attained through a process of learning, which the paradoxical prose-map, as an ambiguous and incomplete text, can only initiate. The physical displacement in love's landscape only leads to a more intense psychic displacement as the travelers are forced to deal with themselves in overcoming obstacles and imprisonment. The fact that the tortures of the first two towers consist mainly of psychological rigors, such as jealousy, envy, and illusion, only adds to the demands of the internal journey.

The ability of Pamphilia and Amphilanthus to free the other characters from entrapment in the towers at first seems to affirm their special status as heroic lovers, but their initial success is undercut by their failures throughout the rest of the *Urania*. When Pamphilia holds the keys to Constancy, the statue on the third tower metamorphoses itself into her breast (p. 141). Yet her beloved does not remain faithful, and she finds herself in the disturbing predicament of trying to remain constant to inconstancy. Although the Throne of Love episode ends triumphantly with the spiritual redemption of the king of Cyprus, his wife, and his son Polarchos, who all become Christians, the projected marriage between Polarchos and the princess of Rhodes fails to materialize, just as that of the heroic lovers will be perpetually thwarted. Polarchos is instead imprisoned in an iron tower (p. 293), emblematic of the ongoing torments of the lovers.

The Throne of Love functions in the *Urania* as a central landmark to measure the principal couple's growing disaffection.[11] The major allegorical episode of the second book is the enchanted Theater of the Rocks, where the illusion of the smiling faces of their lovers entraps four of the key female characters – Pamphilia, Urania, Philistella, and Selarina: "thus flattering love deceiv'd the true, and brought contrary

effects to the most good" (p. 322). Significantly, Pamphilia's role has been transformed from that of rescuer to that of victim; she can be freed only by "the man most loving and most beloved," accompanied by "the fairest creature in disguise" (p. 344). Ironically, Amphilanthus comes to rescue Pamphilia arm-in-arm with *two* disguised women, Musalina and Lucenia, who now command the prince. This "sad spectacle," which Pamphilia sardonically cites as proof of "the truth of mans affection" (p. 377), fails to evoke any satisfactory sense of liberation.

The final enchantment of the *Urania*, the Crown of Stones, is actually contrived by Musalina as a means of erecting an insurmountable wall of doubt and suspicion between the principal couple. She creates a "Hell of Deceit," in which Pamphilia thinks that she sees Amphilanthus standing with his heart ripped open, but is powerless to come to his aid (p. 494). In a parallel enchantment, Amphilanthus believes that he sees Pamphilia dead, her breast torn open, and his name written on her heart (p. 554). He, too, is thrown out of the cave, but unlike the constant Pamphilia he then sets sail for other lands and other mistresses. Although the printed *Urania* ends with the prospect of a wedding between the couple, it is not surprising that in the Newberry Library manuscript containing the second, unpublished part of the *Urania* (Case MS fY 1565.W95), both lovers experience such renewed distrust and inward confusion that each marries another partner.

Only at the very end of the Newberry manuscript do the lovers return to Cyprus, in an episode containing significant retrospective references to the Throne of Love. Remembering her bygone adventures in Venus' isle, Pamphilia wistfully exclaims that "surely wee may now be secure from all charming businesses" (vol. II, fol. 58ᵛ). But such is not the case, as evidenced by the appearance of a young woman, dressed emblematically in yellow, tawny, and black; one character observes that the colors signify the fear and doubt of a lover (fol. 58ᵛ). She explains that as punishment for her mockery of Cupid, she is now doomed to wander in a "strange labourinth" (fol. 61). She recognizes Pamphilia and Amphilanthus as the couple who had once "sett this Country in peace and quiett from that tirible yett sweet inchantment, the throne of love" (fol. 61ᵛ), but they now are unable to aid her. Polarchos, who has become king of Cyprus, is another reminder of thwarted, frustrated love, for he never married and is survived only by a bastard son, Andromarko, who has fought his father in a ceremonial joust in defense of Cupid and has overcome him. The manuscript breaks off in mid-sentence, leaving the enchantments unresolved and the characters perpetually entrapped.

One striking characteristic of Wroth's amatory landscape is its

extreme differentiation of sexual roles. While the male characters may suffer inwardly, they generally retain freedom of action: for example, Polarchos is only temporarily entrapped in the iron tower and escapes through the agency of other knights. On the other hand, the female characters most frequently find themselves in much more passive roles, physically entrapped and immobilized, with release leading only to further entrapment.[12] Pamphilia in the first episode may seem to be an exception, but only *she* has the keys to Constancy, and henceforward becomes extraordinarily vulnerable to capture. Yet Wroth becomes increasingly critical of the restricted roles assigned to women, as evidenced in the Newberry manuscript, where the narrator observes: "itt is a strange, and rare thing in reason that all men should bee borne under that fatall rule of unconstancy, for when did any one see a man Constant from his birthe to his end? Therfor woemen must thinke itt a desperate destinie for them to bee constant to inconstancy" (vol. 1, fol. 8ᵛ).

Wroth's sharp distinction of gender-roles within her romance no doubt reflects the nature of Jacobean court life, in which James' entourage was totally distinct and separate from that of his wife, Anne of Denmark: each had its own independent administration, officers, and code of conduct. Only in entertainments, such as the performance of masques, were the two courts joined, and even here the men had decidedly the more active roles in the procession, while the court ladies were often represented in captive poses, such as in *The Masque of Blackness*, in which Wroth herself performed the part of an imprisoned Moor. The amatory landscape may also reflect her personal situation, for her lover William Herbert, third earl of Pembroke, was one of the richest, most powerful members of James' court, while she belonged to a lower social rank and later suffered the loss of her place in Queen Anne's inner circle of favorites. In contrast to French society, there were no salons in Jacobean England where men and women of slightly differing social ranks might mingle, as in the case of Mme de Rambouillet's *chambre bleue*.[13]

If Wroth's fiction reflects the more rigid differentiation of gender-roles found in Stuart England, her treatment of the Throne of Love still marks a significant departure from that of her predecessors. Instead of presenting an idealized vision of the relations between the sexes, she offers the Throne of Love as an "enchantment," a delusion that frustrates and thwarts the central characters. Wroth herself acknowledges the powerful cultural forces that have helped to shape and perpetuate the romantic ideology in a remarkable passage in which the

title character Urania chides Pamphilia concerning her attachment to Love: "he is not such a Deity, as your Idolatry makes him, but a good child well use[d,] flattred, an insolent thing comming over our harts, as children over the poore birds they catch before they can flie, thinking they master them, when indeede it is their want of wings makes their bondage; and so deare Cosin it is our want of courage and judgement makes us his slaves" (p. 399). Urania's plea that Pamphilia must free herself from an obsession with a destructive and illusory ideal of love is a poignant reminder of the few alternatives available to English women at the beginning of the seventeenth century.

Mlle de Scudéry's pathways to intimacy

As early as 1618, the marquise de Rambouillet sought, eventually with the help of her daughter Julie d'Angennes, to create a privileged environment where both sexes might contribute to a new, more refined kind of discourse that would contrast with the rough manners of the previous generation. Henri IV, the late king, had resembled James I in his tendency to objectify the ladies of the court. In the new salon, however, it was the women who stood as ultimate judges over the manners and wits of men. Madeleine de Scudéry's apprenticeship at the Hôtel de Rambouillet (1638–44) inculcated in her a new model of social interaction capable of replacing the ritualistic but frequently hollow patterns of court behavior that caused much anguish for Wroth's characters. For all its affectation, the speech of the *précieuses* was highly performative and supple, enabling the interlocutors to revise and reorient their positions in their privileged universe. Thus, Scudéry portrays polite conversation as a kind of verbal new frontier, where speakers become explorers on the uncharted territory of wit and *galanterie*. In this innovative setting, women enjoy discursive advantages at least equal to those of men, since the sallies of their admirers invite them again and again to take the high ground of aesthetic and moral judgment. When the first volume of her *Clélie* appeared in 1654, it was immediately the subject of frantic analysis as a *roman à clef*, since her earlier works had already imprinted her in the mind of the Parisian public as a disguiser of real-life events. The futile search for keys and one-to-one correspondences between fictive and actual personalities has drawn attention away from salient structural aspects of the text, such as its geography, but more importantly away from the larger cultural significance of the ideological struggles that persist in Scudéry's work.[14]

The geography of love

In an encyclopedic novel spanning the fall of the Tarquins and the foundation of the Roman Republic, the best-known pages remain those devoted to the Carte du Pays de Tendre, even though this particular passage occupies a problematical position in the work as a whole.[15] One's initial impression after reading the first volume is that the Carte clashes thematically with the *fabula* in which it is inserted. The incident is located at the approximate center of the "Histoire d'Aronce," related by the observer Célère to the Princesse des Léontins. The tale of Aronce's orphaned childhood, his constant brushes with pirates on the high seas, and the political vicissitudes of his protector Clélius, father of the heroine, is hardly one of geosocial stability. In fact, all the major characters are either lost children or exiles, and they have no precise idea of where they are or where they are going. It is only after a frantic series of displacements that the cast of characters is assembled in the deceptive tranquility of Capua. There the feelings of the central figures mature and flower in an atmosphere conducive at last to the refinement of the heart. Clélie's philosophy of secure friendship and the map that allegorizes it represent a nostalgia for stasis, or at least for direction, in the midst of an all-too-mutable and frequently random universe.

The Carte (fig. 27) is the creation of Clélie herself and springs from a set of specific biographical circumstances, both in the story of the character and in the life of the author. In the text, Clélie first mentions the notion of an amatory geography in relation to a classification system she has devised for her friends. When Herminius complains about his failure to achieve the status of *tendre ami*, the heroine offers to produce for him a schematic representation of the sentimental countryside with which he is unfamiliar – the result is the Carte. Nicole Aronson states that the creation of the Carte springs from Paul Pellisson's real-life inquiries in 1653–4, when he was undergoing a six-month "trial" to see if his professed love for Mlle de Scudéry was really true. Already recognized officially as a "personal friend" (*ami particulier*) of the renowned Sapho, "Il s'avisa de demander s'il y avoit loin de Particulier à Tendre" ("he resolved to ask if it were far from Personal to Tender"). Whereas Mary Wroth was forced to recant any biographical intention in a fruitless attempt to save *Urania* from the censors, "Sapho" emerged from beneath the veil of anonymity and even enlarged upon the mimetic dimension of her novel. For example, when Scudéry bade farewell to her real-life follower, Isaac Isarn, she called him "the great purifier of Tendre," drawing explicitly on the fictive geography of her map and giving herself proprietary titles to its lands. Later, when her platonic affection for Pellisson caused a serious crisis in the *samedi* group (who

The map contains the following labels:

The Dangerous SEA

Countreys undiscovered

Tender upon E.

The LAKE of INDIFFERENCE

Goodness

Respect

Exactness

Generosity

Honesty

A Great hart

Sincerity

Forgetfulnes

Playing verses

An amorous Letter

Lightnes

A Gallant Letter

Inequality

Negligence

Lukewarmnes

Great spirit

Friendship

New

Ekim F.

Tender upon Ya

The River of Inclination.

Obedience

Tenderness

Sensibility

Great Services

Empressment

Assiduity

Small Cares

Submission

Complacency

Perfidiousnes

Obloquy

Indiscretion

Mischeif

Pride

Constant-Friendship

Recog in France F.

Tender upon R.

The SEA of ENMITY

27 Translated engraving of Mlle de Scudéry's "Carte de Tendre" in Clelia, An Excellent New Romance, trans. John Davies

attended the regular weekly gatherings of her salon), she employed imagery from the Carte to defend and rationalize her actions, in order to placate her old allies.[16]

The most striking topographical division in the map is the distinction between the loci of social sexuality and the loci of biological sexuality. Allegorical representations of interpersonal relations generally take the form of towns and cities on the map, each one being a step in the development of sentimental attachment.[17] From the departure point of New Friendship to the largest city (and therefore most commonly experienced love itinerary) of Tender-Upon-Inclination, there are no other cities, because the violent course of natural attraction precludes any stops along the way. The narrator, Célère, explains that since Clélie presupposes that the sort of tenderness that springs from inclination needs nothing else to sustain itself, she placed no towns along its banks. The rapid flow of unconstrained emotion makes any intermediate sojourn inconceivable.[18]

On the right-hand path leading to Tender-Upon-Esteem, one passes by necessity through the towns of Great Spirit, Pleasing Verses, Gallant Letter, Amorous Letter, Sincerity, Great Hart, Honesty, Generosity, Exactness, Respect, and finally Goodness, while on the left hand the progression toward Recognisance begins with Complacency, and passes more or less directly through Submission, Small Cares, Assiduity, Empressment, Great Services, Sensibility, Tenderness, Obedience, and Constant Friendship before reaching its goal. All of these towns are associated with the performance of acts of friendship by the masculine suitor. The size of the towns on the map corresponds explicitly to the frequency with which "friends" are able to fulfill their amorous obligations: "Apres cela vous voyez qu'il faut passer par Grands Services: et que pour marquer qu'il y a peu de Gens qui en rendent de tels, ce Village est plus petit que les autres" ("from thence you see we must pass to great services, and for to note there are few men which render such; this village is smaller than the others").[19] It is interesting that the left-hand road toward Recognisance is not only the less traveled, if one is to judge by the size of the stopovers, but also the more interesting to the narrator, who devotes a much longer explanation to it than to the path of Esteem. Perhaps the reason for this is that, while the side of Esteem contains recognized virtues, they involve for the most part merely exhibition of the idealized masculine character, whereas the elements of Recognisance call for a greater openness to the nature and needs of the love-object. One may say that Esteem is inner-directed, while Recognisance is other-directed.[20]

It may appear that the Carte de Tendre offers amatory mobility only to males, and confines females, cloister-like, within the walls of the three principal cities. This is not always the case, however. Though apparently designed as a way to appropriate masculine desire into the space of permissible sentiment, the Carte was sometimes put to use to describe feminine emotions; after the crisis of Pellisson's acceptance, Sapho refers in writing to some of her former female friends who are making stopovers in the negative towns of the Pays de Tendre.[21] Lacking the complete heterosexuality of Wroth's Cypriot route, where both men and women must cross the river and brave the dangers of the towers, Scudéry's route is not entirely devoid of the possibility of feminine displacement.

Of the negative towns on the map, it must be noted that all involve some component of discernible social mistreatment: Indiscretion, Perfidiousness, Obloquy, Pride, and Mischief lie in the direction of Enmity, and Negligence, Inequality, Lukewarmness, Lightness, and Forgetfulness in that of Indifference. The two groups are well organized, for the former may be called sins of egotism, fairly natural by-products of masculine inner-directedness, while the latter are sins of disappointment, stemming from failed other-directedness.[22] In these negative towns, social mistreatment comes sometimes in close contact with the natural topography of the psycho-organic realm, for the village of Forgetfulness, presumably the least social of all, lies far from other human features and close to the Lake of Indifference, while that of Pride is suitably perched on the top of an inaccessible escarpment, suggesting an underlying "humor" to be the cause of this particular fault. Indeed, the fault is identified in the text as loss of direction, or "esgarement," a specifically geographic and rational term that recalls the crucial role of geography and directions in Descartes' *Discours de la méthode*.[23]

Obviously, the plethora of stages in Scudéry's progress toward love marks a distinct departure from Wroth's economical model of the three towers. Although far more numerous, Scudéry's stages seem to involve distinctly less risk for the amorous pilgrim, since the villages seem designed more to welcome than to entrap him, and apart from the odd isolation of Forgetfulness or the precipitous site of Pride, their surroundings apparently involve no danger whatsoever. Rather than the mystic immobility of Wroth's lovers, Scudéry's are faced with the prospect of an unencumbered, if lengthy, road, which demands the resources of intelligence and attentiveness if one is to master the arts of love letters and other services, but which requires little else in the way of inner turmoil or true sentimental education.

Contrary to the urban representation of interpersonal phenomena, physical and emotional situations in their "pure," asocial state are portrayed in the Carte de Tendre by natural features, especially bodies of water, such as the River of Inclination, Lake of Indifference, the Dangerous Sea, and the Sea of Enmity. One may object that the two important tributary streams, the Rivers of Recognisance and Esteem, derive from the social realm, but in fact they denote the affective component of a social process, the emotional resonance of recognition and esteem, with the cities of Tender-upon-Recognisance and Tender-upon-Esteem serving as points of embarcation or transition from the social to the psycho-organic. Wroth's river was a source of unexpected sentimental loss of control, but Scudéry's implies a confidence that nature can and should be harnessed whenever possible to fit the purposes of intellect. Both the advantage of the River of Inclination, as the most direct route to Tendre, and the rational fear of the Dangerous Sea coexist in her watery realm.

Although Célère, the narrator, casts a very moralistic and cautionary interpretation over the allegory of love's fulfillment in the Dangerous Sea of passionate surrender and the Countries Undiscovered of sexual gratification, one should not overlook the significant fact that Mlle de Scudéry included the features at all. Had she been the total prude she is sometimes accused of being, she would hardly have placed the *terra incognita* of fulfillment so enticingly close to the shores of Tendre. After all, one of the primary functions of maps, especially in the early modern period, was to lead to and through unexplored territory. Despite Clélie's expressed intention of adhering to the itinerary of a well-charted, gradual, cautious, and more or less rectilinear *voyage*, the common outlet of all three rivers into the Dangerous Sea in precisely the same direction as the progress of true friendship constitutes a great temptation to continue one's travels.[24]

In fact, the creation of the Carte itself acts in the *fabula* to encourage a continuation of travel, both affective and physical. Because his rival Aronce has already advanced nearly to Recognisance, Horace (who cannot accept his allegorical classification as a secondary *soupirant*) turns the Carte against Clélie herself by accusing her of already wading in the Dangerous Sea of passionate commitment. Clélie's subsequent indignation, coupled with Horace's desperate but successful effort to convince Clélius that his daughter must marry a true Roman, rather than a mongrel like Aronce, destabilize the idyllic amatory world of Capua. Paternal authority, uncaring rivalry, and clandestine scheming produce a series of misunderstandings that temporarily alienate Clélie from

Aronce, and even the tepid accessory Célère from his reasonable mistress Fénice. The apparent triumph of true love comes only through violence: Aronce postpones Horace's marriage by wounding him in a duel, and then saves Clélius from a pair of thugs sent by Tarquin to assassinate him. Even as reason is on the verge of asserting itself in the marriage of the lovers, their bucolic wedding is ruined by the ultimate symptom of topographical instability, a volcanic eruption that devastates the Campanian countryside: the flames and noise of the earthquake "sembloient avoir esbranlé le Centre du Monde; et vouloient remettre la Nature en sa premiere confusion" (I, p. 12: "seemed to shake the Center of the World and to remit nature to its first Chaos," p. 2). Thus the attribute of "tranquillité," which is applied to Clélie at the opening of the volume, is dispelled by the turmoil of nature embodied in perhaps the most vividly descriptive passage of the entire novel.[25]

Scudéry's map differs radically from Wroth's in the amount of choice that it affords to the questing lover. The three towers on the bridge to Venus' palace must be negotiated by all who would arrive there, but the map offers three alternative methods of reaching happiness. Where Wroth's knights and ladies found irreversible conditions thrust upon them, Clélie encourages Herminius and other would-be friends to select the method of approach that suits them best. There is nothing to detain them at any given stage, nor even to prevent them from regressing and starting over. The enchantment of *Urania*'s Cyprus is able to freeze travelers in their tracks or to send them wandering far from Venus' royal way, but the charmed atmosphere of Tendre-Capua imposes no restraint on the will in its path to satisfaction. Scudéry's emphasis on volition as the decisive factor in human endeavors reflects the same spirit of Cartesian heroism that her brother and his rivals had incorporated into their dramas and that is missing in the darker vision of Wroth's world, where Calvinist ordination looms large.

Although Wroth's characters draw upon their purely heroic qualities to undo many an enchanted prison in the *Urania*, they never quite overcome their own mutability and are still, at the end of the romance, captives in the labyrinth of their own desires. If Scudéry offers the more optimistic prospect of liberation, it is because the plotting of sexuality leads to and through an externalized notion of truth. The geographic displacement that follows the appearance of the Carte in the first volume of the novel complements the affective journey sketched out by Clélie in the quiet of Capua. Aronce and his fellow lovers persevere in a castle-to-castle quest for the purloined heroine, proving and reproving their qualities of emotional commitment as they progress. By contrast,

the negative examples of sexuality (Tarquin, Tullia, Mézence, Porsenna) literally do not get anywhere, except by retreat, for their efforts at possessive, authoritarian occupation of the space of emotional value are constantly undercut by the self-dominating protagonists, especially Clélie. She gains the ultimate moral victory by leading a band of hostage virgins in a decisive cartographic removal. As the maidens swim across the swollen Tiber, the reactionary army of the Tuscans can only look on in disbelief and admiration, for the Roman stream is every bit as inviolable to impure interests (young Tarquin had sought to rape Clélie and give the others to his troops), as the River of Inclination is to flawed or selfish lovers. Indeed, like the three cities of Tendre, Rome is an idealized metropolis on the banks of sentiment. Its triumph, an emancipation rather than a conquest, is made possible by operations of the heart and mind that are never really contingent on the mechanics of politics or war. Despite the frequent, graphic descriptions of feats of arms, the novel eventually reduces the clash of warriors to a prolonged *reconnaissance* that serves to define the identities of the seeker and the sought.

The reader is all the more ready to accept such a solution because the novel's narrative structure encourages an expectation of redefined knowledge. With its reiterated loops through inserted tales that discover the partially hidden names, motives, and natures of characters, *Clélie's* narration sets the stage for an eventual triumph of cognitive and sentimental progression. Long before the heroine can be released and regained, the love lives of a host of ancillary characters have been reconnoitered and incorporated into the general fabric of the story, each completing an important facet of the whole. Almost every subplot entails the development of interpersonal commitment that goes hand in hand with reciprocal unveiling; *scènes de reconnaissance* alternate with *scènes d'aveu*. Significantly, the intercalated tales are heavily weighted in favor of a determining feminine judgment, as in the case of the eminent Brutus, whose history is really that of his beloved Lucretia. By insistently doubling the disclosure of identity and feeling in the course of the narrative, Scudéry reinforces the impression that the refinement of sentiment necessarily involves a redefinition of the individual, whose coordinates in the universe of Tendre depend on the level of personal awareness.

In a sense, the amatory geography of early seventeenth-century fiction brings to completion the pioneering phase of cartography begun by Renaissance masters such as Ortelius and Mercator. Map-makers of that age, under the patronage of princely houses or late medieval

merchant dynasties, had proceeded by the principle that knowledge of the place led directly to possession of its riches: *jouissance* followed hard on the heels of trailblazing. But by the time of Wroth and Scudéry, a more complex notion of discovery was emerging as the more ambiguous sides of territorial possession received greater attention; thus their fictions present Cyprus and Tendre as lands of catastrophe or epiphany, strewn both with traps and with opportunities for radical departure.

In the final analysis, the geography of *Urania* and *Clélie* is one of time and thought as well as physical space. Domna Stanton has pointed out that Scudéry's use of anthroponyms suggests the emulation of an idealized past, a mythical place distant from the everyday, contingent world.[26] Those who would see Scudéry as essentially a *précieuse* would be quick to identify that mythos in the Carte de Tendre. The yearning for an idealized, non-contingent locus is also a part of Wroth's romance. Yet even in its most stabilized form, the allegory of the Throne of Love contains the self-consciously challenging obstacles of the river and the three towers, which indicate that the author would never be able to subscribe to an absolutely stable and symmetrical model of idealism. The knightly past cannot be framed except in the presence of a present danger and a future hope. In a similar sense, the Carte de Tendre represents a fundamental, but incomplete, formulation of love's journey. It is in the fire of battle around Ardea and Rome, in the later books of Scudéry's tale, that the union between Clélie and Aronce is finally forged, and their eventual triumph has as much to do with Clélie's resistance to the lecherous Tarquins, father and son, as with the warrior's feats of arms. Inspired in her dreams by the ultimate tragic heroine, Lucretia, Clélie achieves a state of constancy akin to that prophesied in Wroth's third tower. This virtuous development alone allows her to "unlock" not only her fellow exiles, but all the inhabitants of Rome. Only then can the former Vestal advance with her prince toward the future throne of love that awaits them.

The amatory geography initiated in *Urania* and *Clélie* entails the profound reassessment of the economy of sexuality. Foucault demonstrates that the term "economy," which in its original etymology signified the management of possessions such as houses, livestock, and slaves, had already evolved in antiquity into the concepts of *enkrateia* and *sophrosyne*, designating the moderation and channeling of sexuality in the search for self-mastery.[27] The romances we have studied trace a similar development from mere concern with possession of the love-object, through the stages of attainment that shift the attention to the production of truth on the part of the lover. But the itineraries described

by Wroth and Scudéry differ markedly in the degree to which the characters can actually progress towards a genuine understanding and reorientation of their relationships. Instead of offering an ideal model of male–female relations, Wroth's Throne of Love reveals the emptiness and sterility of the cultural patterns of entrapment. Perhaps Wroth's most significant achievement lies in her intensive exposé of the instability of unions based on constancy when that virtue is culturally assigned to only one sex. Scudéry moves beyond Wroth in envisioning a union marked by a far greater degree of empathy, where men and women have more freedom and latitude to articulate their own desires. Yet in both the *Urania* and in *Clélie*, the nostalgic focus on constancy, more than a simple brand of possession, derives from the need for a sign of true love itself.

The consciousness that love is not an autonomous, self-justifying essence but a product of the search for truth, involving a process of personal displacement more than simple, unmediated acquisition, marks a distinctive turning point in the development of the early novel. Even as the characteristics of desire are metamorphosed topographically and topologically into affective loci on the Throne of Love and the Carte de Tendre, the love-pledge is revealed as a sign of a sign, subject to the vicissitudes of all signification, while the fragility of emotional commitment in the new *episteme* is exposed in all its excruciating vulnerability. The quest for a "cohering and sustaining connectedness" is a troubled one, which develops, according to Kathleen B. Jones, as "the quest for authority becomes the search for contexts of care that do not deteriorate into mechanisms of blind loyalty."[28] Like all the power relationships studied by Foucault, no love bond is ever in complete equilibrium. Wroth and Scudéry devise geographies that lead the lovers through stages of self-questioning and reappraisal, where the risk and reward of otherness is unavoidably inscribed in the itinerary, and where the borders of sentimental countries are admittedly arbitrary or incomplete. By doing so, they deny the complacent acceptance of any static emotional universe.

Notes

1 *The History of Sexuality*, vol. 1, trans. Robert Hurley (New York, 1978), p. 35.
2 On the revolution in seventeenth-century cartography, see, among others, G. R. Crone, *Maps and their Makers* (5th ed., Hamden, Conn., 1978), pp. 75–84; Norman J. W. Thrower, *An Examination of Cartography in Relation to Culture and Civilization* (Englewood Cliffs, N.J., 1972), pp. 43–60.

3 Louis Van Delft, "La Cartographie morale au XVIIᵉ siècle," *Etudes françaises*, 21 (1985), 91–113; E. P. Mayberry Senter, "Les Cartes allégoriques romanesques du XVIIᵉ siècle," *Gazette des Beaux-Arts*, ser. 6, 89 (1977), 133–44.

4 Cf. Jean-Michel Pelous, *Amour précieux, amour galant (1654–1675): essai sur la représentation de l'amour dans la littérature et la société mondaine* (Paris, 1980), p. 13–15.

5 *Theatrum Orbis Terrarum: The Theatre of the Whole World* (London, 1606), p. 90.

6 *Rime, Trionfi e Poesie Latine*, ed. Ferdinando Neri (Milan, 1951), lines 152–3 (p. 507).

7 *The Ancient, Famous and Honourable History of Amadis de Gaule*, trans. Nicholas de Herberay (London, 1618–19), book 2, p. 7.

8 For the bridge in dream landscapes, see Fernand Hallyn, "Le paysage anthropomorphe," in Yves Giraud, ed., *Le Paysage à la Renaissance* (Fribourg, 1988), pp. 43–54.

9 Contrast Angelo Poliziano, *Stanze*, trans. David Quint (Amherst, 1979), pp. 70–119; instead of a temple of radiant gold and translucent gems, Wroth's Throne is a completely opaque sanctum, where the light of reason cannot penetrate the hidden meanings of love.

10 Cf. Van Delft, "Cartographie morale," 99.

11 Other scholars have treated the Throne of Love as an embodiment of positive value, rather than a center of discordant illusion: Elaine V. Beilin, *Redeeming Eve: Women Writers of the English Renaissance* (Princeton, 1987), pp. 218–21, and Paul Salzman, *English Prose Fiction, 1558–1700: A Critical History* (Oxford, 1985), pp. 141–3. For further discussion of Wroth's Throne, see Josephine A. Roberts' essay, "Labyrinths of Desire: Lady Mary Wroth's Reconstruction of Romance," *Women's Studies* 19 (1991), 183–92.

12 Ann Rosalind Jones, in *The Currency of Eros: Women's Love Lyric in Europe, 1540–1620* (Bloomington, 1990), observes that the pastoral mode provided Wroth with "a medium for criticizing the sexual politics that systematically deprived women of the power to arrange the social and erotic relations they themselves desired" (p. 124).

13 Carolyn C. Lougee, *Le Paradis des Femmes: Women, Salons, and Social Stratification in Seventeenth-Century France* (Princeton, 1976), argues that the salons functioned as "a melting pot which blurred distinctions of birth and profession" (p. 170), but cautions against assuming too much diversity in social background.

14 Even today a stand-off persists between those critics who maintain the relevancy of real-life parallels, for example Alain Niderst, *Mademoiselle de Scudéry, Paul Pellisson et leur monde* (Paris, 1976), pp. 241–430, and those who dismiss the search for a key as a pointless exercise, such as René Godenne, *Les Romans de Mademoiselle de Scudéry* (Geneva, 1983), p. 206.

15 For the reception of the Carte, see Nicole Aronson, *Mademoiselle de Scudéry ou le voyage au pays de Tendre* (Paris, 1986), p. 225.

16 Aronson, *Scudéry*, pp. 212–13 and 231–5.

17 For the domination of cities in geographers' representation of landscape, see Hugues Neveux, "Le Paysage campagnard français dans la *Cosmographie* de François de Belleforest," in *Le Paysage à la Renaissance*, pp. 35–41.

18 James S. Munro, in *Mademoiselle de Scudéry and the "Carte de Tendre"* (Durham, 1986), postulates that between the very first land/water/air version of the voyage to Tendre, revealed in accounts of the Scudéry circle, and the final geographical disposition, there was an intermediate version still conserved in the problematical text called the *Discours géographique*, in which the allegories of mediation were not village stopovers, but ships on the three rivers of Tendre (pp. 30–8).

19 *Clélie, Histoire romaine* (1654–60; repr. Geneva, 1973), vol. I, p. 401. The English translation by John Davies and George Havers, *Clelia, An Excellent New Romance*, first appeared in 1655–6; we cite from the second edition (London, 1678), p. 42, which is also the source of (fig. 27).

20 The English translation of Scudéry's map contains a number of terms whose seventeenth-century meanings were much closer to the original French text: "Recognisance" (acknowledgement or gratitude); "Complacency" (disposition to please others); "Empressment" (animated display of cordiality); and "Spirit" (wit).

21 Aronson, *Scudéry*, p. 237.

22 Claude Filteau proposes a slightly different arrangement involving a crossing of two axes (*plaisirs/amitié* and *haine/indifférence*): "Le pays de Tendre: l'enjeu d'une carte," *Littérature* 36 (1979), 37–60. While supporting his organization of the negative characteristics, the "vertical" axis of friendship and pleasure poses a major problem in that it is not a true polar opposition, but simply a charting of two stages in a single direction, springing from a single impulse (desire), and distinguished from each other mainly by the application of internal or external controls.

23 On the influence of Descartes on geographical mentalities, see Normand Doiron, "L'Art de voyager," *Poétique* 73 (1988), 83–108.

24 Joan DeJean suggests that the Dangerous Sea and Undiscovered Countries reveal the subversive nature of Mlle de Scudéry's map, which "culminates in the rejection of the possibility of representation" (p. 183): "No Man's Land: The Novel's First Geography," *Yale French Studies* 73 (1987), 175–89.

25 Godenne notes that the author describes only eleven sites in the course of the novel, and also shows that the earthquake episode is the only lengthy passage devoted to a place or scene in the first three volumes of the work (*Romans de Scudéry*, pp. 244, 234).

26 *The Aristocrat as Art* (New York, 1980), p. 91.

27 *The History of Sexuality*, vol. II, trans. Robert Hurley (New York, 1985), p. 63.

28 "On Authority, or Why Women Are Not Entitled to Speak," in Irene Diamond and Lee Quinby, eds., *Feminism and Foucault: Reflections on Resistance* (Boston, 1988), p. 127.

Chapter Fourteen

Gender and conduct in *Paradise Lost*

MICHAEL C. SCHOENFELDT

༈

Of the many works that codified the Renaissance fascination with developing standards of polite behavior, Baldassare Castiglione's *Il Libro del Cortegiano* (1528) and Stefano Guazzo's *La Civil Conversatione* (1574) were by far the most popular in England.[1] These works provided a theoretically rigid social hierarchy with the conduct that both enabled and disguised the social dynamism at its core. Describing in great detail the many postures and tactics of subjection required of the aspiring courtier at a court ruled by an absolute prince, they created an art of courtly submission. Much of what we celebrate as the highest accomplishments of "Renaissance man" (a cliché of gender and history which is still very much with us) – singing, dancing, learning, painting, writing, and fencing – are subordinated in these works to the goal of entertaining princes. If the courtier were only talented, affable, and graceful enough, the texts propose, then he might be able to win the favor of his prince, and so lead him to virtuous action. By endowing submission with the power to please and ingratiate those in authority, then, Castiglione and Guazzo envision the act of submission to princely authority as an empowering gesture.

The third book of *Il Cortegiano* is devoted to defining the role of the court lady. In large part a debate between the misogyny of Gasparo and Frisio and the idealization of woman voiced by the Magnifico Giuliano, the third book plumbs the extreme of attitudes to women available in the Renaissance. Notoriously unresolved, the debate nevertheless lays out with remarkable clarity the dynamics of gender relations that later writers would inherit and adapt. Exploring both the public role of the court lady and the domestic relationship of husband and wife, Guazzo's *Civil Conversatione* assimilates these dynamics to the marital domain on which Milton centered his epic of the fall. Deeply concerned with feminine conduct, albeit in different arenas, these works together offer a

benchmark against which Milton's attitude to gender relations in *Paradise Lost* can be measured. Both works, moreover, track the difficulty that Milton dramatizes of praising active female authority in a language saturated by misogynist and patriarchal assumptions. By locating *Paradise Lost* amid the discourse of Renaissance courtesy, I intend to show how Milton absorbs and revises the predominant attitudes of the courtesy tradition towards feminine conduct. At the same time, I employ the tactics of social negotiation delineated in courtesy literature to amplify the political nuances implicit in the discourse of Adam and Eve. Tracing the gap between stated discursive relations and recommended social practices in Castiglione, Guazzo, and Milton, I attempt to mark some of the ideological strains and aesthetic dissonances imbuing and enriching the Renaissance discourse of gender.

The court lady and the wife

The situation of *Il Cortegiano* is somewhat anomalous in Renaissance culture, in that the discussions are presided over by a woman, Elisabetta Gonzaga, the duchess of Urbino, because her infirm husband cannot be present. As in the England of Elizabeth, a creature construed as inferior because of her gender is endowed by circumstances with an authority over her purported superiors. Yet the very fact that in *Il Cortegiano* misogyny is voiced explicitly, without the sorts of ingratiating disguise required for even the gentlest admonitions to princes, indicates not only the acceptability of such attitudes, but also the fragility of the duchess' position. Indeed, throughout the discussion of the courtly woman, the women, although equal to or higher than the men in status, sit largely silent while the men either denigrate or praise them. In one of the few female interventions in the discussion, Emilia Pia, the duchess' companion, appoints Giuliano de Medici to be "the defender of women's honor" ("protettor dell' onor delle donne") in a debate with Signor Gasparo.[2] As the implied chivalric model indicates, the possibility that woman could sustain a defense of her own honor – despite the impressive wit displayed on occasion by the duchess and Emilia – is not entertained. Because of the cultural linkage of feminine speech with sexual promiscuity, the women at Urbino are precluded from becoming the subject of their own discourse, and must observe with relative silence the process by which they are constructed as the object both of male desire and of male anxiety.

In her famous essay "Did Women Have a Renaissance?" Joan Kelly

investigates the curious positioning of women at Castiglione's Urbino, arguing that despite the fact that the Renaissance noblewoman "seems to be served by the courtier," Castiglione

> indirectly acknowledged the courtier's actual domination of the lady by having him adopt "woman's ways" in his relations to the prince ... To be attractive, accomplished, and seem not to care; to charm, and do so coolly – how concerned with impression, how masked the true self ... In short, how like a woman – or a dependent, for that is the root of the simile.[3]

Kelly identifies some important structural links between "the courtier's posture of dependency" and the "almost universal dependence" of the Italian noblewoman. But the manipulative modes of submission which she characterizes as "woman's ways" are in fact never imagined in *Il Cortegiano* as a behavioral option for the second sex. Rather, they are part of the repertoire of male conduct. In the absolutist world of the court, where men as well as women are cast as subjects, submission and dependence cannot be gendered specifically as feminine. Although women may be doubly subjected, by gender as well as class, it is anachronistic to describe the manipulative submission of the aspiring courtier as a specifically feminine behavior. In Renaissance courtly culture, where almost all actions require the performance of deference to some authority, we should emphasize not the apparent feminization of male conduct, but rather the exclusion of females from the empowering submission available to the male courtier.

One of the bitter ironies suffusing the discussion is the fact that the terms of Giuliano's praise of women are nearly as delimiting as the language of Gasparo's misogyny. Giuliano's ideal court lady, for example, possesses traits which not only distinguish her from man, but also preclude her active participation in the world:

> Above all I think that in her ways, manners, words, gestures, and bearing, a woman ought to be very unlike a man [*debba la donna essere molto dissimile dall'omo*]; for just as he must show a certain solid and sturdy manliness [*una certa virilità soda e ferma*], so it is seemly for a woman to have a soft and delicate tenderness [*una tenerezza molle e delicata*], with an air of womanly sweetness [*dolcezza feminile*] in her every movement. (3.4; p. 206)

The very terms in which Giuliano chooses to praise what his culture would construct as "womanliness" limit feminine conduct to what he later terms "a certain pleasing affability" (p. 207). Even when Giuliano proceeds to argue that "women can understand all the things men can understand and that the intellect of a woman can penetrate wherever a man's can" (3.12; p. 214), one feels that the overarching injunction to

tenderness and affability will make any feminine exercise of the intellect extremely difficult.

Giuliano attempts to clinch his case for feminine virtue by recourse to an exhaustive catalogue of exemplary women. Nevertheless, the majority of the women he cites are suicides who respond to the patriarchal violence of forced marriages or rape not by seeking revenge or justice, but rather by directing such violence towards themselves. Segregated from any notion of manly power, feminine virtue is manifested only in gestures of sacrificial self-immolation. Throughout the discussion, Giuliano discovers how easily Gasparo can neutralize his exemplary tales, either by arguing that they are only exceptions that prove the rule of female inferiority, or by diverting the issue through a jocular misogyny that demands Giuliano's complicity. When Giuliano powerfully asserts the necessary interdependence of male and female, arguing that "as one sex alone shows imperfection, ancient theologians attribute both sexes to God: hence, Orpheus said that Jove was male and female [*maschio e femina*]; and we read in Holy Writ that God created man male and female in His own likeness," Gasparo responds by shifting the terms of the argument from the cosmic to the comic: "I would not have us get into such subtleties, for these ladies would not understand us" (3.14–15; p. 216). Likewise, after Giuliano has listed several virtuous women from Greek and Roman history, Gasparo responds by saying that "those centuries are so remote from us that many lies can be told, and there is no one to gainsay them" (3.33; p. 235). When Giuliano answers with the contemporaneous example of Isabella of Spain, Gasparo counters that "Queen Isabella was given credit for many of King Ferdinand's deeds" (3.35; p. 236). Finally, when Giuliano concedes that "if there are not now found on earth those great queens who go forth to conquer distant lands and erect great buildings, pyramids, and cities," such as "Semiramis, or Cleopatra – neither are there still men like Caesar, Alexander, Lucullus, and those other Roman commanders," Frisio interrupts to say that "now more than ever are there women to be found like Cleopatra or Semiramis; and if they do not have such great domains, power, and riches, still they do not lack the will to imitate those queens in taking their pleasures and in satisfying all their appetites in so far as they are able [*satisfare piú che possano a tutti i suoi appetiti*]" (3.36–7; pp. 239–40). Female ambition is eroticized in order to be neutralized. Misogynist joking about the imperialism of female sexual appetites forestalls discussion of feminine rule.

The Magnifico Giuliano defends women against Signor Gasparo's accusation of "cowardice and timidity" – a pejorative rendering of a

culture's emphasis on the importance of women's silence and obedience – by arguing that "true courage," which "comes from actual deliberation and a determined resolve to act in a given way," is demonstrated as often by women as by men. "Many women," he asserts, "in both ancient and modern times ... have shown greatness of spirit [*grandezza d'animo*] and ... no less than men have done things in the world worthy of infinite praise" (3.18; pp. 219–20). His eloquent description of feminine initiative and courage, however, is quickly vitiated by Frisio, who discovers the epitome of feminine activity in the myopic and cataclysmic accomplishments of the biblical Eve, the woman who is at the center of Milton's epic (3.19; p. 220). Giuliano's clever response – "this very transgression was repaired by a Woman, who brought us so much greater gain than the other had done us damage that the sin that was atoned by such merits is called most fortunate" – supports rather than refutes Frisio's interpretation of Eve's initiative. Caught between a timidity worthy of castigation and a morally damning initiative, woman is invested only with the negative power to induce a man to sin, or the comparatively passive capacity to produce redemptive male offspring.

Exemplary of the ways in which Giuliano's idealization is built from the same cultural assumptions as Gasparo's misogyny is the fact that both interlocutors accept the "fact" that all women long to be men, and only disagree about the cause. Gasparo traces it to "a certain natural instinct that teaches them to desire their own perfection" (3.15; p. 217), a conviction of natural inferiority and a wish for self-improvement; Giuliano responds by arguing that "the poor creatures do not desire to be men in order to become more perfect, but in order to gain freedom and to escape that rule over them which man has arrogated to himself by his own authority" ("fuggir quel dominio che gli omini si hanno vendicato sopra esse per sua propria autorità") (3.16; p. 217). Although his response offers a powerful commentary on the arbitrary nature of male domination, and voices a profound longing for liberation on the part of women, Giuliano does not think to challenge Gasparo's masculinist premise.

Nevertheless, Giuliano does engage in a cogent condemnation of the ideological translation of biological phenomena into social difference. Although woman's comparative physical weakness is frequently taken to be a traditional indication of feminine inferiority, Giuliano invokes the philosophical proposition "that those who are weak in body are able in mind," so proving "without doubt" that women "are by nature better fitted for speculation than men are" (3.13; pp. 214–15). Similarly, Giuliano is able to take the Aristotelean physiology espoused by Gasparo, which

endows the male with greater perfection and more natural heat, as a biological explanation of "woman's firmness and constancy" and "man's inconstancy": "since the male is warm, he naturally derives lightness, movement, and inconstancy from that quality, while on the other hand woman derives quietness, a settled gravity, and more fixed impressions [*più fisse impressioni*] from her frigidity" (3.15–16; pp. 217–18). Giuliano, then, finds a "natural reason" for woman's moral and intellectual superiority in her physical "inferiority." His unwillingness to challenge the masculinist premises of Gasparo's physiological argument, however, betrays the degree to which his praise of women is constructed within the terms of their denigration. Although one feels that the author's intellectual sympathies are with Giuliano, one also feels that the weight of patriarchal assumptions shared by both interlocutors tilts the rhetorical case in Gasparo's favor.

Stefano Guazzo's *La Civil Conversatione* follows a similar trajectory into the domestic realm. Where book 2 concludes with a discussion of "conversation with women," book 3 begins with a debate about the relations between husbands and wives. Rather than a conversation presided over by a largely silent figure of female authority, the two interlocutors – Guazzo (*Cavaliere* in the Italian original) and Annibale – discuss the society of women free of their presence. According to Annibale, the more benign of the two interlocutors in his attitude to women, the rules of male behavior towards women bestow upon them the modes of deference normally granted to social superiors: "a man cannot doe amisse, so that hee honour [*honorarle*], serve [*servirle*], and obeye [women], and omit nothing that may admit him into their favour."[4] Yet the demands of proper female conduct hamper their exercise of the authority normally possessed by the recipients of such deference: "On the other side, women ought to consider that men will not bee so readie to doe them honour, if in Conversation they behave not them selves modestly." "*Silentio* in a woman is greatly commended," observes Annibale, because it gives her a reputation for *prudenza* (1:240; fol. 89). Paradoxically, the very medium in which wisdom is displayed – speech – is denied to the "wise" woman. Only in the ritual display of modesty – women are enjoined to cultivate "the lowelinesse of their lookes" and "the modestie of their behaviour" – is any status granted to woman: "by this discrete humilitie [*questa humile, & discreta maniera*], shee is exalted to higher dignitie, and men have her in the more honour" (1:241; fol. 85v). As in *Il Cortegiano*, the silence and modesty to which women are enjoined debar their possession of the authority which male deference ostensibly bestows.

Because women are excluded from the world of political activity, "conversation with women," argues Annibale, is a kind of "honest leasure [*otio honesto*], which serveth to comfort, yea, and to take from us the greevous passions which oppresse our heartes" (1:245; fol. 87). Yet the society of women is also the source of intense anxiety, since "wee must take heede that wee bee not so wrapped in it, that wee never come out of it, least thereby wee distemper the minde [*distemperare l'animo*], and effeminate it in suche sort [*liquefarlo in modo*], that it loose that courage whiche is proper to man." Because too much talk with women would make men resemble women, "wee must deale so warily in the matter, that it may bee said that wee have been in the very jaws of Scilla, and drunke of Cyrces cup, and yet have escaped both drowning and transfourming" (1:245–6; fols. 87–87v). What had initially seemed a source of restful recreation is here imagined as a hazard requiring heroic vigilance.

Despite such horror of the potentially destructive or "liquefying" effects of female society, the subsequent debate on domestic relations offers a surprisingly positive account of the bond between husband and wife. Interrogating the degree (but not the existence) of the hierarchy that structures the society of husbands and wives, Annibale continually emphasizes the single unit that husband and wife become in the act of marriage. The husband should regard the wife, argues Annibale, as "the one halfe of himselfe" (2:24; fol. 98v). "The husband and wife," he proclaims, "are two bodyes upholding one only minde, and one honour"; they should function as "two Porters beare up togither one burthen [*due portatori sostenere un sol carico*]" (2:25; fol. 99). Guazzo responds to such images of mutual responsibility by recourse to a language that bestializes women in order to make their subjugation appear natural. The husband "that would observe" the egalitarian attitudes endorsed by Annibale, argues Guazzo, will "let the reine lye too loose on the womans neck" (2:24; fols. 98v–99).

Annibale does not, however, wish to dismiss hierarchy entirely from the relationship between husband and wife, but only to render it a model of mutual responsibility. He appeals to the myth of human creation that is at the center of Milton's epic: "in the beginning man was not made of the woman, but the woman of the man, and was taken, not out of the head, that she shoulde beare rule over man, nor out of the feete, that she should be troden down by him, but out of the side, where is the seate of the heart, to the end he should love her hartily, and as his owne self" (2:26; fol. 99v). The affection that issues from the morphology of creation softens the edges of the masculinist hierarchy Annibale

endorses, translating a relationship of sexual domination into one of equal but mutual obligation. He even imagines successfully the circumstances in which a wife rather than the husband might be in charge: although "it is a thing reasonable and agreeable to nature, that the stronger should commaund over the weaker ... some women have the right art to order thinges so wel [*l'arte vera di disporrie i meriti*], that the husbandes should be thought to doe amisse [*commettere errore facendo*], if they should dispose them otherwise" (2:29; fol. 101). But he quickly retreats from the more revolutionary implications of this remarkable moment, mocking strong wives as "restife jades" and compliant husbands as "very fooles that would followe their wife, running away from them [*veri pazzi ... che seguivano la moglie fuggitiva*]," and reinstating absolute obedience: "the wife, as the weaker vessell, must obay the husbande. And as men oughte to observe and keepe the lawes and statutes of the countrey: so women ought to fulfill the commaundementes of their husbandes, by doing whereof they become the mistresses of the house" (2:29–30; fol. 101). Like a domesticized version of the male courtier's empowering submission to the state, feminine authority is for Guazzo's Annibale incumbent upon submission to masculine command.

Indeed, although the debate begins with an apparently clear distinction between Annibale's emphasis on "mutual love" and Guazzo's stress on the need to control women, both interlocutors laugh heartily at a cruel joke involving a headstrong woman and her husband. Annibale's scorn for the husband who chases his wife reminds Guazzo of the story of a

> husbande, who, his wife having drowned her self in a River, went crying along the river side, seeking her agaynste the streame: and being told that there was no question but that she was gone downward with the streame: Alas, sayth he, I cannot think it, for as in her life tyme she used to doe every thing agaynste the hayre [*havena per costume di far tutte le cose a rovesci*], so now in her death she is surely mounted against the stream. (2:29–30; fol. 101)

The humor directed at this corpse – the remains of a woman superficially very different from those obedient suicides catalogued by Castiglione's Giuliano as examples of female virtue – offers silent testimony to the extremely limited space which Renaissance patriarchy allows for feminine initiative. Although Annibale attempts to invest the relationship between husband and wife with an emotional energy which ameliorates the violence of the gender hierarchy, the jokes that both interlocutors share about willful wives and weak husbands betray the duress on which this hierarchy depends.

It is this discourse about gender and conduct from which *Paradise Lost* is created, and in which it is implicated. Indeed, critical discussions of *Paradise Lost* often read like unintentional imitations of the debates about the role of women in *Il Libro del Cortegiano* and *La Civil Conversatione*. Where the feminist critique of Milton has produced a cogent if ultimately reductive account of Milton's attitude to gender, largely insensitive to those moments when the poet strains against the weight of patriarchal tradition, the defense of Milton has required an equally partial emphasis upon the comparative beneficence of the masculine hierarchy he draws, and the relative benignity of the sub-mission demanded of Eve. My intention in this essay is not so much to resolve these battles as to discover why the poem can serve such disparate ideological ends. By defining submission as a gesture at once necessary and empowering, Renaissance courtesy theory allows us to comprehend how for Milton gender is both dynamic and static, a source of essential difference and the occasion for animated exchange. The dilemma confronting Milton is one that still faces the contemporary theorist of gender: how to represent the phenomenon of sexual differ-ence without reinscribing or reversing the hierarchy on which tradi-tional concepts of gender-specific traits are based. By attending closely to Milton's conspicuous failures and remarkable successes at using an inherited language of hierarchy to convey the novel phenomenon of equality, we can perhaps become more aware of the liabilities and expediencies of our own discourse of gender.

"So absolute she seems": Milton's Eve

The discussion in *La Civil Conversatione* of marital conduct is initiated by Annibale's observation that "many occasions offer themselves, whereby the divell, enimy to our quiet, putteth himselfe betweene the husband and the wife" (2:4; fol. 91). It is appropriate that this secular version of the story of *Paradise Lost* is the spur to the debate about the respective duties of husbands and wives, since both courtesy book and Christian epic attempt to forestall or redeem the effects of demonic intervention between spouses. Yet critics have paid surprisingly little attention to the role of social conduct in Milton's poem on the origins of humanity. Samuel Johnson, for example, complains that the epic is flawed because its "plan . . . comprises neither human actions nor human manners." Since the work "admits no human manners till the Fall," he argues, "it can give little assistance to human conduct."[5] This is I think

one of the rare moments when Johnson is absolutely wrong, for manners supply the medium of the text's hierarchical intercourse before and after the fall. Transmuting dogma into drama, manners synchronize and problematize moral and political status throughout Milton's profoundly stratified universe. Deeply concerned with the social and theological ramifications of behavior, *Paradise Lost*, like the courtesy books it assimilates and reforms, offers much "assistance to human conduct."

In *Paradise Lost*, however, unlike both Castiglione and Guazzo, Milton discovers a mode of feminine behavior which is at once empowering and impressive. The same figure that Castiglione's Frisio invokes as exemplary of negative feminine initiative – Eve – is in Milton's epic made the paragon of courteous conduct. By completing Guazzo's domesticization of the courtly tropes developed by Castiglione, Milton transforms his culture's shared anxiety about feminine initiative into awe at Eve's capacity to generate the significant forms of pre- and postlapsarian social life. As Frisio makes abundantly clear, the story of Adam and Eve can be deployed to defend misogyny, since woman is demeaned both by being created second, and by being the first to fall. But the story of the first man and woman also contains a potentially profound critique of social differences based on birth. The rhyme "When Adam delved and Eve span, / Who was then the gentleman?" for example, was often used to buttress Leveller attacks on the social hierarchy.[6] Milton's history of sexuality vibrates unstably between these subversive and conservative poles, as it tries to coordinate issues of gender difference and social hierarchy. As we shall see, human authority in *Paradise Lost* resembles the angels that populate Milton's heaven, decidedly masculine and yet capable of assuming either sex.

The epic of course locates itself in a strict hierarchy of divinely sanctioned male superiority: "Hee for God only, shee for God in him."[7] Nevertheless, the diurnal conduct of Adam and Eve continually deviates from the hierarchy the text affirms. Despite Milton's frequent recourse to the argument that Eve's secondary birth dictates her subordinate status – an argument whose logic would make the animals superior to humans and Lucifer superior to Christ – it is Eve rather than Adam who first questions the order of the universe, first proposes an efficient division of labor, first eats the forbidden fruit, and first exercises the conciliatory power of submission. Throughout the epic, Eve's capacity to generate social behavior, to articulate marital desire, and to interrogate paradisal existence challenges the masculine hierarchy based on precedence and physiology that the work habitually reaffirms.

In a frequently cited passage from *Tetrachordon*, Milton proposes that "it is no small glory to [man] that a creature so like him [i.e., woman], should be made subject to him."[8] The more woman is like man, in other words, the greater the glory bestowed on her male superior. Yet in *Paradise Lost* Eve veers perilously close to Adam – so close that she approaches the state *Tetrachordon* proceeds to envision, where "the wiser should govern the lesse wise, whether male or female." Milton terms this meritocratic principle "a superior and more natural law" than an exclusively gender-based hierarchy. Yet, like Guazzo, who admits that "some women have the right art to order thinges" but who makes the necessary qualification for such authority obedience to men (2:29), Milton quickly recoils from the egalitarian implications of his meritocratic argument:

> Seeing woman was purposely made for man, and he her head, it cannot stand before the breath of this divine utterance, that man the portraiture of God, joining to himself for his intended good and solace an inferior sex, should so become her thrall, whose wilfulness or inability to be a wife frustrates the occasional end of her creation; but that he may acquit himself to freedom by his natural birthright, and that indelible character of priority, which God crowned with him. (2:589)

By making Eve the magnificent, inquisitive, ingenious, desirable creature that she is, Milton perhaps intends simply to embellish Adam's crown of priority. But Eve's very proximity to Adam begins to destabilize the masculine hierarchy her remarkable talents should assert.

Our first view of Adam and Eve records a baffling blend of mutuality and hierarchy. First, they are distinguished as a pair from the other animals: "Two of far nobler shape erect and tall, / Godlike erect, with native Honor clad / In naked Majesty seem'd Lords of all." Yet cognizance of their comparatively equal stature vanishes in a declaration of the sexual politics advertised by their respective physiques:

> Though both
> Not equal, as thir sex not equal seem'd;
> For contemplation hee and valor form'd,
> For softness shee and sweet attractive Grace,
> Hee for God only, shee for God in him:
> His fair large Front and Eye sublime declar'd
> Absolute rule; and Hyacinthine locks
> Round from his parted forelock manly hung
> Clust'ring, but not beneath his shoulders broad. (4:295–303)

In this passage, physiology becomes ideology. The "absolute rule" that Milton spent so much of his energy and time combating seems to be a

prerogative of masculine paradisal existence. But as we read these lines – rendered at least partially through Satan's status-conscious eyes – we need to keep in mind Giuliano's powerful critique of interpreting masculine strength as a manifestation of intellectual superiority. Furthermore, just as the scene seems to resolve itself into the patriarchal hierarchy that its initial grouping of Adam and Eve would abrade, the erotic details suffusing Eve's hair and behavior undercut the subordination they are meant to declare:

> Shee as a veil down to the slender waist
> Her unadorned golden tresses wore
> Dishevell'd, but in wanton ringlets wav'd
> As the Vine curls her tendrils, which impli'd
> Subjection, but requir'd with gentle sway,
> And by her yielded, by him best receiv'd,
> Yielded with coy submission, modest pride,
> And sweet reluctant amorous delay.　　　　(4:304–11)

Hair offers a curiously unstable site for the registration of gender difference if one assumes, on the model of paradisal vegetation, that it must be trimmed to chosen lengths. Milton's emphasis upon the comparative length of naturally lengthening hair as a manifestation of the sexual hierarchy is licensed by Pauline authority – "Doeth not even nature it selfe teach you, that if a man have long haire, it is a shame unto him? But if a woman have long haire, it is a glory to her" (1 Corinthians 11:14–15 [AV]). But like the physiognomy of the bodies from which it issues, hair reveals an apparently natural distinction to be culturally constructed, and so unsettles the differences it purports to advertise. Likewise, the oxymorons that culminate in "modest pride" register the strangely submissive authority that Eve attains. Her hair implies a "subjection" that she nevertheless "yields"; she yields it, moreover, on her own terms, "coy[ly]," even "reluctant[ly]," "requir[ing]" that it be achieved only through "gentle sway." By dictating the terms of her submission, and delaying the desire she generates, Eve practices a kind of erotic deference which exercises control over the desires of her confessed superior.[9] Like Castiglione's courtier, who submissively seeks the good will of an absolute ruler in order authoritatively to lead him to virtue, and like Guazzo's wife, who acquires authority in the act of obedience, Eve discovers in the tropes of subjection to Adam's "absolute rule" a technology of command.

A related tension between equality and hierarchy surfaces in the terms of address shared by Adam and Eve. Adam first addresses Eve as "Sole partner and sole part of all these joys, / Dearer thyself than all"

(4:411–12). Later he terms her "Best Image of myself and dearer half" (5:95); where "image" suggests Eve's secondary status, "best" advertises a superiority which chafes against such subordination. In both salutations, "dearer" endows Eve with a value greater than her status as Adam's "image" would allow. Here, and elsewhere, Eve is praised profusely, but in terms that identify the female object as a commodity in a patriarchal economy.[10] In contrast to Adam's politically intricate terms of endearment, Eve's salutations to Adam appear to rehearse humbly the ontogenic justification for her subordination: "O thou for whom / And from whom I was form'd flesh of thy flesh, / And without whom am to no end, my Guide / And Head" (4:440–3). Yet as the language of Adam's praise contains an undertow of diminution, so the terminology of Eve's submission implies the possibility of her glorification. Eve indeed discovers in her subordinate status a happiness superior to Adam's precisely because of Adam's superiority: "I chiefly who enjoy / So far the happier Lot, enjoying thee / Preëminent by so much odds, while thou / Like consort to thyself canst nowhere find" (4:445–8). She has so completely internalized the ideology of her subjection that she discovers within it a mark of her superior state. Mixing authority and inferiority, Eve's modest account of her preeminent happiness mirrors the terminology of egalitarian subjugation used by her superior.

Eve's discovery of a superior happiness in her inferiority to Adam harbors a bitter irony, for Adam indeed addresses Eve as his "Fair Consort" (4:610), belying her argument that Adam cannot find "like consort." Moreover, an equal partner is exactly what Adam initially requests from God. Unlike the speaker of Andrew Marvell's "Garden," who declares that "Two paradises 'twere in one / To live in Paradise alone," Adam experiences paradisal solitude as a grievous lack rather than a gratifying plenitude: "In solitude / What happiness, who can enjoy alone" Adam asks (8:364–5). When God tells Adam he has given him plenty of creatures among whom to "Find pastime, and bear rule," as if such imperious pursuits were the sum of human existence, Adam argues that human happiness requires not absolute rule, but equality, and in the process voices one of the great questions of seventeenth-century social organization:

> Among unequals what society
> Can sort, what harmony or true delight?
> Which must be mutual, in proportion due
> Giv'n and receiv'd.　　　　　　　　　　(8:383–6)

Adam desires neither a superior nor an inferior – he is already surrounded by both – but an equal. His abiding hunger for what he terms "fellowship" or "Collateral love, and dearest amity" (389, 426) suggests a social appetite that even companionship with God cannot satisfy.

Adam's first description of Eve shows him groping awkwardly for a language in which he might express the novel phenomenon of sexual difference free of hierarchical disparity; he describes her as "Manlike, but different sex" (8:471). Significantly, the Adam who has just intuitively named all the creatures of the earth has great difficulty in characterizing the tense blend of similarity and difference that constitutes the opposite sex. Moreover, as he proceeds to describe to Raphael the "peculiar comfort" he derives from his society with Eve, Adam's language swerves into the lexicon of inequality that his originary desire had excluded; Eve is "so lovely fair, / That what seem'd fair in all the World, seem'd now / Mean, or in her summ'd up, in her contain'd" (471–3). Rather than being an afterthought, Eve is "the sum of earthly bliss" (522). In Adam's narration of his creation, then, inequality first surfaces in the human sphere not in the expected patriarchal form, but rather as evidence of Eve's possible superiority.

Eve's initial experience of the world is very different from Adam's: Adam is born to a solitude and superiority he does not desire, while Eve desires a privacy and power Eden seems designed to deny her. Where Adam looks up to God to request a consort, Eve looks down and desires a creature like herself, besmitten with its "answering looks / Of sympathy and love" (4:464–5). Her innately solipsistic, even autoerotic, desires must be socialized, made to conform to the masculinist hierarchy she enters. Yet her resistance to this socialization endows her with a quiet authority, making her the object of divine and mortal persuasion. Moreover, the very traits that advertise Adam's purported supremacy render him initially less attractive to her; he is "fair indeed and tall ... yet methought less fair, / Less winning soft, less amiably mild, / Than that smooth wat'ry image" (477–80). With that image Eve is in absolute control: "I started back, / It started back ... pleas'd I soon return'd, / Pleas'd it return'd as soon" (462–4). This control is briefly replicated in her initial moment with Adam. "She turned; / I followed her," relates Adam, suggesting in miniature the superiority that his desire for Eve, and Eve's self-containment, bestow upon her. "They were very fooles," remarks Guazzo's Annibale, "that would followe their wife, running away from them" (2:29). Adam's desire for Eve makes him willingly adopt the inferiority of such a chase: "She was what Honor knew, / And with obsequious Majesty approv'd / My pleaded reason" (8:507–10).

Like her "modest pride," Eve's "obsequious majesty" blends authority and subordination, courtly supplication and monarchical power. But the obsequiousness soon overtakes the majesty, as a hierarchy based on gender, power, and precedence emerges from the phenomenon of sexual difference. Adam tells the newly created Eve: "Part of my Soul I seek thee, and thee claim / My other half" (4:487–8). The gestures themselves advertise both the affective power of imagining another human as "part of my soul," and the hierarchical appropriation published in the word "claim"; "thy gentle hand / Seiz'd mine," remembers Eve, "I yielded" (488–9). The tension between the gentleness of the hand and the violence of its gesture exposes the strain involved in Milton's wish to take the coercive edge off the masculinist hierarchy he endorses. Having internalized the values of this hierarchy, Eve now concedes Adam's superiority: "from that time [I] see / How beauty is excell'd by manly grace / And wisdom, which alone is truly fair" (489–91). Offering an unstable compound of coercion and kindness, appropriation and surrender, the moment adumbrates the ideological complexity through which Adam's superiority is advertised and sustained.

The same is true of Paradisal dialogue. The speech of Adam and Eve, like their work in the garden, is surprisingly egalitarian, especially when one considers the premium placed on feminine silence by Milton's culture. Indeed, Eve utters one of the most aesthetically impressive speeches in the epic, articulating her desire for Adam, and its place in Edenic existence, with a power and order that epitomized prelapsarian love.[11] In "With thee conversing I forget all time," Eve demonstrates her profound valuation of the "civil conversation" exemplified in *Il Cortegiano* and *La Civil Conversatione*. Yet this speech is prefaced by an unequivocal utterance of the theological principles underpinning her inferiority to Adam, an inferiority that would preclude her fitness for the conversation she has just displayed: "My Author and Disposer, what thou bidd'st / Unargu'd I obey; so God ordains, / God is thy law, thou mine: to know no more / Is woman's happiest knowledge and her praise" (4:635–8). If there is no society among unequals, then Eve's articulate expression of unquestioned obedience to Adam's masculine authority obviates her capacity to supply Adam with the society he seeks. If we locate Eve's self-deprecatory introduction to her remarkably artful speech amid the Renaissance discourse of courtesy, however, we can see that she is indeed practicing the essence of courtly conversation, *sprezzatura* – not just a capacity "to make whatever is done or said appear to be without effort and almost without any thought about it," but a kind of stylish feigning of modesty about one's own

immensely artful performances.[12] Derived from the verb *sprezzare*, "to disdain" or "to hold in contempt," *sprezzatura* involves the expression of a graceful contempt towards one's greatest accomplishments. Comprehended as a deployment of *sprezzatura*, Eve's declaration of her inferiority to Adam becomes at once a source and an example of the "sweet attractive grace" with which the narrator credits her (4:298). Her artful expression of blind obedience attests, then, to her impressive verbal dexterity, not to the intellectual and ontological inferiority it ostensibly declares.

Her intricately patterned love lyric is followed, moreover, by a question whose unanswerability implies her intellectual superiority: "But wherefore all night long shine these, for whom / This glorious sight, when sleep hath shut all eyes?" (4:657–8). Adam attempts to supply an answer, proposing that "Millions of spiritual Creatures walk the Earth / Unseen, both when we wake, and when we sleep" as the imagined audience for heavenly fireworks when Adam and Eve nod (677–8). But Adam's pedagogical authority in this scenario is quietly undercut by the fact that Adam, apparently sensing the insufficiency of his response, will re-ask Eve's question of his own angelic superior, Raphael (8:15–28).

Indeed, dubiety about Adam's superiority imbues the entire encounter with Raphael. When Adam spies the sociable angel descending from heaven, he calls to his spouse ("haste hither *Eve*") so she may share this remarkable sight with him (5:308–13). Yet he follows this implicitly egalitarian invitation with a command that Eve "go with speed, / And what thy stores contain bring forth" (5:313–14), the reference to "*thy* stores [my emphasis]" assuming a division of labor far more drastic than that which Eve will later propose when she suggests that for maximum efficiency they work apart, but on similar tasks. Adam, by contrast, indicates that household labor divides along gender lines – a division which the scene itself proceeds to enact. Like Guazzo's Annibale, who remarks that "those men are to be laughed at, who having wise and sufficient wives, wil (as they say) set hens abroode, season the pot, [and] dresse the meate," Milton is unable to imagine an approbatory model of masculine domesticity (2:41; p. 106).

Eve, however, does not allow the premises of Adam's command to go unchallenged. She incisively corrects Adam's mistaken conception of paradisal economy, asserting that "small store will serve, where store, / All seasons, ripe for use hangs on the stalk." In Eden, in other words, one need not worry about bare cupboards. Yet the quiet authority Eve achieves in her superior knowledge of Edenic economy quickly modulates into a conventional figuration of feminine submission, as "at Table

Eve / Minister'd naked, and thir flowing cups / With pleasant liquors crown'd" while Adam and Raphael talk (5:443–5). But even as the actions of this scene exhibit the more oppressive aspects of a patriarchal hierarchy, in which woman functions as the silent servant who makes leisurely male conversation possible, Adam takes the opportunity to ask Raphael the compelling question Eve had asked him about why the stars shine at night (4:657–8). The fact that Adam appeals to a higher authority on a subject he had pretended to teach Eve subtly tarnishes his reputation for superior knowledge. Eve diplomatically chooses the occasion of Adam's astronomical inquiry to depart from "where she sat retir'd in sight" (8:41) in order to hear the answer later from Adam, because that will be more pleasurable, and will sustain the fiction of masculine intellectual supremacy. Eve's reticence exemplifies the "great modestie" recommended by Guazzo's Annibale, where even when a woman "knoweth a matter perfectly," she should "seeme to speake of it verie doubtfully" (1:241–2; p. 85v). As she exits, Milton endows her with a courtly prominence that her willed marginality defies; she leaves "With lowliness Majestic" (42), "With Goddess-like demeanor . . . Not unattended, for on her as Queen / A pomp of winning Graces waited still" (59–61). Fascinatingly, Milton resorts to the language of monarchical pageantry, where power is expressed in hordes of attendants, to depict the innate eminence of a solitary Eve.

In the conversation between angel and human, Raphael relates to Adam the details of Satan's rebellion, but Adam tells Raphael of something that seems to the angel as threatening as Satan's outright rebellion: Adam's profound love for Eve. Adam's celebration of this marginalized yet majestic being credits her with a touching yet troubling power over him: "here passion first I felt, / Commotion strange, in all enjoyments else / Superior and unmov'd, here only weak /Against the charm of Beauty's powerful glance" (8:530–3). The language of weakness – Eve's prerogative in the masculine hierarchy – is appropriated by Adam. The feelings he has for Eve defy the superiority he claims otherwise to exercise over her. Adam can rehearse effectively the principle of primogeniture which would justify his superiority by reference to the priority of his creation:

> For well I understand in the prime end
> Of Nature her th' inferior, in the mind
> And inward Faculties, which most excel,
> In outward also her resembling less
> His Image who made both, and less expressing
> The character of that Dominion giv'n
> O'er other Creatures. (8:540–6)

But he also knows by experience that Eve contains qualities which problematize her supposed inferiority; although created second, she seems like "one intended first, not after made / Occasionally" (8:555–6). Adam affirms his sense of Eve's authority in precisely those terms in which the case for his own purported superiority was made; not only does she seem like "one intended first," but she also possesses a power over him which verges on the "absolute rule" which his fair large front purportedly declares:

> yet when I approach
> Her loveliness, so absolute she seems
> And in herself complete, so well to know
> Her own, that what she wills to do or say,
> Seems wisest, virtuousest, discreetest, best.

The metrical awkwardness of the final line exposes the immense struggle involved in articulating equal love in a hierarchical universe. Like the Magnifico Giuliano in Castiglione's *Cortegiano*, Adam discovers the rhetorical difficulty of praising feminine accomplishment to a patriarchal audience. Critics are fond of likening Milton's own predicament in describing heaven to Raphael's statement of the problems inherent in relating "To human sense th' invisible exploits / Of warring Spirits" (5:565–6). I would argue that Adam's dilemma here – enunciating a principle of difference that defies inequality while confronting directly a representative of the masculine hierarchy in heaven – is precisely that facing Milton in his portrait of Adam and Eve throughout *Paradise Lost*. Rather than discovering a fully egalitarian lexicon for the relations of Adam and Eve, though, Milton allows a language steeped in hierarchy to emit periodic expressions of their respective authorities.

Thus, although Adam's "fair large front" declares an "absolute rule," Eve's "loveliness" grants her a power over Adam that verges on the "absolute." Catherine Gallagher has recently called attention to the surprising convergence of Toryism and feminism in the late seventeenth century in such figures as Margaret Cavendish and Mary Astell, made possible "because the ideology of absolute monarchy provides, in particular historical situations, a transition to an ideology of the absolute self."[13] Milton's recourse to the *roi absolu* he abhorred, as an image both of Adam's "absolute rule" and of Eve's *moi absolu*, offers a mirror image of this transition. Even the revolutionary Milton must employ the terminology of the absolute monarch he opposed in order to depict the individual authority he endorsed. The sovereign self is constructed from the very materials that would constrict it. Eve's capacity to generate erotic desire and to exist as "detached," "perfect," "free from all

restraint" (all available meanings of "absolute") subverts the inferiority her secondary generation advertises. Even "Authority and Reason" – the hallmarks of Adam's purported excellence – "on her wait," serving their purported subordinate (8:551–4). In a simile certainly chosen with the skeptical Raphael in mind, Adam compares the "awe" generated by Eve's "greatness of mind and nobleness" to that produced by "a guard Angelic" (8:557–9).

Raphael greets Adam's eloquent confession of amorous weakness with the "contracted brow" of angelic censure, warning him against "attributing overmuch to things / Less excellent" (8:565–6). Raphael suggests that Adam's feeling of inferiority in Eve's presence is in fact a repudiation of two authorities, both imagined as female: "Accuse not Nature, *she* hath done her part; / Do thou but thine, and be not diffident / Of Wisdom, *she* deserts thee not, if thou / Dismiss not her" (8:561–4; my emphasis). Remarkably, Adam's obedience to feminine principles will ensure masculine superiority. Adam argues that his profound admiration of Eve derives not, as Raphael implies, from "her out-side form'd so fair, nor aught / In procreation common to all kinds" but rather from

> those graceful acts,
> Those thousand decencies that daily flow
> From all her words and actions, mixt with Love
> And sweet compliance, which declare unfeign'd
> Union of Mind, or in us both one Soul. (8:596–604)

Adam eloquently grounds his love neither in appearance nor touch, but rather in the consecrated banalities of marital existence. Together they possess, asserts Adam, a marriage of true minds to which Raphael would admit impediments. Adam's description of Eve's "sweet compliance" eroticizes the courtly *sprezzatura* we have seen Eve display in her conduct to Adam. In their union, argues Adam, they achieve an intellectual mutuality that the pressures of the stratified universe they inhabit would prohibit. As the resident of a profoundly graduated and exclusively masculine heaven – although we are told that "Spirits when they please / Can either Sex assume, or both," we perceive with the fallen Adam that God "peopl'd highest heav'n / With Spirits Masculine ... Angels without Feminine" (1:423–4; 10:889–93) – and sent to warn Adam and Eve about Satan, not to offer them marital counseling, Raphael is particularly ill-equipped to comprehend the migratory authority amid sexual difference that Adam describes in his relationship with Eve. The voice of angelic authority sounds rather shrill against Adam's compelling defense of his love for Eve.

Throughout this dialogue, we must remember that Adam's extraordinary appreciation of feminine virtue occurs as part of the afterdinner conversation of two males who have just been served by a woman. As in *Il Cortegiano* and *La Civil Conversatione*, woman is at once a central subject of male conversation and positioned at its margins. A related tension between Eve's primacy and her marginality can be heard in the conversation between Adam and Eve the morning of the fall. Eve speaks "first" this morning, ingeniously proposing that they work apart in order to quell more efficiently the "wanton growth" about which both have expressed concern (9:205–25). Adam's laudatory response – "Well hast thou motion'd ... for nothing lovelier can be found / In Woman, than to study household good, / And good works in her Husband to promote" (229–34) – foists a hierarchy of gender onto Eve's "highly creative" suggestion.[14] Expressing a concern, at once tender and condescending, for the welfare of Eve, the "weaker vessel," without him, Adam again translates anatomy into politics, agreeing with St. Paul and Guazzo's Annibale that "the wife, as the weaker vessell, must obay the husbande" (2:30; p. 101). By using the ideology of feminine inferiority to argue for their working together – "other doubt possesses me, lest harm / Befall thee sever'd from me" – Adam articulates his emotional need for Eve in the terms of her custodial need for him: "The Wife, where danger or dishonor lurks, / Safest and seemliest by her Husband stays, / Who guards her" (267–9).

Eve reacts "As one who loves, and some unkindness meets," appropriately hearing in Adam's words a hint of how "un-kind" male and female are in his emphasis upon the hierarchical significance of the differences between them. Despite her claim in book 4 that "what thou bidd'st / Unargu'd I obey," Eve persists in her wish to work apart. She wonders how Adam came to "harbor" such negative "Thoughts ... of her to thee so dear" (288–9). The question betrays the inherent contradiction of a heterosexual yet patriarchal culture, inquiring how a concept of woman's inferiority can be harmonized with a notion of a woman as the fit object of masculine desire. Eve proceeds to ask another unanswerable question, this time exposing the claustrophobia bred by the need for continual vigilance, eternal companionship, and perpetual subordination: "If this be our condition, thus to dwell / In narrow circuit strait'n'd by a Foe, / Subtle or violent ... / How are we happy, still in fear of harm?" (9:322–6). (As is well known, Milton now puts into Eve's mouth a version of his own eloquent plea from *Areopagitica* for the need of virtue to be tested.) Eve cleverly interprets Adam's call for perpetual wariness as a suspicion of divine providence:

> Let us not then suspect our happy State
> Left so imperfect by the Maker wise,
> As not secure to single or combin'd.
> Frail is our happiness, if this be so,
> And *Eden* were no *Eden* thus expos'd. (9:337–41)

We are meant I think to feel deeply the force of her critique of the precarious and confined existence Adam describes. Adam, indeed, has no real rejoinder. Discussing the husband's prerogative to confine his wife at home, Guazzo's Annibale remarks that "a dishonest women can not be kept in, and an honest ought not ... And in truth she only is to bee counted honest in deed, who having liberty to do amisse, doth it not" (2:24; fol. 99). Adam likewise refuses to command his wife to remain with him. He tries, though, to convert his surrender into an exercise of his authority by recourse to the paradox that forced presence is in fact heightened absence: "Go; for thy stay, not free, absents thee more" (372). Eve brilliantly grants Adam the fiction of this precarious authority, saying that she leaves "With thy permission then," converting her discursive victory into an act of wifely submission. The narrator tells us that she "Persisted, yet submits, though last"; the syntactical twists and turns register the baffling politics of their relationship at this moment. We watch as "From her Husband's hand her hand / Soft she withdrew," reversing the gesture and direction of their first touch. Then Adam had "seiz'd" her hand, but now she frees herself, at least briefly, from a world in which such acts of patriarchal appropriation are celebrated.

Satan's courtly idealization of Eve provides an immediate and striking contrast to the reproof and inferiority we have just seen Adam offer. Far from arming Eve against their foe, Adam's stern warnings render her more susceptible to Satanic flattery, and especially to his offer of independence and self-improvement. In his approaches to Eve, Satan successfully adopts the strategically submissive conduct that is a central element of the books of Castiglione's *Cortegiano* devoted to the courtly male.[15] Using the sweetened pill of praise prescribed by Castiglione as a tactic for influencing the behavior of a superior, Satan extols Eve as "sovran Mistress," "Empress of this fair World," "Sovran of Creatures," "Fairest resemblance of thy Maker fair," and "Goddess humane," and tells her that she deserves to be "ador'd and serv'd / By angels numberless, thy daily Train" (9:532, 538, 568, 612, 732, 547–8). By bestowing upon her such exalted political titles, Satan literalizes Adam's characterization of Eve's absoluteness; he also deploys the same terminology of monarchical pageantry that the narrator uses to describe

Eve's majestic exit in book 8. Eve initially responds to the serpent's adulation with appropriately witty skepticism: "Serpent, thy over-praising leaves in doubt / The virtue of that Fruit, in thee first prov'd" (615–16). But even as Eve challenges the ritual hyperbole of courtly praise, displaying yet again a kind of *sprezzatura* in her graceful self-deprecation, Satan's flattery stirs the desire for autonomy she has just voiced with Adam.

After eating the fruit, Eve initially finds that it accomplishes all that the serpent promises – the enhancement of status and knowledge. Indeed, she contemplates the possibility of sustaining the sexual super-iority present in what she apprehends as her increased wisdom, hoping to "keep the odds of Knowledge in my power / Without Copartner." This would compensate, she hopes, for the inferiority Adam has just described in detail to her, supplying "what wants / In Female Sex." It might also, she reasons, render her at least "more equal, and perhaps, / A thing not undesirable, sometime / Superior; for inferior who is free" (9:816–25). Unable to imagine the coexistence of hierarchy and freedom, Eve desires a superiority that Adam ostensibly possesses but seems neither to want nor to be capable of maintaining. The Orwellian phrase "more equal" highlights both the illogic of her wish, and the asymmetry of the sexes that the fall throws into relief. Even in falling, though, Eve conceives a new form of social life, like that Milton briefly imagined in *Tetrachordon*, in which women as well as men might possess the "power" bestowed by "the odds of knowledge."

In a cruel parody of Adam's original desire for an equal companion, Eve offers the fruit to Adam so "that equal Lot / May join us, equal Joy, as equal Love; / Lest thou not tasting, different degree / Disjoin us" (9:881–4). Unfortunately for Eve, however, misogyny and subjugation, not "equal Joy" and "equal Love," are produced by the fall. Remark-ably, especially because Milton was such an ardent defender of divorce on grounds of spiritual incompatibility, Adam's immediate response is not to contemplate separation, but rather to feel himself already fallen with Eve, even before he eats the forbidden fruit. The "Enemy," Adam asserts, "mee with thee hath ruin'd, for with thee / Certain my resolution is to Die" (905–7). The narrator tells us that by falling with Eve rather than asking God to make "another Eve," Adam is ...fondly overcome with Female charm" (9:999). But this explanation seems particularly inadequate to the splendid love the mortal couple have articulated and practiced up to this point. Had Adam dismissed this Eve and asked God for another, he would have retrospectively devalued each of his compell-ing utterances of love for her. At the beginning of book 9, the narrator

laments that he "now must change / Those Notes to Tragic." The work would have felt much more like a classical tragedy, however, if Adam had chosen to sacrifice Eve to sustain his own paradisal existence. Adam's loyalty to Eve allows the circumstances of classical tragedy to issue in Christian comedy. The strain between obedience to God and fidelity to Eve, between theology and social practice, is immense, felt deeply by Adam and by the poem's readers.

Postlapsarian discourse is quickly drawn by the fall into overtly repressive versions of the gender hierarchy that Milton wishes to depict as gently imbuing paradisal existence. Eve, for example, turns her inferiority back upon Adam, castigating him for failing to exercise over her the "absolute rule" with which the narrative voice of book 4 explicitly endowed him: "Being as I am, why didst not thou the Head / Command me absolutely not to go ... Too facile then thou didst not much gainsay, / Nay, didst permit, approve, and fair dismiss" (9:1155–9). Eve here deploys the now-unquestioned assumption of her own subjection as a tactic for reprehending the conduct of her superior. Yet the very boldness of the censure defies the absolute power she assumes Adam possesses. Adam in turn generalizes his experience to all occasions where men do not tyrannize over women: "Thus it shall befall / Him who to worth in Woman overtrusting / Lets her Will rule; restraint she will not brook, / And left to herself, if evil thence ensue, / Shee first his weak indulgence will accuse" (9:1182–6). Significantly, only after the fall does the sort of misogyny normally assigned to the tale of the first man and woman begin to surface. Forgetting his original appetite for her society, Adam tells Eve that "But for thee / I had persisted happy" (10:873–4). Like the misogynist Guazzo of *La Civil Conversatione*, who asserts that "if the worlde coulde bee maynteined without women, wee shoulde live like God himselfe" (1:232; fol. 81v), Adam interrogates the very reason for the existence of woman: "O why did God, / Creator wise, that peopl'd highest Heav'n / With Spirits Masculine, create at last / This novelty on earth?" (10:888–91). The precious mutuality implicit in the unstable hierarchy of the sexes before the fall evaporates, leaving only the "mutual accusation[s]" of two who wield the patriarchal hierarchy as an instrument of guilt.

As Adam curses Eve, terming a "serpent" and a "fair defect / Of nature" the creature without whom he could not conceive paradisal existence, Eve "with Tears that ceas'd not flowing, / And tresses all disorder'd, at his feet / Fell humble, and imbracing them, besought / His peace" (10:910–13). Her words and gestures move Adam precisely because of the profound and sincere submission they aver. "Thy

suppliant / I beg, and clasp thy knees," she declares, positioning Adam as an absolute ruler with a creature attesting total submission at his feet. Yet her "lowly plight ... in *Adam* wrought / Commiseration." The vision of Eve "at his feet submissive in distress," combined with her trenchant declaration of "love sincere, and reverence in [her] heart," subdues Adam's ire; "As one disarm'd, his anger all he lost, / And thus with peaceful words uprais'd her soon" (945–6). This remarkable moment at once offers the fulfillment of a misogynist fantasy of absolute female submission and supplies the consummate example of Eve's unequalled social and verbal imagination. Eve's subjugation paradoxically exercises the nearly military power to "disarm" the anger with which Adam has fortified himself against her. Initiating a more complex politics, Eve proposes that they redirect their enmity at Satan, and find solidarity in a common enemy. In declaring that "both have sinn'd but thou / Against God only, I against God and thee," Eve restates in terms of her own guilt the epic's most blatant declaration of masculine superiority – "Hee for God only, shee for God in him." But in doing so, she also behaves in a way which is intimately related to the conduct of the Son (as critics have long noted), seeking the full weight of God's punishment on herself in her plea that "all / The sentence from thy head remov'd may light / On me, sole cause to thee of all this woe, / Mee mee only just object of his ire" (10:914–36). Moreover, after the reconciliation with Adam, Eve continues to generate ways to limit punishment to themselves, proposing either that they have no children or that they commit suicide (10:986–1006). A postlapsarian incarnation of Eve's "sweet attractive grace," her prostration at Adam's feet not only advertises the absolute humiliation a patriarchal culture demands of woman, but also provides the first instance in the epic, and in human history, of the simultaneously redemptive and manipulative powers of submission.

Indeed, it is by imitating Eve that Adam imagines the possibility of a mode of conduct towards God which might begin to repair what they have lost. Extrapolating from the power that Eve's submission exercised over him, Adam suggests that he and Eve initiate their reconciliation with God by returning to the place "where he judg'd us, [and] prostrate fall / Before him reverent, and there confess / Humbly our faults, and pardon beg." As adept at intellectual analogy as Eve is at imaginative invention, Adam reasons that "Undoubtedly [God] will relent and turn / From his displeasure." Eve's "lowly plight, / Immovable" supplies the pattern for their joint prayer "In lowliest plight."[16] By authoring the social application of supplicatory posture, Eve inaugurates the civilizing

process of postlapsarian humanity; by turning such prostration to God, Adam initiates the reconciliation of human and divine.

The situation of the final two books reprises the experience of the middle four. Again an angel visits earth, but this time Eve is allowed neither to eavesdrop upon, nor to exclude herself from, the discourse between Adam and the angel. Rather, Eve is here given "gentle Dreams" intended to compose "all her spirits ... To meek submission" (12:595–7) while Adam is granted a vision of biblical history. Adam translates this vision into profound but somewhat prosaic lessons in proper conduct: "Henceforth I learn, that to obey is best, / And love with fear the only God, to walk / As in his presence, ever to observe / His providence, and on him sole depend" (12:561–4). Michael approves Adam's homily, and pledges that subjection of the self to rules of ethical conduct – a moralized version of courtly self-fashioning – will issue in a redeemed and redeeming inner life (the "paradise within thee") which contains the essence of the paradisal garden Adam and Eve must leave. Pleasing an absolute God by obedience to this moral code will for Milton supplant the courtly project of subjecting the self to the whims of a mortal monarch. Rather than the self-improvement Eve sought in eating the fruit is self-governance grounded in submission to God. If in *Paradise Lost* Satan's greatest torment lies in the fact that Hell is an interior state he cannot escape (4:20–3), then humanity's greatest hope lies in the corollary discovery that Paradise is ultimately a function of disposition rather than geography.

Milton, though, leaves it to the woman who has been sleeping throughout this lesson to clarify the processes by which this inner paradisal existence may be incorporated into postlapsarian social practice. The content of Eve's dreams – unlike that of her earlier Satan-inspired dream – is never revealed. But like the "nightly visitation[s] unimplor'd" of Milton's celestial muse, these dreams not only compose Eve's "spirits ... to meek submission," but also inspire her with a knowledge of the postlapsarian human situation that equals, if not surpasses, the behavioral precepts available to Adam. Although Adam is sent to awaken Eve, she is already awake when he arrives; instead of authoritatively telling her what he has seen and learned, she addresses him as he listens. Willingly submitting to Adam, Eve nevertheless is given the last speech in the epic (12:610–23), a blank verse sonnet which brilliantly locates the mysterious internal garden described by Michael within the terrestrial institution of postlapsarian marriage. "Lead on," she tells Adam, "In mee is no delay; with thee to go, / Is to stay here; without thee here to stay, / Is to go hence unwilling." Adam "answer'd

not," responding with respectful silence to the quiet authority of Eve's submissive speech. By declaring that "with thee to go, / Is to stay here," Eve identifies social relations as one site of the mysterious "paradise within thee, happier far" promised by Michael. Unlike his contemporary John Bunyan, whose *Pilgrim's Progress* (1678) begins with Christian plugging his ears so that he will not hear the cries of his wife and children as he abandons them to search for "Life, life, eternal life," Milton finds familial bonds to epitomize rather than oppose the quest for spiritual redemption.[17] His Eve is given the crucial task of articulating the processes by which marital companionship may enclose what is most important of the garden she and Adam must leave. Affiliated with the redemption creatively as well as procreatively, she may take "further consolation" not only in the thought that "though all by mee is lost ... By mee the Promis'd Seed shall all restore," but also in the power of her words and conduct to generate and interpret the fundamental patterns of postlapsarian existence.

In our final view of Adam and Eve, they leave Paradise "hand in hand," in the egalitarian posture they had assumed there (4:320). Instead of the "narrow" paradisal existence that Eve had critiqued the morning of the fall looms a terrifying yet liberating expanse: "The World was all before them, where to choose / Thir place of rest." Such openness, however, is also profoundly isolating, as they "Through *Eden* took thir solitary way." The haunting penultimate word of this epic so obsessed with the origins of society indicates that the fallen couple are granted the mixed blessing of the solitude Eve had desired and Adam had shunned. Although Adam's homily emphasizes the importance of "walk[ing] / As in [God's] presence" (12:562–3), perhaps mortals need at least the fiction of privacy in order to produce the social life whose practice will inaugurate the Paradise within. "Imparadis't in one another's [hands], / The happier *Eden*," to borrow a phrase from Satan's description of their prelapsarian relationship (4:506–7), Adam and Eve exit Paradise.

In *Paradise Lost*, then, the aspirations and behaviors of the Renaissance courtier are absorbed and redirected to purposes far beyond their original goal of survival at an absolutist court. Ingratiating submission to a mortal monarch is replaced by sincere obedience to a kingly god. Moral self-cultivation supplants theatrical self-presentation. Most importantly, the franchise of creative submissive conduct is expanded to include women. Indeed, Milton emphasizes that the first woman is the terrestrial source of such behavior. In this emphatic redirection of its tropes, Milton teaches us much about the resources and limitations of

the Renaissance discourse of courtesy, while courtesy literature in turn allows us to see how gestures of submission in Milton are at once static and dynamic, unquestioned declarations of one's place in a hierarchy and the necessary condition for rising. When reacting to the submission that the text and the tradition demand of woman, we must keep in mind the omnipresence of submission as a mode of social behavior in the Renaissance. In his exploration of the way that Eve's relation to Adam mirrors other hierarchical relationships, both those he cherished and those he labored to repudiate, Milton offers a compelling if incomplete correlation of the parallel inequities of status and gender. By locating Eve's gestures of submission against the vibrant and empowering submission demanded of the Renaissance courtier, we can see more clearly what possibilities Milton awakens, and what remain dormant, in his portrait of the two great sexes that animate the world.

Like the "Celestial Patroness" who inspires Milton's frequently masculinist poetry, Eve functions as the progenitor of a decidedly patriarchal culture. The imagination of female subjectivity was somehow immensely liberating for the former Lady of Christ's, allowing him to ventriloquize troubling questions about the universe whose creator he was justifying, and to express compellingly his own reformist convictions. This should not be surprising, since Milton's God is himself a master of subversion, "by small / Accomplishing great things, by things deem'd weak / Subverting worldly strong, and worldly wise / By simply meek" (12:566–9). Working within a Christian system designed to repudiate the primogeniture of worldly hierarchies in its declaration that the last shall be first, Milton appropriately appealed to the secondary figure his culture termed a "weaker vessel" to accomplish great things. Eve is a central figure in Milton's redefinition of epic heroism and his reformation of human conduct, epitomizing in her willing adoption of supplicatory posture "the better fortitude / Of Patience and Heroic Martyrdom / Unsung" (9:31–3). Throughout the epic, Eve's capacity to produce the significant patterns of human social life and to engineer solutions to pressing social problems grants her a dignity that neither the text nor the masculine hierarchy it asserts can fully contain. Assimilating and reforming the courtly guide to polite behavior, *Paradise Lost* locates the genesis of terrestrial courtesy in the "greatness of mind" possessed by its central female character. In doing so, it uses the constrictions of courtesy literature to construct a space – albeit limited, and only sporadically inhabited – for the conception of active female virtue.

Notes

1 Cf. Daniel Javitch, "Rival Arts of Conduct in Elizabethan England: Guazzo's *Civile Conversation* and Castiglione's *Courtier*," *Yearbook of Italian Studies* 1 (1971), 178–98.
2 *The Book of the Courtier*, trans. Charles S. Singleton, (Garden City, N.Y., 1959), 2.97, p. 194. I have compared Singleton's translation to, and occasionally cite key phrases from, *Il Libro del Cortegiano* (1528), ed. Giulio Preti (Turin, 1960), as well as from the translation of Sir Thomas Hoby (1561), *The Book of the Courtier*, ed. W. B. Drayton Henderson (London, 1928).
3 Cited by Kuchta above, p. 245 n. 1.
4 *The Civile Conversation of M. Steeven Guazzo*, trans. George Pettie (books 1–3, 1581) and Bartholomew Young (book 4, 1586), ed. Edward Sullivan (London, 1925), 1:239; Annibale is clearly travestying the Marriage Service here. I have compared Pettie's translation to *La Civil conversatione del Sig. Stefano Guazzo* (Venice, 1579), p. 85, which I cite by folio number in the text, following reference to volume and page of Pettie's translation. For other works by Pettie, see Juliet Fleming's essay in this volume.
5 "Life of Milton," cited in James Thorpe, ed., *Milton Criticism: Selections from Four Centuries* (New York, 1950), pp. 80, 76. The affinity between Milton's epic and the conduct book is noted in Levin L. Schucking, *The Puritan Family: A Social Study from the Literary Sources*, trans. Brian Battershaw (New York, 1970), p. 103.
6 See Christopher Hill, *Milton and the English Revolution* (Harmondsworth, 1978), pp. 71–2. Milton's republicanism is linked to his unease with gender hierarchy by Susanne Woods; "How Free Are Milton's Women?" in Julia M. Walker, ed., *Milton and the Idea of Woman* (Urbana, 1988), p. 19.
7 *Paradise Lost*, 4:299, cited from Merritt Y. Hughes, ed., *John Milton: Complete Poems and Major Prose* (New York, 1957). All citations of Milton's poetry are from this edition.
8 Don M. Wolfe *et al.*, eds., *Complete Prose Works of John Milton* (New Haven, 1953–82), vol. II, p. 589. All citations of Milton's prose are from this edition.
9 For "that venerable masculinist tradition of female delay in which reluctance makes the object of desire more desirable still," see Patricia Parker, *Literary Fat Ladies: Rhetoric, Gender, Property* (London, 1987), pp. 16–17, 192, 197.
10 Cf. Mary Nyquist on "Heav'n's last best gift" (5:19), a phrase which "cannot finally obscure Eve's secondary status as a 'gift' from one patriarch to another"; "The Genesis of Gendered Subjectivity in the Divorce Tracts and in *Paradise Lost*," in Nyquist and Margaret W. Ferguson, eds., *Re-membering Milton: Essays on the Texts and Traditions* (New York, 1987), p. 106.
11 4:639–56. These lines have been remarked on by virtually all critics, for example, James Grantham Turner, *One Flesh: Paradisal Marriage and Sexual Relations in the Age of Milton* (Oxford, 1987), p. 238, and Janet Halley, "Female Autonomy in Milton's Sexual Politics," in Walker, ed., *Milton and the Idea of Woman*, p. 248.
12 *Il Cortegiano*, 1:26; p. 43. Cf. Frank Whigham, *Ambition and Privilege: The Social Tropes of Elizabethan Courtesy Theory* (Berkeley, 1984), p. 93. I owe this

point about the definition of *sprezzatura*, and its appropriateness to Eve's expressions of humility, to James Turner.

13 "Embracing the Absolute: The Politics of the Female Subject in Seventeenth-Century England," *Genders* 1 (Spring 1988), 25.

14 Cf. Keith Stavely, *Puritan Legacies: "Paradise Lost" and the New England Tradition 1630–1890* (Ithaca, 1987), p. 46.

15 On the tactical deference of the courtier in Satan, see my "'Among Unequals What Society?': Strategic Courtesy and Christian Humility in *Paradise Lost*," forthcoming in Wendy Furman, Christopher Grose, and William Shullenberger, eds., *Riven Unities: Milton's Vision of Self, Gender, Society, and Death*, a special issue of *Milton Studies* 28 (Spring 1992), 71–93.

16 10:1087–9, 937–8, 11:1. For Eve's initiative in setting the new paradigm of heroic submission, see Maureen Quilligan, *Milton's Spenser: The Politics of Reading* (Ithaca, 1983), pp. 239–42.

17 Ed. Roger Sharrock (Harmondsworth, 1965), p. 41. Of course in part 2, published in 1684, Christian's wife and children follow in his footsteps, and are finally reunited with him in the Celestial City.

Index

৯৯

Index

Index